INDIAN HIGHWAY

Musée d'art contemporain de Lyon
Indian Highway IV

Koenig Books

Bloomberg is proud to continue its support of the Serpentine Gallery by sponsoring *Indian Highway*. Following the rapid economic, social and cultural developments in India in recent years, *Indian Highway* is a timely presentation of the pioneering work being made in the country today. This group exhibition is a snapshot of a vibrant generation of artists working across a range of media. The theme of *Indian Highway* reflects the importance of the road in migration, as well as referencing technology and the 'information superhighway', which has been central to India's economic boom.

Bloomberg is about information: accessing it, reporting it, analysing it and distributing it, faster and more accurately than any other organisation while constantly adapting to an ever-changing marketplace. Bloomberg is the fastest-growing real-time financial information network in the world and provides business and financial professionals with the tools and data they need on a single, all-inclusive global platform. The New York-based company employs more than 10,000 people in over 126 offices around the world.

Bloomberg is a company that values people and our philanthropy programme is central to creating an environment and an atmosphere that inspires and challenges our clients, employees and local communities. Our philanthropy programme reflects the philosophy of founder Michael R Bloomberg who has made a commitment to increase access to education and to improve communication across cultures and boundaries. Bloomberg's sponsorship of the Serpentine Gallery's *Indian Highway* and the Serpentine's unique and outstanding Education Projects reflects this philosophy and its core principles of innovation and adventurous creativity.

Bloomberg

CONTENTS

PREFACE

I.
... Within a perimeter arbitrarily cut into the terrestrial surface[1]

'The singular is a question of perception', writes Dipesh Chakrabarty, with regard to history.[2] According to such thinking, Eurocentrism as the invention of the 'barbarian', or Marcel Detienne's construction of 'the rooted autochthon', even the very notion of 'civilisation' – these are just questions of viewpoint or angle. So much the better for the conscience of the West!

In Jack Goody's view, the Eurocentric bias began in the Bronze Age, around 3,000 BC, when 'the culture of cities' flourished, and the first complex societies developed. At this time, the West committed a 'theft of history', in which the achievements of other cultures were appropriated.[3] And now, long afterwards, saving face has entailed the invention of 'emergence' (as applied to certain 'third world' countries), tourism and globalisation. It has also entailed the extinction of Enlightenment ideals.

Some 5,000 years after this 'theft', the curator Harald Szeemann modestly imported 'China' into Europe when he put the country's contemporary art on display in 1997 at the fourth Lyon biennial, *L'Autre* ('The Other'). And later, at the Venice Biennale, he amplified the phenomenon. This took place some time after Jean-Hubert Martin's exhibition *Les Magiciens de la Terre*,[4] but it was still exoticism.

To postulate the sudden existence of 'China', 'India', 'the Middle East' and 'Africa' reinforced the myth of the West, and meant adopting, 'butt to butt',[5] a dualistic historiographic fable: Us/Them, here/there, inside/outside ...

In 1927 – in other words, long before Edward Said's account of the Western exoticising of the East, *Orientalism* (1978) – the celebrated Indian poet Rabindranath Tagore wrote of 'the curry odour of realism', and 'the pretensions of poverty [...] that were used to spice up the literary effect in Bengal'.

But what kind of history would it be that avoided Eurocentrism and orientalism of every kind? And what kind of exhibition?

A desperate attempt, perhaps. *Indian Highway IV* is more like an exercise in reciprocity. Let us call it a *Partage d'Exotismes* (a sharing of exoticisms).[6]

After Tagore, our (as opposed to 'their') bad conscience was exposed by Frantz Fanon (*Black Skin, White Masks*, 1952), Aimé Césaire (*Discourse on Colonialism*, 1955) and Albert Memmi (*The Colonizer and the Colonized*, 1956).

Well after the postulation of sociologist Max Weber's 'ideal types', historian Paul Veyne's notion of 'intrigue' and Michel de Certeau's 'heterology' (science of 'the other'), which were questions asked of History, but well before the invention of French Theory (in reality, an Anglo-Saxon invention), it took some time for a comparativist, 'multi-city', global, connected history to evolve. It also took time for the infinite variations of temporalities and imagined communities to be observed (such as by Benedict Anderson in his book of 1983), and, finally, for multiple modernities to be conceived (notably by Israeli sociologist Shmuel Noah Eisenstadt).

The quarrel of hegemonies is not over. 'Subaltern studies' have made a large contribution to Bruno Latour's 'symmetric anthropology', and to cultural studies and their Indo-Anglo-Saxon avatars.

The erosion of the Enlightenment's rationalist, universalist heritage has now made considerable progress. After *Partage d'Exotismes*, here comes exoticism *shared* (more or less, and without an 's'). So let us join S. Subrahmanyam in taking a 'sidestep', and working, as far as possible, on a 'betwixt and between', in other words exchange and circulation.

Let us follow the impure, blood-drenched, but also pacifying furrow of Latour's idea that: 'There have never been barbarians. We have never been modern.'[7] Let us put the charm of symmetry into practice and articulate our reflexivities with passion and meticulousness. And let us follow this furrow to drive home the point that: 'Incapable of seeing in him the attachments that make him act, he who believes himself, on this account, to be Western, imagines other people not to be that, and consequently to be wholly "Other", whereas they differ only in that which, precisely, attaches them.'

To put it briefly, we might suggest that there is no more essence in hybridism than in creolism. There is only history.

To quote Carlo Ginzburg: 'The historian must start with the hypothesis that in every individual whomsoever, even the most abnormal (and it may be the case that every individual is abnormal, or at least may appear to be so), there is a coexistence of elements shared by a variable number of individuals (between none and several billion).'[8]

At this point, we can perhaps attempt the perilous exercise of tackling an exhibition entitled *Indian Highway*.

II.
Our resemblances of today have taken different routes[9]

The Monk and the Demon, an exhibition curated by Fei Da Wei in 2004, gave a complex and (inevitably) ephemeral image of contemporary Chinese art. *Indian Highway*, devised by Julia Peyton-Jones, Hans Ulrich Obrist and Gunnar B. Kvaran for the Serpentine Gallery in London and the Astrup Fearnley gallery in Oslo, examines the Indian dynamic.

The exhibition will cross three continents: Europe, South America and Asia. *Indian Highway* reflects a new global artistic economy, and it will be successively reinterpreted by more than ten curators, on the basis of the initial format. Each local incarnation of this work in permanent progress will be different, and it will reveal itself in all its completeness only at the end of its itinerary and its diverse interpretations. Each of its stages introduces something different: new associate curators, new artists (in Lyon: Sarnath Banerjee, Hemali Bhuta, Desire Machine Collective, Shanay Jhaveri, Jagannath Panda, Valay Shende, Sumakshi Singh, Thukral & Tagra), new works (by Subodh Gupta, N.S. Harsha, Barthi Kher, Dayanita Singh, etc.), new spatial configurations, and in this case an exhibition devoted to guest artists Studio Mumbai & Michael Anastassiades.

If *Indian Highway* were a television series, one could now write: 'Season 2, episode 4: The Highway Takes Off'. Opening in February 2011, *Indian Highway IV* will spend five months in Lyon, occupying 2,000 square meters of exhibition space, with thirty-one artists (some prominent on the international circuit, others young and less well known), new monumental works, site-specific installations, the Studio Mumbai & Michael Anastassiades exhibition (which won the Jury's Congratulations at the Venice Architecture Biennale in 2010)

and a reworking of Bose Krishnamachari's curatorial project for the 2012 Kochi Biennial.

As a new curatorial principle, *Indian Highway*'s proposal responds to flows, controversies, multiple critical positions, forms of knowledge (or lack of it), analysis, prospects and traditions, subaltern studies and post-colonial attitudes. It responds to works of extreme diversity. At best, it acts out an intense circulation of forms, aesthetics and ideas. And this is the only approach that remains valid in late modernity for grasping cultural complexity and multiform creativity.

For the fact is that, whatever the subject, the conventional exhibition, with its universalist, thematic, closed outlook, is now obsolete, given that its character has traditionally been dictated in a unilateral way by a central authority or institution for ready-made consumption and circulation.

Indian Highway, by contrast in its consistency – and *Indian Highway IV* is an indication of this – seeks as far as possible to put aside yesterday's thinking, which presupposes something from 'there' as opposed to 'here', and to avoid exoticisms, while superimposing interpretive stories and diverse circumvolutions.

The following stages will see *Indian Highway V, VI, VII*, etc. at MAXXI in Rome, then Moscow, Singapore, Hong Kong and Delhi.

Thierry Raspail
Associate Curator
Director of the Musée d'Art Contemporain, Lyon

1 Paul Veyne, *Comment on écrit l'histoire*, Le Seuil, Paris, 1971.
2 In Dipesh Chakrabarty, *Provincializing Europe: Postcolonialist Thought and Historical Difference*, Princeton University Press, Princeton, 2000.
3 See Jack Goody, *The Theft of History*, Cambridge University Press, Cambridge, 2007.
4 Magicians of the Earth, Centre Georges Pompidou and the Grande Halle at the Parc de la Villette, Paris, 1989.
5 To quote from the title of a work in our collection by Bruce Nauman.
6 The title of the 2000 Lyon biennial, curated by Jean-Hubert Martin.
7 Bruno Latour, *Nous n'avons jamais été modernes, essai d'anthropologie symétrique*, La Découverte, Paris, 1991, and Bruno Latour, *Sur le culte moderne des dieux faitiches*, La Découverte, Paris, 2009.
8 In Carlo Ginzburg, *Myths, Emblems, Clues*, Radius Books, Santa Fe, 1990.
9 Robert Musil, *Diaries, 1899–1941*, Basic Books, New York, 1998.

FOREWORD

Following the remarkable and rapid economic, social and cultural developments in India in recent years, *Indian Highway* is a timely presentation of the pioneering work being made in India today, embracing art, architecture, film, literature and dance. The culmination of extensive research over a lengthy period of time, *Indian Highway* is a snapshot of a vibrant generation of artists working across a range of media, from painting, photography and sculpture to installation and Internet-based art and video. It features those who have already made an impact on international art juxtaposed with emerging practitioners.

Some artworks in the exhibition have been selected for their connection to the theme of *Indian Highway*, reflecting the importance of the road in migration and movement as well as being the link between rural and urban communities. Other works make reference to technology and to the 'information superhighway', which has been central to India's economic boom. A common thread throughout is the way in which these artists demonstrate an active political and social engagement, examining complex issues in an Indian society undergoing transition, including environmentalism, religious sectarianism, globalisation, gender, sexuality and class.

Indian Highway is the second chapter in our focus on the arts of three major cultural regions – China, India and the Middle East – reflecting a shift from Western to emerging global economies, conceived and organised by the Serpentine Gallery and the Astrup Fearnley Museum of Modern Art. It follows *China Power Station*, presented by the Serpentine at Battersea Power Station, London, in 2006; at the Astrup Fearnley Museum of Modern Art, Oslo, in 2007; and at the Musée d'art moderne Grand-Duc Jean, Luxembourg, in 2008.

Indian Highway adopts a model of curating in which, at each new presentation of the exhibition, a guest curator is invited to develop their own project as a temporary, autonomous element within the show. Conceptually, the exhibition draws on Édouard Glissant's notion of *mondialité*, which seeks to foster dialogue while resisting the homogenising forces of globalisation. For the inaugural presentation of *Indian Highway* at the Serpentine Gallery in 2008, Delhi-based artists Raqs Media Collective provided an additional curatorial voice by engaging the participation of a number of documentary filmmakers. This curatorial model was continued at the Astrup

Fearnley Museum of Modern Art in 2009, when artist Bose Krishnamachari was invited to curate a section of the exhibition, and at HEART – Herning Museum of Contemporary Art, Denmark, in 2010, when artist Shilpa Gupta presented a programme of contemporary Indian films.

At Musée d'art contemporain de Lyon, working in collaboration with museum director Thierry Raspail, we have again developed a new presentation of *Indian Highway*, in which the range of participating artists has been expanded further by inviting Studio Mumbai Architects to create their own 'show within a show'. Over the next three years, continuing the initial curatorial concept, a different Indian artist or group will curate a section within the exhibition at each subsequent international venue in Rome, Moscow, Hong Kong and Delhi, allowing it to grow and develop in new and unexpected ways as a complex, dynamic system.

From the conception of *Indian Highway* to its realisation at the Serpentine Gallery, we have been immensely fortunate to receive great support and encouragement, most particularly from our friends and colleagues in India. We are enormously grateful to the many artists, representatives and collectors who opened their studios, galleries and homes, and who contributed so much to our understanding of the extraordinary history and culture of India. The hundreds of individuals and organisations involved have been exceptional and without them, realising the exhibition would have been impossible. We are indebted to them all and extend the broadest and most heartfelt thanks to everyone who has participated in this project.

We are particularly grateful to all of the artists who accepted the invitation to exhibit their work in *Indian Highway*, for their enthusiasm and commitment in helping us realise the exhibition, not only in London and Oslo, but also as the exhibition travels the world.

This exhibition would not have been possible without the collectors who generously agreed to lend their works for the exhibition and we are indebted to them. We also extend our thanks to the artists' representatives for the assistance they have offered in many aspects of organising this exhibition.

We acknowledge all those who have offered their expertise, advice and suggestions. We mention in particular our associate, Savita Apte, for her invaluable guidance and involvement in numerous aspects of the exhibition in London and Oslo, and Francesco Manacorda for his early advice, as well as our excellent guides and advisors in India: Niyatee Shinde and Priya Jhaveri in Mumbai; Vidya Shivadas in Delhi; and Suman Gopinath in Bangalore.

To expand the focus of *Indian Highway* beyond the visual arts, a season of public events relating to Indian culture has been programmed to accompany the exhibition during its presentation at Musée d'art contemporain de Lyon. In addition to gallery talks, the series includes performances of Indian dance and fusion music, as well as a programme of experimental electronic music by DAWOOD/DEORA. We are very grateful to all the participants for their willing involvement in this project.

Like the exhibition, this publication has been developed and augmented as it has been revised and reprinted for each institution presenting *Indian Highway*. We are delighted to include a guide to the current flourishing art scene in India by curators and writers Suman Gopinath and Grant Watson. The catalogue also features texts on the artists and their historical and cultural context by Geeta Kapur, the eminent scholar of Indian visual culture; by Ranjit Hoskote, co-curator of the Gwangju Biennale 2008; and by Savita Apte, associate to *Indian Highway*. Additional texts reflect on the extended activity in contemporary art on the subcontinent, focusing in particular on Pakistan, Sri Lanka and Bangladesh, written respectively by Iftikhar Dadi,

Assistant Professor of Art History, Cornell University; Sharmini Pereira, founder of Raking Leaves, an independent publishing house of artists' books; and Naeem Mohaiemen, artist, filmmaker and digital media artist (www.shobak.org) working in Dhaka and New York. We cannot thank all the authors enough for their insightful contributions, which challenge us to think about the exhibition more deeply as well as the context of the extraordinary backdrop against which it takes place.

An exhibition of this scale and ambition would not have been possible without the tireless work and dedication of the teams at the Serpentine Gallery, the Astrup Fearnley Museum of Modern Art, HEART – Herning Museum of Modern Art and the Musée d'art contemporain de Lyon. We would especially like to thank Thierry Raspail, Director, Musée d'art contemporain de Lyon, and his esteemed colleagues Thierry Prat and Marilou Laneuville, for their engagement and collaboration on this exhibition.

Julia Peyton-Jones
Director, Serpentine Gallery, and Co-Director, Exhibitions and Programmes

Hans Ulrich Obrist
Co-Director, Exhibitions and Programmes, and Director, International Projects, Serpentine Gallery

Gunnar B. Kvaran
Director, Astrup Fearnley Museum of Modern Art

Nalini Malani
Alice (detail), 2006
Acrylic and enamel reverse painting on Mylar
183 x 82 cm

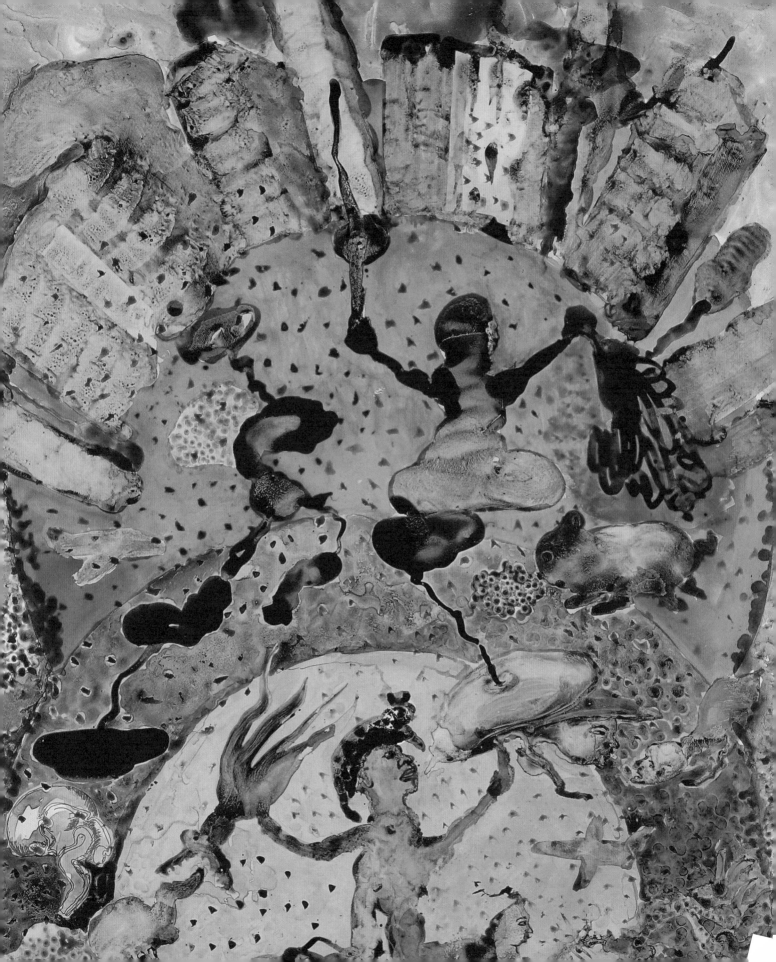

GUIDE TO CONTEMPORARY INDIA

A highway is understood as a network between cities, towns and other places; historically, highways have served as corridors for the movement of travellers, goods, armies and ideas. The Indian highway cuts across different landscapes – rural, urban, village, wilderness – and through different realities including the metropolitan and the tribal. Rudyard Kipling's description of India's most famous highway, the Grand Trunk Road, as a 'river of life', is apt even in these times. The highway's continuation as a link to changing realities is reflected in contemporary art.

At a certain moment in India's history the rural idyll was a privileged template for an idea of the 'national' couched in Gandhian terms as well as in terms relevant to the vast majority of the population. Generations of artists depicted this pastoral setting or chose to work within it – Rabindranath Tagore established the Fine Art faculty at his university in Santiniketan in rural Bengal in 1919 and groups of artists habitually set up camps in remote places, sometimes working alongside fishermen and farmers.

Taking the metaphor to the present, if the highway were to link the topography of contemporary art in India today, the city would become an important frame of reference. This is perhaps more so now than ever before, as the Indian art world is experiencing unprecedented expansion, fuelled by a rapidly growing domestic economy and intense levels of global interest, manifested through the inclusion of Indian artists in major exhibitions, biennials and cultural events where India is given 'favoured nation' status. Consequently, at the risk of privileging the city above the many other sites of artistic production, for this guide, we have chosen to focus on the urban centres of *Mumbai*, *New Delhi*, *Kolkata*, *Bangalore* and *Baroda*. While we take personal responsibility for this choice of cities, we have decided to invite a group of writers to help us organise the following list of what is considered to be the most relevant institutions and organisations in each place. These writers are Zehra Jumabhoy, Assistant Editor of *Art India* magazine (Mumbai); Vidya Shivadas, writer and curator at Vadehra Art Gallery (Delhi); Sandhya Bordewekar, writer and independent curator (Baroda); and Anshuman Dasgupta, writer, curator and faculty member of Kala Bhavan, Visva-Bharati University (Kolkata). By collaborating with this group we hoped to cover the gaps in our knowledge as well as get the perspective of people who live and work in each city. In order to provide a balanced picture and counter the

seeming dominance of the private sector, we focus the list on a broad range of different organisations. Much of the growth in recent years has come about through an influx of private money, with dealers and collectors leading the way in developing a world-class infrastructure in gallery architecture, organisational systems and international promotion. But other entities such as independent and non-profit organisations, artist-run projects, academic departments, grant-making bodies and state institutions such as museums (including public/private hybrids) all contribute towards the cultural scene. We hope the guide reflects the diversity of participants involved in contemporary Indian art.

Importantly we decided not to include artists, as this list would inevitably be too large, too subjective and too incomplete, but chose instead to focus exclusively on infrastructure. Needless to say, artists and their work provide the key to everything which is included here. The list for each city takes a slightly different focus, with, for example, the commercial capital Mumbai being weighted towards private galleries, and Baroda, principally an artistic community gathered around a university department, including studios and workshops. These differences also reflect the interests of the various reporters and emphasise the personal rather than official nature of this survey. Finally, any guide of such a large and amorphous art scene, particularly on the scale of India, allows for a disclaimer. What has been included must not be thought of as complete but just a starting point. Ultimately, the best outcome of such a guide would be for others to immediately contest it and start researching and proposing a different one.

Mumbai

With its wealth and entrepreneurial dynamism, Mumbai has a history as a centre for artistic activity. One of the first art colleges in India, the Sir J J School of Art, was established in Bombay in 1857 during the colonial period, and Bombay Art Society was founded in 1888 to encourage amateurs and educate public opinion. During the early-1950s the city was home to the Progressive Artists Group, a key element in the development of contemporary Indian art, whose founding members included K H Ara, S K Bakre, H A Gade, M F Husain, S H Raza and F N Souza. The Jehangir Art Gallery situated in Colaba was built in 1952 as a complex of exhibition halls, as well as a private gallery and café, and was for a long time one of the few places where artists could show their work in the city. Like the Bombay Art Society it survives to this day, and is part of the main concentration of the arts scene

at the southernmost point of the city along with the National Gallery of Modern Art (NGMA, Mumbai branch) and a plethora of commercial spaces. Despite the success of the commercial galleries and auction houses, Mumbai also struggles with enormous structural problems, and a small but significant group of artists reflect this fact by producing projects that are concerned with making social interventions – often working collectively to provide alternative support and distribution systems.

Delhi

In 1947 New Delhi became the capital of independent India and its symbolic function as a showcase for the country was reflected through the arts. Two years after Independence, the idea of a national gallery was proposed at a conference in Calcutta and in 1954 the NGMA was inaugurated at Jaipur House near India Gate and, in the same year, the Lalit Kala Akademi was established as a governmental agency for the visual arts. India's first prime minister Jawaharlal Nehru himself suggested that the country's leading artists should be employed in decorating great public buildings and one of these commissions was the giant Yaksha and Yakshi sculptures by Ramkinkar Baij for the Reserve Bank of India. Today, New Delhi is in many respects the intellectual capital of the country with important universities and research ties to the rest of the world. The Department of Aesthetics at Jawaharlal Nehru University and Sarai at the Centre for the Study of Developing Societies are two notable faculties that address visual culture and help produce a sophisticated and sometimes contested discursive framework around artistic practice. The commercial gallery scene thrives alongside the cultural agencies that play a role and not-for-profit organisations such as KHOJ, International Artists' Association have allowed many artists to make experimental projects and connect to an international network. In a new development, several private museums backed by galleries and collectors are soon to open in the capital, the first, the Devi Foundation opened in August 2008.

Kolkata

Since the 19th century, Kolkata has been at the centre of India's intellectual and cultural life. A school of industrial art was founded as a private institution in 1854 but given to the state in 1864 to later become the Government School of Art. Subsequently both inside and outside academia, work made in a naturalistic style for a European clientele was challenged and the search for a nationalist and modernist aesthetic, became a principle concern for artists including those from the Bengal School. The Fine Art faculty of Rabindranath Tagore's university at nearby rural Santiniketan was founded in 1919 and became the centre for a group of artists who produced iconic works of Indian Modernism that can

still be viewed on campus. Kolkata's pivotal role in the development of a national aesthetic, its history of left-wing politics and its avant-garde film culture has bequeathed a powerful heritage to the city which is still vibrant today. A discursive tradition continues with organisations such as Seagull Books publishing on art, politics, literature and criticism and the Centre for Studies in Social Sciences, currently assembling a visual archive of 19th- and 20th-century Bengal. The recently established collective, Calcutta Art Research is compiling an archive of Kolkata today, drawing, among other things, contributions by artists from abroad who have spent time in the city.

Bangalore

Often seen as a paradigm of contemporary India but lacking the same artistic legacy as the other cities mentioned in this guide, Bangalore is now an important centre for the visual arts in the South. Despite its rich business class, the commercial art market is small with only a few notable galleries; state institutions are few, with a Bangalore branch of the NGMA soon to be launched. Interestingly, there is a tradition of artist-run initiatives in the region, with the country's first artist commune Cholamandalam established in 1966 on the seafront in nearby Madras/Chenai. Temporary projects by artists ultimately slip out of a guide such as this, but the more stable ones are mentioned, particularly a handful of artist-run collectives and residency programmes. These latter testify to the fact that while Bangalore is an international hub in economic terms, the city's artists still feel the need to actively initiate and maintain communication with a wider cultural sphere.

Baroda

Raja Ravi Varma who is widely given the accolade of being the first modern Indian painter, was closely associated with Baroda. In 1900, he was commissioned to make a portrait of Sayajirao Gaekwad, ruler and patron of the arts. Gaekwad also established a school, which in 1949, became the Maharaja Sayajirao University of Baroda, the Fine Art faculty of which has since become one of the most important art institutions in the country. From the beginning, faculty members included many of India's senior artists, including K G Subramanyam, Gulammohammed Sheikh and Nasreen Mohamedi, while others such as Bhupen Khakhar were part of Baroda's artistic community. The curriculum was progressive, with artists being encouraged to experiment, as well as being international, with visitors from abroad such as Timothy Hyman and Peter de Francia. It is not an exaggeration to say that almost all of the significant artists in India have passed through Baroda at some point, consequently making it an important inclusion in the guide.

THE GUIDE

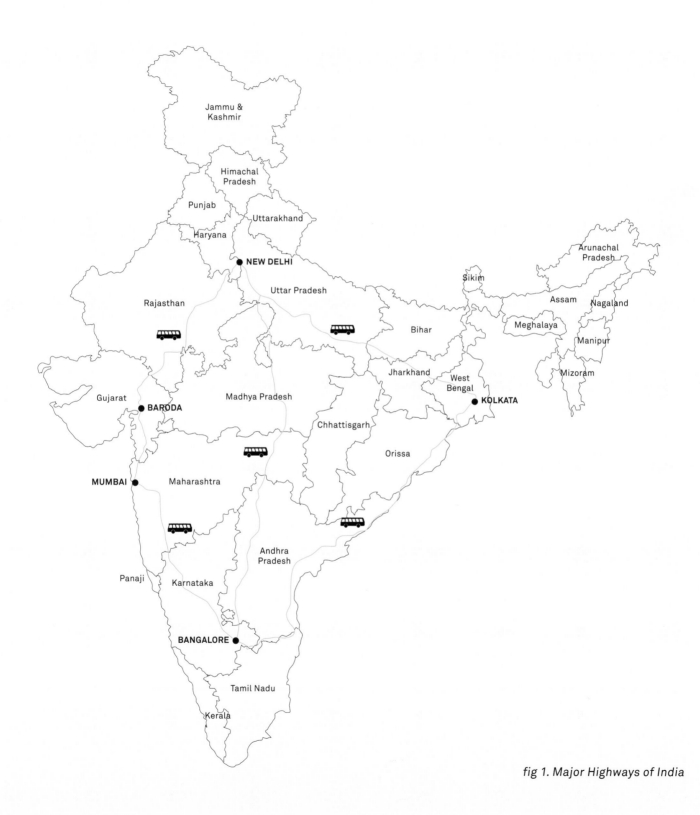

fig 1. Major Highways of India

Key to Guide

★ Government Museums and Organisations
◆ Art Schools and Education
■ Galleries
O Collectives and Initiatives
● Foundations and other Organisations
▲ Auction Houses
≡ Media
S Studios
P Art Project
A Art Resources

MUMBAI

Galleries ■

Bodhi Art and Bodhi Space
Bodhi Art encourages broad-based practices ranging from painting and sculpture to photography and installations. It supports public art projects through its galleries in Mumbai, Berlin, New York and Singapore. The 2008 exhibition *Everywhere is War (and rumours of war)* was one of the largest curated shows of the year and was international in scope, marking the beginning of Bodhi's programme to include foreign artists on their exhibition rosters in Mumbai. The Bodhi Art Award is a platform to expose emerging work to a wider audience and assist in early steps into the professional arena. The gallery produces comprehensive catalogues of the artists they exhibit.
www.bodhiart.in

Chemould Prescott Road
Gallery Chemould, founded in 1963 by Kekoo and Khorshed Gandhy, is one of India's oldest commercial art galleries. The Chemould story began in 1941 when there were practically no venues showing Modernist art. Kekoo Gandhy began to use the showroom window of his frame manufacturing business to show artists including K H Ara and M F Husain, displaying works in specially designed frames to promote them to prospective clients. Chemould has the distinction of first representing the major artists of early Modernist and contemporary Indian art.
www.gallerychemould.com

Galerie Mirchandani + Steinruecke
Established in 2006 by Usha Mirchandani and her daughter Ranjana Steinruecke, the gallery is located behind the Taj Mahal Hotel in Colaba, Mumbai and represents a range of young and mid-career artists from India. It also organises solo shows with international artists including Kiki Smith and Jonathan Meese.
www.galeriems.com

Chatterjee & Lal
The gallery comprises the husband and wife team of Mortimer Chatterjee and Tara Lal, who began promoting a younger generation of artists in 2003 and have since hosted many exhibitions throughout the city. They have recently opened their new gallery located in downtown Colaba: the space has been conceived to show cutting-edge work in a range of media, including video, installation and 3-D art forms.
www.chatterjeeandlal.com

Gallery Maskara
'Gallery Maskara's mission is to take a global and multi-disciplinary approach to art that responds to the fabric of our time thus fuelling collaboration, critical dialogue and public engagement.' This Colaba project space known as 'Warehouse on 3rd Pasta', served as a cotton storehouse in pre-independence India and has been renovated by conservation architect Rahul Meharotra, marking a shift from the traditional white cube and providing a unique venue for site-specific installations.
www.gallerymaskara.com

Sakshi Gallery
This professionally-run organisation is managed by Synergy Art Foundation Limited, India's first corporate entity focused on art. The founding director, Geeta Mehra, has shown some of India's most established artists and launched many of the country's younger artists. Sakshi has a library of reference books on art and publishes books.
www.sakshigallery.com

The Guild Art Gallery
The Guild Art Gallery supports and nurtures younger artists by providing a platform for investigational and project-based works. Representing several recognised contemporary artists, it shows work both in Mumbai and New York that encompasses multi-media art, photography, conceptual art, sculpture, graphics and painting.
www.guildindia.com

Pundole Art Gallery
One of India's first art galleries, Pundole Art Gallery was founded by Kali Pundole in May 1963. Synonymous with the Progressive Artists Group, Pundole Art Gallery has been the primary dealer for modern Indian masters such as M F Husain and Akbar Padamsee. Today, the gallery promotes Modern and contemporary Indian art through important exhibitions, retrospectives, publications and art education.
www.pundoleartgallery.in

Auction Houses ▲

Christie's
Christie's sales of modern and contemporary Indian art concentrate on the geographic regions of India, Pakistan, Bangladesh and Sri Lanka. The sales focus on works from the second half of the 20th century. Works by Indian Modernists, including those by the Progressive Artists Group, are typically featured in auctions, alongside works by a younger, increasingly avant-garde generation of artists from South Asia.
www.christies.com

Sotheby's
Highlights of prominent London sales are usually taken to traditional art market centres like New York or Paris to stimulate overseas interest. In August 2008, Sotheby's placed New Delhi on the world art auction map by displaying 14 Damien Hirst works at the city's Oberoi Hotel to attract new buyers from the Indian subcontinent. Oliver Barker, Senior International Specialist in Contemporary Art at Sotheby's, said 'Collectors in India are very much trying to find ways into Western art … in many ways, this is the most important exhibition by a non-Indian artist to be held in India.'
www.sothebys.com

SaffronArt
A global company with Indian roots, SaffronArt, founded in 2000, is an online auction house owned by Dinesh and Minal Vazirani. It provides a platform to access, purchase and view Indian art. With gallery spaces in Mumbai and New York, and offices in London, they provide a substantial range of art, information and advice.
www.saffronart.com

Government Museums and Organisations ★

National Gallery of Modern Art, Mumbai
Converted from an old public hall, the Museum's dynamic, three-tiered structure houses collections from India's eminent living artists and provides an overview of the country's contemporary art scene.
www.ngmaindia.gov.in

Art Schools and Education ◆

Sir J J School of Art
Founded with a donation by Sir Jamsetjee Jeejeebhoy for whom it was named in 1857. In 1866, John Lockwood Kipling, Rudyard Kipling's father, a professor at the School, established three 'ateliers'. Kipling's impact is visible in the relief panels above the entrance of Crawford Market and its fountain within. Several craftsmen and artists associated with the School were responsible for the city's Victoria Terminus building, the first classes in architecture having started in 1900. The prestige of the institution has been impacted by claims that it is conservative in its methods and lacks resources.
www.jjsa.in

Rachana Sansad Academy of Fine Arts and Crafts
The Academy's Fine Arts course includes drawing, photography, film-making, sculpture and various other elements. With artists like Nikhil Chopra teaching in its Faculty of Art, the institution is building a reputation.
http://rachanasansad.in

Kamla Raheja Vidyanidhi Institute of Architecture (KRVIA)
KRVIA was established in 1992 with an expansive approach to architecture, integrating it with other disciplines from the expanded field of cultural studies. Through its varied research and consultancy projects, KRVIA engages actively with the city and provides a platform for debate and discussion. It is known for its progressive teaching style and the quality of its department members, with some of the best artists teaching at or affiliated with the Institute.
www.krvia.ac.in

Jnanapravaha
'Jnanapravaha aims to provide a neutral yet stimulating space for the global exchange of creative Indian thought. Our parent organisation, Jnana Pravaha, Varanasi, is devoted to the study of Indology, epigraphy and Sanskrit, while we at Jnanapravaha, Mumbai, are committed to Arts Education in the broadest sense of the term.' Jnanapravaha holds exciting courses on aesthetics and often sponsors lectures and facilitates interactions between artists and the public.
www.jp-india.org

Mohile Parikh Center for the Visual Arts
Established in 1990, the Center provides a space for developing and raising the level of discourse and discussion in the visual arts through public events.
www.mohileparikhcenter.org

Collectives and Initiatives ○

CAMP (Critical Art and Media Practices)
CAMP works 'to test the ground between art practices, multiple ideas of the public, and "private" life and property. To consider such thresholds of publication and ownership as sites for challenging work … To engage with urban activity in our region, at infrastructural scales. This means working directly with infrastructures such as water, cable TV and the internet; and developing alternative, post-network forms of analysis and participation.' CAMP has been recently initiated in collaboration with KHOJ Delhi and founded by Shaina Anand, Ashok Sukumaran and Sanjay Bhangar.
www.camputer.org

Other Institutions and Galleries to Hire ■

The Bombay Art Society
Founded in the 1880s to encourage amateurs and 'educate' public opinion, the Bombay Art Society is an arts organisation whose exhibitions were once major social events. The Society is still active today and is one of the venues, together with other museums, art galleries, educational institutions, boutiques, restaurants and heritage buildings in South Mumbai, that hosts the annual *Kala Ghoda Arts Festival.*
www.bombayartsociety.org

Jehangir Art Gallery
Jehangir Art Gallery is Mumbai's most famous public art gallery and a tourist attraction. Founded by Sir Cowasji Jehangir and built in 1952, it is managed by the Bombay Art Society and situated at Kala Ghoda, behind the Prince of Wales Museum, with four exhibition halls. Previously it was the only place for hire for exhibitions, before private galleries proliferated. It still continues to be hired by both artists and galleries because of its location and size, mammoth in itself, and its history is linked with the renaissance of Indian art.

NEW DELHI

Collectives/Initiatives ○

Sarai
Sarai is a space for research, practice and conversation about contemporary media and urbanism. It consists of a coalition of researchers and practitioners with a commitment to developing a model of public and creative research-practice, where multiple voices can be expressed in a variety of forms. Begun in 1998, founded by members of the Raqs Media Collective – Jeebesh Bagchi, Monica Narula, Shuddhabrata Sengupta – and others including Ravi Vasudevan and Ravi Sundaram, it is a programme of the Centre for the Study of Developing Societies.
www.sarai.net

Tasveer Ghar
Established in 2006 by Sumathi Ramaswamy, Christiane Brosius and Shuddhabrata Sengupta, with Yousuf Saeed as the Project Director, Tasveer Ghar is a transnational, virtual 'home' for collecting, digitising and documenting South Asian popular art, such as posters, calendar art, pilgrimage maps and paraphernalia, cinema hoardings, advertisements and other forms of street and bazaar art. It operates from three nodal institutions, one of which is Sarai.
www.tasveerghar.net

Delhi Film Archive
Delhi Film Archive (DFA) is an autonomous platform, voluntarily run by film-makers and supporters of free speech. Independent of any state body or institutional support, the archive includes documentaries, short-films, images and other materials and aims to stimulate a collective response to censorship and the control of ideas. DFA is the New Delhi chapter of Films For Freedom, a national collective of film-makers that emerged in 2003 to protest against censorship at the *Mumbai International Film Festival* and other public spaces across India. Film-makers associated with DFA include Amar Kanwar, Kavita Joshi, Nakul Sood, Rahul Roy, Ranjani Mazumdar and Saba Dewan.
www.delhifilmarchive.org

The Nigah Media Collective
Nigah was created in 2003 by Gautam Bhan and others when a Delhi-based group gathered to articulate diverse perspectives on politics and social activism. It has evolved as a means to use different forms of media – including film festivals, exhibitions and photographs – to discuss issues of gender and sexuality, replacing silence on these topics with inclusive and progressive debate.
http://nigahdelhi.blogspot.com

Foundations and Other Organisations ●

KHOJ
Part of the global Triangle Arts Trust, KHOJ began in 1997, with a role as an incubator for art and ideas, artistic exchange and dialogue. Its programming aims to assist and develop forms of art such as media art, performance, video, environmental, public and community-based art, sound and other experimental modes of cultural production. KHOJ promotes cross-cultural exchange within the visual practices of the 'Global South'.
www.khojworkshop.org

Sanskriti Kendra
The cultural centre of the Sanskriti Foundation, Sanskriti Kendra was established by collector O. P. Jain in 1993 to primarily provide art-cultural residencies for international and Indian artists and writers. It runs regular children's workshops in Delhi, houses the beautiful Museum of Everyday Art and supports the prestigious annual Sanskriti Award for artists and writers.
www.sanskritifoundation.org

Devi Art Foundation
Devi Art Foundation is one of India's major non-profit contemporary art institutions. It stages permanent and temporary exhibitions from an extensive collection of over 7,000 works of South Asian modern, contemporary and tribal art, assembled from the collection of founder Anupam Poddar and his mother Lekha Poddar. The exhibition programme at

the Foundation involves a series of external curators – the inaugural show *Still Moving Image* (August – November 2008) was curated by Deeksha Nath and presented photography and video art.
www.deviartfoundation.org

Foundation for Indian Contemporary Art (FICA)
FICA is a non-profit organisation that encourages, promotes and supports innovative work in the field of the visual arts. 'We are working towards establishing a contemporary art museum in 2010 which will host regular art events, educational programmes and special exhibitions. We are committed to making contemporary art accessible, increasing greater interaction among art institutions and the public and generating art philanthropy.' FICA has launched an Emerging Artists Award, hosts a writing workshop for aspiring art historians and critics and sponsors public art projects.
www.ficart.org

INTACH Conservation
Established in 1990, the Delhi Centre of the Indian National Trust for Art and Cultural Heritage (INTACH) is also referred to as the Art Conservation Centre, Delhi, and specialises in the conservation of oil, watercolour, tempera, acrylic and mixed-media paintings; traditional Indian art such as Tanjore, Thangkha, Kalamkari and Pichchwai paintings; painted textiles; prints and photographs; and sculptures in wood, stone, metal, bone and ivory. They restore works by contemporary artists as well as historical objects.
www.intach.org

Government Organisations and Museums ★

Indira Gandhi National Centre for Art
A resource centre for artists that runs a diverse range of programmes, including one that utilises multi-media computer technology in order to create cultural information software. The Centre has a tremendous research collection of digital images, including material on archeological sites.
www.ignca.nic.in

Lalit Kala Akademi
The Lalit Kala Akademi (LKA), together with the Sahitya Parishad Akademi and Sangeet Natak Akademi, was established by the Government in 1954 as a national agency to explore and promote theatre, music and visual arts.
www.lalitkala.gov.in

National Gallery of Modern Art, New Delhi
The National Gallery of Modern Art (NGMA) is the only national museum for modern and contemporary art, established in 1954. The Gallery is administered and run by the Government of India. There is a branch in Mumbai

(established 1995), a new building in New Delhi and a new museum in Bangalore.
www.ngmaindia.gov.in

All India Fine Arts and Crafts Society
Formed in 1928, the Society worked as a liaison office for Government cultural exchanges after Independence when the country did not have any official cultural department. It continues to organise art exhibitions and make awards to artists across the country.
www.aifacs.org.in

Crafts Museum
The core collection of the Crafts Museum was compiled to serve as reference material for craftsmen who, due to modern industrialisation, were increasingly losing touch with arts and crafts traditions in terms of materials, techniques, designs and aesthetics. The large permanent collection of 20,000 items of folk and tribal arts, crafts and textiles is housed in a discrete, concrete building designed by the architect Charles Correa.
www.nationalcraftsmuseum.nic.in

Art Schools and Education ◆

School of Arts and Aesthetics, Jawaharlal Nehru University
The School of Arts and Aesthetics is one of nine schools in the Jawaharlal Nehru University (JNU), a premier institute of learning whose main focus is research and postgraduate courses. JNU is one of the few places in India that offers postgraduate degree courses in the theoretical and critical study of the cinematic, visual and performing arts. More importantly, these disciplines are offered in one integrated programme that allows students to understand the individual arts in a broader context of history, sociology, politics, semiotics, gender and cultural studies. The three streams of study offered at the school are Visual Studies, Theatre and Performance Studies and Cinema Studies.
www.jnu.ac.in/SAA

Galleries ■

Anant Art Gallery
Anant represents and promotes Indian contemporary art with a commitment to exploring artistic and cultural values with innovative exhibitions. The Gallery's exhibition catalogues are an important source of Indian art documentation, written by eminent art scholars.
www.anantart.com

Delhi Art Gallery
Special focus on Old Masters, Bengal School, Maharashtra and Bombay School. The gallery also researches and produces books on artists and functions as an archive.
www.delhiartgallery.com

Apeejay Media Gallery
'A premium forum committed to showcasing high-quality experimental work in new media and emerging technologies from India and abroad.' Their publications include *Video Art in India*, 2003, one of the first books dedicated to the subject.
www.apeejaymediagallery.com

Photoink
Started by Devika Daulat Singh in 2001, Photoink is a photo agency and publication-design studio. It serves as a platform for young, independent photographers whose works navigate identity, sexuality and gender politics.
www.photoink.net

Gallery Espace
Established in 1989 by Renu Modi with an exhibition of autobiographical works by M F Husain, Espace has constantly traversed borders and boundaries, showcasing primarily Indian artists across generations and mediums.
www.galleryespace.com

Nature Morte
In 1997, Peter Nagy began Nature Morte in New Delhi as an itinerant gallery and a curatorial experiment. Since then it has become synonymous with challenging and experimental forms of art in India; championing conceptual, photographic and installation genres. In 2003, Nagy opened a permanent gallery in South Delhi and in 2007, in collaboration with the Bose Pacia Gallery of New York, a space in central Kolkata, Bose Pacia Kolkata.
www.naturemorte.com

Vadehra Art Gallery (VAG)
Established in 1987, VAG has been promoting contemporary Indian art through exhibitions, retrospectives and publications as one of the premier art galleries in India. They represent some of the finest artists whose work points to the sheer range and diversity of modern and contemporary Indian art practice. VAG has collaborated with the Grosvenor Gallery in London and recently opened a book store in New Delhi.
www.vadehraart.com

Other Institutions and Galleries to Hire ■

India International Centre (IIC)
India Habitat Centre
Travancore Palace
Triveni Kala Sangam
The Stainless Gallery
Rabindra Bhavan

KOLKATA

Foundations and Other Organisations ●

KHOJ Kolkata
The Kolkata chapter of the Delhi-based organisation opened in May 2008 and announced its forthcoming residency programmes in September 2008.
www.khojworkshop.org

Calcutta Art Research Foundation (CARF)
CARF is conceived as a network-based facility, aiming at promoting dialogue and collaboration between Kolkata and the international art world. The Swiss curator Anders Kreuger and Indian artist Praneet Soi initiated the Foundation. CARF places emphasis on process and research-related art, using the city as a base as well as a resource for its activities. Since December 2005 it has functioned as a place for visiting international artists and is currently engaged in documenting and archiving the public cultures of Kolkata.

Galleries ■

Centre of International Modern Art (CIMA)
CIMA launched in 1993 under the auspices of ABP Ltd, a leading Indian media group known for its moorings in culture, and has curated and organised over 100 exhibitions that have won critical and popular acclaim. The Centre has implemented several projects in association with international museums, funding agencies and educational institutions. CIMA has recently opened a media art gallery and has started displaying crafts.
www.cimaartindia.com

Seagull Arts and Media Resource Centre
Seagull functions as a reference library, an archive and an institution for the dissemination of various forms of arts, as well as a performance space/exhibition centre. It shows both established and emerging experimental artists. Seagull has established a reputation whereby artists who make provocative work engage with the Centre.
www.seagullindia.com

Gallery Kolkata
'Gallery Kolkata, founded in 2004, was initiated to bridge the gap between art and its connoisseurs; an attempt to bring artworks of eminent artists within the reach of the masses ... talk about art as investment, art as a way of life and bring forth high quality meaningful art at affordable prices, thus breaking the conception of art being only a rich man's forte.' The Gallery specialises in mixed shows, with an experimental translocal mix.
www.gallerykolkata.com

Mon Art Gallerie
Mixed shows, with an openness to emerging talent.
www.monartgallerie.net

Aakriti
Founded in 2005, the Aakriti Art Gallery has more than 1,000 works in its collection which are put on display by rotation. The new wing, adjoining the primary gallery, has a permanent space for exclusively showcasing sculptures.
www.aakritiartgallery.com

Akar Prakar
Encourages young experimental talent and balances this by exhibiting the work of older generations.
www.akarprakar.com

Art Schools and Education ◆

Visva-Bharati
Visva-Bharati is the university at Shantiniketan started by writer, artist and composer Rabindranath Tagore in the early 20th century. Kala Bhavan, the university's art college, still remains one of the most important art schools in India.
www.visva-bharati.ac.in

BANGALORE

Galleries ■

GALLERYSKE
GALLERYSKE was founded in 2003 by Sunitha Kumar Emmart. The gallery represents some well-established artists together with a younger generation of artists, both from India and abroad.
www.galleryske.com

Sumukha
Sumukha was established in 1996 as a gallery dedicated to promoting Indian contemporary art. The gallery regularly holds exhibitions, workshops and special art events in Bangalore, as well as in its space in Alwarpet, Chennai.
www.sumukha.com

Tasveer
'Tasveer is an organisation committed to the art of photography and photography as art.' Dedicated to promoting and showcasing contemporary photography, Tasveer has created a network of galleries in Bangalore, Delhi, Kolkata and Mumbai, exhibiting India's emerging and established photographers.
www.tasveerarts.com

Collectives and Initiatives O

1 Shanthi Road
1 Shanthi Road Studio / Gallery was founded by Suresh Jayaram as an artist-led initiative that provides an informal space for visual arts, creative collaborations and new media experimentation. It has hosted several shows and previews and has helped to organize two significant international artists' workshops – KHOJ 2003 in Mysore and KHOJ 2004 in Bangalore. It also has a residency programme for artists in association with KHOJ Delhi.
www.1shanthiroad.com

Bengaluru Artists Residency One (BAR1)
Bengaluru Artist Residency One is a non-profit exchange programme by artists for artists founded in 2001, supported by Pro Helvetia (the Swiss Arts Council) in New Delhi. It aims to foster local, national and international exchange of ideas and experiences through guest residencies in Bangalore. Since its inception it has hosted several artists from India and abroad.
www.bar1.org

Bangalore Artists Centre
The Centre is a society run by artists which connects to local and international networks through initiatives including residency programmes.

COLAB Art and Architecture
COLAB is an independent centre for art and architecture, initiated by curator Suman Gopinath and architect Edgar Demello. It aims to open up discourses on art and architecture across a range of practices, people and places.

Art Project P

Blank Noise
Blank Noise is a public, participatory arts project that began in 2003 with a small group of nine participants led by Jasmeen Patheja. Conceived as a personal reaction to street sexual harassment, the project has grown through workshops and local volunteers to a five-city, 100-plus volunteer project that seeks to address sexual violence on the street through dialogue, made possible through sustained public interventions. Blank Noise events and public interventions have taken place in locations including Lucknow, Patna, Delhi, Hyderabad, Chennai, Bangalore, Mumbai, Kolkata and Jaipur.
http://blog.blanknoise.org

Art Schools and Education ◆

Ken School of Art
The artist R M Hadapad was the founder-principal of Ken School of Art, which he nurtured for over three decades into

a major cultural centre in Karnataka. 'The school remains anything but a cultural hothouse. It does not even boast of a sophisticated studio, library or display space for the students. It is neither exclusive nor elitist. It continues to double up for an educational institution by day and a warm home by night. A few young students from rural Karnataka stay overnight in the school premises. As the regular classes fold up by the evening, the modest premises serve also as a public space for art lovers, past students and hobbyists. A list of its past students reads like a "who is who" of the contemporary celebrities on the national and international art scene.' (*Frontline Magazine*)

College of Fine Arts – Karnataka Chitrakala Parishath
Founded in 1964, Karnataka Chitrakala Parishath offers graduate and postgraduate degrees. The large art complex also houses the Roerich and H K Kejriwal Collections of art and artefacts and a large collection of crafts, paintings and leather puppets from Karnataka state.
www.karnatakachitrakalaparishath.com

Srishti School of Art, Design and Technology
Srishti School of Art, Design and Technology was founded in 1996 by the Ujwal Trust with the objective of providing art and design education in an environment of creativity and maximising individual potential. Srishti's interdisciplinary approach promotes self-initiated learning and independent thinking, while expanding perceptual perspectives and developing artistic vocabularies. Courses are taught by industry-experienced faculty and the curriculum is built on a broad-based liberal arts foundation.
www.srishti.ac.in

Centre for the Study of Culture and Society (CSCS)
CSCS was established in 1996 by a group of scholars interested in developing new approaches to studying culture in India. 'The major thrust of CSCS has been to understand culture in its most inclusive sense – as encompassing the diverse attempts of people to produce meaning of various kinds. Such an endeavour will pose a serious challenge to the existing disciplines, and have a significant impact on cultural policy as well as alter the place occupied by "culture" in our political understanding. We use the phrase "culture and society" to emphasise that culture must be seen not as a transcendent entity but as part of a network of social and political relations, indeed as integral to the formation of such relations.'
www.cscsarchive.org

Art Resources A

Art Resources and Teaching (ART)
Set up by Dr Annapurna Garimella in 2001, ART aims to strengthen and foster relationships within and beyond the perimeters of art and architectural history, archaeology,

craft, design and related disciplines. ART's resources include a comprehensive library and archive with over 10,000 articles from Kannada and English dailies, national magazines and journals on diverse subjects ranging from archaeological politics and copyright law to gender studies and contemporary popular culture.
www.artscapeindia.org

Ananya
A non-profit cultural organisation established to promote, propagate and nurture cultural art forms of India.
www.ananyaculture.org

Foundations ●

India Foundation for the Arts (IFA)
The mission of IFA is to enrich the practice, knowledge, access and experience of arts in India, by supporting projects across all disciplines. IFA makes grants and acts as a bridge between arts groups and the donor community. 'Support for the arts should be widely accessible without prejudice to class, language, religion or gender. It is vital to encourage reflection on the arts as well as reflective arts practices. Transparency, mutual trust and give-and-take must characterise the business of arts philanthropy.'
www.indiaifa.org

Arnawaz Vasudev Charities
A private trust whose principal objective is to promote art education and activities while providing financial assistance to deserving young artists.
www.vasudevart.com

Other Institutions and Galleries to Hire ■

Venkatappa Art Gallery
Chitrakala Parishath Galleries

Auction Houses ▲

Bid & Hammer
www.bidandhammer.com

BARODA

Art Schools and Education ◆

Maharaja Sayajirao University of Baroda
The university's art school, the Faculty of Fine Arts, was established in 1949–50, designed in a completely different style from the colonial model of 'Arts and Crafts Colleges'. An extraordinary lady Vice-Chancellor, Hansa Mehta, hand-picked young Indian artists from across India to head the various departments. The Faculty was developed as

a liberal space where student-artists were encouraged to experiment and find new ways of expression to become conceptually adept and technically versatile. Most of the important contemporary Indian artists today have been associated with Maharaja Sayajirao at some point in their student years.
www.msubaroda.ac.in

Galleries ■

Faculty of Fine Arts Exhibition Hall
Run by Maharaja Sayajirao University of Baroda
www.msubaroda.ac.in

Sarjan Art Gallery
Sarjan Art Gallery exhibits traditional arts alongside experimental and contemporary work. The gallery has a collection of historical and contemporary art works, including paintings, sculptures, drawings, photographs and portfolios.

Red Earth Galleries
Previously Lanxess ABS Gallery, this space hosted several prominent recent shows for the Uttarayan Art Foundation. Red Earth aims at building a global audience for contemporary Indian art through its collaborations with galleries in New York, London and Cologne. The gallery runs residency programmes and international workshops.

Artist Studios S

Priyasri Patodia Artists' Studios/Asit Shah Art Home Studios/Aley Shah Studio for Sculptors
Krupa Amin, Priyasri Patodia, Asit Shah and Aley Shah are local industrialists/patrons who have offered studios to young artists, for a specific period of time with no rent, but in exchange for artwork as mutually agreed.

Printmaking Studios S

Chhaap Studio
Chhaap is a non-profit co-operative studio for printmaking set up by five Baroda-based artists. Its main objective is to promote prints and create awareness about printmaking. The Chhaap Committee includes Kavita Shah, Gulammohammed Sheikh, Vijay Bagodi, Akkitham Vasudevan and B V Suresh. Chhaap also has workshops for children to introduce the history of printmaking and how to look at and make prints.
www.chhaap.com

Atul Dalmia Printmaking Workshop
Run by the printmakers Rini and P D Dhumal on same principles as Priyasri Patodia Artists' Studios, Asit Shah Art Home Studios and Aley Shah Studio for Sculptors.

Residencies and Studios S

Uttarayan Foundation Artists' Centre
Residencies, workshops, camps and displays.

OTHER NOTABLE ART INITIATIVES IN INDIA

Rajasthan
Sandarbh Artist Workshop/Residency
Founded by Chintan Upadhyay to increase interaction in art and culture between rural and urban areas, Sandarbh Artist Workshop/Residency is a non-profit artist initiative in the Vagad Region, Rajasthan, that organises short-span site-specific artists' workshops and one-month residencies in rural locations in collaboration with the local NGO, Beneshwer Lok Vikas Sansthan (BLVS). Beginning in 2006, the residencies have become a learning ground for recently-graduated young artists, like Sandip Pisalkar, Sakshi Gupta and Shreyas Karle, as well as participating international artists.
http://sandarbhblvs.blogspot.com

Shillong
Alt-Shillong
Alt-Shillong is an an open space for culture and politics based in the capital of Meghalaya state, run by Tarun Bhartiya – a poet, film-maker and activist with Freedom Project Shillong – along with Robin S Ngangom, a poet and translator of Manipuri writing.
http://altshillong.wordpress.com

Guwahati
Desire Machine Collective
Desire Machine Collective is an artist collective in Guwahati, Assam, comprising Sonal Jain, a Fine Arts graduate from Maharaja Sayajirao University of Baroda, and Mriganka Madhukaillya, a Physics graduate from Fergusson College, Pune. Working in varied art practices, ranging from photography and multi-media to video and film, they constantly strive to redefine the form and meaning art takes in relation to changing contexts. They recently partnered with KHOJ and Arts Network Asia and organised an artist residency on a ferry on the Brahmaputra River.
www.desiremachinecollective.net
http://dm.architexturez.org/aboutus.htm

MEDIA

Magazines ≡

ART India
Founded in 1996 *ART India* is the country's premier visual arts magazine with a focus on contemporary Indian art. It is well-known for its (often uncomfortably) honest appraisals of the art scene. *ART India* has a history of publishing for the first time most of India's critics.
www.artindiamag.com

Art & Deal
www.artanddealmagazine.com

Marg Publications
www.marg-art.org

Journal of Arts & Ideas
http://dsal.uchicago.edu/books/artsandideas

Time Out
A Mumbai edition of the listings magazine *Time Out* was launched in 2004 with editions for Delhi and Bangalore following in 2007. *Time Out* includes extensive coverage of art, music, books and other cultural news and events, although the standard *Time Out* 'event driven' editorial policy necessarily restricts what is covered and how.
www.timeoutmumbai.net

E-Magazines ≡

Matters of Art
www.mattersofart.net

Artconcerns
www.artconcerns.com

Indian Art News
www.indianartnews.com

Books ≡

When was Modernism? Essays on Contemporary Cultural Practice in India
Geeta Kapur, 2000

The Living Tradition: Perspectives on Modern Indian Art
K G Subramanyan, 1987

Representing the Body: Gender Issues in Indian Art
Vidya Dehejia (ed), 1998

Contemporary Indian Sculpture: The Madras Metaphor
Josef James, 1993

Contemporary Art in Baroda
Gulammohammed Sheikh, 1997

Santiniketan: The Making of a Contextual Modernism
R Siva Kumar, 1997

The Triumph of Modernism: India's Artists and the Avant-garde, 1922–47
Partha Mitter, 2007

Camera Indica: The Social Life of Indian Photographs
Christopher Pinney, 1997

Sarai Readers 01–07
Centre for the Study of Developing Societies, 2001–7

Makings Of Modern Indian Art: The Progressives
Yashodhara Dalmia, 2001

Towards a New Art History: Studies in Indian Art (Essays Presented in Honour of Prof. Ratan Parimoo), Shivaji Panikkar, Parul Dave Mukherji and Deeptha Achar, 2004

Twentieth-Century Indian Sculpture: The Last Two Decades, Shivaji Panikkar, 2000

The Making of a New 'Indian' Art: Artists, Aesthetics and Nationalism in Bengal, c. 1850–1920
Tapati Guha-Thakurta, 1992

Art and Visual Culture in India 1857–2007
Marg Publications, National Culture Fund and Bodhi Art, 2008

A Guide to 101: Modern and Contemporary Indian Artists, Amrita Jhaveri, 2005

Indian Art: An Overview
Gayatri Sinha (ed), 2003

Other books by the authors mentioned above are recommended. There have also been several large monographs of artists published by the galleries who show their work.

Some of the material in this guide, including all unattributed direct quotations, has been assembled from the organisations' websites

SUMAN GOPINATH & GRANT WATSON

Ayisha Abraham

Born in 1963, London, UK
Lives and works in Bangalore, India
Studied at M.S. University of Baroda, Gujarat, India;
Rutgers University, New Jersey, USA

Solo Exhibitions
2010 *Night Shift*, Max Mueller Bhavan, Bangalore, India
2005 *Film Tales*, GALLERYSKE, Bangalore, India
1999 *Ends and Beginnings*, site-specific installation in a bungalow,
Bangalore, India
1998 *Looks the Other Way*, Eicher Gallery, New Delhi, India
1995 *Looks the Other Way*, Franklin Furnace, New York, NY, USA
1993 *The Migration of Memory*, Brecht Forum, New York, NY, USA

Group Exhibitions
2010 *Video Art India*, Fundació la Caixa, Barcelona, Spain
2009 *Intimate Lives*, Tao Art Gallery, Mumbai, India
2009 *Material Texts*, Kashi Art Gallery, Kochi, India
2008 *Horn Please*, Kunstmuseum Bern, Bern Switzerland
2008 *Mostra Internacional de Cinema*, São Paulo, Brazil
2008 *Mechanisms of Motion*, Anant Art Gallery, New Delhi, India
2007 *Blind Alley*, Anant Art Gallery, New Delhi, India
2006 *Around Architecture*, Shivaji Nagar, New Delhi, India
2004 *Subtlety-Minimally*, Sakshi Gallery, New Delhi, India
1998 *Telling Tales*, Bath Festival, UK; New Delhi, India
1998 *Private Mythologies*, Japan Foundation, Tokyo, Japan

Awards / Residencies
2005 KHOJ International Residencies, Mumbai, India
2002 Sarai Fellowship
2001 Majlis Fellowship
1993 Nomad Residency, Banff Center of the Arts, Alberta, Canada

Ayisha Abraham is a Visual Arts Consultant, Srishti School of Art,
Design and Technology, Yelahanka, Bangalore, India. She is also
a member of the BAR1 (Bengaluru Artists Residency) collective,
who organize artists residencies and exhibitions.

Ayisha Abraham
One Way, 2006
DVD
15 minutes

AYISHA ABRAHAM

Ayisha Abraham is an installation artist and experimental film-maker, whose work examines the narratives of identity, memory and history. Travelling between cultures, traversing boundaries and refusing the comfortable unities offered by the idea of national roots, Abraham represents the inherent complexities of a multi-faceted cultural experience. She achieves this by formally intercutting her films with dislocating images and sounds. Abraham adopts the pundit's concerns of a 'clash of civilizations' and gives it a human face.

Having studied painting in India and the United States before shifting to experimental video, Abraham frequently travelled between Delhi, Baroda, Bangalore and Harlem, USA, contributing to the fragmented and discontinuous nature of her work.

In her first experimental film *Straight 8*, 2005, Abraham researched, over a three-year period, amateur films shot in 8-mm, super-8 mm and 16-mm dating back to the 1940s in and around the city of Bangalore. Creating an archaeology of film from recycled footage, Abraham rearticulates a lost history in a way that reveals much about contemporary concerns and presents 'parts of "culture" inhabiting the private archives of memory.' Using the scratched and faded found footage, conversations with the protagonist of the film, Tom D'aguiar, an Anglo-Indian government servant based in Bangalore, are undertaken through a prism of forgetting and remembering that presents the viewer with a forest of signs to interpret.

The video *You are Here*, 2008, splices an array of images originally shot on 8-mm film, from home movies to found footage, to shape a narrative around a day in the life of mid-20th century India. A series of radio frequencies interrupts the flood of images that make up the modern Indian subconscious and, when spliced together, can seem as fragile as that of the deteriorating film.

Abraham's most celebrated film, *One Way*, 2006, is one of six in a series of short films collectively titled *State of the World* and screened at *Directors' Fortnight* at Cannes, 2007. It is a documentary-style portrait of Nepalese immigrant Shyam Bahadur who has been forced into exile in Bangalore. The film explores people who have been displaced from their home and upon return they feel nostalgia for the formerly stable area now alien to them. Abraham is adept at taking the urgent issues of her milieu to present them as detective work, racing across edits to ask the deepest questions about identity in India today.

Abraham allows the protagonist to narrate his own story as she intercuts archival footage and present-day recordings of Bahadur's humdrum existence in the ever-changing and bustling centre of India's high-tech trade. She provides us with the sense of disorientation regularly impacting life in India as Bahadur grapples with the modern planning of two-lane and one-way streets in Bangalore. Through his disorientation he registers the very real possibility that his own exile is a one-way street from which he can never return home.
Leila Hasham

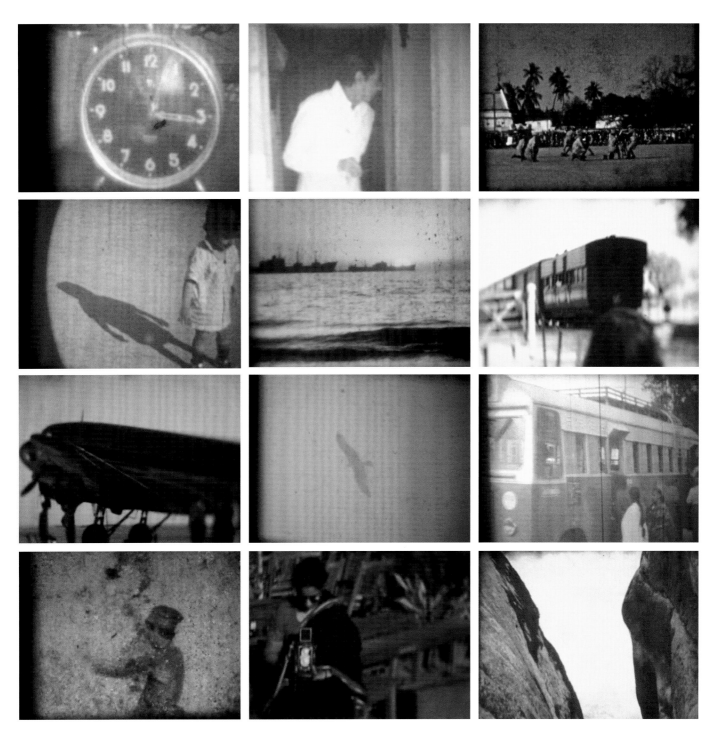

Ayisha Abraham
You are Here, 2008
DVD
7 minutes

Ayisha Abraham
One Way, 2006
DVD
15 minutes

Ayisha Abraham
One Way, 2006
DVD
15 minutes

Ayisha Abraham
One Way, 2006
DVD
15 minutes

Ravi Agarwal

Born in 1958, New Delhi, India
Lives and works in New Delhi, India
Studied at Business School, New Delhi, India

Solo Exhibitions

2010 *Flux: dystopia, utopia, heterotopia*, Gallery Espace,
New Delhi, India
2008 *An Other Place*, Gallery Espace, New Delhi, India
2006 *Alien Waters*, India International Centre, New Delhi, India
2000 *Down and Out*, National Vakbondsmuseum, Amsterdam,
Netherlands; India Habitat Centre Gallery, New Delhi, India
1995 *A Street View*, All India Fine Arts and Crafts Society,
New Delhi, India

Group Exhibitions

2010 Commonwealth Games, Sports and the City, LKA,
New Delhi, India
2010 *Where Three Dreams Cross*, Whitechapel Gallery, London;
Fotomuseum Winterthur, Winterthur, Switzerland
2009 *Detour*, Gallery Chemould, New Delhi, India
2009 *Astonishment of Being*, Birla Academy of Art & Culture, Kolkata,
India
2009 *Recycle*, Travancore House, New Delhi; Nature Morte,
Kolkata, India
2008 *Extinct, 48°C Public.Art.Ecology*, New Delhi, India
2008 *Still Moving Image*, Devi Art Foundation, New Delhi, India
2008 *Click! Contemporary Photography in India*, Vadhera Gallery, New
Delhi, India
2007 *Horn Please, Narratives in Contemporary Indian Art*,
Kunstmuseum, Bern, Switzerland
2007 *Double Take*, Gallery Espace, New Delhi, India
2006 *Watching Me Watching India*, Frankfurt Fotographie
International, Frankfurt, Germany
2003 *Crossing Generations: DiVERGE: Forty years of Gallery
Chemould*, National Gallery of Modern Art, Mumbai, India
2002 *Documenta 11*, Kassel, Germany
1995 *Shaman, Postcards for Gandhi*, Vadhera Art Gallery, New Delhi,
Mumbai, Bangalore and Madras, India
1995 *First National Exhibition of Photography*, Lalit Kala Akademi,
New Delhi, India

Awards / Residencies

2009 Swiss Arts Council, Switzerland
2008 IFCS (UN) Special Recognition Award
2007 Associate Residency at KHOJ Residency, New Delhi, India
1998 Ashoka Fellowship Award for social entrepreneurship

Ravi Agarwal
Stone Quarry from the series *Down and Out,
Labouring Under Global Capitalism* (detail),
1997–2000
C-print
61 x 91.4 cm

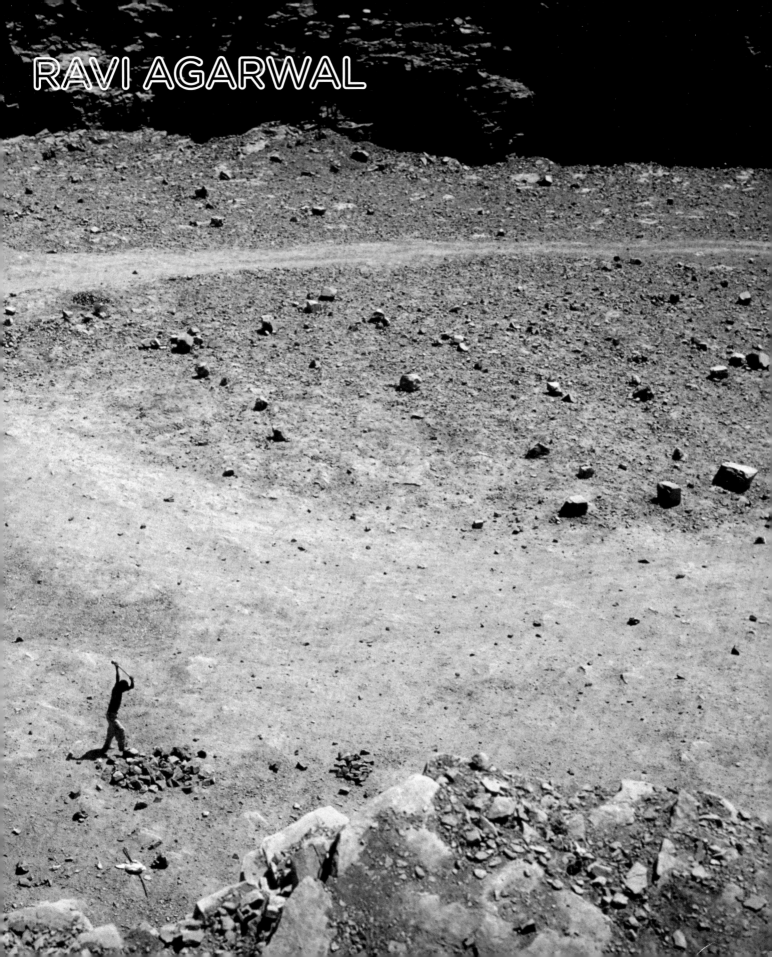

RAVI AGARWAL

Ravi Agarwal combines social documentary and environmental activism in his photographs and films. As the founder of the NGO Toxics Link, one of India's leading environmental, non-profit organisations, the artist's resistance to ecological and environmental depletion adds an urgent element to his films and photographs and becomes a medium in itself for his activism.

Emerging in the first flush of India's booming economy in the 1990s, Ravi Agarwal balances his awareness of globalisation and rapid urban development by also negotiating cultural tradition. Often dedicating years to photograph a project, returning repeatedly to the same area or travelling with groups of migrant works, Agarwal's images of the river, street and labour provide an incisive socio-political commentary on the so-called informal sector of India's economy.

Have you seen the flowers on the river, 2007, a series of six photographs and a video produced during an eco-art residency, is a personal and social documentation on New Delhi's rapidly changing landscape, focusing on the Yamuna River. Charting the steady demise of the river and the communities sustained by its waters, Agarwal's photographs trace the journey of the marigold flowers sown on the river bed through a system of exchange. As the land becomes precious for its per-acre real estate value, the marigold fields and the people whose lives are inextricably bound to the river are threatened.

In the contemporary urban environment, Agarwal's images lament the reduction of resources when value is accrued through 'usefulness', based on what can be offered both economically and politically. The river is also linked to the cyclical idea of life, death and rebirth, through the narrative of the marigold returning to the water that bore it.

The video work *Machine*, 2007, also captures contradictions inherent in contemporary urban culture. Agarwal reflects on how the poor are 'thrown out of their homes in the city and are ferried back in as household labour. Like a relentless machine, ceaselessly going on and on.' In contrast to the brightly coloured images of the marigold fields, the video of the machine moving in an endless loop of whirs and clicks creates a sense of dislocation and alienation. The absence of human figures stain these images with a sense of regret of uninhibited urban development.

In Agarwal's photographic series *Urbanscapes*, 2008, buildings and spaces marked for demolition are presented in stark contrast to slick media images of India's developing cities. Agarwal transforms these ruined structures into areas of hope or as an alternative future by infusing the dark grey interiors with small clippings of pastoral landscapes, whether its through the rich reds of the bougainvillea trees or the bright oranges of the marigold fields.

Agarwal's work has recently focused on self-explorations with *Shroud*, 2007, a series of self-portraits, where he is photographed at different times of the day by the riverbank, encased in a clear plastic shroud. These images examine his relationship to the river not only as a site of exchange and a place of mysticism but also as a lifeline to a city of 15 million people, articulating his desire for unity with both the environment and as an individual to create a 'personal ecology.' **L.H.**

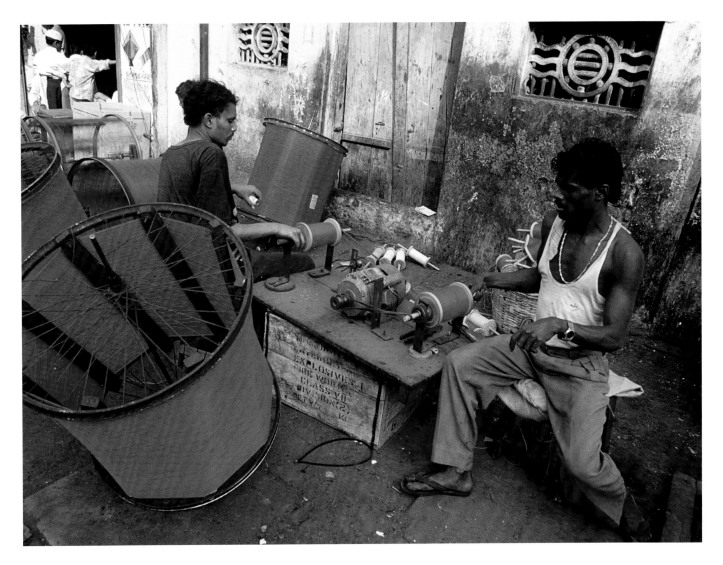

Ravi Agarwal
Kite String Maker from the series *Down and Out,*
Labouring Under Global Capitalism, 1997-2000
C-print
61 x 91.4 cm

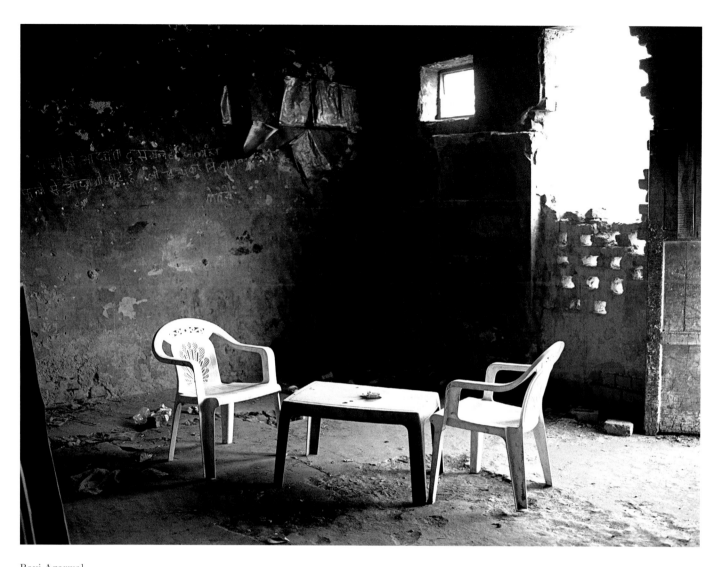

Ravi Agarwal
Untitled from the series *Alien Waters,* 2004-2006
C-print
76.2 x 101.6 cm

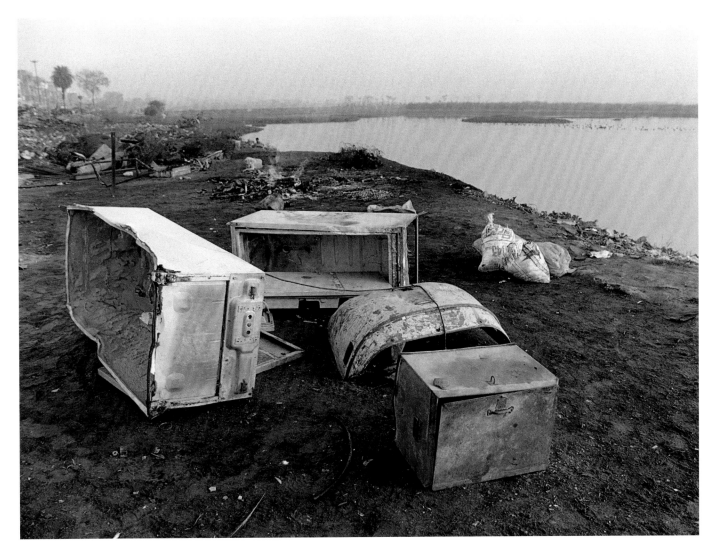

Ravi Agarwal
Untitled from the series *Alien Waters,* 2004-2006
C-print
76.2 x 101.6 cm

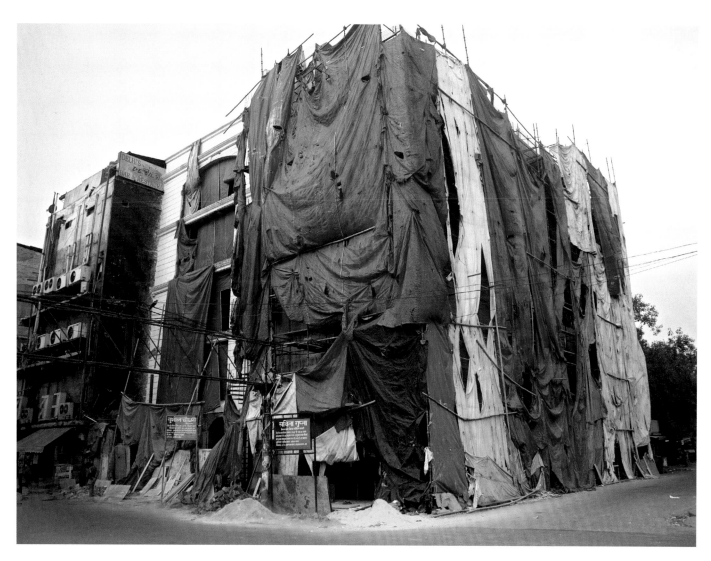

Ravi Agarwal
Debris I, 2007
C-print
50.8 x 76.2 cm

Ravi Agarwal
Machine, 2007
DVD
1:50 minutes

Sarnath Banerjee

Born in 1972, Kolkata, India
Lives and works in New Delhi, India
Studied at Goldsmiths College, London, UK; University of Delhi,
New Delhi, India

Solo Exhibitions
2009 Solo booth at the Frieze Art Fair, London, UK
2008 *Tito Years*, Project 88, Mumbai, India
2007 *Complex systems*, Karton Gallery, Budapest, Hungary

Group Exhibitions
2009 *ARCOmadrid*, International Contemporary Art Fair,
Madrid, Spain
2008 *India Moderna*, Institut Valencià d'Art Modern, Valencia, Spain
2008 *Chalo India*, Mori Museum, Tokyo, Japan
2008 São Paulo Biennial, São Paulo, Brazil
2008 KHOJ Live Arts, New Delhi, India
2007 *Horn Please*, Kunstmuseum Bern, Bern, Switzerland
2007 Literaturhaus, Stuttgart, Germany
2006 Fondazione Sandretto Re Rebaudengo, Turin, Italy
2006 ifa Gallery, Stuttgart, Germany
2005 ifa Gallery, Berlin, Germany
2003 *Comica*, Institute of Contemporary Arts, London, UK
2003 *Response/ability*, OXO Tower, Barge House, London, UK

Graphic Novels
2007 *Barn Owl's Wondrous Capers,* Foundation of the Arts,
Bangalore, India
2006 *Corridor*, Vertige Graphic, Paris, France
2004 *Corridor*, Penguin Books, Chicago, USA

Publications
2001 (August–October) Contributed a regular, two-page column to
The Hindu, a leading Indian newspaper.
Using comics as a potential tool for development communication,
wrote a four-page comic reflecting on the experiences of a filmmaker
shooting a documentary about how newborn girls are killed in
North Bihar.
2001 (January–February) Published in the New Delhi-based journal,
The Little Magazine
Wrote film reviews for the newspaper *Indian Express*.
2000-2001 Illustrated and wrote *Road to Harappa* for Mumbai-based
Gentleman magazine: a series of one-page comic strips based on the
experiences of a documentary filmmaker travelling through India.

Awards / Grants / Residencies
2008 Best Young Publisher Award, British Council
2006 Mocha Film Award, Digital Film Festival, Best Animation Film
2006–2007 Akademie Schloss Solitude, Stuttgart, Germany
2004–2005 Egide Bursary, French Cultural Centre, New Delhi, India
2002–2003 Charles Wallace Trust Scholarship to study Image and
Communication at Goldsmiths College, London, UK
2001–2002 SARAI Project Centre for the Study of Developing Societies,
New Delhi – Fellowship to research a graphic novel based in New
Delhi, India
2000–2002 MacArthur Foundation, Chicago, IL, USA – fellowship to
research the sexual landscape of contemporary India
2000–2002 citiIndian Foundation of the Arts – fellowship to research
the graphic novel *Barn Owl's Wondrous Capers*, Bangalore, India

Sarnath Banerjee
Greasy, 2010
Gouache and ink on paper
76 x 57 cm

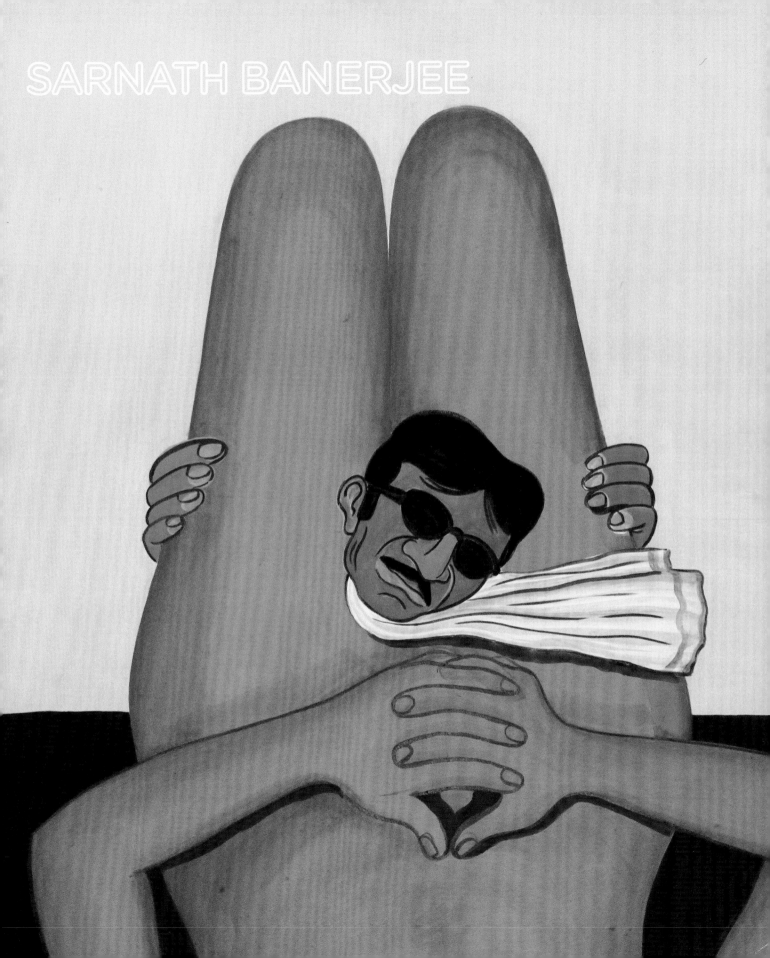

SARNATH BANERJEE

The drawings submitted in Lyon are part of an ongoing work carried out by Sarnath Banerjee for the last five years or so, under the auspices of an umbrella narrative called the *Greater Harappa Project*.

In this new body of work, created in the latter half of 2010, Sarnath Banerjee tries to explore a sense of history among people who have grown up in urban India in the 70s and 80s – men and women in their 40s who have spent their formative years before the speedboat of liberalisation had taken over society. It isn't a lament, nor is it any form of nostalgia, it is merely an unsentimental record of an era through the material objects that signified it. This is the reason why the artist has often used inanimate objects, such as products, popular brands and relics, to reveal a certain epoch of history.

When Edmund Hillary reached the top of Mount Everest, he surveyed the spectacular vista that lay stretched out before him. It was a bright day and there was a great sense of victory. However within seconds a deep melancholy enveloped Hillary's heart. He realised that he had seen this sight before, and outrageously so, from an even higher altitude. He had seen it from an aeroplane.

Sherpa Tenzing was two steps behind. He noticed the big man crumble before him. A few frozen minutes passed by. Then, in a moment of clarity, such as happens in such high altitude, he came up with these words of consolation:

'Hillary Sahib, don't look in front, look behind to see what we have achieved, not what lies before us.'

'The arrival of a nation' is the dominating theme of the *Greater Harappa Project*.

When a 1,200 horsepower Mercury Marine outboard engine is fitted to an old fishing trawler, the ancient vessel eventually assumes the speed that the engine promises, however, somewhere in the high seas, cracks appear on its hull.

Over the years, Banerjee has been creating a series of graphic commentaries that address these cracks of post-liberalised India, while at the same time always having a lens directed at a pre-liberalised Nehruvian India. As we know, India is a fast-capitalising society that suffers from bipolar disorder. There are bound to be losers and winners. Banerjee is interested in the processes that determine this, and examines them by creating a series of documentary comics, which, when loosely linked and bound together, will take an introspective view on how India has got to this stage. The project is akin to a forensic examination of the near past that attempts to resurrect, examine and catalogue cultural and material relics using text and images – a collection of reputable and disreputable women, men, objects and symbols that have either gained or lost, or have stayed unaffected, in this great flood of liberalisation.

Previously he has recorded those who are outwitted by this change, such as the theatre-prop maker in Lucknow, or the manufacturer of skin ointments in the local trains of Bengal. Also there are those who have gained from it, such as Agent Rajan of Monga Realtors, or the South Delhi mother who wants to raise super kids. He examined homogenisation of career prospects, along with the monoculture of education, represented by a disproportionate rise in engineering and management universities. The *Harappa* files also throw light on a growing nexus between industrialists and rightwing politicians, and investigate the newly formed gated communities in the capital and the growing conservatism of the middle class.

As the country experiences a rapid rise in globalisation, the local universes are transforming. The government has stepped down from its parental role and allowed the Indian middle class to find its own solutions. These micro-visual essays are an attempt to document this journey. The narrative moves through human and material artefacts, where personal and national histories coalesce, elucidate and confuse in equal parts.
Sarnath Banerjee

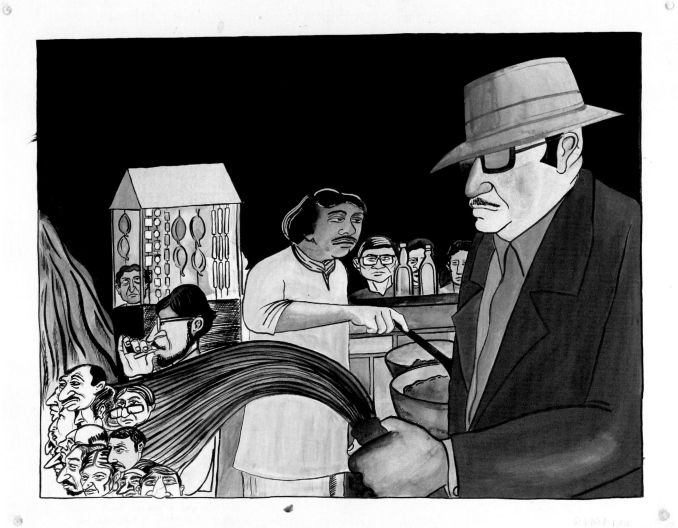

Sarnath Banerjee
Phantom, 2010
Ink on paper
49 x 64.5 cm each (set of 3)

Sarnath Banerjee
Detective Sharad, 2010
Gouache and ink on paper
49 x 64.5 cm

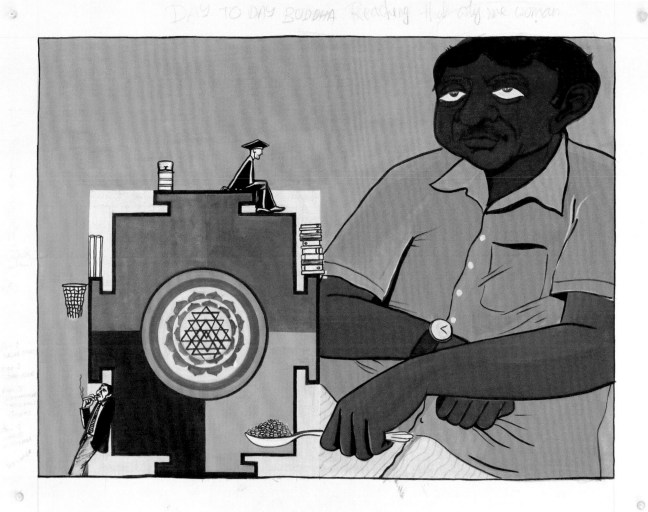

Sarnath Banerjee
Day to Day Buddha, 2010
Gouache and ink on paper
49 x 64.5 cm

Sarnath Banerjee
Complan Boy, 2010
Acrylic and ink on paper
55.5 x 75 cm

Sarnath Banerjee
Little Men, 2010
Acrylic and ink on paper
55.5 x 75 cm

Sarnath Banerjee
Churning, 2010
Gouache and ink on paper
57 x 76 cm

Hemali Bhuta

Born in 1978, Mumbai, India
Lives and work in Mumbai, India
Studied at M S University of Baroda, Gujarat, India; and L.S. Raheja
School of Art, Mumbai, India

Solo Exhibitions
2010 *The Hangover of Agarlum*, Project 88, Mumbai, India

Group Exhibitions
2010 *Tracing Reality*, Kashya Hildebrand, Zurich, Switzerland
2010 *Ballard Estate*, Religare Arts Initiative, Delhi, India
2009 *Revisioning Materiality Part II*, Gallery Espace, Delhi, India
2009 *Moment As Monument*, Tranvancore Gallery for Thomas Erben
Gallery, New York, NY, USA; Gallery Seven as part of the Art Summit,
Delhi, India
2009 *First Look*, Project 88, Mumbai, India
2008 *Parables of Thread*, "The Loft" in Mumbai, India
2008 *Recent Works*, Project 88, Mumbai, India
2008 *Video Wednesdays*, Gallery Espace, New Delhi, India
2008 *Visuals of a Post-Visual World*, Priyasri Art Gallery, Mumbai, India
2007 *Recent Works by Four Artists*, Jehangir Art Gallery, Mumbai, India
2005 *Canvas for a Cause*, N.G.M.A., Mumbai, India

Awards / Grants / Residencies
2010 Montalvo Arts Centre, Saratoga, CA, USA
2009–2010 INLAKS Scholarship, Mumbai, India
2009 FICA Award for Emerging Contemporary Artists of India,
New Delhi, India
2009 Artist-in-Residence for a writers' workshop at the Guild Art Gallery,
Mumbai, India
2008–2009 Nasreen Mohamedi Scholarship, Vadodara, India
2007 One-month residency programme at Partapur, Rajasthan, India
2003 AIFACS Society Prize for Painting (Students Category), Bombay Art
Society, Mumbai, India

Hemali Bhuta
Growing, 2009
Incense sticks with various scents
304.8 x 304.8 x 304.8 cm

HEMALI BHUTA

Hemali Bhuta's work deals with the effect of time on a space, through which she tries to transform the impression and identity of the exhibition space into a tangible experience. Usually drawing on her personal experiences, memories and understanding of various elements, including philosophy, her works aim to articulate issues of belonging, security, individuality and change. Through her work, she aims to investigate transitory spaces and also find a way to overcome them. Inspired by life itself and its ephemeral nature, her works have always adapted to the spaces in which they are exhibited.

Her art draws on psychology, philosophy and mythology from various sources, and she is primarily concerned with the notion of an in-between or transitory space and those elements that contain or create these spaces. For her, 'in-betweenness' is a plane where the limitations of dimensionality do not apply. It is a spiritual plane of endless interconnected possibilities that make up the wholeness of it all. Only when 'in-betweenness' is understood does intuition act to bring about the realisation that separation exists only in the mind. Hemali likes to explore this quintessential situation, to belong to neither of the two sides as opposed to our constant efforts to belong somewhere, thereby ensuring our own security.

Keeping in mind the formal quality of a work, Hemali will create two opposite spaces: that of black and white, or negative and positive, or the contour or outline and the space that is contained within it. Upon creating these two opposites, Hemali aims to explore the transitional space between them. Hemali has arrived at the concept of the corners as an outgrowth of the *growing* in the black box. She will explore the way her works progress or merge into one another and thus create a chain of reactions or responses with each other. And within this chain of thoughts, processes, ideas, are in-between spaces or silences that one experiences.

Growing, for her, is a reaction to and a continuation of a previous work called *The Shedding*. Both works are based on the action-reaction phenomena. In *The Shedding*, the dense forest gets denuded as the hair starts to shed. In *Growing*, it is about the growth of it back into a thick forest. Only the forms change.

The incense stick is predominantly used for prayer or 'puja'. It is truly ironic that an object that is used for a ritual and is supposedly considered 'pure', should actually be reduced to just a smell to overpower the existing natural smells around us. It merely stimulates the senses of the user. The original installation included incense sticks of varied fragrances, some mounted on the wall, others hung from the ceiling, to form a pattern of lines. Initially, it resembled a pleasure garden with distinct scents – rose, jasmine, *nag champa*, musk, lavender. But it quickly became difficult to distinguish one scent from another as the work grew. Old identities were lost; an altogether new scent, a new identity was assumed.

Hemali looks at how the materials that she uses allow themselves to be transformed into something beyond, hence flirting with the idea of identities, both gaining and losing them in order to take up new ones.

Her choice of materials are mainly mundane, organic, ephemeral yet factory made, depending on a very intuitive or visceral selection, but at the same time have their own connotations and thus entail specific cultural and socio-political significance.

Amruta Nemivant

Hemali Bhuta
Stepping Down, part of the project *The Hangover of Agarlum*, 2010
Wax, cotton thread and metal grid
Approximately 60 m²

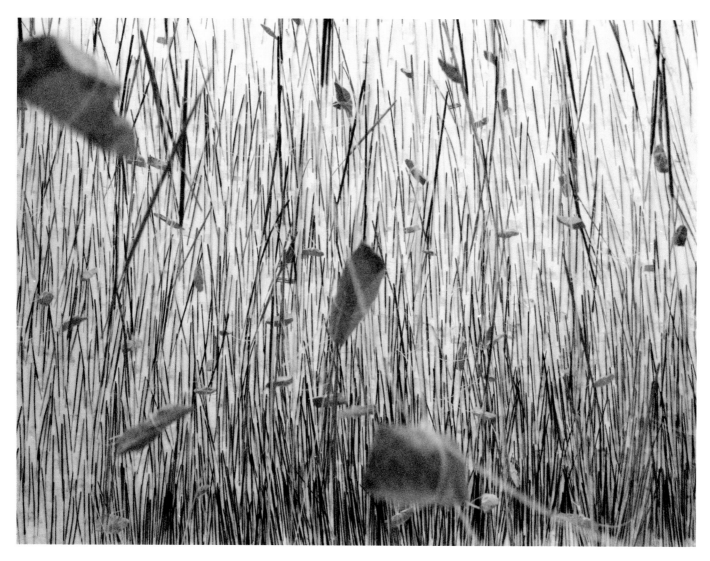

Hemali Bhuta
Growing (detail), 2009
Incense sticks with various scents
304.8 x 304.8 x 304.8 cm

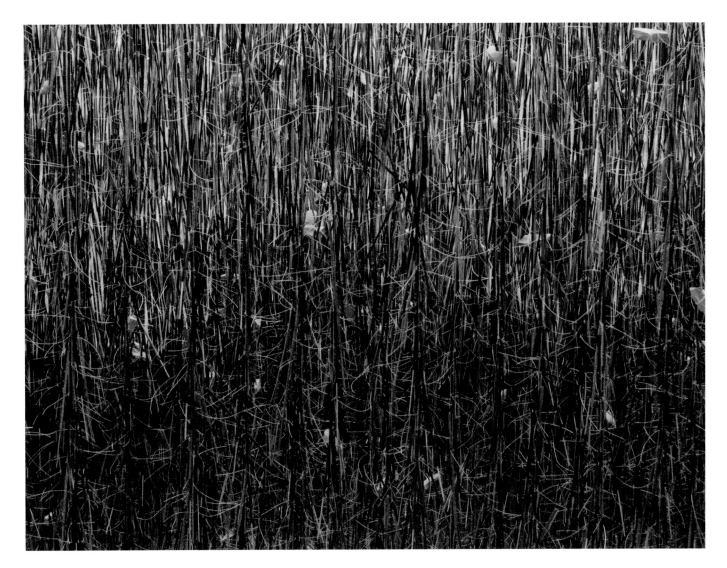

Hemali Bhuta
Growing (detail), 2009
Incense sticks with various scents
304.8 x 304.8 x 304.8 cm

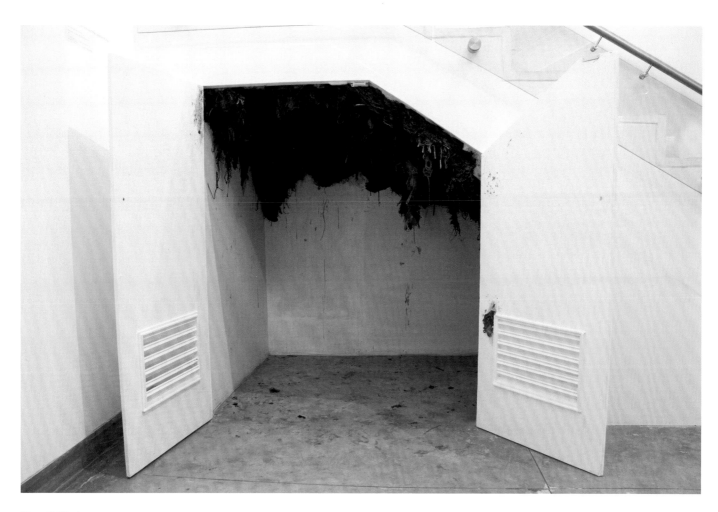

Hemali Bhuta
The Hopeless Corners and the Useless Things, part of the exhibition
Re-visioning Materiality II, 2009
Burnt rubber bands, plywood and adhesive
Dimensions variable

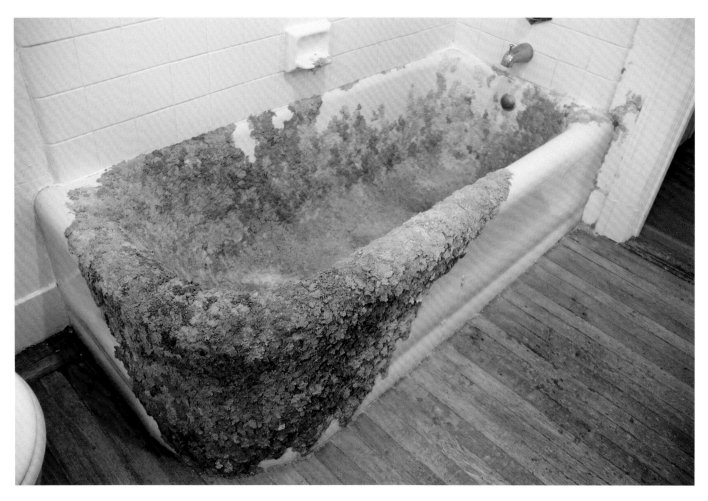

Hemali Bhuta
The Green Tub, 2010
Bath soap, bath salt and washable colours
Dimensions variable

Nikhil Chopra

Born in 1974, Kolkata, India
Lives and works in Mumbai, India
Studied at M.S. University of Baroda, Gujarat, India; Maryland
Institute College of Art, Baltimore, MD, USA; Ohio State University,
Columbus, OH, USA

Solo Exhibitions

2010 *Yog Raj Chitrakar: Memory Drawing X*, Chatterjee and Lal,
Mumbai, India; Dr. Bhau Daji Lad Museum, Mumbai, India
2007 *Yog Raj Chitrakar: Memory Drawing II*, Chatterjee and Lal,
Mumbai, India
2005 *Sir Raja III*, Kitab Mahal, Mumbai, India

Group Exhibitions

2010 *Production Site: The Artist's Studio Inside-Out*, Museum of
Contemporary Art, Chicago, IL, USA
2009 *Marina Abramovic Presents...*, Manchester International Festival,
The Whitworth Gallery, Manchester, UK
2008 *Everywhere is War*, Bodhi Art, Mumbai, India
2008 *KHOJ Live 08*, International Performance Art Festival,
KHOJ International Artists' Association, New Delhi, India
2008 *Emerging Discourses II*, Bodhi Art, New York, NY, USA
2008 *Time Crevasse*, Yokohama Triennale, Yokohama, Japan
2007 *Beings and Doings*, Queen's Gallery, British Council,
New Delhi, India
2007 *House of Mirrors*, Grosvenor Vadehra Gallery, London, UK
2007 *Posing*, Abrons Art Center, New York, NY, USA
2006 *Asian Contemporary Art Week*, Asia Society, New York,
NY, USA; Brooklyn Museum, New York, NY, USA
2004 *Contemporaneity: International Video Art in Kyrgyzstan*,
G Aitiev Kyrgyz National Museum of Art, Bishkek, Kyrgyzstan

Residencies

2009 *Residency and Reflection*, Kunstenfestivaldesarts,
Brussels, Belgium
2007 International Performance Art Residency, KHOJ International
Artists' Association, New Delhi, India
2007 KHOJ Kasheer, Kashmir, KHOJ International Artists'
Association, New Delhi, India
2003 Edith Fergus Gilmore Materials Grant, Ohio State University,
OH, USA

Costumes designed by Tabasheer Zutshi

Nikhil Chopra
What will I do with all this land? (detail), 2005
Black and white photograph on Ilford paper
55.8 x 43.1 cm

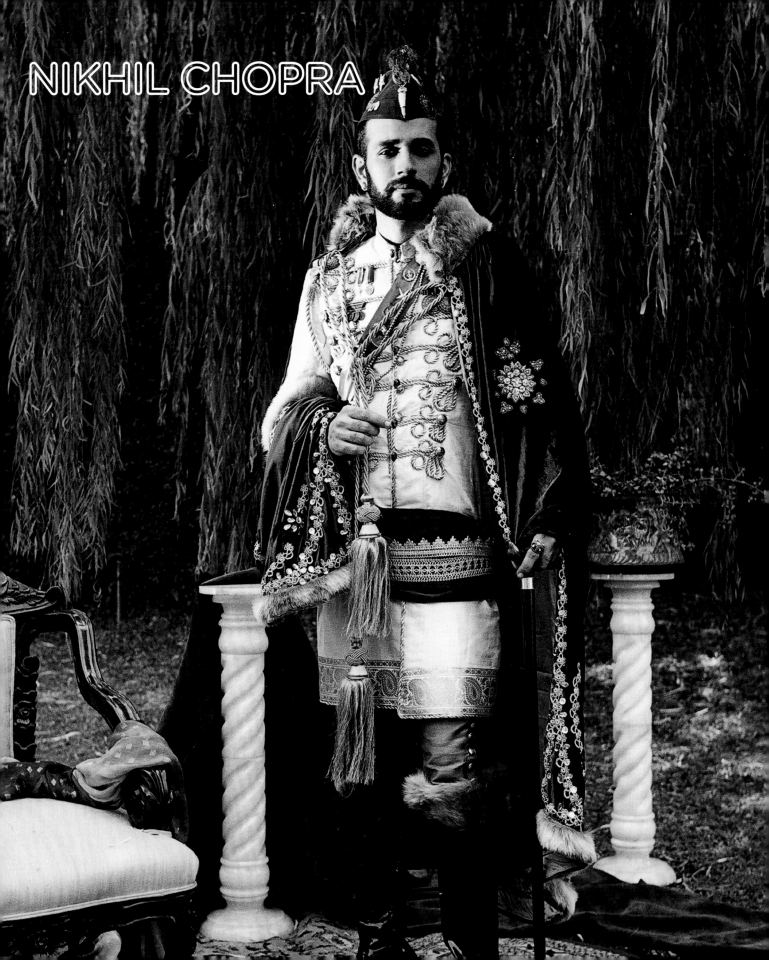

NIKHIL CHOPRA

Nikhil Chopra works at the boundaries between theatre, performance, live art, painting, photography and sculpture. He devises fictional characters that draw on India's colonial history as well as his own personal history. He inhabits these characters in largely improvised performances that last up to three days.

Chopra's character, Sir Raja, was created when he was living in Ohio in 2002. A stereotype of the Indian prince from the country's colonial era, Chopra uses this alter-ego to create tableaux for live performances, films and photographs. In the performance *Sir Raja II*, 2003, the character could be found at the end of a 350-foot red carpet, seated motionless at a table spread with food, fruits and flowers. Here Chopra created a live Vanitas painting and challenged the viewer to confront past and present issues of colonialism, exoticism and excess. The theme of death and references to European painting also appeared in the Mumbai performance *The Death of Sir Raja III*, 2005, where he lay adorned in silk and jewels, surrounded by velvet drapes and rich oriental rugs, as if he were posing for a painting depicting his own death. During performances Chopra does not interact with the audience, who, unlike in theatre, are free to come and go throughout. The artist is, however, always aware of the viewer's gaze and the constant potential for the boundary between player/viewer to be breached adds to the tension and intensity.

In *What will I do with all this land?*, 2005, Sir Raja is shown journeying on horseback through his vast inherited estate in a series of atmospheric black and white photographs. These portraits of the robed prince alone in the epic landscape of Kashmir are reminiscent of 19th-century British Imperial photography of Indian dignitaries. The narratives around Sir Raja do not, however, refer to a specific person or moment in history but are rather woven from Chopra's personal memory, old family photographs, ancestral home and endless family stories.

Chopra's most recent character, Yog Raj Chitrakar, is loosely based on the artist's grandfather, Yog Raj Chopra. Educated at Goldsmiths College of Art, London, in the 1930s, Yog Raj Chopra was a frequent open-air landscape painter who spent a large part of middle age capturing the grandeur of the Kashmir Valley.

The character Yog Raj Chitrakar has many faces: explorer, draughtsman, cartographer, conqueror, soldier, prisoner of war, painter, artist, romantic, dandy and queen. These are signified by the elaborate costumes, which are changed throughout performances to indicate the character's transformation. Yog Raj Chitrakar sets up camp, indoors or outdoors, and makes large scale drawings of what he sees: cities in transition, places at the cusp of change, the collision of history and the present, architecture and nature. The large-scale drawings, as well as the props used in the performances, are left as remnants. However, it is the performative process that is the most important aspect of the work to Chopra, who states: 'I want the experience of a work to precede the object and I want the making to be at the centre of it.'
Rebecca Morrill

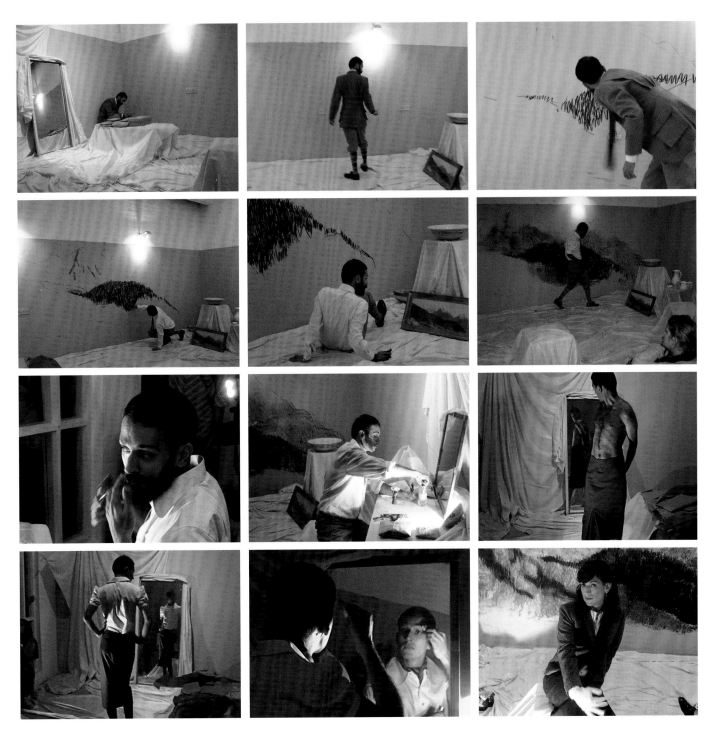

Nikhil Chopra
Yog Raj Chitrakar: Memory Drawing I, 2007
Documentation of a performance

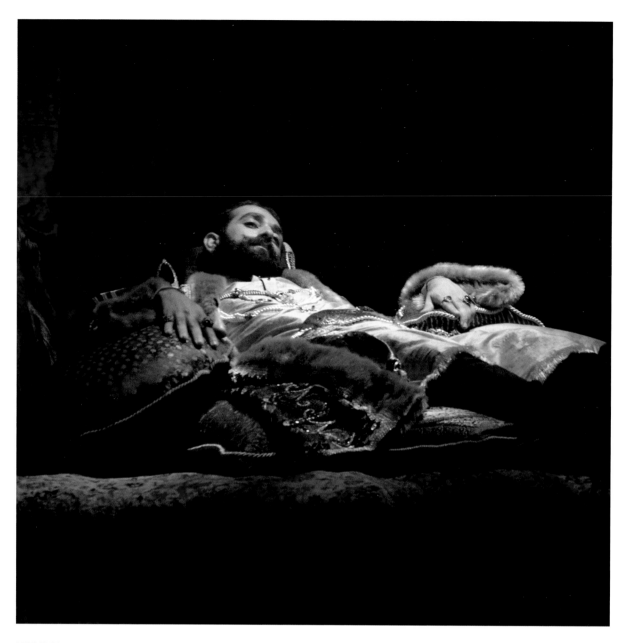

Nikhil Chopra
The Death of Sir Raja III (detail), 2005
Documentation of a performance

Nikhil Chopra
What will I do with all this land?, 2005
Colour photograph on Kodak paper
48.2 x 48.2 cm

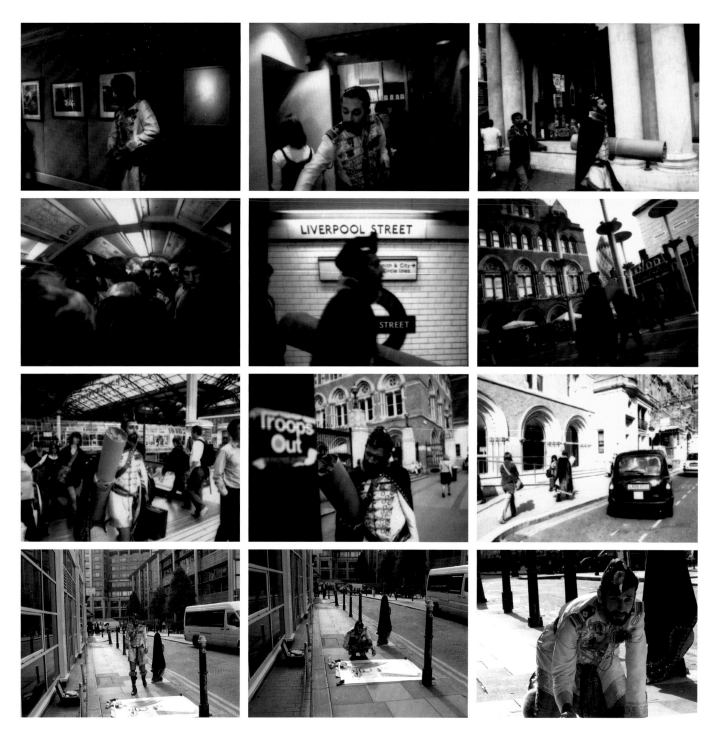

Nikhil Chopra
Sir Raja III visits Spitalfields Market, 2005
Documentation of a performance

DESIRE MACHINE COLLECTIVE

Sonal Jain
Born in 1975, Shillong, India
Lives and works in, Guwahati, India
Studied at M S University of Baroda, Gujarat, India

Mriganka Madhukaillya
Born in 1978, Jorhat, India
Lives and works in Guwahati, India
Studied at Fergusson College, Pune, India; and National Institute of
Design, Ahmedabad, India

Group Exhibitions
2010 *Being Singular Plural: Moving Images from India*,
Deutsche Guggenheim, Berlin, Germany
2010 *ID/entity*, Vadehra Art Gallery, New Delhi, India
2010 *Frieze Film*, Frieze Art Fair, London, UK
2010 *And the, panopticon, as well*, Biennial of Young Artists,
Bucharest, Romania
2009 *Unreal Asia*, International Short Film Festival, Oberhausen,
Germany
2009 *The Landscape of Where*, Galerie Mirchandani + Steinruecke,
Mumbai, India
2009 *Video Wednesday*, Gallery Espace, New Delhi, India
2008 *48°C Public.Art.Ecology*, New Delhi, India
2008 *Place*, Anant Art Gallery, New Delhi, India
2008 *Festival du Nouveau Cinéma et le Vidéographe*, Montreal, Canada
2008 *Courts Métrages, les 21 Instants Vidéo* (Marseille); touring multi-
media exhibition *Instants Vidéo* (Video Moments) shown in France,
Canada (Quebec), Lebanon, Palestine, Venezuela and Argentina.
2008 Amsterdam-India Festival**,** Amsterdam, Netherlands

Desire Machine Collective
Residue, 2010
Digital film transferred from Super 16mm film
39 minutes

DESIRE MACHINE COLLECTIVE

Interacting with the agendas of Desire Machine Collective is like taking a walk through Professor Canterel's estate in Raymond Roussel's *Locus Solus*. Fabricating edible solar cells goes hand in hand with music and dance on a ferry on the Brahmaputra, along with capturing sounds from sacred groves on digital grooves, to very serious filmmaking and the making of politically provocative installation artworks. And if my conversations with the Collective are anything to go by, much more in this vein will follow very soon. Desire Machine Collective seek to give expression to the ludic and manic aspects of things coming to life in the undecidability of the environment in which they work, while also taking passages through a catastrophically creative landscape towards the ineffable, towards the boundaries of perception.

To understand how ludic play and an investigation of where perception disappears go together in the same creative space, one needs to take cognisance of new life forms, driven by a relentless recording of perceptions, as a way of life. The crystalline efflorescence of nature mimics the same for technology as it does the many passages of history through the Indian 'Northeast', which in turn is complicated by the dispersals of consciousness by state violence and all the forms of magical lives that bloom in response to such arbitrary violence. There is no way of summing all this up within a master narrative of concerted cultural or political focus. All lessons learnt in school about our favoured motto, 'unity in diversity', wither in the noise of political confrontations on the frontiers of nations and world political systems. On the one hand, such an opening up of the senses to passages of hybrid cultural noise creates a need to document each strand that makes up the flow of noise. On the other hand, the senses seek to escape such noise, in perceptual fatigue, into the realm of valueless perception, where all is calm and smooth flow.

Frontiers defined by passages of goods, ideas, sensations and people going in all directions are good places to be in, for they allow us to see clearly all the routes that such passages take. The flower in Assam blooms with petals touching now China, next Burma, next Calcutta, next Saks Fifth Avenue and so on. In short, we can journey into all the worlds that such a zone of passages feeds and nourishes. Maybe the logic of state violence on frontiers is to precisely keep everyone in the indeterminate state of being carriers of cultural sensations into the global all the time and incessantly so; but it also means that this site will throw back at us the monstrous phantasmagorias that such hectic and anxious passages of hybrid cultural noise are bound to produce. The democratisation of forms of artistic expression to the carriers now means that the consumers in their homesteads will need to confront the magical monstrous imagery that the passage of raw materials for the objects of the desires entails.

Three machines then – at one end, nature as the machine that spews out the raw materials of the objects of our desire, and at the other end, the machine of passive desire that desires by looking at the screen that presents an endless litany of the desirable. And in the middle we have the machine of passages, the machine animated by desire as such in its naked and pure forms, where the raw material of nature and the raw material of desire become one and the same. But isn't such a space where desire and matter are one and the same thing the ideal space to start a radical investigation of our dreams, which are but passages that seek to shape matter to the designs of our desires? In all dreams there is the noise of the collective that takes our perception of the real in various directions. A desire machine collective is then a public that comes together to set up our dreams for us to see and experience so that we may walk away at the end of the day with the touch of the foundational that structures our senses, that somehow remains intact not despite but because of all the noisy dispersals of history. **Kaushik Bhaumik**, Deputy Director, Osian Cinefan Film Festival of Asian and Arab Cinema

Desire Machine Collective
Residue, 2010
Digital film transferred from Super 16mm film
39 minutes

Desire Machine Collective
Residue, 2010
Digital film transferred from Super 16mm film
39 minutes

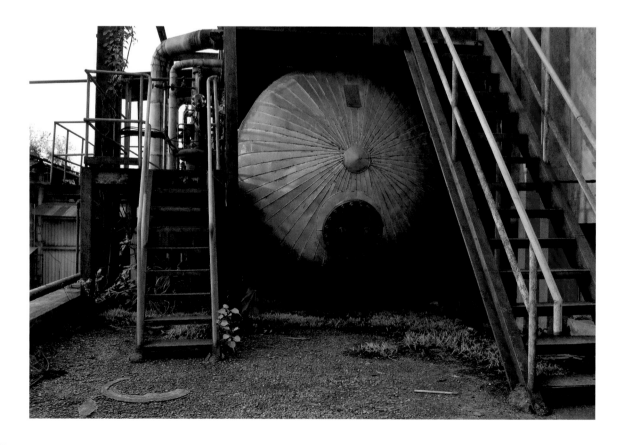

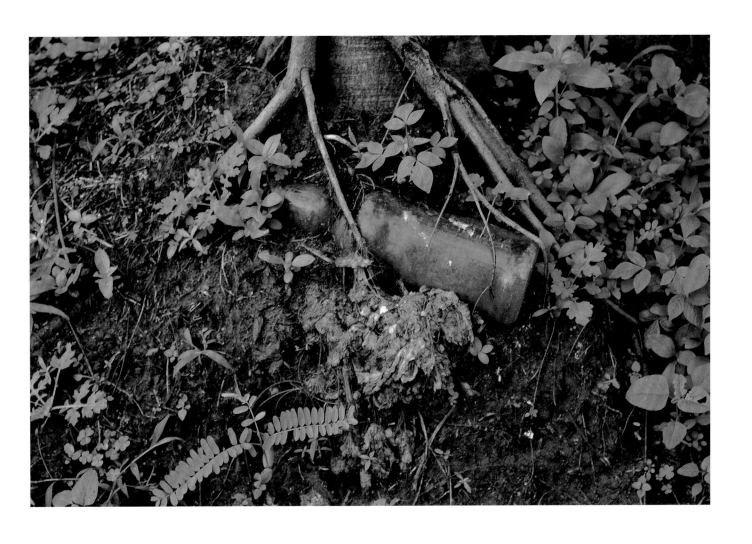

Desire Machine Collective
Residue, 2010
Digital film transferred from Super 16mm film
39 minutes

Sheela Gowda

Born in 1957, Bhadravati, India
Lives and works in Bangalore, India
Studied at Ken School of Art, Bangalore, India; M.S. University of
Baroda, Gujarat, India; Bangalore University, India; Vishwa-Bharati
University, Santiniketan, India; Royal College of Art, London, UK

Solo Exhibitions

2011 *Therein and Besides*, Iniva, London, UK
2010 *Behold,* National Art School Gallery, Sydney, Australia
2010 *Postulates of contiguity*, Office for Contemporary Art Norway,
Oslo, Norway
2008 *Crime Fiction*, GALLERYSKE, Bangalore, India
2008 *Touching Base*, Museum Gouda, Netherlands
2006 Bose Pacia Gallery, New York, NY, USA
2004 *On Earth and in Heaven*, GALLERYSKE, Bangalore, India
1987 Venkatappa Art Gallery, Bangalore, India

Group Exhibitions

2010 *Orientations, Trajectories in Indian Art*, Foundation De 11 Lijnen,
Oudenburg, Belgium
2009 *Making World*, 53rd Venice Biennale, Venice, Italy
2009 *Art in Times of Uncertainty*, Thessaloniki Biennale, Greece
2009 *Provisions*, Sharjah Biennial, Sharjah, United Arab Emirates
2009 *Where in the World*, Devi Art Foundation, New Delhi, India
2008 *Reflections of Contemporary India*, La Casa Encendida, Madrid,
Spain
2008 *India Moderna*, Institute Valencià d'Art Modern, Valencia, Spain
2007 *Horn Please, Narratives in Contemporary Indian Art*,
Kunstmuseum Bern, Bern, Switzerland
2007 *The 00's – The History of a Decade That Has Not Yet Been Named*,
9th Biennale de Lyon, Lyon, France
2006 *With Love*, Miami Design District, Miami, FL, USA
2005 *Indian Summer*, École nationale supérieure des Beaux-Arts,
Paris, France
1977-1983 Annual shows with the art group Samyojitha,
Bangalore, India

Awards / Grants / Residencies

1998 Sotheby's Prize for Contemporary Indian Art
1998 GS Shenoy Award
1994-1996 Senior Fellowship, Government of India
1986 Residency at the Cité Internationale des Arts, Paris, France
1985 Karnataka Lalit Kala Akademi Award
1984-1986 Inlaks Foundation Scholarship for post-graduate studies at
the RCA, London, UK
1979-1982 Karnataka Lalit Kala Akademi Scholarship for
higher studies

Sheela Gowda
Tongue, 2002
Gum Arabic, thread and wooden table
548.6 x 30.4 cm

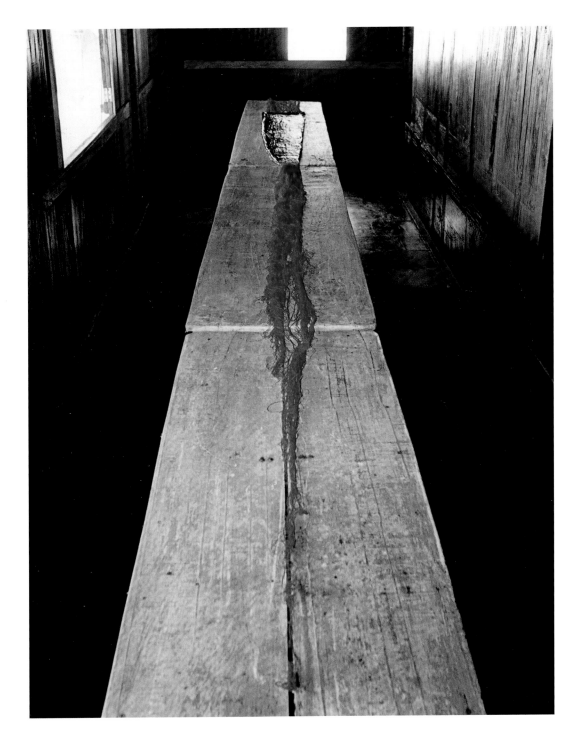

SHEELA GOWDA

The materials used by Sheela Gowda are particularly significant for both the atmosphere they evoke through texture, colour and smell and also their metaphoric potency. Gowda incorporates substances that straddle a banal, everyday presence with an elevated poetic reference both to urban and rural India. These include cow dung, which has sacred implications but is also used as a domestic cooking fuel and building material; gold-leaf and ceremonial dyes used for body adornment and rituals; and domestic materials such as coconut fibre, needles, threads and cord. Her use of these materials is not an underlining of their traditional contexts and meanings but a deliberate subversion and critique.

Gowda's process-based work frequently blurs the boundary between fine art and craft. Across her practice, she questions the role of female subjectivity in the mix of religion, nationalism and violence that comprises contemporary Indian society. In *And Tell Him of My Pain*, 1998, Gowda pulled over 250 metres of thread through each of 108 needles and then made a cord of them by anointing the mass with red *kumkum* (natural pigment) and glue. The cords are then suspended from walls and draped across spaces so that it becomes a three-dimensional drawing. The meaning of *And Tell Him of My Pain* is multi-layered. It refers to spice culture – traditionally part of women's experience – as well as the textile industry, and brings to mind the pain of female domestic life in a patriarchal society.

She abandoned conventional forms of painting and turned to sculpture and installation. While she is reticent to use her work to make strident statements, her recent works, such as *Agneepath*, 2006, are more political in subject, drawing on images from the media of urban unrest, conflict and tragedy.

Her large-scale sculptures and installations incorporate commonplace manufactured materials of the type salvaged and recycled by impoverished migrant workers, such as lead plumbing pipes, asphalt, plastic sheeting and metal barrels. Her monumental *Darkroom*, 2006, constructed from metal tar-drums that are unaltered and stacked on top of each other or flattened into sheets to be used as constituent parts. *Darkroom* simultaneously evokes the grandeur of classical colonnades or turreted castle and the simplicity of an ad hoc temporary shelter built by India's road-workers. Inside the structure, the darkness is broken by tiny dots of light through holes punctured in the metal ceiling, which appear like a constellation of stars. This combination of harshness and lyricism runs through much of Gowda's work.

Gowda is also interested in the idea of material displacement as a means of evoking new meaning in objects. In *Ground*, 2007, she collected discarded Indian grinding stones, rendered obsolete by modern kitchen appliances, which she found on the streets of Bangalore, the Silicon Valley of India and a city that has undergone hyperdevelopment in recent years. Gowda dispersed these cooking stones across Lyon during the city's 2007 *Biennale*. Having been dislocated from their original context, these previously unremarkable, abandoned objects regained meaning as a potent reminder of the speed with which age-old traditions are disappearing.
R. M.

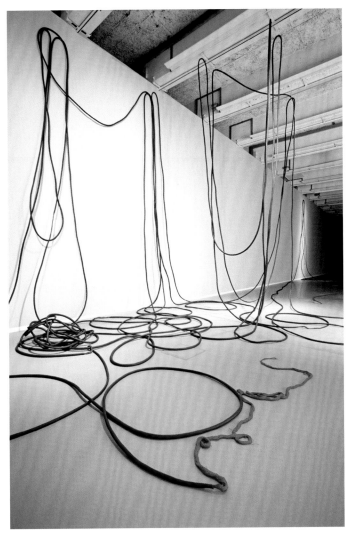

Sheela Gowda
And Tell Him of My Pain, 2007
Needles, thread, pigment and glue
Two pieces: each 112,5 m x 1 cm

Sheela Gowda
And Tell Him of My Pain (detail), 2007
Needles, thread, pigment and glue
Two pieces: each 112,5 m x 1 cm

Above:
Sheela Gowda
Darkroom, 2006
Interior view
Tar drums, tar drum sheets, asphalt and mirrors
238.8 × 259.1 × 304.8 cm

Right:
Sheela Gowda
Darkroom, 2006
Tar drums, tar drum sheets, asphalt and mirrors
238.8 × 259.1 × 304.8 cm

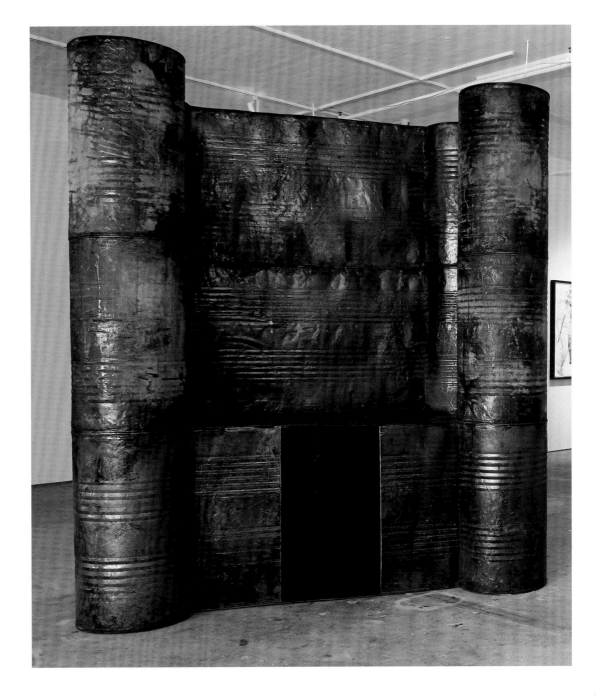

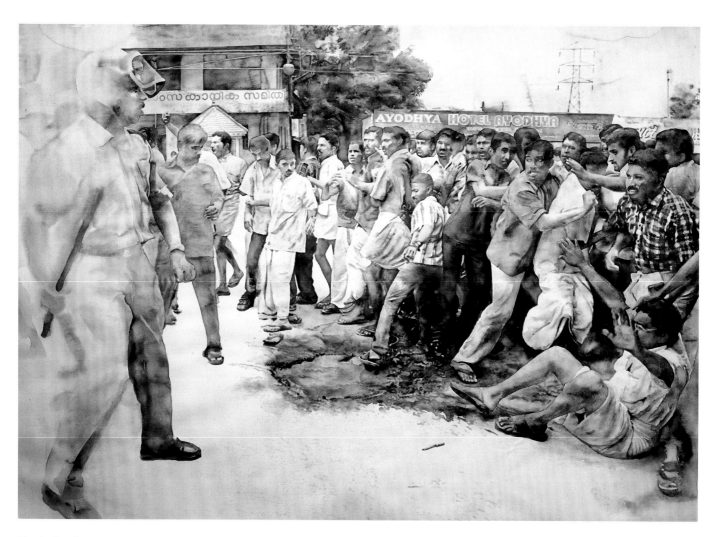

Sheela Gowda
2/7, 2006
Watercolour on inkjet print
111.7 x 157.4 cm

Sheela Gowda
Agneepath, 2006
Watercolour on inkjet print
111.7 x 200.6 cm

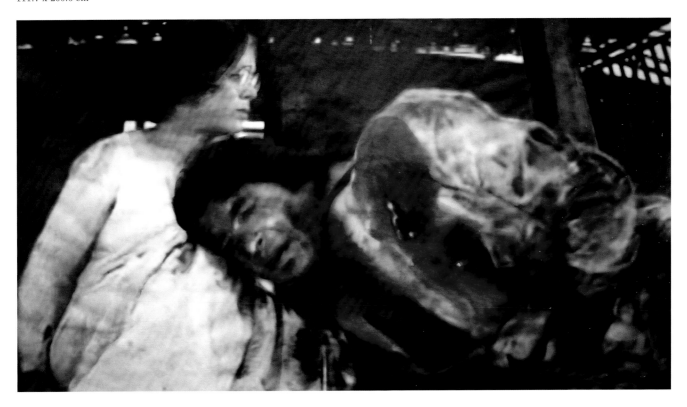

Sakshi Gupta

Born in 1979, New Delhi, India
Lives and works in New Delhi, India
Studied at the College of Art, New Delhi, India; Government College
of Art, Chandigarh, India

Solo Exhibitions
2009 GALLERYSKE, Bangalore, India
2007 GALLERYSKE, Bangalore, India
2006 *i~object*, Gallery One, Bangalore, India

Group Exhibitions
2010 *GALLERYSKE for Gallery BMB*, Gallery BMB, Mumbai, India
2010 *The Empire Strikes Back*, Saatchi Gallery, London, UK
2009 *The Power of the Ornament*, Belvedere, Vienna, Austria
2008 *Urgent: 10 ml of Contemporary Art Needed*, Foundation for Indian
Contemporary Art, Vadehra Art Gallery, New Delhi, India
2008 Krinzinger Projekte, Vienna, Austria
2008 *Current*, GALLERYSKE, Bangalore, India
2007 *Lush*, Art Basel Miami, Miami, FL, USA
2007 *Indian Art Oggi*, Spazio Oberdan, Milan, Italy
2005 *47th National Exhibition*, Lalit Kala Akademi, Lucknow, India

Awards / Residencies
2008 Artist in residence, Gallery Krinzinger, Vienna, Austria
2007 Inlaks Scholarship, Cittadellarte - Fondazione Pistoletto,
Biella, Italy
2006 Kashi Art Residency, Kochi, India
2006 Artist in Residence, Bangalore Artists Centre, India
2004 National Scholarship
2004 Community-based workshop, KHOJ International Artists'
Association, New Delhi, India

Sakshi Gupta
Landscape of Waking Memories (detail), 2007
Galvanised wire, mesh and chicken feathers
165.1 x 93.9 x 25.4 cm

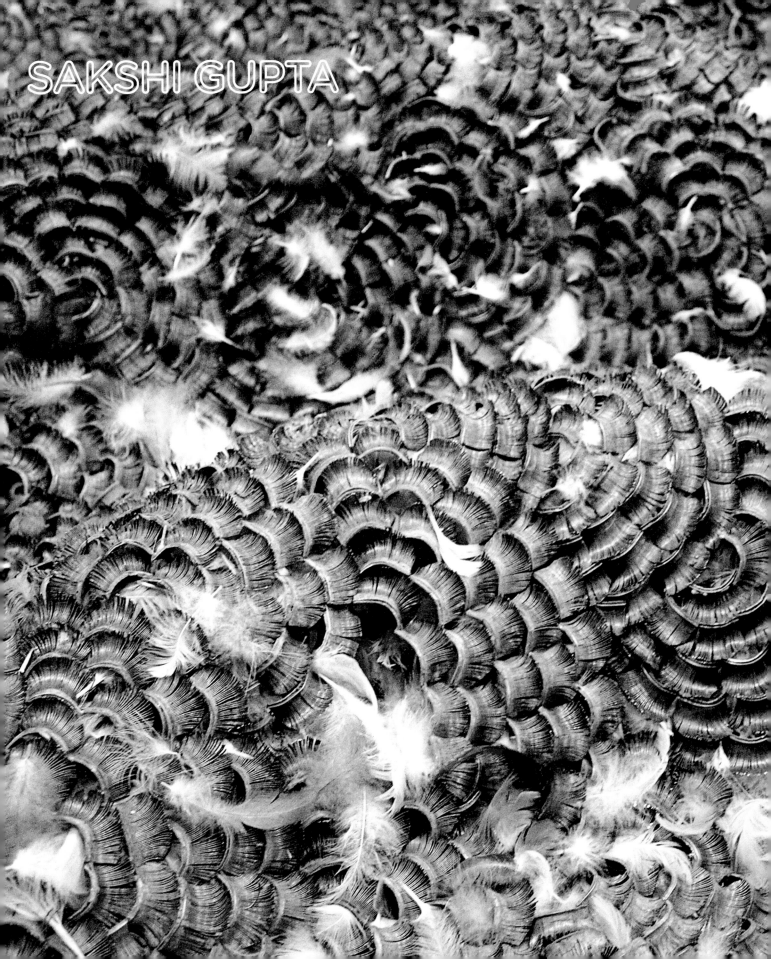

SAKSHI GUPTA

SAKSHI GUPTA

Sakshi Gupta recycles scrap-materials, often with industrial origins, to produce sculptures that transform the meaning of the materials to provoke spiritual contemplation. This emphasis on materiality results in an evocative and ephemeral lightness and fragility. Through this engagement with material weight, Gupta's works can be understood as a commentary on the contemporary world – highlighting the shift from the economics of heavy industry to the weightless age of information and technology.

The spectacular sculpture *Some Beast*, 2008, uses rusty iron to create the form of a suspended ceiling fan that itself resembles a writhing beast, in the process of moulting and shrugging off its skin which cascades to the floor. Its domineering presence above the viewer imposes some of the terror and obeisance ceremonially accorded to both the mythical and religious beasts of traditional culture and the machines of war today. Yet the zoomorphic engendering of a mundane domestic object also evokes vulnerability and weariness, high-lighting how exhausting the process of transformation in the modern world can be.

Gupta also draws heavily on personal experience. The body of work *Nothing is Freedom, Freedom is Everything, Everything is You*, 2007, refers to the contradictions faced by young people: the hopes and expectations that are not guaranteed to materialise; the struggles and unexpected joys; and new opportunities to make the personal choices that may not have existed for previous generations. The first piece in this series uses discarded locks, welded together to create a collection of seven pillows, each

weighing 20kg. Instead of offering rest, these pillows evoke sleepless nights in a claustrophobic environment. The second work uses nuts, bolts, cogs and bearings arranged in a symmetrical pattern on a horizontal surface suggesting a traditional carpet, representing the highs and lows of life. When displayed, the viewer is invited to walk on it, to experience the contradition of the unrelenting discomfort of walking on a simulation of lush carpet. The third sculpture is a figurative bust made out of discarded factory waste which Gupta has explained represents her belief that freedom of choice exists within individuals.

Landscape of Waking Memories, 2007, combines wire and mesh with chicken feathers to create an object that at first glance resembles a soft, sensual quilt but, on closer inspection, reveals itself to be sharp and unyielding. Gupta has commented how 'the places/people and situations that appear to be comforting sometimes become the source of unease themselves, making me re-evaluate life from its very foundation.'

Gupta has also produced external site-specific sculptures, during residencies and at the twice-yearly artists' workshop in Rajasthan, India. Continuing to use the principles of working with impoverished materials, her exterior works combine discarded debris from local factories with natural found objects such as roots, fronds and feathers. The objects she creates are frequently anthropomorphised and evoke deliberate unease and anxiety to represent the sense of discomfort and conflict that the artist feels in her own life. **R.M.**

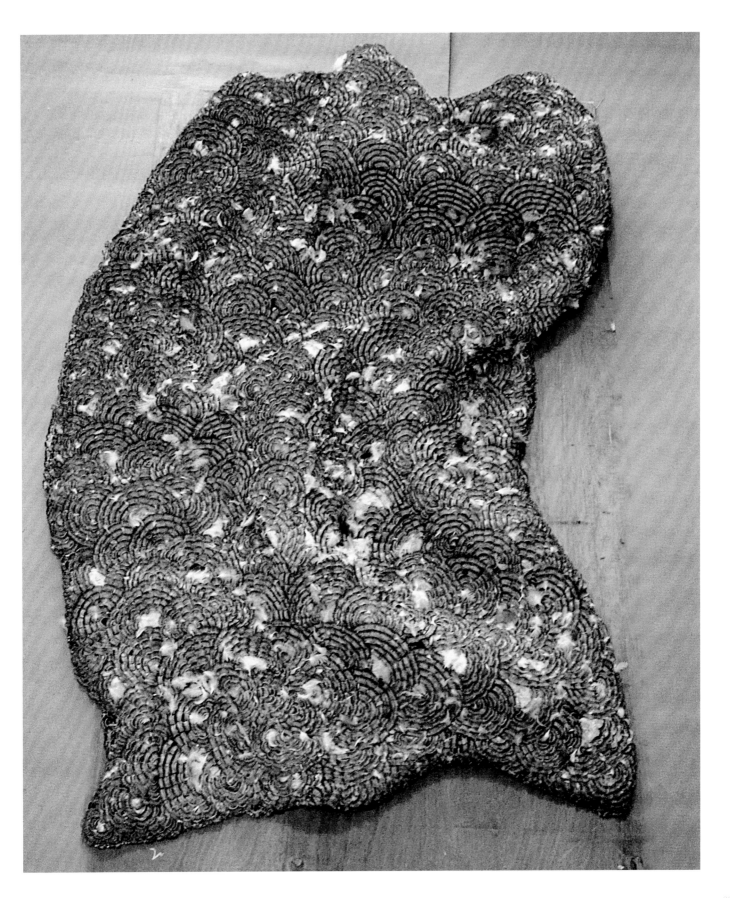

Previous page:
Sakshi Gupta
Landscape of Waking Memorie, 2007
Galvanised wire, mesh and chicken feathers
165.1 x 93.9 x 25.4 cm

Sakshi Gupta
Some Beast (detail), 2008
Scrap iron and soldering material
Dimensions variable

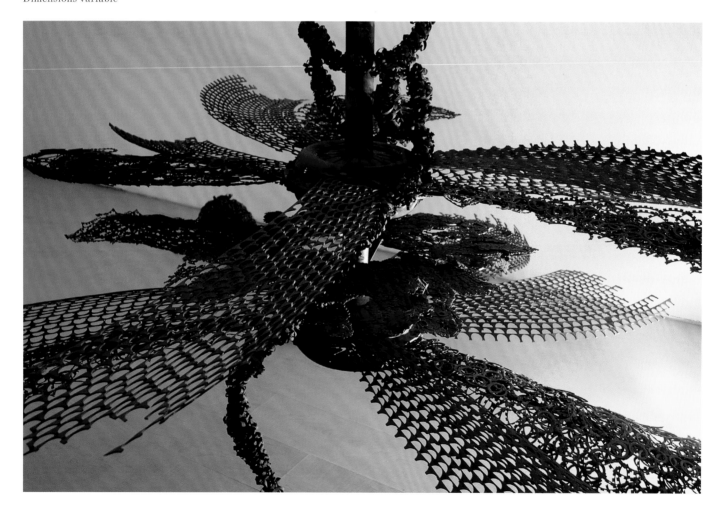

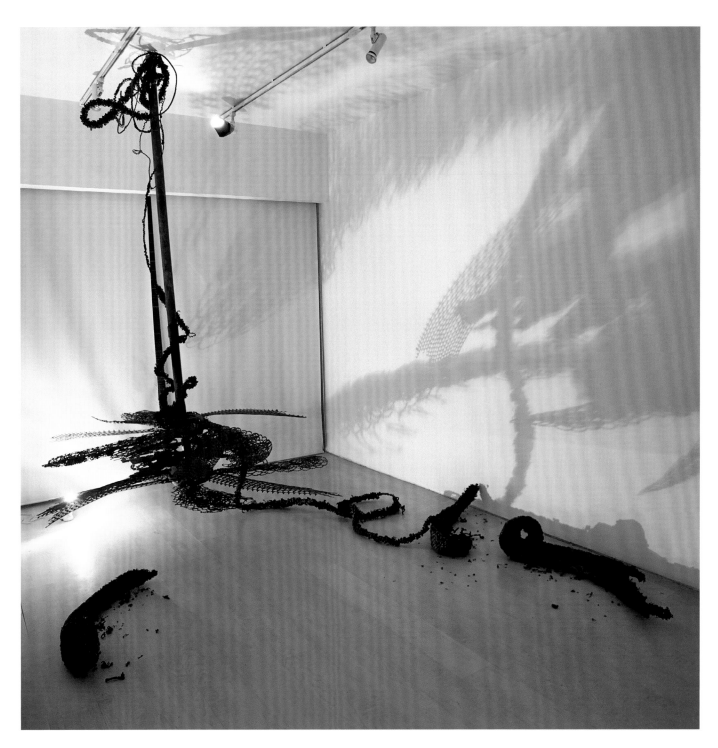

Sakshi Gupta
Some Beast, 2008
Scrap iron and soldering material
Dimensions variable

Sakshi Gupta
Freedom is Everything, 2007
Plywood and scrap metal
365.7 x 213 cm

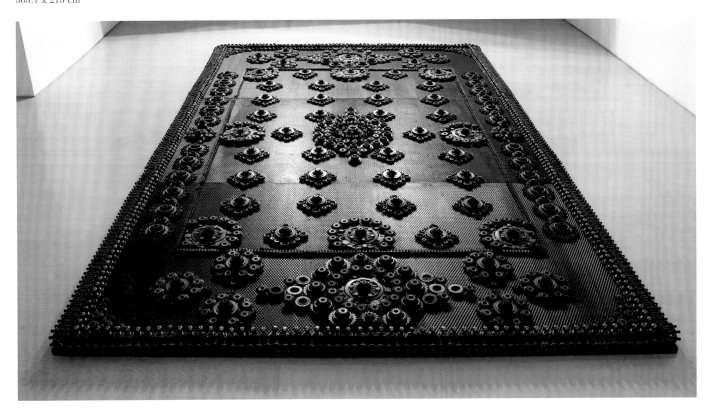

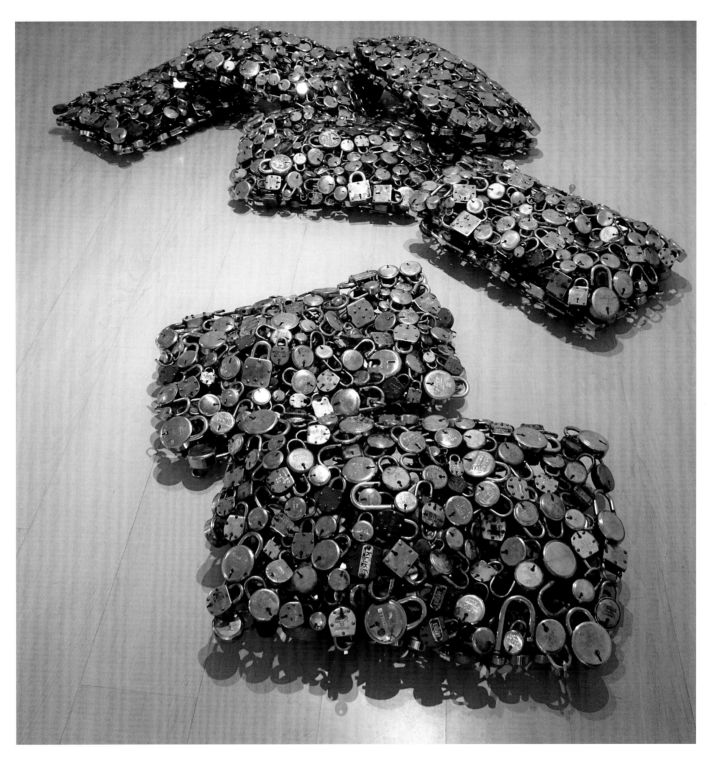

Sakshi Gupta
Nothing is Freedom, 2007
Metal locks
73.6 x 45.7 x 20.3 cm

Shilpa Gupta

Born 1976, Mumbai, India
Lives and works in Mumbai, India
Studied at Sir J J School of Art, Mumbai, India

Solo Exhibitions

2010 *A Bit Closer,* Contemporary Arts Center, Cincinnati, OH, USA
2010 *2652,* Dvir Gallery, Tel Aviv, Israel
2010 *Half a Sky,* OK Offenes Kulturhaus, Linz, Austria
2010 Château de Blandy-les-Tours, Blandy, France
2009 Yvon Lambert, Paris, France
2009 Lalit Kala Akademi with Vadehra Art Gallery, New Delhi, India
2009 *Second Moon,* Galleria Continua, San Gimignano, Italy
2009 *While I Sleep,* Le Laboratoire, Paris, France
2008 *BlindStars StarsBlind,* Kala Ghoda and Bodhi Space, Wadi Bunder, Mumbai, India
2007 *Artists' Studio,* Apeejay Media Gallery, New Delhi, India; Sakshi Gallery, Mumbai, India
2005 Provisions Library, Resource Center for Activism and Arts, Washington DC, USA
2004 *Your Kidney Supermarket,* Oxford Bookstore, Mumbai, India
2003 *Blessed Bandwidth.net,* Net Art Commission from Tate Online, London, UK

Group Exhibitions

2010 *Last Ride In A Hot Air Balloon: The 4th Auckland Triennale,* Auckland, New Zealand
2010 *The Tradition of the New,* Sakshi Art Gallery, Mumbai, India
2010 *Contemplating the Void: Interventions in the Guggenheim Rotunda,* Guggenheim Museum, New York, NY, USA
2010 *Asia In Motion – Video Art and Beyond,* Fukuoka Asian Art Museum, Fukuoka, Japan
2010 *Experimenta Utopia Now,* International Biennial of Media Art, The Arts Center, Black Box, Melbourne, Australia
2010 *Vancouver Biennale in Transition: New Art from India,* Richmond Art Gallery, Vancouver, Canada
2010 *The 11th Hour,* Tang Contemporary Art, Beijing, China
2010 *Practicing Memory – Every Moment in an All-Embracing Present,* Cittadellarte – Fondazione Pistoletto, Biella, Italy
2010 *The Armory Show,* Yvon Lambert, New York, NY, USA
2010 Art Basel 41, Yvon Lambert and Dvir Gallery, New York, NY, USA
2010 *Looking Glass,* Religare Art Gallery, New Delhi, India
2009 *The Generational: Younger than Jesus,* New Museum, New York, NY, USA
2009 *Biennale Cuvée – World Selection of Contemporary Art,* OK Offenes Kulturhaus, Linz, Austria
2009 *Le spectacle du quotidien,* 10th Biennale de Lyon, Lyon, France
2009 *The World Is Yours,* Louisiana Museum of Modern Art, Humlebæk, Denmark
2009 *Everyday Miracles Extended,* Walter and McBean Galleries, San Francisco Art Institute, San Francisco, CA, USA; REDCAT, Los Angeles, CA, USA
2009 *The Armory Show,* Galleria Continua and Bodhi Art, New York, NY, USA
2009 Frieze Art Fair, Yvon Lambert, London, UK
2009 FIAC, Galleria Continua, Paris, France
2009 Dubai Art Fair, Galleria Continua, Dubai, United Arab Emirates
2008 *A Year in Exhibitions,* 7th Gwangju Biennale, Gwangju, South Korea
2008 *I Have a Dream,* Kuandu Biennale 2008, Kuandu Museum of Fine Arts, Taipei, Taiwan
2008 *India Crossing,* Studio La Città, Verona, Italy; Bodhi Art Gallery, Mumbai, India
2008 *Youniverse,* 3rd Seville International Biennial of Contemporary Art, Seville, Spain
2008 FIAC, Yvon Lambert Gallery, Paris, France
2008 Frieze Art Fair, Yvon Lambert Gallery, London, UK
2008 *India Moderna,* Institut Valencià d'Art Modern, Valencia, Spain
2008 *India Time,* Paolo Curti /Annamaria Gambuzzi & Co, Milan, Italy
2008 Dubai Art Fair, Galerie Volker Diehl and Albion Gallery, Dubai, United Arab Emirates
2008 *Affair,* 1x1 Gallery, Dubai, United Arab Emirates
2008 *Time Crevasse,* International Triennale of Contemporary Art, Yokohama, Japan
2007 *The 00's – The History of a Decade That Has Not Yet Been Named,* 9th Biennale de Lyon, Lyon, France
2006 Liverpool Biennial, Liverpool, UK
2005 3rd Fukuoka Asian Art Triennale, Fukuoka Asian Art Museum, Fukuoka, Japan
2004 Media City Seoul Biennale, Seoul, South Korea

Awards

2005 Leonardo Global Crossings Award, runner-up
2004 Transmediale Award, Berlin, Germany
2004 Sanskriti Award, Sanskriti Pratishthan, New Delhi, India
2004 International Artist of the Year, South Asian Visual Artists Collective, Canada

TRANSFORMATIONS
Film programme curated by Shilpa Gupta
for Indian Highway IV

NIKHIL CHOPRA
Yog Raj Chitrakar. Memory Drawing. Part 1, 2008
Video, 1:07 minutes

BAPTIST COELHO
Corporal Dis(Connect) Mode #1 Standard Mode and Intoxicated Mode, 2007
Video, 1 minute

SUNIL GUPTA
Love, Undetectable #11, 2009
Video, 2:30 minutes
Love, Undetectable #12, 2009
Video, 0:25 minutes
Love, Undetectable #13, 2009
Video, 6:00 minutes

TUSHAR JOAG
Jataka Trilogy, 2004
Video, 6:33 minutes

KIRAN SUBBAIAH
Hello... I am, 2009
Video, 5:40 minutes
Now I See It, 1999
Video, 1:17 minutes

VIVAN SUNDARAM
The Brief Ascension of Marian Hussain, 2005
Video, 2:40 minutes

,

Shilpa Gupta
Untitled, 2004
Interactive video projection and sound
8 minutes
600 x 800 cm

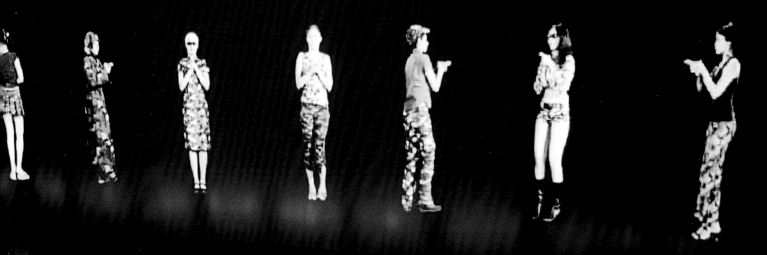

SHILPA GUPTA

Shilpa Gupta is an interdisciplinary artist who uses interactive video, photography and performance to query and examine themes of consumer culture, desire, security, militarism and human rights. Much of Gupta's work relies on audience participation, with the viewer challenged to respond in order to extend the meaning of, or even to complete, the work's meaning; she is a social activist whose works are to be activated.

The viewer who engages with one of her works is invited to follow a series of steps, through which the viewer might reasonably presume the meaning would be revealed. Instead, Gupta strands participants with ambiguity and uncertainty, speculating on the work's intention. In a broader social and political context, Gupta reflects on ways in which we comply with specific codes of conduct and ordering devices generated by hegemonic groups, enabling them to administrate the masses.

This is echoed in the video projection *Untitled*, 2004, presented at the *Lyon Biennale*, where spectators are visually captured and transformed into shadows by a live camera. Through this medium, spectators perform in a live computer game of simulated landscapes and shadow play, forming an integral part of the narrative. While questioning our lived and perceived realities, Gupta resists the notion of art as a commodity. Her choice of medium and presentation spaces exemplifies this resistance to commodification – the artwork becomes an experience rather than a coveted object, with a symbiosis between the viewer/participant and the artist.

The issue of authorship is key to Gupta's practice, resonating clearly in the performance work *There is no explosive here*, 2007. The viewer is encouraged to exit the gallery and enter the public domain carrying a bag with the printed statement 'There is no explosive here'. Suspicion and uncertainty are raised by this 'true' statement, not only for the person carrying the bag but also by those she encounters who read the text in a public space. Gupta blurs the boundary between artist, viewer and the work to create a fluid interaction in which all contributors share responsibility, thereby challenging embedded racial and social stereotypes and drawing attention to anxieties within society.

Blame, 2002–4, produced in the context of Aar-Paar, a public art exchange between India and Pakistan, 2000–5, expounds the utopian vision of blurring cultural, religious and national boundaries. Made in the same year as the Gujarat genocide, which resulted in thousands of Muslims deaths, this work has a poignant resonance. Gupta distributed bottles of simulated blood in and around Mumbai train stations and asked users to establish differences between the various blood samples. With an inscription labelled on the bottles, 'blaming you makes me feel so good, so I blame you for what you cannot control – your religion, your nationality,' Gupta presents the impossibility of establishing any form of categorisation or seeing differences and, in doing so, transcends the negative implications of religion, nationalism and fanaticism.

Employing a variety of media, whether it is via interactive video installations, performance or photography, Gupta blurs the boundary between art and the culture of everyday life, prompting questions about how we think and who we are. **L.H.**

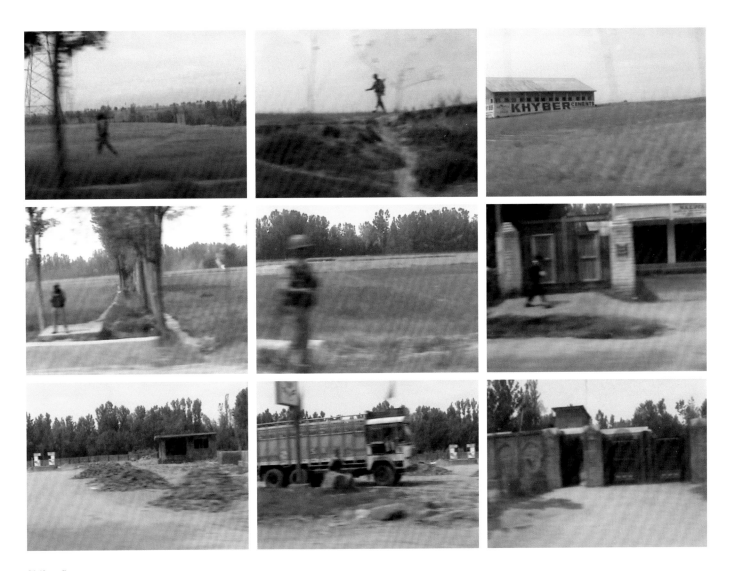

Shilpa Gupta
National Highway Number 1, 2002-2004
DVD
6:28 minutes

Shilpa Gupta
Shadow 3, 2007
Interactive video projection incorporating the viewers'
simulated shadow
800 cm wide

Shilpa Gupta
In Our Times, 2008
Singing microphones with speeches from Jinnah and Nehru
at the time of India and Pakistan's independence, 1947
144.7 x 193 x 60.9 cm

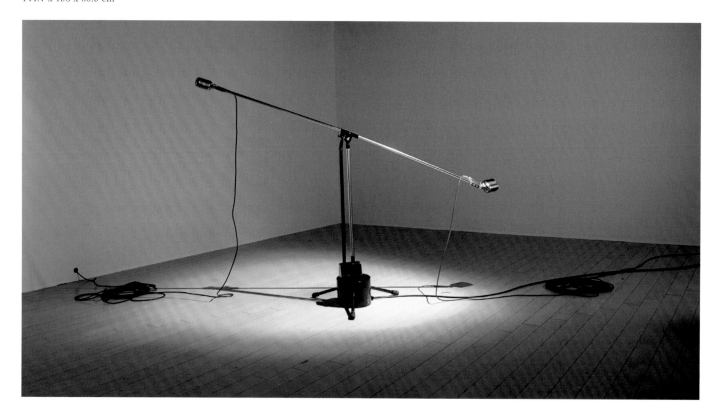

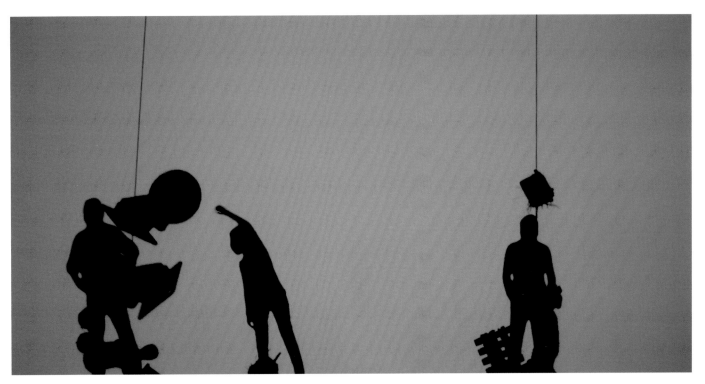

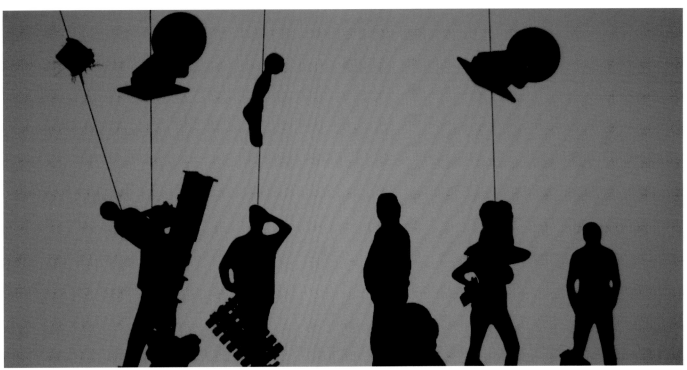

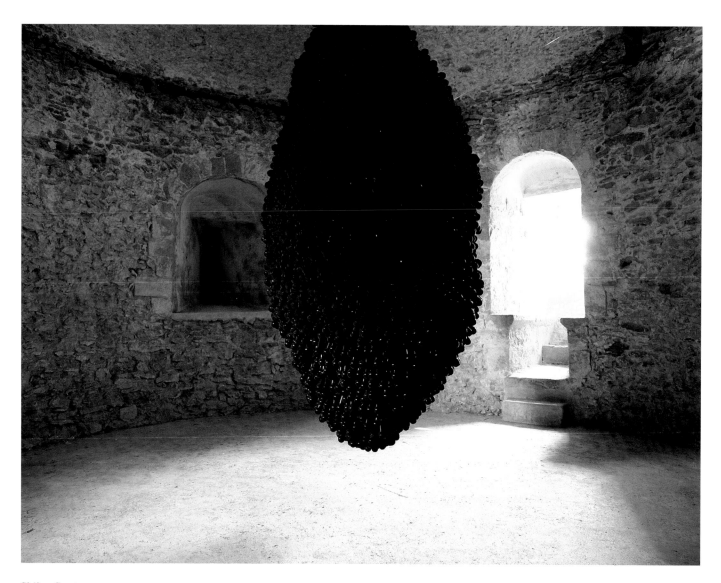

Shilpa Gupta
I Keep Falling at You, 2010
1500 microphones with embedded speakers,
audio editing setup
370 x 180 x 150 cm

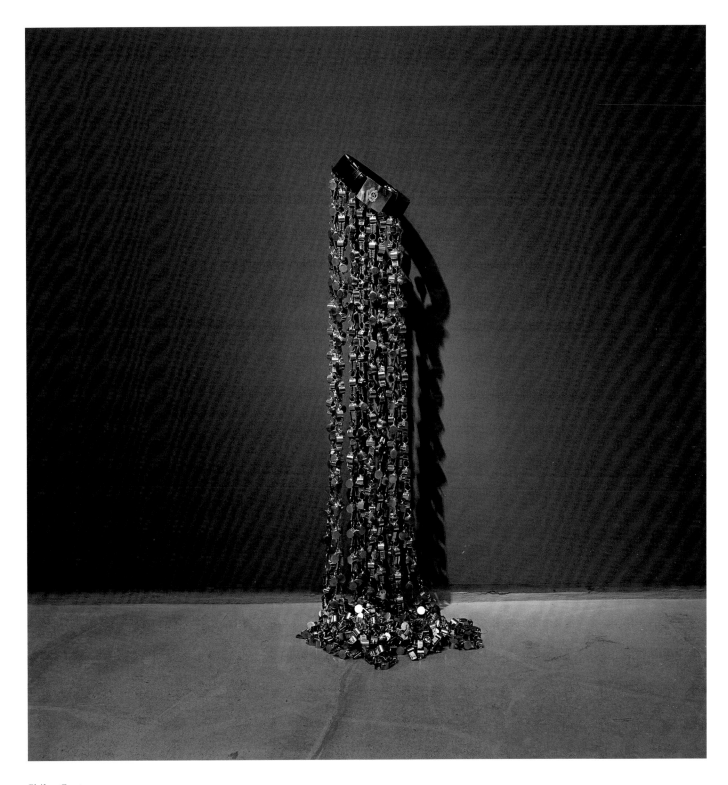

Shilpa Gupta
Untitled, 2008
Security belt with whistles
116.8 x 22.8 cm

Subodh Gupta

Born in 1964, Khagaul, Bihar, India
Lives and works in New Delhi, India
Studied at the College of Arts and Crafts, Patna, India

Solo Exhibitions

2011 Hauser & Wirth, Sara Hildén Art Museum, Tampere, Finland
2011 Hauser & Wirth, New York, NY, USA
2010 Hauser & Wirth, Zurich, Switzerland
2010 *Et tu, Duchamp?*, KÖR am Kunsthalle Wien, Vienna, Austria
2010 *Take Off Your Shoes and Wash Your Hands*, Tramway, Glasgow, Scotland, UK
2010 *Oil on Canvas*, Nature Morte, New Delhi, India
2010 *School*, Hauser & Wirth, London, UK
2009 *Common Man*, Hauser & Wirth, London, UK
2008 *Still Steal Steel*, Jack Shainman Gallery, New York, NY, USA
2008 *There is Always Cinema*, Galleria Continua, San Gimignano, Italy
2008 *Line of Control*, Arario Beijing, Beijing, China
2008 *Gandhi's Three Monkeys*, Jack Shainman Gallery, New York, NY, USA
2007 *Silk Route*, BALTIC Centre for Contemporary Art, Gateshead, UK
2006 *Hungry Gods*, Nature Morte, New Delhi, India
2004 *I go home every single day*, The Showroom Gallery, London, UK
1996 *Grey Zones*, Jehangir Art Gallery, Mumbai, India

Group Exhibitions

2010 *Hareng Sauer: Ensor and Contemporary Art,* Stedelijk Museum voor Actuele Kunst, Ghent, Belgium
2010 *lille3000: La Route de la Soie*, Tri Postal, Saatchi Gallery London in Lille, Lille, France
2010 *REM(A)INDERS*, Galleria Continua, Beijing, China
2010 *Urban Manners 2*, SESC Pompeia, São Paulo, Brazil
2010 *The Empire Strikes Back: Indian Art Today*, Saatchi Gallery, London, UK
2010 *Contemplating the Void*, Guggenheim Museum, New York, NY, USA
2010 *Art for the World (The Expo)*, Expo Shanghai 2010, Shanghai, China
2009 *6th APC – The 6th Asia Pacific Triennial of Contemporary Art*, Queensland Art Gallery, Brisbane, Australia
2009 *Altermodern*, Tate Triennial 2009, Tate Britain, London, UK
2009 *Un Certain État du Monde?*, The Garage Centre for Contemporary Culture in Moscow, Moscow, Russia
2009 *Indian Narrative in the 21st Century: Between Memory and History*, Casa Asia, Madrid, Spain
2009 *LIVE and LET LIVE: Creators of Tomorrow*, Fukuoka Asian Art Museum, Fukuoka, Japan
2008 *God & Goods*, Villa Manin, Udine, Italy
2007 *Sequence 1, Painting and Sculpture from the François Pinault Collection,* Palazzo Grassi, Venice, Italy
2005 *Always a Little Further*, 51st Venice Biennale, Venice, Italy
2003 *8th Havana Biennial*, La Havana, Cuba
2002 *Kapital and Karma*, Kunsthalle Wien, Vienna, Austria

Awards / Residencies

2004 French Government residency in Paris, visiting Professor at École nationale supérieure des Beaux-Arts, Paris, France
1997 Emerging Artist Award, Bose Pacia Modern, New York, NY, USA
1997 UNESCO – Ashberg Bursaries for Artists, Gasworks, London, UK
1990-1991 Research Grant Scholarship, Lalit Kala Akademi, New Delhi, India
1987-1988 Students Grant Scholarship, Government of Bihar, Patna, India

Subodh Gupta
Take Off Your Shoes and Wash Your Hands (detail), 2007
Exhibition view at the macLYON
Structure of stainless steel and stainless steel kitchen utensils
407 x 2764 x 42 cm
Unique piece

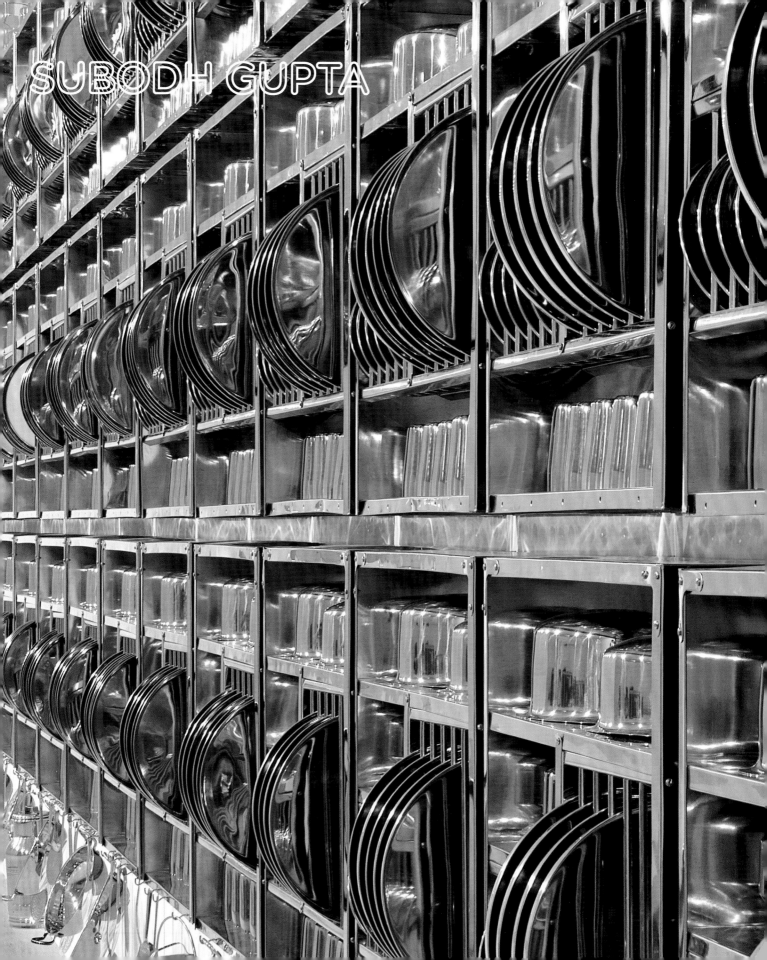

SUBODH GUPTA

SUBODH GUPTA

Subodh Gupta's practice shifts between different mediums including painting, sculpture, photography, video and performance. Throughout his work, he uses objects that are recognisable icons of Indian life – domestic kitchenware, such as stacked stainless-steel tiffin boxes and symbols of the street such as bicycles, scooters and taxis. By relocating them from their original context and placing them in museums and galleries, he elevates their status from common object to valued artwork.

Born in a small town in the northern province of Bihar, one of the poorest regions of India, Gupta completed a painting degree in Patna before moving to New Delhi. Cultural dislocation and his experience of the stark contrasts between rural and urban are themes that permeate Gupta's artistic practice.

His work is a commentary on the threat to traditional ways of life resulting from India's rapid modernisation and urbanisation. In *Pure*, 1999, Gupta is filmed covered in a thick layer of cow dung, then hosed off in a shower. Cow dung is a domestic fuel for many Indian homes, but also used for ritual cleansing in villages, something Gupta observed was a tradition not transferred to city life. He reflects on such differences in a series of sculptures including *Bullet*, 2007, where he juxtaposes bicycles and scooters with milk-churns, representing his surprise at seeing milk being delivered on bikes in cities rather than being collected directly from the cow.

Gupta is acclaimed for communicating effectively on both local and global levels. He has exhibited widely to an international audience, presenting indigenous elements of his culture through an immediately accessible language and aesthetic. He liberally employs clichés about the concerns and preoccupations of the Indian populace with humour and touching sentimentality.

Gupta is particularly celebrated for sculptural installations of shiny brass, copper, aluminium or steel kitchenware – bowls, plates, pots, pans, cutlery and other cooking utensils – such as in *Curry*, 2006. These objects are now commonplace in kitchens across India but are still powerful signifiers of middle-class aspirations for prestige and sophistication. In his large-scale installation, *Silk Road*, 2007, tiffin boxes are stacked high and rotate on a conveyor belt, creating a dizzying array of gleaming towers that echo the skyscrapers of India's ever expanding cities.

Other works by Gupta explore India's increasingly globalised vision of travel and the economic migration of its workforce. Bulging packages – *ghathris* – are cast in bronze and presented on a rotating airport baggage carousel, as in his large-scale installation *Across Seven Seas*, 2006, or precariously balanced on the roof of a sinking Ambassador taxi, as in *Everything is Inside*, 2004. Such bundles contain the prized consumer goods brought back to India by migrant workers travelling from the Gulf States and represent their pride in bringing back wealth for their families.

The recent work *Gandhi's Three Monkeys*, 2007–8, is overtly political work and references India's hero of peace who is ironically portrayed as three colossal heads in militaristic headgear. Using worn and patinated brass domestic utensils, the forms of a soldier's helmet, a terrorist's hood and a gas mask reinforce Gupta's dialectics of war and peace, public and private, global and local – themes that run throughout his work. **R.M.**

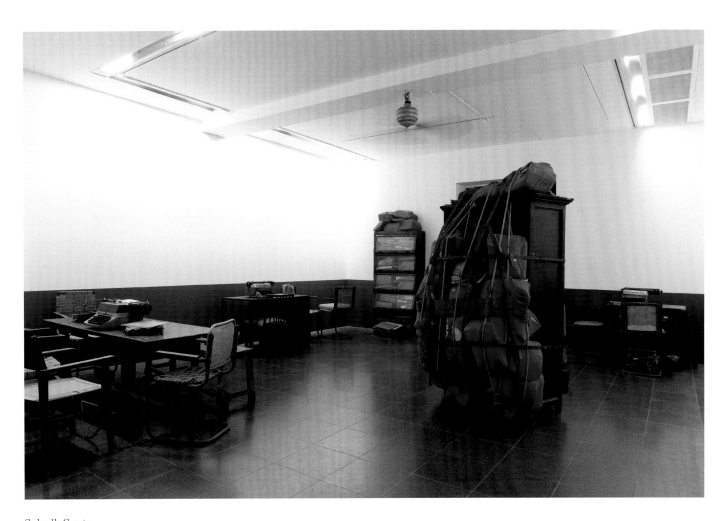

Subodh Gupta
Date by Date, 2008
Installation, mixed media
Variable dimensions
Installation view *Indian Highway I*, Serpentine Gallery,
London, 2008
(10 December 2008 to 22 February 2009)

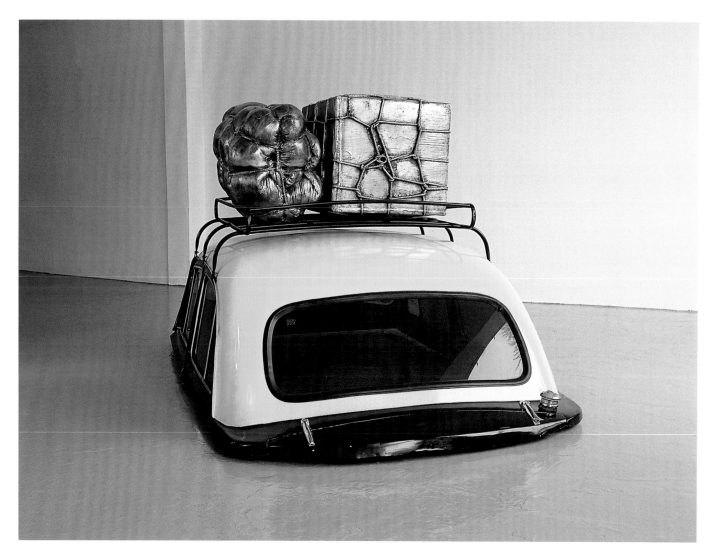

Subodh Gupta
Everything is Inside, 2004
Taxi and bronze
276 x 104 x 162 cm

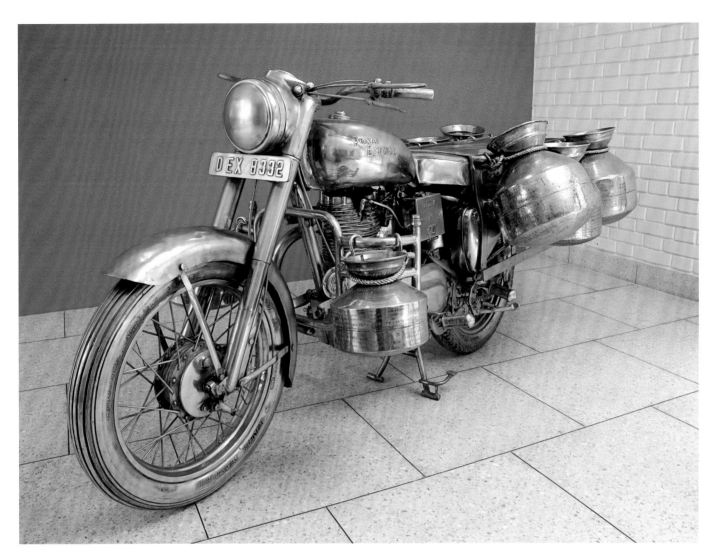

Subodh Gupta
Bullet, 2007
Royal Enfield motorcycle, brass and chrome

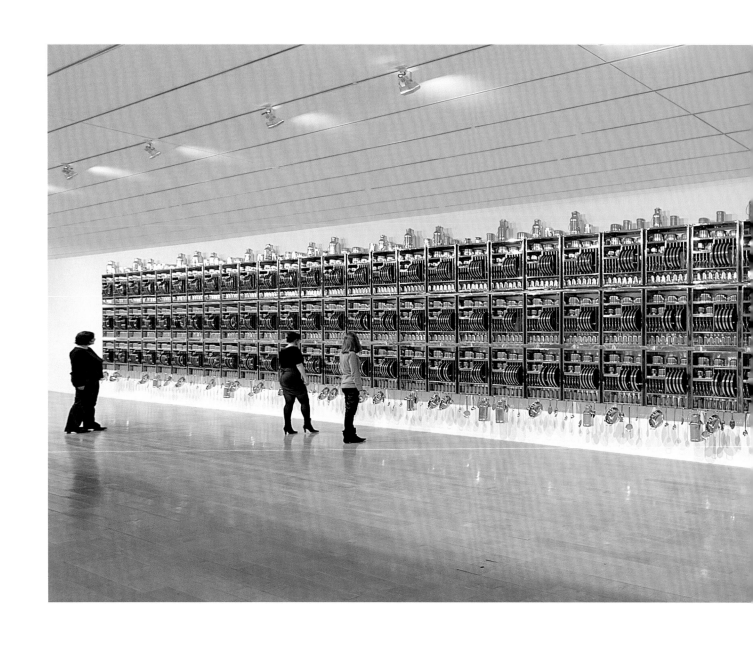

Subodh Gupta
Take Off Your Shoes and Wash Your Hands, 2007
Exhibition view at the mac^{LYON}
Structure of stainless steel and stainless steel kitchen utensils
407 x 2764 x 42 cm
Unique piece

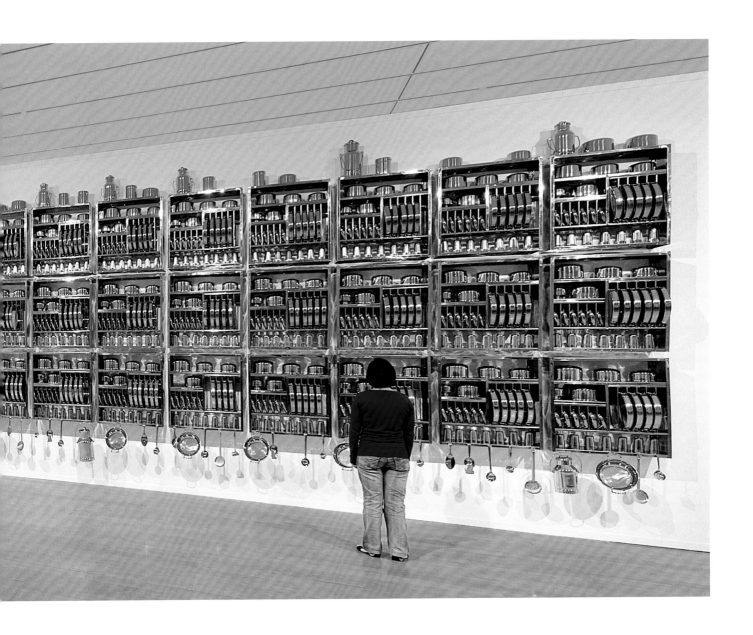

N.S. Harsha

Born 1969, Mysore, India
Lives and works in Mysore, India
Studied at Chamarajendra Academy of Visual Arts / CAVA,
Mysore, India; M S University of Baroda, Gujarat, India

Solo Exhibitions

2009 *Picking through the Rubble*, Victoria Miro Gallery, London, UK
2009 *Nations*, Iniva, London, UK
2009 *Cultural Debris*, Sakshi Gallery, Mumbai, India
2008 *Come Give Us a Speech*, Bodhi Art, New York, NY, USA
2008 *Leftovers*, Maison Hermès, Tokyo, Japan
2008 *Future*, Deng Kong Elementary School in Tamsui, Taiwan
2006 *Charming Nation*, Gallery Chemould, Mumbai, India
2005 *Indian Summer*, École nationale des Beaux-Arts, Paris, France

Group Exhibitions

2010 *Orientations: Trajectories in Indian Art*, Foundation De 11 Lijnen,
Oudenburg, Belgium
2010 *Touched*, Liverpool Biennial, Liverpool, UK
2010 *There is always a cup of sea to sail in*, 29th São Paulo Biennal,
São Paulo, Brazil
2010 *In the Company of Alice*, Victoria Miro Gallery, London, UK
2010 *Roots*, Sakshi Gallery, Bangalore, India
2009 *All That Is Solid Melts Into Air*, Museum van Hedendaagse Kunst
Antwerpen, Antwerp, Belgium
2008 *India Moderna*, Institut Valencià d'Art Modern, Valencia, Spain
2008 *Reflections of Contemporary India*, La Casa Encendida,
Madrid, Spain
2008 *Still Life: Art, Ecology and the Politics of Change*, Sharjah
Biennial, Sharjah, United Arab Emirates
2007 *Santhal Family*, Museum van Hedendaagse Kunst Antwerpen,
Antwerp, Belgium
2005 *New Narratives*, Chicago Cultural Center, Chicago, IL, USA
2004 *Artists-in-Labs*, Center for Microscopy (ZMB), Universität Basel,
Basel, Switzerland
2003 *Edge of Desire: Recent Art in India*, Art Gallery of Western
Australia, Perth, Australia; Asia Society, Queens Museum, New York,
NY, USA
2002 2nd Fukuoka Asian Art Triennial, Fukuoka, Japan
2000 *Drawing Space*, Beaconsfield Gallery in association with Victoria
and Albert Museum, London, UK
1999 *APT 3*, Third Asia Pacific Triennial of Contemporary Arts,
Brisbane, Australia

Awards / Residencies

2008 *Artes Mundi 3*, National Museum Cardiff, Wales, UK
2004 Wanchai-Hong Kong International Artists Workshop, Hong Kong
2003 Sanskriti Award, Sanskriti Pratishthan, New Delhi, India
1997 KHOJ International Artists' Workshop, Modinagar,
New Delhi, India
1992 Dasara Fine Art Award, Mysore, India

N. S. Harsha
Come give us a speech
(detail), 2008
Acrylic on canvas
182.8 x 1,097.2 cm

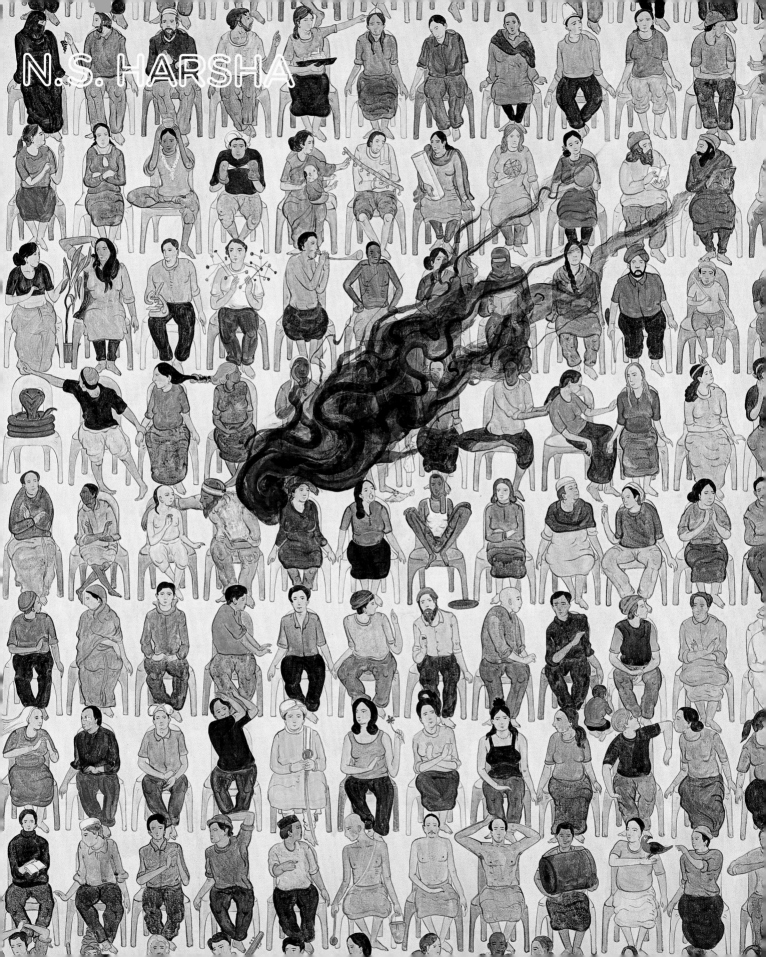

N.S. HARSHA

N. S. Harsha's wide-ranging work includes detailed figurative paintings and drawings, semi-abstract panels, sculptures and installations, site-specific projects and community-based collaborations. Harsha is celebrated for his reworking of the tradition of Indian miniature painting, assimilating Mughal, Pahari and Rajasthani schools and translating them to the monumental style of traditional wall paintings. Like other stalwarts of the Baroda School, Ghulam Mohammed Sheikh and Bhupen Khakkar on whose foundations he builds, Harsha embraces the modern Indian narrative enriched with popular art forms as a platform for a powerful social and political commentary. As the miniature painting format has regularly been used to highlight social and political inequities, Harsha's reference to them represents an embrace of the tradition updated by his personal idiom to embody contemporary conditions.

His large-scale and intricately detailed canvases depict a microcosm of Indian life. The multitude of figures are animated in unison, focused on an incongruous, comically strange or curious event. Harsha's paintings wittily combine common rites and rituals of Indian life with images drawn from world news. This tendency is most poignantly evident in *Smoke Goes Up Smoke Goes Down Your Search For Me Is Always On*, part of a cycle of 12 paintings made between 2004 and 2006. Ultimately Harsha's works are a sensitive and empathetic depiction of the human condition alluding to the convergence of local and global concerns, refracted through the prism of his life in Mysore city. *Mass Marriage,* 2003, is an extension of his concerns about diversity revealed through repetition and multiplicity, strategies which pervade his paintings as well as his installation works.

Other paintings are vignettes featuring characters set against a dark background. Some are straightforward critiques of the art world while others highlight the increasing tension between poor rural and rich urban communities as city developers encroach on farming land. Agricultural labourers are depicted as subservient to educated urbanites in suits, holding briefcases. This imbalance is emphasised further by the provocative texts incorporated into his paintings such as *They Will Manage My Hunger*, 2005.

Harsha's large-scale installation *Cosmic Orphans*, 2006, was a site-specific painting installed at the Sri Krishnan Temple, created for the *Singapore Biennale*. Harsha covered the the ceiling above the inner sanctum as well as the floor surrounding the temple's tower with paintings of sleeping figures, reminiscent of the multitudes that sleep helpless on platforms at Indian railway stations in the eternal wait for trains. Harsha deliberately chose, temple-spaces not normally associated with traditional painting. Indian cultural inheritance has strong taboos against stepping on another human being, provoking the audience to consider the boundaries of the sacred and profane so strictly adhered to by the priests. Consequently the pathway to the inner sanctum and onwards towards transcendence becomes an insurmountable boundary.

For the Serpentine, this idea of an insurmountable boundary is evident in the site-specific wall painting in which Harsha depicts a crowd restrained by a makeshift fence. Harsha has painted this directly on the gallery wall, where the gallery audience is confronted and asked to think about their relationship to the crowd. **S.A., R.M.**

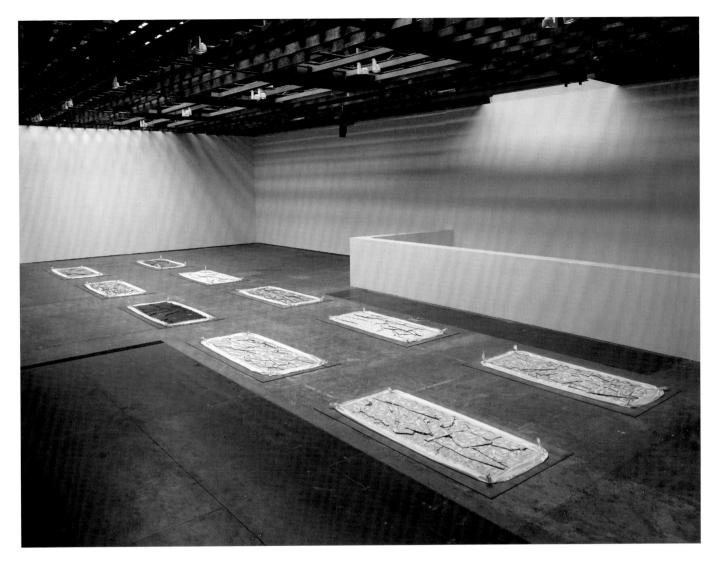

N. S. Harsha
Either Side of the Path of Enlightenment, 2009
Installation comprised of ten parts: oil on plywood, silk, plywood
243.8 x 121.9 cm each
Overall dimensions variable
Installation view Victoria Miro Gallery, London

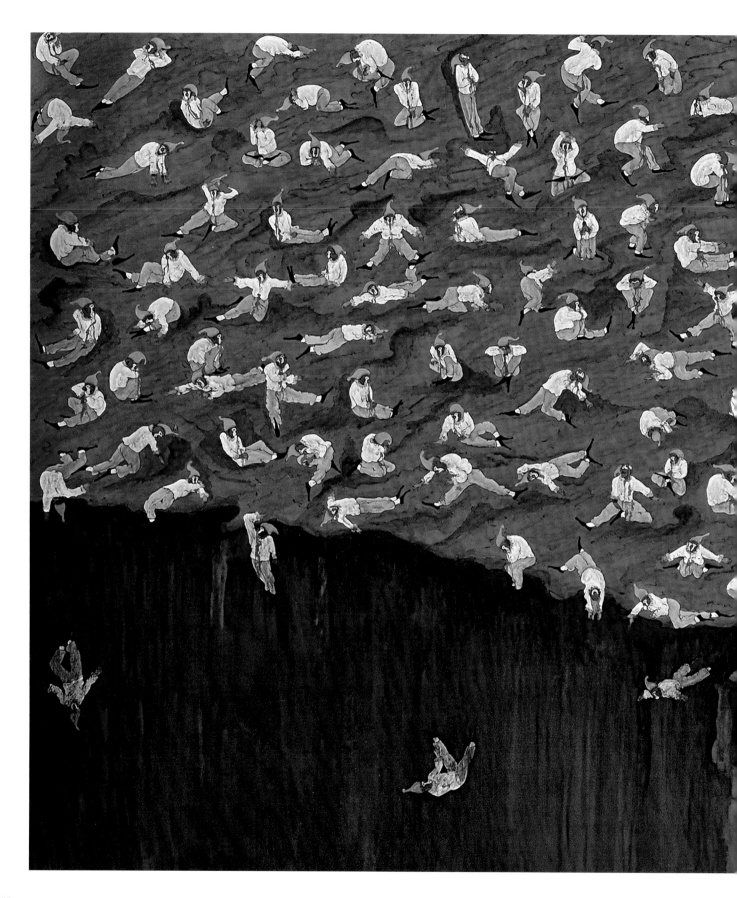

N. S. Harsha
Melting Wit, 2005
Acrylic on canvas
168 × 290 cm

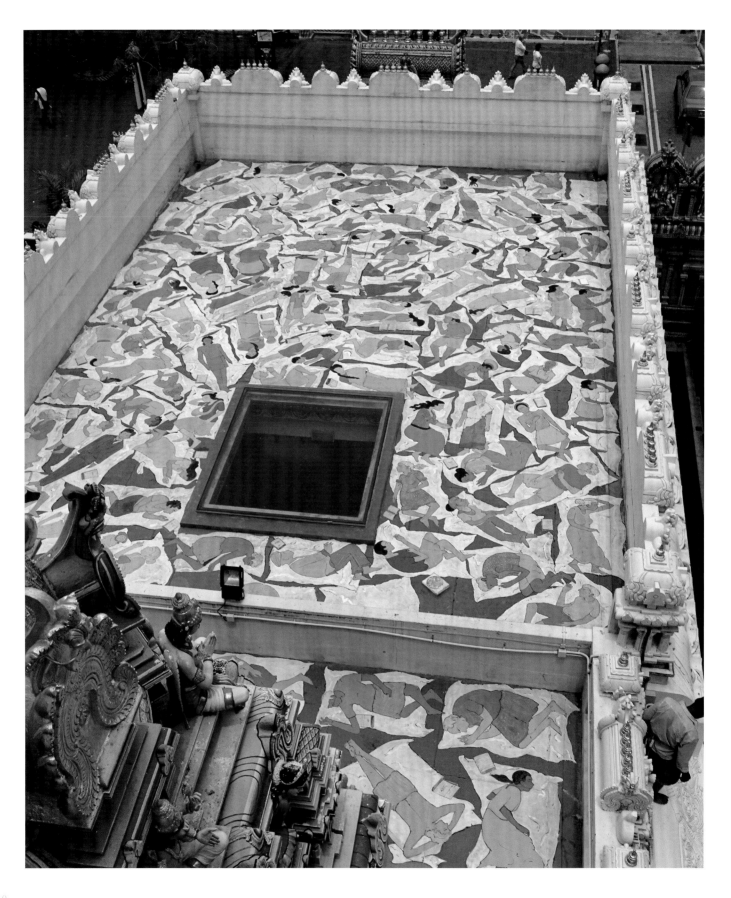

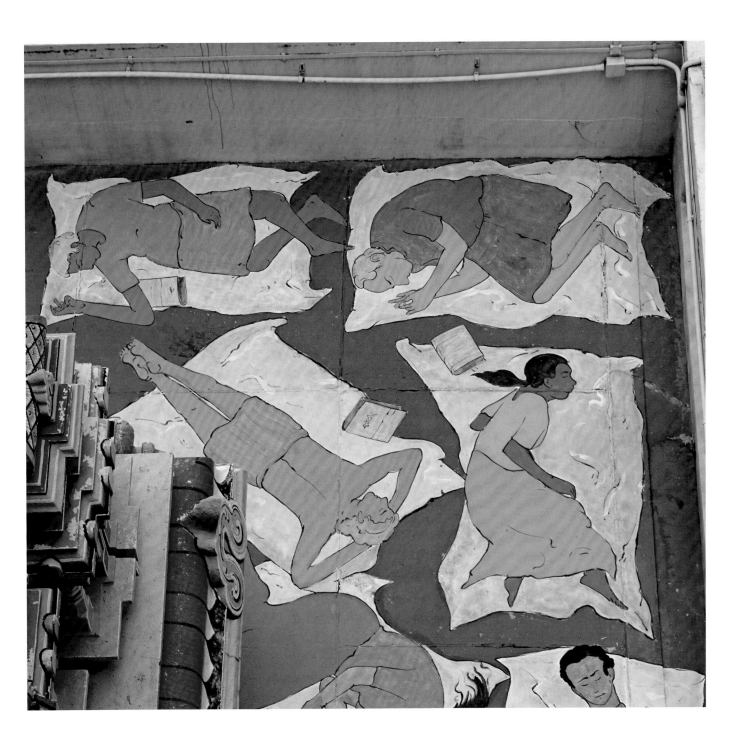

Above:
N. S. Harsha
Cosmic Orphans (detail), 2006
Mural on Sri Krishnan Temple, Singapore Biennale
7 x 11 m

Left:
N. S. Harsha
Cosmic Orphans, 2006
Mural on Sri Krishnan Temple, Singapore Biennale
7 x 11 m

Abhishek Hazra

Born in 1977, Kolkata, India
Lives and works in Bangalore, India
Studied at Srishti School of Art, Design and Technology,
Bangalore, India

Solo Exhibitions

2009 *Inheritance of Alphanumeric Characters*, GALLERYSKE,
Bangalore, India
2006 *Some Fables on the Unstable Oscillation of Uniformity*,
GALLERYSKE, Bangalore, India

Group Exhibitions

2010 *Notes on the (Dis)appearance of Real*, The Stainless Gallery,
New Delhi, India
2010 *Spiral Jetty*, Nature Morte, New Delhi, India
2010 *Beam Me up*, online project
2010 *Videoarte India*, Fundació 'la Caixa', Barcelona, Spain
2010 *Ballard Estate*, Religare Arts, New Delhi, India
2009 *Living Off The Grid*, Anant Art Centre, New Delhi, India
2009 *Tell-Tale: Fiction, Falsehood & Fact*, Gallery Experimenter,
Kolkata, India
2009 *On Certainty*, Bose Pacia, New York, NY, USA
2009 *Analytical Engine*, Bose Pacia, New York, NY, USA
2008 *Version Beta*, Biennial of Moving Images, Centre pour l'image
contemporaine, Geneva, Switzerland
2008 *'Third_life'*, Bombay Art Gallery, Mumbai, India
2008 *Video as Video: Rewind to Form*, Swimming Pool Project Space,
Chicago, IL, USA
2008 *Six Degrees of Separation*, KHOJ International Artists'
Association and Anant Art Gallery, New Delhi, India
2008 *URGENT: 10ml of Contemporary Needed!*, Foundation for Indian
Contemporary Art, Travancore House, New Delhi, India
2008 *Experiment Marathon Reykjavik*, Reykjavik Art Museum,
Reykjavik, Iceland; Serpentine Gallery, London, UK
2008 *Mechanisms of Motion*, Anant Art Gallery, New Delhi, India
2008 *To Kill at Dusk with Foam*, online video art exhibition

Awards / Grants / Residencies

2009–2010 *Moved, Mutated and Disturbed Identities*, Casino
Luxembourg, Forum d'Art Contemporain, Luxembourg
2008 *New Media Workshop*, Uttarayan Arts Centre, Baroda, India
2008 *Art Omi International Artists Residency*, New York, NY, USA
2008 Artist in Residence at Gasworks, London, UK (funded by Charles
Wallace India Trust Award)
2007 India Foundation for the Arts, Bangalore, India

Abhishek Hazra
Laughing in a Sine Curve, 2008
Single-channel video
4:52 minutes

ABHISHEK HAZRA

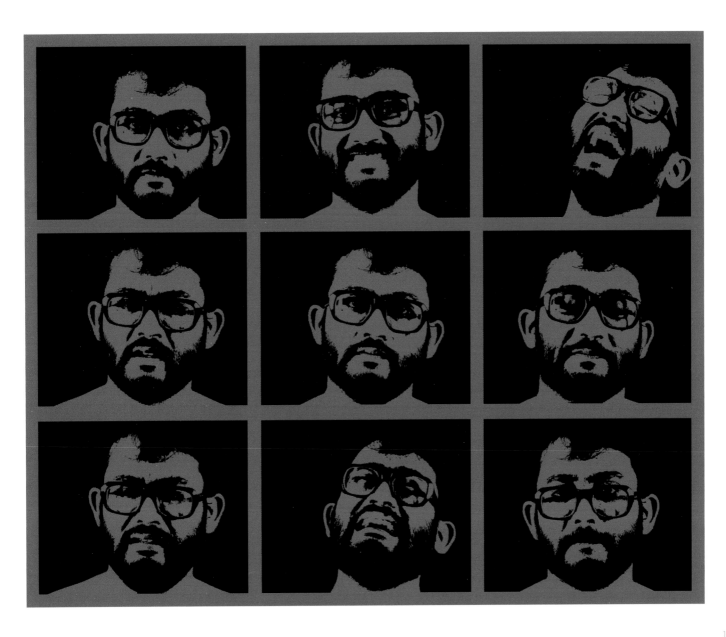

ABHISHEK HAZRA

The social history of science and the contested relationship of formalised scientific knowledge with the messy texture of an embodied reality forms one of the central strands of Abhishek Hazra's practice. Working primarily with video, animation, performance, spoken-word and text-based pieces, his works often set up speculative scenarios to explore a given conceptual terrain. They weave together a diverse array of seemingly unrelated references, contexts and histories that eschew comprehensiveness in favour of the fragmented and the idiosyncratic.

The performance video, *Laughing in a Sine Curve*, is an attempt to physically emote an important mathematical curve that often occurs in fields such as physics and electrical engineering and is fundamental to our scientific understanding of natural processes. In expressing the curve as a sequence of continuous transformations between paroxysms of laughter and crying, the work is an attempt to think critically about the limits of analytical models in comprehending the complexity of real-world processes.

In *Thanks to Lysenko, We Got Haldane!*, Abhishek reflects on the geo-political narratives that often frame the public discourse on science by using a scientific 'error' (Linus Pauling's triple-helical model of DNA) to comment on a political 'error' that adversely affected 20th-century genetics (Trofim Lysenko's fraudulent genetics in Stalinist Russia). In juxtaposing the celebrated biologist J.B.S. Haldane's move to India in the late 1950s with Marxist cultural politics in 20th-century Bengal, the work also comments on the intellectual's troubled relationship with partisan politics and the contested territory of scientific objectivity.

In pointing to the globally networked nature of contemporary art and academic scholarship, *Index of Debt* tries to open up questions around the circuits of capital and the ideas of agency and objectivity with respect to patronage and philanthropy. In the video we encounter a set of unusual index cards that mimic international currency notes. The texts printed on them are extracts from the acknowledgment section culled from a wide range of recent, academic books in South Asian studies. The audio track of the video is an assemblage of extracts from an interview with Robert Loder and Alessio Antoniolli of Gasworks, London, and Triangle Arts Trust, that reflects on the complicit nature of 'institutional critique'.

In London, Bengali is often perceived as an 'Islamic' language. *Shouting Needham from the Rooftops* amplifies this misreading to think about the politics of language and the ambivalent histories of nation-state making in South Asia. It also engages with the complex legacy of Orientalist scholarship even in interventions that attempted to counter Eurocentric presumptions. In the performance, done in a South London neighbourhood, Hazra approximated the Islamic call to prayer and through the day shouted out, through a typical 'public rally' megaphone, extracts from a Bengali translation of Joseph Needham's monumental history of Chinese science.

The *Tautology of Typology* reflects on the contradictions of language and patterns of cognition. Across a series of prints and small videos, this work explores various formal and informal classification systems, from adjectival suffixes to Pokémon characters. It also proposes a hypothetical, but technically feasible protocol for the cyclical transformation of organic compounds from one type to another – aliphatic to aromatic and vice versa.

In *Is My ID Me OR Is It My Dog?* Hazra re-contextualises VALIE EXPORT's iconic performance, *From the Portfolio of Doggishness*, to voice other concerns around the manner in which the contemporary nation states, often in collusion with large corporations, exercise technologies of control and produce obedient data-subjects. The 'inauthentic' backdrop of large dams introduced in the photo-documentation of the performance, refers to the techno-scientific utopia that marked post-independence India. **Alok G. Sudarshan**

At his table, people with salaries ranging from Rs124/- to Rs1800/- enjoyed the same privileges. He judged people by their sanctity and seriousness in work, and not by their social or area [WE HAVE] ... He condemned wealth earned without effort and believed that too much money can suppress individual initiative. He could also never tolerate overconfidence and pedantic attitude.

August 30, 1962
He (Prof. Haldane) asked if they used naked light in any of the Indian collieries. I said no (I did not really know). He said [OF] ... was no gas in some of the Scottish coalfields.

September 10, 1962
As my wife ... to go to the club, I induced her to call on J.B.S Haldane and his wife. They introduced me to a bright research scholar, Jayekar. Mrs. Haldane's cackling voice and forthright style of speech irritated my wife, but she was most impressed

Haldane did not join the Communist Party until 1942 although he had earlier become chairman of the editorial board [ACQUIRED] ... political comment. On several issues there was disagreement with the CP and for obscure reasons, it kept him from joining a scientific delegation to the USSR. He accused it of altering

J.B.S Haldane had a life long interest in the evolution of life. As a devout Mendelist-Morganist he contributed [CHARACTERS] ... reading of his work on the mathematical theory of natural selection is a must for students of genetics and biology. It is now widely accepted that he along with R.A Fisher and Sewall Wright, laid the foundation of a

Abhishek Hazra
Thanks to Lysenko, We Got Haldane!, 2009
Single-channel video and C-print
Dimensions variable

Abhishek Hazra
Laughing in a Sine Curve, 2008
Single-channel video
4:52 minutes

Abhishek Hazra
Laughing in a Sine Curve, 2008
Single-channel video
4:52 minutes

2005

Bakhle, Janaki. 2005. Two men and music: nationalism in the making of an Indian classical tradition. Oxford: Oxford University Press.

I conducted research in India funded by a dissertation research grant awarded by the **American Institute of Indian Studies.** I am grateful to

Abhishek Hazra
Index of Debt, 2008
Single-channel video
14:56 minutes

1995

Barlas, Asma. 1995. *Democracy, nationalism, and communalism: the colonial legacy in South Asia.* Boulder, Colo: Westview Press.

proved a rash undertaking in a school with no "Gramscians" or "South Asianists" to guide me. Not only did I end up struggling with Gramsci's

Abhishek Hazra
Index of Debt, 2008
Single-channel video
14:56 minutes

M. F. Husain

Born in 1915, Pandharpur, Maharashtra, India
Lives and works in Dubai, United Arab Emirates; London, UK;
Mumbai, India
Studied at Sir J J School of Art, Mumbai, India

Solo Exhibitions

2010 Brown University, Providence, RI, USA
2007 *India in the Era of Mughals*, India International Center, New Delhi,
India
2007 *From the Vault*, Aicon Gallery, London, UK
2006 *Epic India*, Peabody Essex Museum, Salem, MA, USA
2005 *Lost Continent*, Victoria and Albert Museum, London, UK
2005 *M. F. Husain: Early Masterpieces 1950s–70s*, Asia House, London, UK
2001 *Ashtavinayak*, Tao Gallery, Mumbai, Inde
2000 *New Works*, Fine Art Resource, Berlin, Germany
1995 *Inaugural Exhibition,* River of Art, Art Today, New Delhi, India
1973 Birla Academy of Art and Culture, Kolkata, India
1950 Bombay Art Society Salon, Mumbai, India

Group Exhibitions

2011 Delhi Art Gallery, New Delhi, India
2006 *The Moderns Revisited*, Grosvenor Vadehra, London, UK
2005 *Ashta Nayak: Eight Pioneers of Indian Art*, Gallery Arts India,
New York, NY, USA
1985 *100 Jahre Indische Malerei*, Altes Museum, Berlin, Germany
1985 *Six Indian Painters*, Tate Gallery, London, UK
1982 *Modern Indian Painting*, Hirschorn Museum, Washington DC, USA
1982 *Contemporary Indian Art*, Festival of India, Royal Academy of Art,
London, UK
1982 *India: Myth and Reality - Aspect of Contemporary Indian Art*,
Museum of Modern Art, Oxford, UK
1972 São Paulo Biennial, Brazil
1969 *21 Years of Painting*, Jehangir Art Gallery, Mumbai, India
1966 *Art Now in India*, Newcastle, UK; Ghent, Belgium
1959 Tokyo Biennale, Tokyo, Japan
1948 Progressive Artists Group, Bombay Art Society's Salon, Mumbai,
India

Awards

2004 Lalit Kala Ratna, Lalit Kala Akademi, New Delhi, India
1967 Ours d'Or pour le film *Through the Eyes of a Painter*, Berlin Film
Festival, Germany
1966 Awarded Padma Shree and Padma Bhush, Government of India

Husain has received Honorary Doctorates from the following:
Jamia Millia Islamia, New Delhi, Inde
Mysore University, Mysore, Inde

M. F. Husain
Between the Spider and the Lamp, 1960
Oil on board
228.6 x 101.6 cm

The most prolific artist to emerge in the postcolonial period, M. F. Husain dominated Indian Modernism. His career as a professional artist began with Indian independence, with which he links his anti-colonial, nationalist stance. As part of the Progressive Artists Group, which wished to break with the revivalist nationalism established by the Bengal School of Art and encourage an Indian avant-garde, engaged at an international level, Husain rejected the prevalent academism and revivalist tendencies, favouring the invigoration of his art with references from Pahari painting, Gupta sculpture and folk tradition, and liberating future generations of artists to use tradition as a thesaurus. Early works such as *Red Sky*, 1951, were dynamic, small-scale oil paintings that introduced the dark contour lines with which Husain is associated. As a reflection of this fusion, Husain developed the archetypal Indian figure, distilled from tradition and fluently metamorphosed to depict such varied personages as Gandhi and Mother Teresa. At a time when the international art world was proclaiming the death of figuration and painting, Husain resolutely continued both, constantly evolving his own personal idiom. He rejected the imposed hierarchy of medium, favouring acrylic over oil for its flat two-dimensionality and reinstating watercolour and gouache into modern Indian art. Regardless of size, his works exhibit monumentality, accentuated further by his use of colour and structure.

In a career spanning seven decades few subjects have escaped him. His purview has encompassed science and technology, film and theatre, music, politics, mythology, philosophy and world religions – working on these subjects in epic series or cumulative narratives, he often revisits themes after an interval of several years. His most sensitive works have involved his homage to woman replete with sensuousness and grace, in all her avatars as mother, lover, goddess, creator, preserver, protector and destroyer. Beginning with *Duldul*, 1951, horses present another constant interest, representing the concept of *ardhanareshvara* – the embodiment of the perfect balance of male and female characteristics – and evolving the theme through sustained cross-fertilisation with Chinese ideologies, Mario Marini's equestrian sculptures and Indian philosophy. Autobiography is another recurring theme first investigated in *Autobiography*, 1965, and culminating with *Nine Decades*, 2008, a cycle of 12 canvases which map Husain's life against the dominant social, cultural and political forces which shaped and influenced him.

Husain has produced a continuous painting surrounding the exterior of the Serpentine Gallery, which is an abridged narrative of Indian cultural history. Selected from different periods in Husain's career, the continuous painting presents a mini-retrospective of his work. These paintings are integrated into a structure around the exterior of the building, designed by architects Nikolaus Hirsch and Michel Müller. Elaborating on his theme of a history of India, the architectural frame becomes a three-dimensional storyboard. The rhythm of the wooden panels corresponds to date and time spans, thus creating a meandering storyline within the elongated and narrow structure.

While Husain normally works in series, the new work represents the first time a complete series of paintings by Husain will be viewed as one contiguous narrative. Clearly evident are the forceful black contour lines, the richly-hued palette, the dominant figurative motif and the thrusting motion often conveyed in Husain's works. Husain's canvases proclaim the *lila*, a Hindu concept that means 'pastime', 'sport' or 'play' of the creative process, affirming passion while embodying timeless and temporal qualities. **S.A.**

Opposite page:
Nikolaus Hirsch and Michel Müller
Design for structure for M. F. Husain's
paintings for the exterior of the
Serpentine Gallery, 2008

Below:
M. F. Husain
New Delhi Suite, 2003
Oil on canvas
60.9 x 45.7 cm

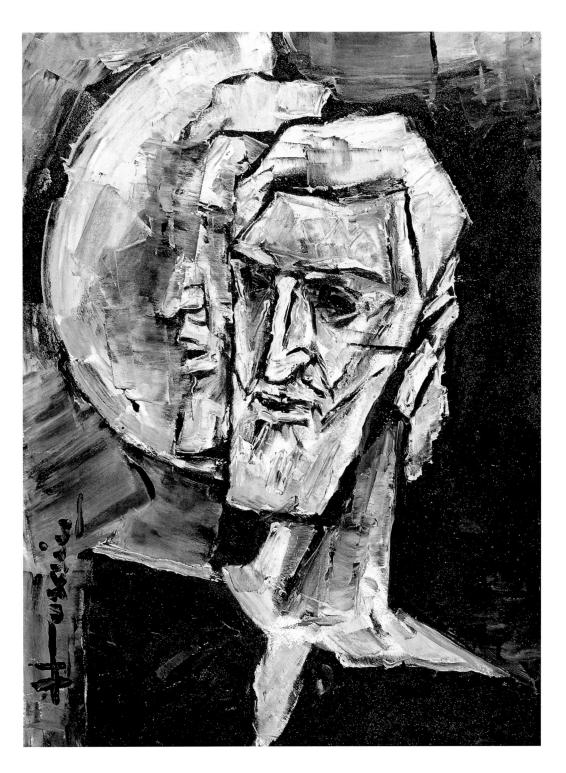

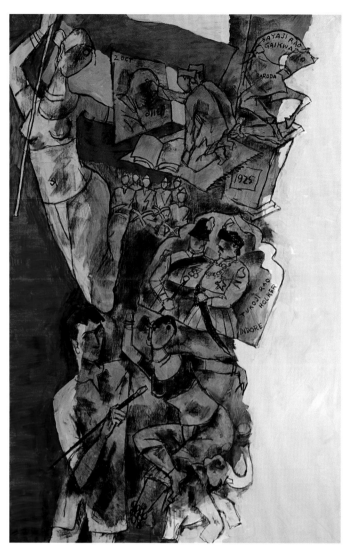
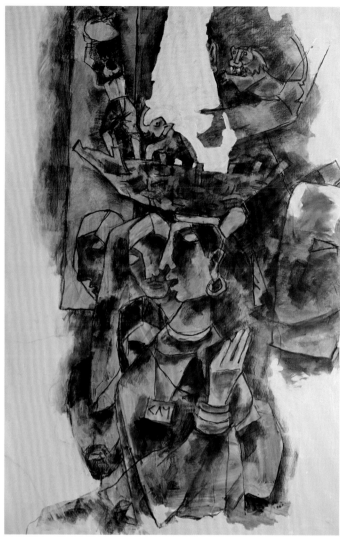

M. F. Husain
Nine Decades, 2008
Acrylic on canvas
Each 182.8 x 121.9 cm

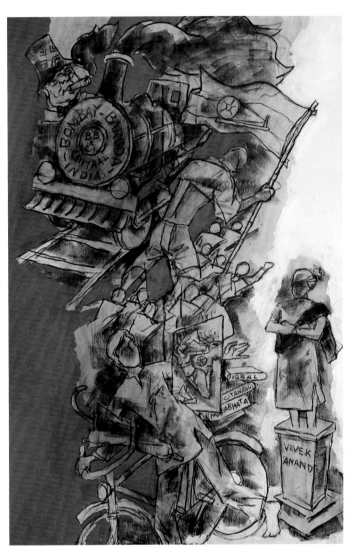 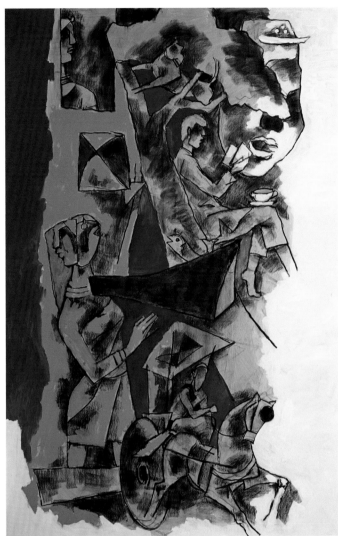

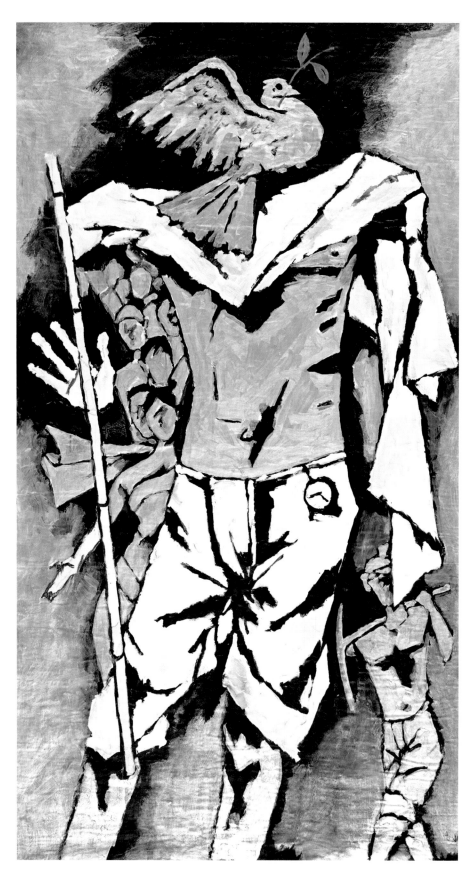

M. F. Husain
Map of India: Commemorating 50 years of Indian indepedence, 1997
acrylic on canvas
168 x 91 cm

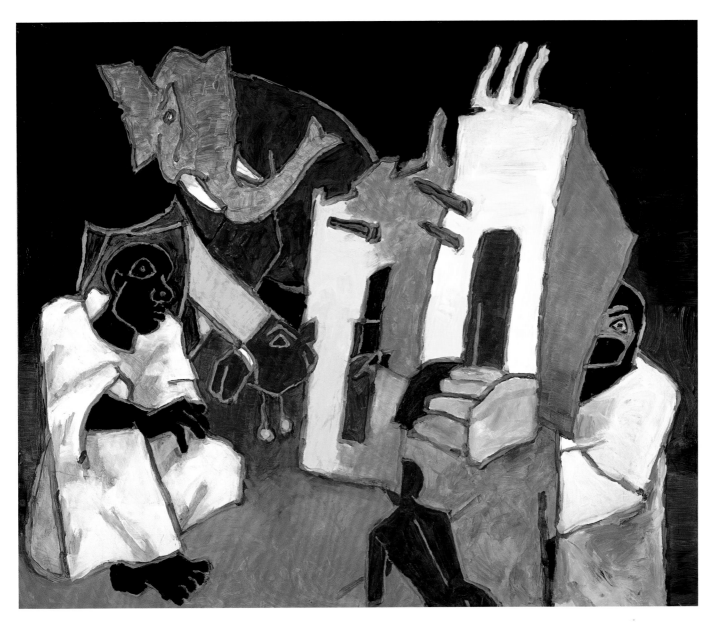

M. F. Husain
Lost Continent, 2006
Acrylic on canvas
152 x 183 cm

Shanay Jhaveri

Born in 1985, Mumbai, India
Lives and works in London, UK; Mumbai, India
Studied at Brown University, Providence, RI, USA; Royal College
of Art, London, UK

Professional Activities

2010 Frieze Art Fair, curator for Frieze Film, London, UK
2010 Tate Modern, curator of the screening series *Outsider Films
on India*, London, UK

Bibliography as Editor

2012 *Outsider Films on America: 1963–2008* (Forthcoming)
2010 *Being Here Now*, guest editor for *Marg Magazine*, Marg
Publications, Mumbai, India
2010 *Outsider Films on India: 1950–1990*, The Shoestring Publisher,
Mumbai, India
2007 *Wallpaper* City Guide: Mumbai*, city editor and writer,
Phaidon Press, London, UK

Essays and Book Chapters

2010 *As Hair Scatters and Regrows*, Nikhil Chopra, Chatterjee and Lal
2010 *To See Again and Again*, in *Shilpa Gupta*, edited by Nancy
Adajania, Prestel Publishing, London, UK

Articles

2010 'Work in Progress', *Bidoun Magazine*, London, UK
2010 Column in *The Daily Jang*, London, UK
2010 'Interview', *Art Asia Pacific Magazine*, London, UK
2010 'Interview', *Guggenheim Museum Magazine*, London, UK
2010 'Profile', *Art Asia Pacific Magazine*, London, UK
2010 'Artist Recipe', *Wallpaper* Magazine*, London, UK
2010 'International Report', *Art India Magazine*, Mumbai, India
2009 'Review', *Art India Magazine*, Mumbai, India
2008 'Global Briefings', *032c*, Berlin, Germany
2008 'View', *Vogue India Magazine*, Mumbai, India
2008 'Trip', *Wallpaper* Magazine*, London, UK
2007 'International Report', *Art India Magazine*, Mumbai, India
2007 'Global Retail', *Wallpaper* Magazine*, London, UK

Films

2006 *Within, and Said*
2005 *Adoration/Adornment*

Awards

2007 The William and Alethe Weston Fine Arts Award, Brown
University, Providence, RI, USA
2006 26th Annual Student Art Show, First Prize for *Adoration/
Adornment*, Brown University, Providence, RI, USA

Shanay Jhaveri
*Outsider Films on India
1950–1990*, 2010

OUTSIDER

FILMS
ON
INDIA
1950–1990

EDITED BY
SHANAY JHAVERI

The impetus for one of curator-writer Shanay Jhaveri's current undertakings came largely from living in an India that, due to an economic boom, acquired a new set of pluralities and a multiplicity of relationships. He found it difficult to negotiate with the transformative powers of globalisation subsuming the nation while appreciating its effects. It proved wholly alienating and he was troubled by what might be considered his 'insider' status. To fully comprehend the effects of the present, Jhaveri felt a personal need to mine India's relationship with the West, extending back to the time before economic liberalisation. Having not lived through this period and those movements, the need to form a memory of his own, to remember what had transpired before, lead him to use expressions of outsider perspectives, both material and utopian, as conduits of understanding. It is an ongoing investigation, the central concerns of which have been collected in the book *Outsider Films on India: 1950–1990*, 2010.

Jhaveri's approach is not exhaustive, but rather divergent and antithetical. The book in itself was structured around a predetermined time frame. Eschewing colonial and national narratives was a conscious decision. The focus was instead on the first decades of India's independence, commencing with the 1950s – years generally associated with the efforts of Jawaharlal Nehru, India's first prime minister, towards establishing a modern nation-state with democratic, secular and socialist foundations. A period of tremendous transition, both celebrated and critiqued by communists and independent left-wing thinkers, it was a moment when Indian modernism developed, as Geeta Kapur has noted, in dialogue with its own civilisational inclinations,

its myriad traditions and a strong left-wing culture in alliance with progressive movements elsewhere in the world. There was a large amount of cross-cultural exchange, and a number of artists, filmmakers and writers from the West visited India. It was a period that lasted into the 1980s, but with the coming of the '90s, India was inducted into the global economy, and a very perceptible shift occurred in the country's developmental discourse. From national and progressive, it became global and pro-capitalist, a change that has generated renewed interest in the country, especially in the last decade.

The collection of essays in *Outsider Films on India: 1950–1990* is extremely varied; contributors include academics, programmers, artists and critics. Each piece of writing is pregnant with its own unique implications, successfully reconfiguring the exploration from a mere deliberate inquiry into a more significant meditation on foreignness, memory and the individual experience. The volume formed the basis for a set of screenings and discussions that took place at the Tate Modern, London, in June 2010. The book, the screenings and the endeavour as a whole are crucially defined by their emphasis on non-definitive selections. Jhaveri's project is less an encyclopaedic effort, and more a personal one that takes on a different iteration every time it is presented. Constantly evolving, never complete, the *Outsider Film* project is purposefully self-reflexive, its intention less to pin down, in any assured way, the episodes of decades past than to discern them, and, in certain cases, distil their lingering, albeit altered, inscription within present circumstances.

Shanay Jhaveri

A
DIALOGUE
ON
THE RIVER
WITH
SHANAY
JHAVERI
—
PRIYA JAIKUMAR

1
Ronald Bergan, *Jean Renoir:
Projections of Paradise*
(London: Bloomsbury, 1992),
p. 280.

2
Nandi Bhatia, "Whither
the Colonial Question?
Jean Renoir's *The River*"
in Dina Sherzer (ed.), *Cinema,
Colonialism, Postcolonialism:
Perspectives from the French
and Francophone Worlds*
(Austin: University of Texas,
1996), pp. 51–64.

Director
Jean Renoir

Script
Rumer Godden
(novel & screenplay)
Jean Renoir
(screenplay)

Cinematography
Claude Renoir

Music
M A Partha Sarathy

Editing
George Gale

Producers
Kenneth McEldowney
Jean Renoir

Production
Eugène Lourié

Cast
Thomas E Breen
Patricia Walters
Radha Burnier
Adrienne Corri

Format
99 minutes
colour

Release
December 1951

THE

SJ

Considered a decisive moment for Jean Renoir, *The River*, since its
release in 1951, has received much and continuous attention. Critics
of the time labelled it an instant "classic", most impressed by its portrayal
of what was believed to be an "authentic" landscape, and Renoir gained
the reputation of a master cinematographer because of the film's
experimentation with naturalism, colour and sets. Since then, discursive
frameworks have wrung themselves around the film and dominate
how it is regarded even today. One such approach fixates on the film's
ahistoricism and its orientalist disposition.

Renoir famously stated that he was drawn to Rumer Godden's
autobiographical novel because it allowed for a "film about India without
elephants and tiger hunts". Renoir delivered on his promise; gone is the
kind of exoticism that was part of German orientalist traditions, as seen
in Fritz Lang. The film also breaks away from other portrayals of India,
which to this point were based mainly on British imperial history or
fiction, the examples including Henry Hathaway's *Lives of a Bengal Lancer*
(1935), Zoltan Korda's *The Drum* (1938), and adaptations of Rudyard
Kipling's *Kim* (Victor Saville, 1950) and *Soldiers Three* (Tay Garnett, 1951).
The film portrays India as almost idyllic, characterized by what Ronald
Bergan has called "simplicity", "serenity", "human realities" and "religious
spirituality".[1] Referring to his preoccupation with (and believed fetishization
of) the country's environment, Renoir has been accused of engaging
in a "complicitous relationship with orientalist portrayals of India as
an 'exotic' site" and also of eliding any form of historicity, deliberately
avoiding engagement with "the socio-political ramifications of the end
of British imperial rule and the advent of independence, which began
a new chapter in Indian history".[2] André Bazin, among others, has
defended both Renoir and his film, stating that "To reproach him for not
using this fleeting love story as a vehicle to describe the misery of India
or to attack colonialism is to reproach him for not treating an entirely
different subject" and pointing out that it is in essence a film about

1
Ronald Bergan, *Jean Renoir:
Projections of Paradise*
(London: Bloomsbury, 1992),
p. 280.

2
Nandi Bhatia, "Whither
the Colonial Question?
Jean Renoir's *The River*"
in Dina Sherzer (ed.), *Cinema,
Colonialism, Postcolonialism:
Perspectives from the French
and Francophone Worlds*
(Austin: University of Texas,
1996), pp. 51–64.

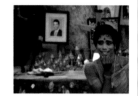

Shanay Jhaveri
From the book *Outsider Films
on India 1950–1990*, 2010

ALL IS BURNING: A PASOLINIAN ENCOUNTER WITH INDIAN MODERNITY AS SEEN IN NOTES FOR A FILM ON INDIA

— KAUNTEYA SHAH

PIER PAOLO PASOLINI

Notes for a film on India

— *1968*

1
John Berger, *Hold Everything Dear: Dispatches on Survival and Resistance* (London: Verso, 2007), p. 78.

Director	Pier Paolo Pasolini
Script	Pier Paolo Pasolini
Cinematography	Roberto Nappa / Federico Zanni
Music	Ennio Morricone
Editing	Jenner Menghi
Producer	Gianni Barcelloni
Format	34 minutes / black and white
Release	August 1968

NOT
A FIL
ON

The economic boom that followed World War II and the beginning of the Cold War was in turn followed by a period of intense disaffection in Europe, culminating in the events of 1968. The cinema of the period, led by the nouvelle vague in France, captured not only a society intent on consuming itself but also the resistance to this. In Italy, the psychological, spatial and cultural ramifications of an irrevocably transformed landscape led to a radical re-questioning, eloquently expressed in the cinema of Michelangelo Antonioni, Bernardo Bertolucci and Pier Paolo Pasolini.

In the desperation of our current moment — as the powerful, in their relentless pursuit of security, become desensitized to the aggression and devastation left in their wake, and as the cold logic of neo-liberalism becomes normalized — Pasolini's oeuvre is of enduring value. After watching his *La Rabbia* (1963), John Berger said: "It arrives like the proverbial message put in a bottle and washed up forty years later on our beach."[1] In *Paul S'en Va* (2004), Alain Tanner has also transported to contemporary Geneva the words and ideas of Pasolini, that rare poet who, intensely political and alive to the most subtle arrangements of domination, is also a seer of the psychic wound brought forth by this oppression.

Pasolini's impressions of his first visit to India in 1961, with the novelist Alberto Moravia, were collected in the book *Scent of India* (1963). It describes the incident of some men in a car, hooting and taunting, coming deliberately in the film-maker's way. He ponders this aggression and vulgarity as a cipher for the future of India's middle class, a reflection that haunts him on his return to India in 1967 for *Notes for a Film on India* (1968). Today, the juggernaut of corporate globalization devours rural India with gigantic dispossession of land, mass suicide by farmers, and ecological devastation. Indians are fêted around the world for taking over European steel works and car factories, as IT wonder-boys, and for their rapacious middle class in a consumerist frenzy. It is therefore astonishing to be confronted by Pasolini's film. As a questioning of modernity and the seeds of "embourgeoisement" in India, *Notes for a Film on India* has the force of prophecy.

1
John Berger, *Hold Everything Dear: Dispatches on Survival and Resistance* (London: Verso, 2007), p. 78.

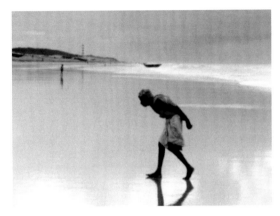

142 For the concluding episode,
Malle finally arrives at Bombay,
which he believes is, despite
its political problems and
religiosity, "the future India",
and visits the "red light district".

A closing image from episode I: 143
"Impossible Camera".

Since the creation of the film, Chandigarh has been at the centre of a number of staged revisitations, and appears to be undergoing a process of cultural as well as physical rehabilitation. Its citizens have relentlessly improvised to create an organic relationship with Le Corbusier's vision in keeping with the landscape of their own desires and needs. This process suggests that "you can see not only the invasion of Corbu's urban dream by poor, village India, but also signs that Nehru's political ideals have actually worked after a fashion."[5]

New evaluations have been sought with the hope that they can be ascribed to the legacy of the city. In 2007, a few antique dealers from around the world organized sales of the furniture that had been specially created to fit out the new city. In response, procedures have been initiated by the local authorities to have the city designated as a UNESCO World Heritage site. Also, they have passed an order whereby no more furniture can be sold by foreign entities, and prisoners in the local jail have been put to work to restore some of the broken pieces.

Such local government re-evaluations are a recent phenomenon, instigated by the international reclamation of both the city and the country into a new economy of transactions. India's intellectuals have long striven to resuscitate the city from vilification by city officials, holding numerous conferences such as "Chandigarh: 50 years of the idea", in which various aspects of the city were debated and examined. Alternative approaches have been offered to fit the prospects of a "city of the future". In view of the more brutal contracts presented by contemporary India's volatile, inequitable urban landscape of Gurgaon, Surat and Bengaluru (the new cities of the future), the question first articulated by Tanner and Berger in *Une Ville à Chandigarh* is perhaps worth posing again.

238 5
Burma, op. cit.

239

240 241

Shanay Jhaveri
From the book *Outsider Films on India*
1950–1990, 2010

Jitish Kallat

Born in 1974, Mumbai, India
Lives and works in Mumbai, India
Studied at the Sir J J School of Art, Mumbai, India

Solo Exhibitions

2010 *Public Notice 3*, Art Institute of Chicago, Chicago, IL, USA
2010 *Likewise,* Arndt Berlin, Berlin, Germany
2010 *The Astronomy of the Subway*, Haunch of Venison, London, UK
2008 *Aquasaurus,* Sherman Contemporary Art Foundation,
Sydney, Australia
2008 *Skinside Outside,* Arario Seoul, Seoul, South Korea
2008 *Public Notice-2,* Bodhi Art, Singapore
2008 *Universal Recipient*, Haunch of Venison, Zurich, Switzerland
2007 *Unclaimed Baggage*, Albion, London, UK
2007 *365 Lives*, Arario Gallery, Beijing, China
2005 *Rickshawpolis-1*, Nature Morte, New Delhi, India
1997 *P.T.O.*, Gallery Chemould and Prithvi Gallery, Mumbai, India

Group Exhibitions

2010 *Metropolis,* New Art Gallery Walsall, Walsall, UK
2010 *Skulptur i Pilane*, Pilane Burial Grounds, Tjörn, Sweden
2010 *Urban Manners 2*, SESC Pompeia, São Paulo, Brazil
2010 *The Empire Strikes Back*, Saatchi Gallery, London, UK
2009 *India Contemporary*, Gemeentemuseum, The Hague, Netherlands
2009 *Chalo! India: A New Era of Indian Art,* National Museum, Seoul,
South Korea; Essl Museum, Vienna, Austria
2009 *Mythologies,* Haunch of Venison, London, UK
2009 *Indian Narrative in the 21st Century: Between Memory and
History,* Casa Asia Center, Madrid, Spain
2008 *Die Tropen*, Martin-Gropius-Bau, Berlin, Germany
2006 5th Asia-Pacific Triennial of Contemporary Art, Queensland Art
Gallery, Gallery of Modern Art, Brisbane, Australia
2006 6th Gwangju Biennale, Gwangju, South Korea
2001 *Century City*, Tate Modern, London, UK
1998 *Art of the World*, Passage de Retz, Paris, France

Awards

2001 Sanskriti Award, Sanskriti Prathisthan, New Delhi, India
1996-1997 Awarded Fellowship at Sir J J School of Art, Mumbai, India

Jitish Kallat
Cenotaph (A Deed of Transfer) (detail), 2007
20 Lenticular prints
Each 44.5 x 66 cm

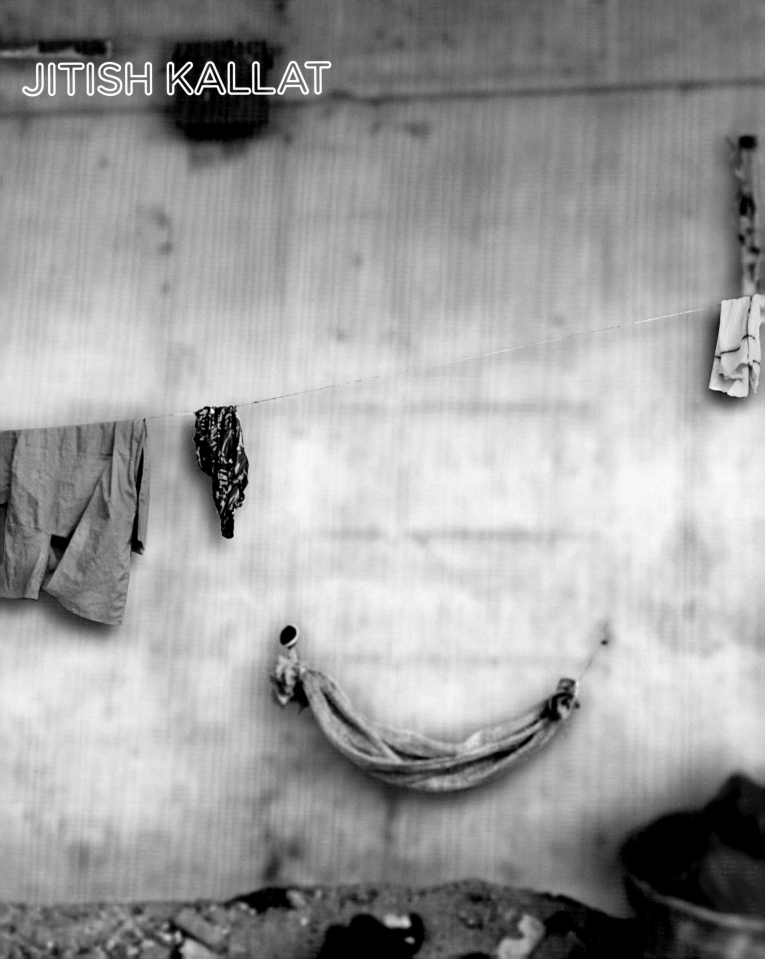

JITISH KALLAT

JITISH KALLAT

Jitish Kallat's practice combines painting, photography and collage, as well as large-scale sculptures and multi-media installations. Jitish graduated from the Sir J J School of Art, Mumbai, in 1996, part of a group of precocious and ambitious young artists who have been instrumental in globalising Indian contemporary art. Kallat honed his interest in painting by embracing abstraction within the tenants of high Modernism, learning to exploit colour to elicit an emotive response. Audacious and self-confident, Kallat firmly rejected abstraction and any loyalty to high Modernism by the time of his first solo show, within two years of art school. Entitled *PTO*, the show was the first in a series of exhibitions which co-opted the allegiance of multiple gallery spaces, in this case spanning north and south Mumbai.

Kallat's early works incorporated references to the style, form and thematic concerns of urban billboards, which were interwoven with popular culture, news stories, media events and the socio-economic and political anxieties of the citizens of Mumbai. The artist has since been widely recognised for his figurative paintings that highlighs the convergences of cultural dualities – a sleek, large-scale portrayal of the politics, poverty, dirt and grime of Mumbai. Dystopic narratives of urban life, are portrayed as romantic or heroic to achieve the high gloss of globally acceptable contemporary art.

With his series *Rickshawpolis* in 2005, Kallat initiated his engagement with vehicles and snarled traffic as metaphors for modern cities like Mumbai, Shanghai and Dubai. For Kallat, rickshaws have become a recurring motif for city dwellers and urban dissonance. For his suite of photographs titled *365 Lives*, 2007, he documented dented skeletal remains of vehicles, each dent corresponding to a wound. His bold, somewhat confrontational style recalls the energy and audacity of his native Mumbai, while his signature works contain an underlying edge of brutality.

A lenticular print displays a succession of images within a single frame. A change in the viewing angle can convey the illusion of three-dimensionality, creating a sense of animation. The truth is not in any single image but is situated somewhere in between. Kallat's use of lenticular prints began with *Death of Distance*, 2006, a photographic series that critiques the vast, insatiable 24-hour news channels broadcast in India. A giant rupee coin stands on edge next to a series of lenticular prints that juxtaposes two news reports, shifting from one text to another depending on the viewer's position. One reports the launch of a new telecommunications plan, announcing 'call anywhere in India for one rupee'; the other recounts the story of a young Indian girl who committed suicide because her mother could not give her one rupee to buy a school meal.

In *Cenotaph (A Deed of Transfer)*, 2007, Kallat documents with lenticular prints the demolition of a row of illegally built slum dwellings which were situated on the Tulsi Pipe Road, part of his childhood drive to and from school. While modernising Mumbai, the slum dwellers were re-located due to widening roads and the addition of pavements. *Cenotaph* documents the stages of removal which, when viewed from different angles, extend the narrative of the evacuation. The documentation is ambiguous and urban development may be viewed optimistically or as an act of brutality and violence against voiceless individuals who are deemed to obstruct progress. **S.A.**

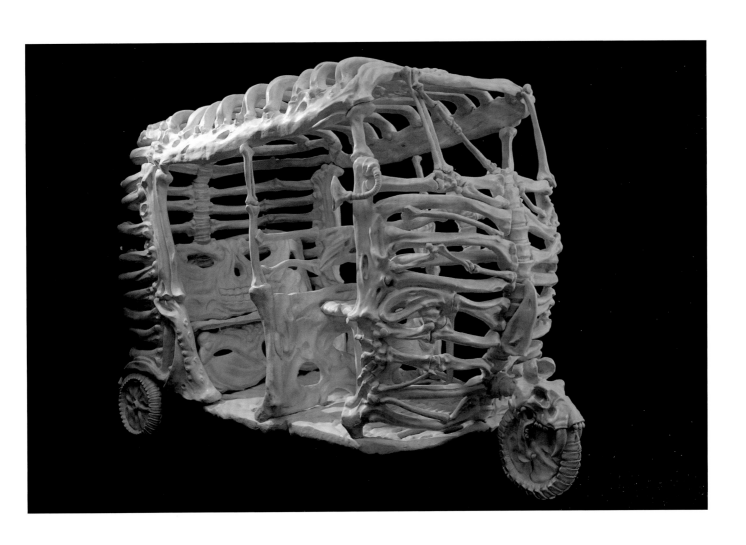

Jitish Kallat
Autosaurus Tripous, 2007
Resin, paint, steel and brass
259.1 x 134.6 x 167.6 cm

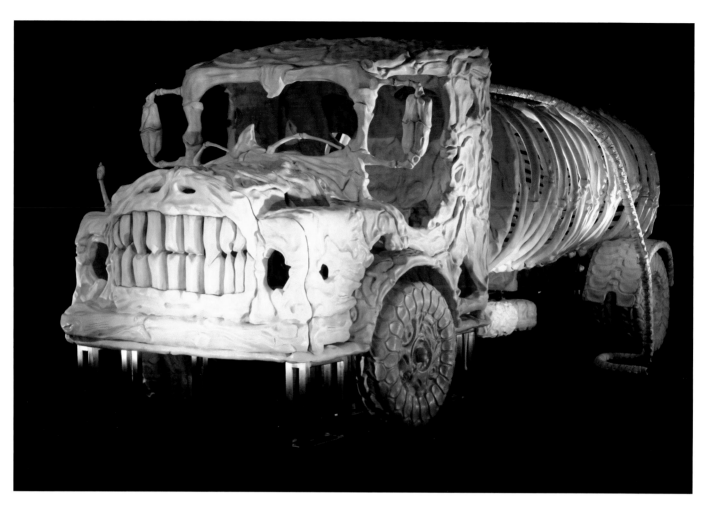

Jitish Kallat
Aquasaurus, 2008
Resin, paint, steel
254 x 688,3 x 269,2 cm
Edition 1/3 + 1 AP

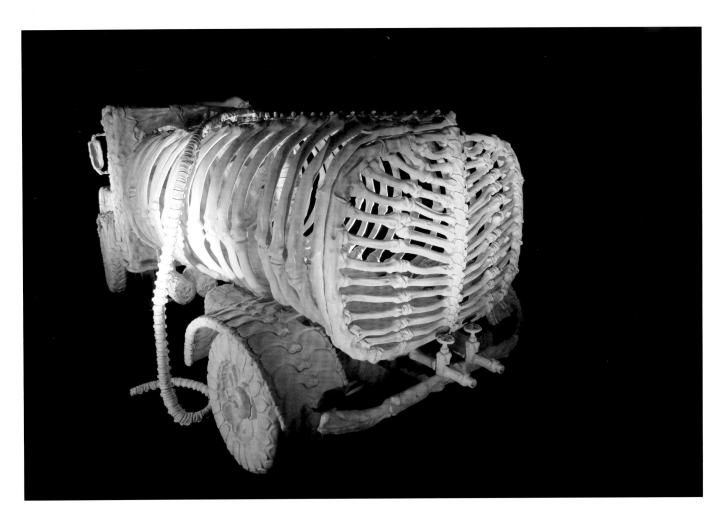

Jitish Kallat
Aquasaurus, 2008
Resin, paint, steel
254 x 688,3 x 269,2 cm
Edition 1/3 + 1 AP

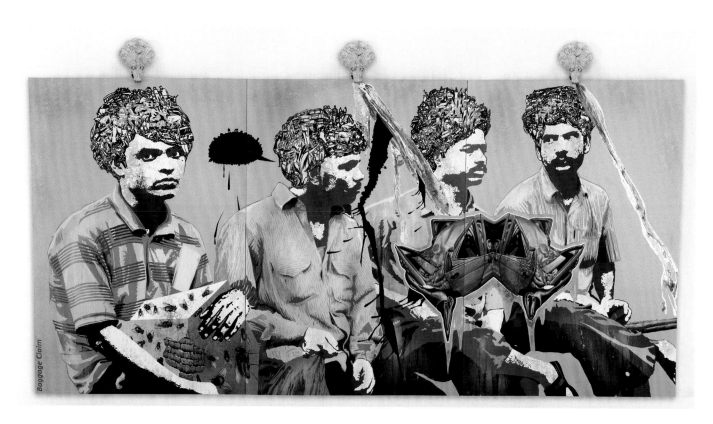

Jitish Kallat
Baggage Claim, 2010
Acrylic on canvas, bronze
243,8 x 518,2 cm (triptych),
26,7 x 27,9 x 45,7 cm (bronze elements)

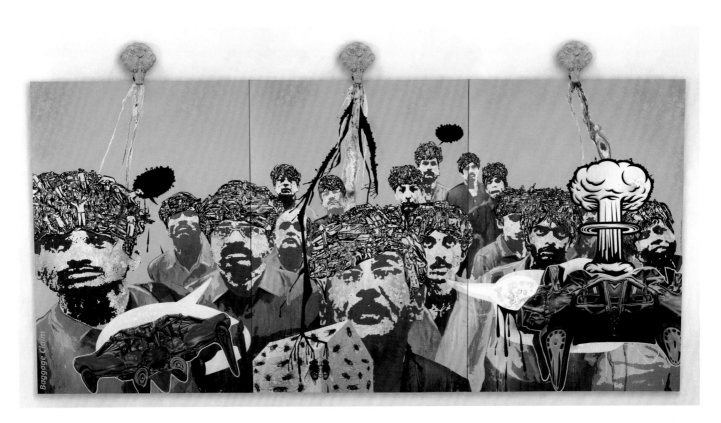

Jitish Kallat
Baggage Claim, 2010
Acrylic on canvas, bronze
243,8 x 518,2 cm (triptych),
26,7 x 27,9 x 45,7 cm (bronze elements)

Amar Kanwar

Born in 1964, New Delhi, India
Lives and works in New Delhi, India
Studied in Cochin, Mumbai and Delhi, India

Solo Exhibitions

2010 *Amar Kanwar,* Marian Goodman Gallery, New York, NY, USA
2009 *Amar Kanwar,* Film Huis Den Haag, The Hague, Netherlands
(selection from *The Torn First Pages*). In collaboration with *Movies that Matter,* Amnesty International Film Festival
2008 *The Torn First Pages*, Haus der Kunst, Munich, Germany;
Stedelijk Museum, Amsterdam; Hertogenbosch, Netherlands
2008 Govett Brewster Art Gallery, New Plymouth, New Zealand
2007 Marian Goodman, Paris, France
2007 Whitechapel Art Gallery, London, UK
2007 *Amar Kanwar, Selected Work 1997 – 2006*, Apeejay Media Gallery,
New Delhi, India
2004 *Amar Kanwar: A Trilogy of Films*, The Renaissance Society,
Chicago, IL, USA
2003 Tensta Konsthall, Stockholm, Sweden

Group Exhibitions

2010 Aichi Trienniale, Aichi, Japan
2010 *Snapshots of Tourism*, Helsinki International Artists Centre,
Helsinki, Finland
2010 *Being Singular Plural: Moving Images from India*, Deutsche
Guggenheim, Berlin, Germany
2010 *Signs of Life*, Kunstmuseum Luzern, Lucerne, Switzerland
2010 *The View from Elsewhere*, Australian Cinematheque at the
Queensland Gallery of Modern Art, Brisbane, Australia
2009 *What a Wonderful World,* Göteborgs Internationella
Konstbiennal, Gothenburg, Sweden
2009 *The Symbolic Efficiency of the Frame*, Tirana Biennale,
Tirana, Albania
2009 Flaherty Film Festival and Seminar, Colgate University
New York City, New York, NY, USA
2009 *Significant and Insignificant Events,* Istanbul Museum of
Modern Art, Istanbul, Turkey
2009 *Trouble at the Front / Troubles aux frontières*, Marian Goodman
Gallery, Paris, France
2009 *Expanded Box*, ARCOmadrid, Madrid, Spain
2009 *Lines of Control,* The Third Line Gallery, Dubai,
United Arab Emirates
2009 *The World in 1989,* Haus der Kultur der Welt, Berlin, Germany
2008 *The Greenroom: Reconsidering the Documentary and Contemporary
Art (Part I)*, Hessel Museum and Center for Curatorial Studies,
Bard College, Annandale-on-Hudson, NY, USA
2007 *Documenta 12*, Kassel, Germany
2006 *Zones of Contact*, Museum for Contemporary Art, Biennale
of Sydney, Australia
2004 *Image War: Contesting Images of Political Conflict*,
Whitney Museum, New York, NY, USA
2004 *In Progress*, Locarno International Film Festival,
Locarno, Switzerland
2003 *Territories*, Kunst Werke Institute of Contemporary Art,
Berlin, Germany
2002 *Documenta 11*, Kassel, Germany

Awards

2009 Jury special mention, One Billion Eyes Indian Documentary Film
Festival, for *The Many Faces of Madness*
2006 Honorary Doctorate in Fine Arts, Maine College of Art,
Portland, ME, USA
2005 1st Edvard Munch Award for Contemporary Art, Oslo, Norway

Amar Kanwar
The Face, 2005
DVD
4:35 minutes

AMAR KANWAR

AMAR KANWAR

Amar Kanwar is a film-maker whose lyrical and meditative work explores the political, social, economic and ecological conditions of the Indian subcontinent. Having directed and produced over 40 films, which are a mixture of documentary, poetic travelogue and visual essay, much of Kanwar's work often traces the legacy of the decolonialisation during which India gained independence from Britain and the Partition in 1947 of the Indian subcontinent into Islamic Pakistan and Hindu India. Recurrent themes are the splitting of families, sectarian violence and border conflicts, interwoven with investigations of gender and sexuality, philosophy and religion, as well as the opposition between globalisation and tribal consciousness in rural India.

Kanwar's compelling films are created using image, ritual objects, literature, poetry and songs. Rather than focusing on traumatic or political situations, he attempts to move beyond trauma and its direct representation to a more contemplative space. He experimented with this strategy in his most celebrated film, *A Season Outside*, 1997, exploring the border tensions along the thin white line between India and Pakistan. Scripted and narrated by the artist, the work is a personal journey and poignant meditation on the philosophies of violence and non-violence.

Along with his numerous single-screen films, Kanwar has also developed multi-screen video installations, in which films are projected in constellations that create sophisticated layering of image and meaning within a conscripted space. In *The Lightning Testimonies*, 2007, he reflects upon a history of conflict in the Indian subcontinent through experiences of sexual violence. Traversing across 60 years and several borders, the eight synchronised projections present disparate narratives that finally converge. Women from different times and regions come forward as stories are revealed through people as well as through the images and objects that survive as silent witnesses.

The Lightning Testimonies explores how such violence is resisted, remembered and recorded and moves beyond the realm of suffering into a space of quiet contemplation, where resilience creates the potential for transformation. Beyond its immediate subject matter, the work also examines the contrasting methodologies and vocabularies used by different individuals and communities for archiving and recalling memory.

Kanwar's latest work is a three-part installation, *The Torn First Pages*, 2004–8, which examines the political and humanitarian situation in Burma and the struggle between dictatorial regime and the democracy movement. The title of the work is related to the story of a bookshop owner in Mandalay in the mid-1990s accused and subsequently convicted and imprisoned for tearing out the first page of every book he sold. The extracted pages were printed with a legally required slogan of the military regime and a denunciation of democratic forces. His action thus represented a private yet powerful resistance against the repressive authorities, pertinent to the artist's experience of Burma. *The Torn First Pages: Part I, Part II and Part III* is a 19-channel video installation with projections onto paper sheets, with films shot and old and new archival footage clandestinely filmed in Burma, India, Europe and the USA. Independent stories are connected by a metaphorical reference to the struggle for a democratic society, exile, memory and individual courage. **R.M.**

Amar Kanwar
A Season Outside, 1997
DVD
30 minutes

Amar Kanwar
The Lightning Testimonies, 2007
8-Channel DVD installation
32:31 minutes

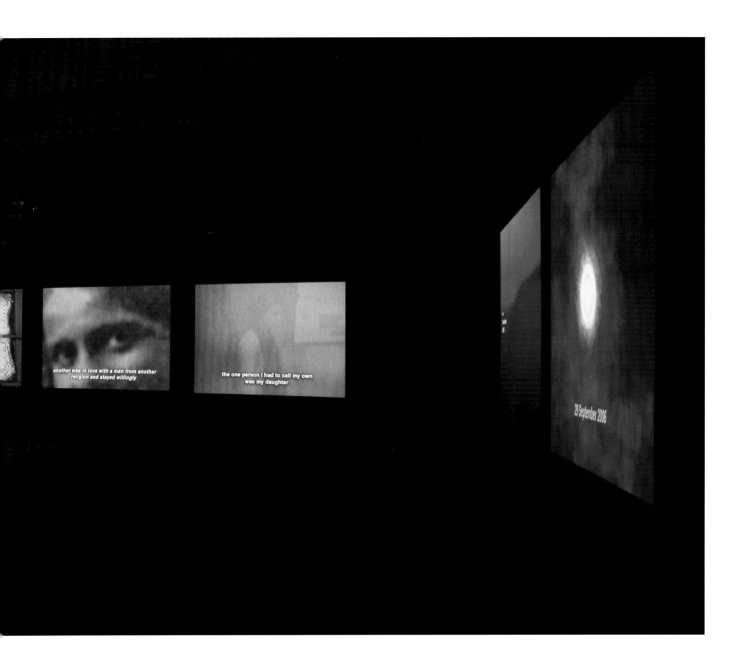

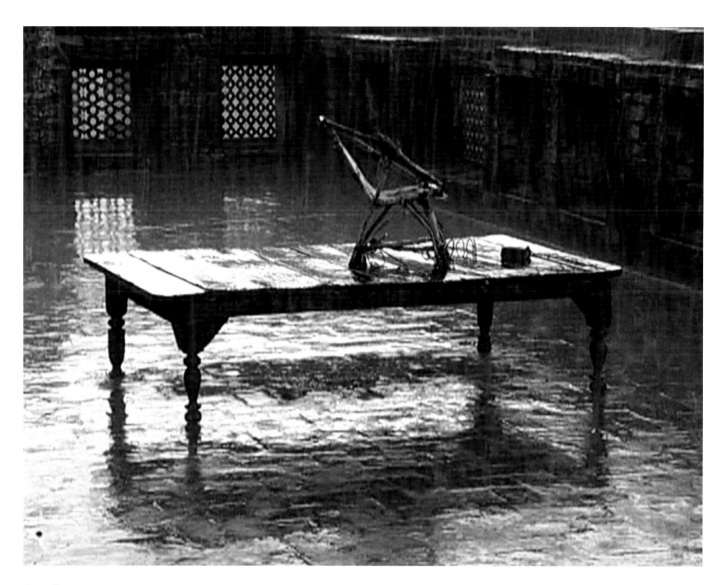

Amar Kanwar
The Lightning Testimonies, 2007
8-Channel DVD installation
32:31 minutes

Amar Kanwar
The Lightning Testimonies, 2007
8-Channel DVD installation
32:31 minutes

Bharti Kher

Born in 1969, London, UK
Lives and works in New Delhi, India
Studied at Middlesex Polytechnic, Cat Hill, London, UK; Newcastle
Polytechnic, Newcastle, UK

Solo Exhibitions

2010 *Inevitable undeniable necessary*, Hauser & Wirth, London, UK
2010 *Hauser & Wirth Outdoor Sculpture: Bharti Kher*, St. James's
Church, London, UK
2010 *Disturbia, utopia, house beautiful*, GALLERYSKE,
Bangalore, India
2008 *Sing to them that will listen*, Galerie Emmanuel Perrotin,
Paris, France
2008 *Virus*, BALTIC Centre for Contemporary Art, Gateshead, UK
2007 *An Absence of Assignable Cause*, Jack Shainman Gallery,
New York, NY, USA
2004 *Hungry dogs eat dirty pudding*, Nature Morte, New Delhi, India
1993 *AIFACS*, New Delhi, India

Group Exhibitions

2010 *Gothenburg Culture Festival*, Gothenburg City Hall,
Gothenburg, Sweden
2010 *Tokyo Art Meeting Transformation*, Museum of Contemporary Art,
Tokyo, Japan
2010 *Lebenszeichen. Altes Wissen in der zeitgenössischen Kunst /
Signs of Life. Ancient Knowledge in Contemporary Art*, Kunstmuseum
Luzern, Lucerne, Switzerland
2010 *Susan Hefuna – Bharti Kher – Fred Tomaselli: Between the
Worlds*, Kunstmuseum Thun, Thun, Switzerland
2010 *Facing East: Recent Works from China, India and Japan from the
Frank Cohen Collection*, Manchester Art Gallery, Manchester, UK
2010 *The Empire Strikes Back: Indian Art Today*, Saatchi Gallery,
London, UK
2010 *Pattern ID*, Akron Art Museum, Akron, OH, USA
2010 *Tauba Auerbach, Matthew Day Jackson…*, Galerie Emmanuel
Perrotin, Paris, France
2010 *lille3000: La route de la soie*, Tri Postal, Saatchi Gallery London
in Lille, Lille, France
2010 *21st Century: Art in the First Decade*, Queensland Art Gallery,
Gallery of Modern Art, Brisbane, Australia
2009 *Marvellous Reality*, Lalit Kala Akademi, New Delhi, India
2009 *Indian Narrative in the 21st Century: Between Memory and
History*, Casa Asia, Madrid, Spain
2009 *Shifting Shapes. Unstable Signs*, Yale University School of Art,
New Haven, CT, USA
2009 *Conflicting Tales – Works from the Burger Collection in Berlin:
Subjectivity (Quadrilogy, Part 1)*, Temporary space at Zimmerstrasse
90–91, Berlin, Germany
2009 *Les artistes indiens d'aujourd'hui*, Palais Bénédictine,
Fécamp, France
2009 *Nature Nation,* Museum on the Seam, Jerusalem, Israel
2008 *Distant Nearness*, The Nerman Museum of Contemporary Art at
Johnson County Community College, Kansas City, KS, USA
2008 *Passage to India*, Frank Cohen Collection, Wolverhampton, UK
2008 *Artistes Indiens, Collection Claude Berri*, Espace Claude Berri,
Paris, France
2008 *Ours, Chat, Cochon & Cie*, Musée cantonal des Beaux-Arts de
Lausanne, Switzerland
2008 *Where in the World*, Devi Art Foundation, New Delhi, India
2008 *Mutant Beauty*, Anant Art Centre, New Delhi, India
2008 *India Moderna*, Institut Valencià d'Art Modern, Valencia, Spain
2008 *Chalo! India: A New Era of Indian Art,* Mori Art Museum,
Tokyo, Japan
2008 *Re-imaging Asia*, House of World Cultures, Berlin, Germany
2008 *Still Moving Image*, Devi Art Foundation, Gurgaon, India
2008 *Expenditure Busan Biennale*, Museum of Modern Art, Busan,
South Korea

2007 *Urban Manners*, Art for the World Europa, Milan, Italy
1993 *Trends in Contemporary Indian Art*, Art Heritage, New Delhi, India

Awards / Residencies

2007 YFLO Woman Achiever of the Year
2004 French Government Residency
2003 Sanskriti Award, Sanskriti Pratishthan, New Delhi, India
2002 KHOJ Residency, India
1997 KHOJ Artists Workshop, India

Bharti Kher
Virus, 2008
Bindi wall-work
300 cm diameter

BHARTI KHER

Working with sculpture, photography and painting, Bharti Kher explores issues of personal identity, social roles and Indian traditions but also, from a broader perspective, 21st-century issues around genetics, evolution, technology and ecology.

Kher uses the bindi as a central motif in her work, transforming the surfaces of both sculptures and paintings to connect disparate ideas. The bindi is a forehead decoration traditionally made with red pigment and worn by Hindu men and women. It represents the 'third eye', the all-knowing intrinsic wisdom, and is a symbol of marital status. Recently bindis have been transformed into stick-on vinyl, disposable objects and a secular, feminine fashion accessory. In Kher's work, the bindi transcends its mass-produced diminutiveness becomes a powerful stylistic and symbolic device, creating visual richness and allowing a multiplicity of meanings, including tensions inherent in shifting definitions of femininity in contemporary India.

Kher's early figurative paintings explore a female perspective of modern India's patriarchal society through representations of contemporary Indian interiors. Depicting a pluralism, with ancient Indian customs juxtaposed with modern Western values, Kher reveals how, while increasingly receptive to foreign influence, many Indians still remain reverent of their own culture in an overtly conspicuous fashion. This clash of cultures is very apparent to Kher – a British-born child of the Indian Diaspora who has, in contrast to dominant outward migration trends, moved to India as an adult. Recently, her panel paintings have been covered with thousands of bindi, creating abstract arrangements encoded with patterns of exile, immigration, crossing boundaries and the passage of time.

In response to repressions, towards women in India, a number of works by Kher denounce domestic tyrannies that define many women's lives. In *The Girl with the Hairy Lip Said No*, 2004, Kher disrupts a table laid for a tea-party with broken chinaware, false teeth and a hair-lined cup, at once critiquing both the English custom of afternoon tea and the Indian bride-viewing tea rituals for arranged marriage ceremonies.

Animals are another recurring theme in Kher's work, serving as a metaphor for the body and transformation. *I've seen an elephant fly*, 2002, is a hyper-realistic, life-sized fibreglass sculpture of a grey elephant, covered with white sperm-shaped bindis. While in Buddhist and Hindu mythology the white elephant is sacred, in the West it is a metaphor for something frivolous and useless. In *I've seen an elephant fly*, grey skin is clearly visible behind a white covering, which emphasises the second skin, thereby confusing its identity and value. Kher poses questions about her own complex identity.

In *The Skin Speaks a Language Not Its Own*, 2006, the elephant reappears as a pathos-inducing figure, leaving the viewer unsure whether death or recovery is the next stage. This exploration of 'inbetween-ness' with an absence of cause and reason ia a recurrent theme for Kher.

In the sculpture *Solarum Series II*, 2007, Kher returns to the natural world. The tree, a potent symbol that appears in ancient mythologies from many cultures, is used by Kher to also reference contemporary issues, like biological cloning. The branches of *Solarum Series II* bear the heads of hundreds of creatures: a disturbing and dystopic vision of a genetically engineered hybrid. **R.M.**

Bharti Kher
Choleric, phlegmatic, melancholy, sanguine, 2009-2010
Bronze
255 x 230 x 190 cm

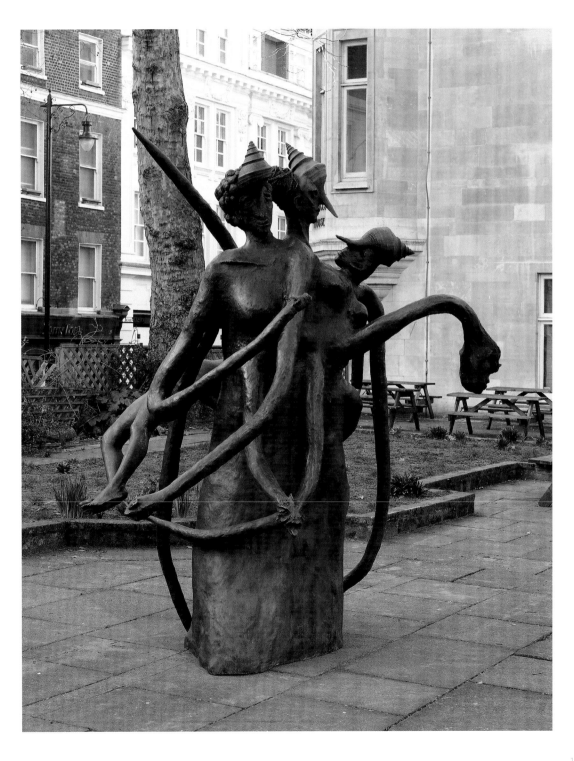

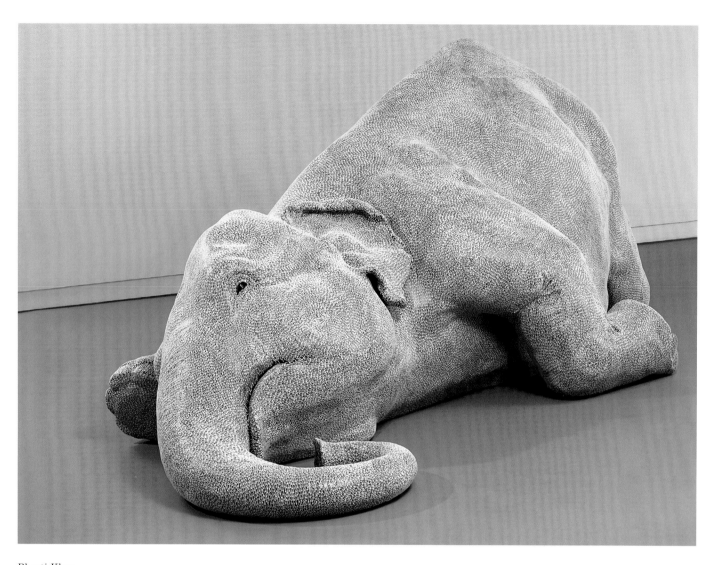

Bharti Kher
The Skin Speaks a Language Not Its Own, 2006
Bindis on fibreglass
Lifesize

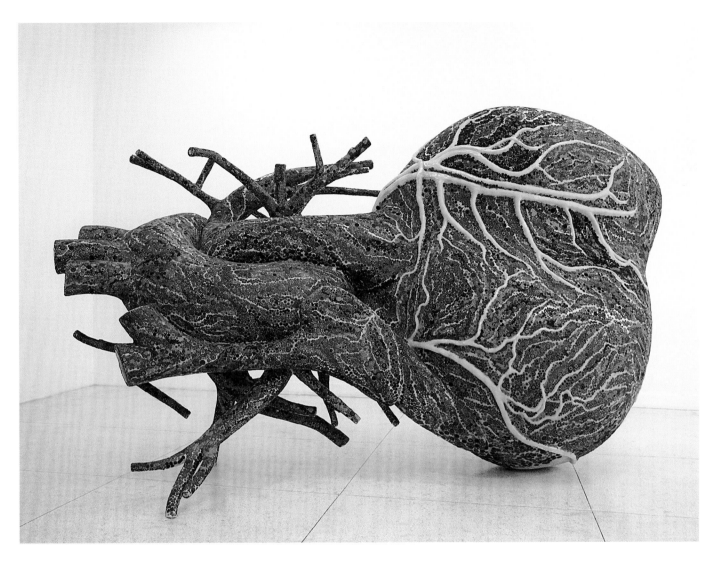

Bharti Kher
An Absence of Assignable Cause, 2007
Bindis on fibreglass
173 x 300 x 116 cm

Next pages:
Bharti Kher
Of Bloodlines and Bastards, 2006
Bindis on fibreglass
Each panel 244 x 122 cm

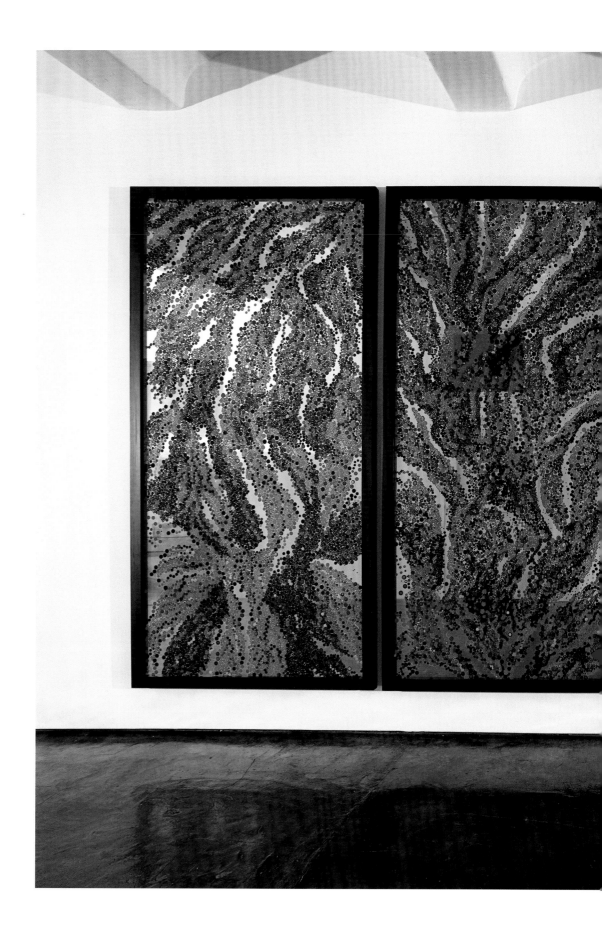

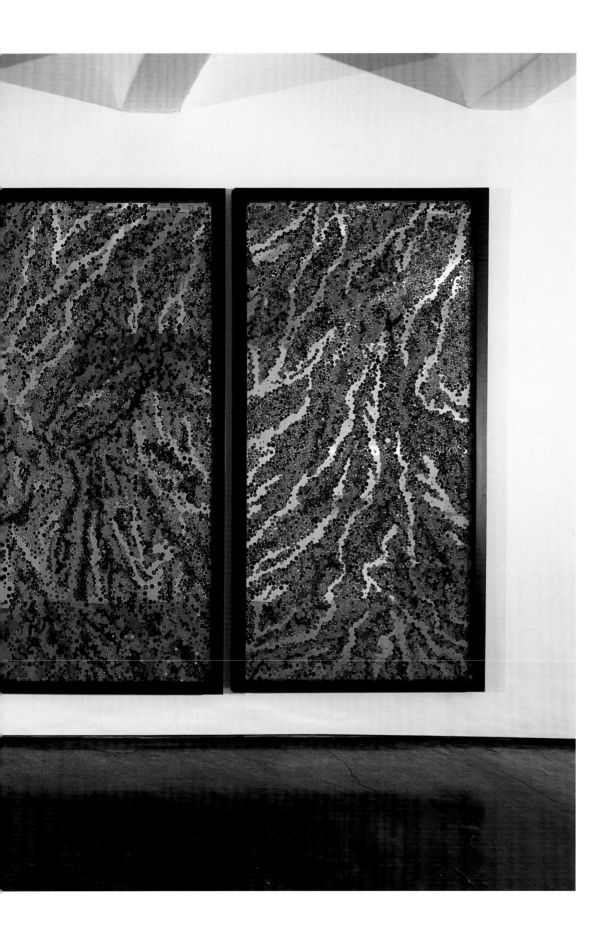

Bose Krishnamachari

Born in 1963, Kerala, India
Lives and works in Mumbai, India
Studied at Sir J J School of Art, Mumbai, India; Goldsmiths College,
London, UK

Solo Exhibitions

2010 *'NO' Bose Krishnamachari,* 1x1 Contemporary, Dubai,
United Arab Emirates
2010 LaVA – Laboratory of Visual Arts, revisited at Gallery BMB,
Mumbai, India
2009 *Only One*, To Let – White Ghost, Kashi Art Gallery, Kochi, India
2008 *Ghost*, Aicon Gallery, London, UK
2007 *LaVA* (Laboratory of Visual Arts, a travelling installation
project), Mumbai, Bangalore, Kolkata, Kochi, Baroda,
New Delhi, India
2006 *Ghost / Transmemoir*, Gallery Artsindia, New York, NY, USA
2005 *Exist*, Jehangir Art Gallery, Mumbai, India
2003 *De-Curating – Indian Contemporary Artists*, Sakshi Art Gallery,
Mumbai, India

Group Exhibitions

2010 *Beyond Objecthood*, Gandhara Art Gallery, Nandalal Bose Hall,
Kolkata, India
2010 *A Syco, The Viewing Room*, Elysium Mansion, Mumbai, India
2010 *Dakshin Paschim*, Emami Chisel Art, Kolkata, India
2010 *Harvest*, Arushi Arts, New Delhi, India
2009 *GODOWN*, Guild Art Gallery, Mumbai, India
2009 *Harvest 2009*, Arushi Arts, New Delhi, India
2009 *Expressions at Tihar*, A Tihar Jail Project, The Indira Gandhi
National Centre for the Arts, New Delhi, India
2009 *Living Art Expanse*, Gallery De Arte, New Delhi, India
2008 *Pastiche – Exhibition of Paintings*, Chaithanya Art Gallery,
Kochi, India
2008 *Mutant Beauty*, Anant Art Gallery, New Delhi, India
2008 *Harvest,* Arushi Arts, New Delhi, India
2008 *Ten Years of Contemporary Indian Art*, Galerie Müller & Plate,
Munich, Germany
2008 *Everywhere is War*, Bodhi Art, Mumbai, India
2007 *Strangeness*, Anant Art Gallery, Kolkata, India
2007 *India 20*, Lalit Kala Akademi, New Delhi, India
2006 *Bombay: Maximum City*, lille3000, Tri Postal, Lille, France
2006 *The Shape that is*, Jendela and Concourse, Esplanade, Singapore
2001 *Mutations – Rumor City*, Tokyo, Japan
1999 *Embarkations*, Sakshi Art Gallery, Mumbai, India
1997 *50 Years of Art in Mumbai*, National Gallery of Modern Art,
Mumbai, India

Awards / Grants / Residencies

2010 Rachana Sansad Golden Jubilee Year 2010
2010 Angamaly Fest-09/10 for achievements in the field of Art
2009 Manzoni-FHM Style Icon 2009 (artist and serious art and style)
2009 Kerala Lalalitha Kala Academy Fellowship
1999 Charles Wallace Indian Trust Award
1996 Mid America Arts Alliance Award
1993 British Council Travel Award
1985 Kerala Lalit Kala Akademi Award

Bose Krishnamachari
*White Builders and
The Red Carpets* (detail), 2008
Mixed-media installation
Dimensions variable

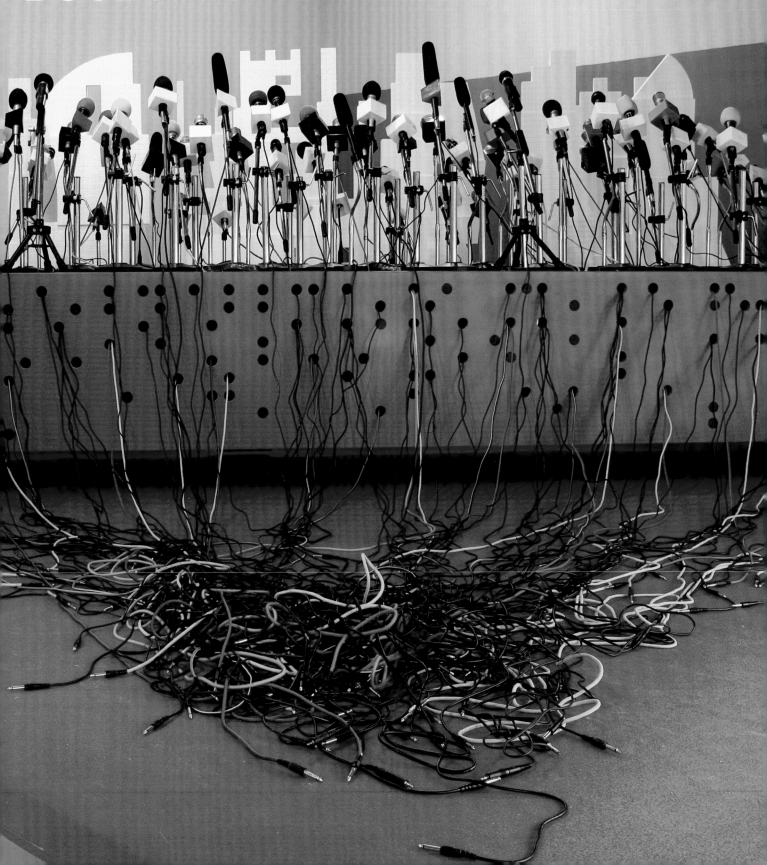

Bose Krishnamachari is an artist and curator whose artistic practice includes bold, abstract paintings, figurative drawings, sculpture, photography and multimedia installations. While stylistically varied, a common thread throughout his work is a critique of power structures that operate within the art world and more broadly in contemporary society. In his first solo show in 1990, Krishnamachari deployed a minimalist style, producing an abstract black on black with white perforated paper, reminiscent of Braille. As viewers could neither touch nor read the language, an ironic comment on contemporary culture and art gallery decorum in particular, could be understood.

In both his art and his curating, Krishnamachari examines the art historical canon and exposes its inequalities. *De-Curating – Indian Contemporary Artists*, 2003, included 94 sketches and paintings of living Indian artists – both well-established and emerging practitioners. The works resulted from three years of travelling across India, meeting, talking, photographing and drawing. This journey was, in his words, 'a hand-made tribute to the memory of that "whole-time worker", the artist's and undermines the value judgements of art history, presenting the artists as equally significant. Krishnamachari's desire to support and promote lesser-known artists also extends to his curatorial activities. He has previously devised exhibitions that offer Indian artists visibility in larger cities and opportunities for exposure within the international contemporary art world.

Other works by Krishnamachari look beyond the art world, and seek to examine the psyche of the 'average Mumbaikar' and make visible what he describes as the 'ocean of anxieties that have arisen from the everyday question of acceptance'. One series includes six large ballpoint-pen portraits of household staff from the artist's Mumbai residence, as well as 108 photographic portraits of individuals who participant in the artist's life, keeping alive the encounters he had with them. These works are a reminder of how wealth and class are still dividers in contemporary Indian society.

The large-scale multimedia installation *Ghost/Trans-memoir*, 2006-08, takes a different approach to mapping Mumbai. The work comprises 108 used *tiffin* boxes suspended from a frame and wired with headphones and miniature screens. *Tiffin* boxes play a central role in Indian life, with millions being filled daily by house-wives, collected, exchanged, re-exchanged and sorted until the right home-cooked lunch reaches the right office-worker. Overall, the installation captures some of the buzz and chaos of the street, while the small screens present interviews with people from Mumbai. These portray their thoughts, celebrations, frustrations, religions and emotions, and are a reminder of the individual voices and stories to be found among a total of 20.8 million Mumbaikars.

In another installation, Krishnamachari takes a more overtly political standpoint, commenting on the press conference platforms used by the perpetrators of war to justify their actions. *White Builders and the Red Carpets*, 2008, presents 108 microphones on a long red table, poised for a press conference. Behind the table, 13 white chairs, represent the kind of powerful individuals who would address the press at such an event, with backs shaped like imposing architectural forms that symbolise their ambitions as 'builders' – who perpetuate wars for economic gain. The specific number of chairs is also a reference to Leonardo Da Vinci's *The Last Supper* and a reminder of the frequent role played by religion in the culture of war. *White Builders and the Red Carpets* is also a commentary on the distribution of information and how crucial it may be for survival in the new media era where numerous 24-hour news channels operate where once there was scant distribution and access to such media. **R.M.**

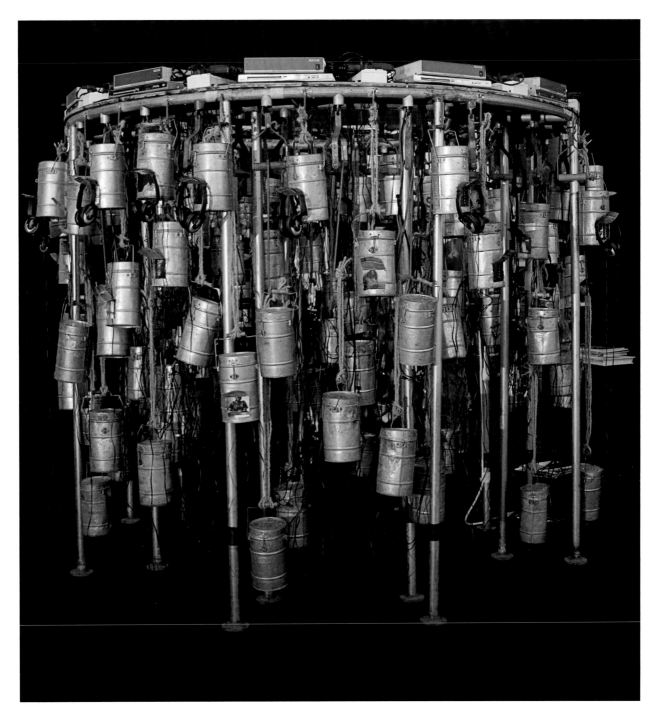

Bose Krishnamachari
Ghost/Transmemoir, 2006-2008
108 used tiffins, LCD monitors, amplifiers, DVD players,
headphones, cables, scaffolding and wood
Dimensions variable

Bose Krishnamachari
Ghost/Transmemoir (detail), 2006-2008
108 used tiffins, LCD monitors, amplifiers, DVD
players, headphones, cables, scaffolding and wood
Dimensions variable

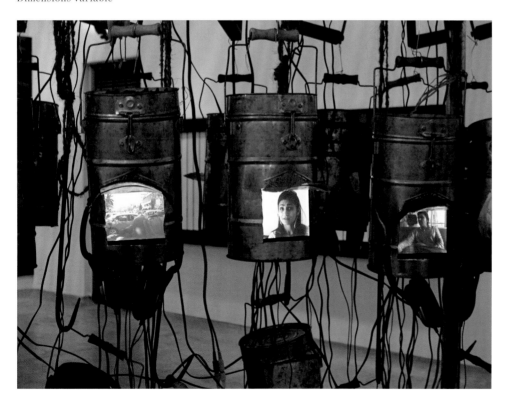

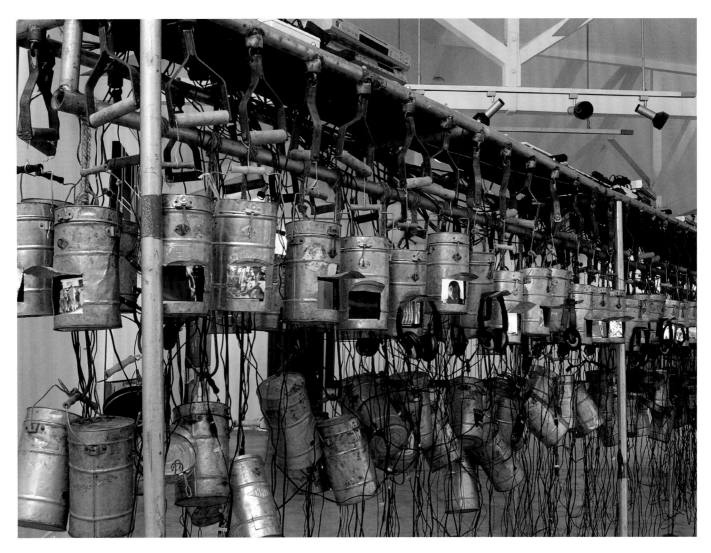

Bose Krishnamachari
Ghost/Transmemoir (detail), 2006-2008
108 used tiffins, LCD monitors, amplifiers, DVD players,
headphones, cables, scaffolding and wood
Dimensions variable

Bose Krishnamachari
De-Curating (detail), 2003
Graphite and silver leaf on Kent paper
43.1 x 43.1 cm

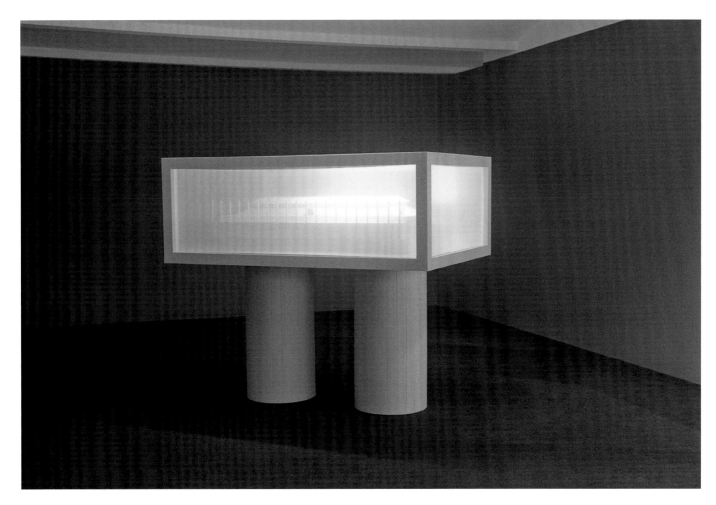

Bose Krishnamachari
Amuseum/Ghost, 2008
Corian, laminated polyurethane on Forex and cine screen
168 x 120 x 61.5 cm

Nalini Malani

Born 1946, Karachi, Pakistan (pre-partition India)
Lives and works in Mumbai, India
Studied at Sir J J School of Art, Mumbai, India; Paris, France

Solo Exhibitions

2010 *Splitting the Other*, Cantonal Museum of Fine Arts,
Lausanne, Switzerland
2009 *Cassandra*, Galerie Lelong, Paris, France
2009 *Nalini Malani*, The Govett-Brewster Art Gallery, New Plymouth,
New Zealand
2008 *Listening to the Shades*, Arario Gallery, New York, NY, USA
2007 *Nalini Malani*, Walsh Gallery, Chicago, IL, USA
2007 Irish Museum of Modern Art, Dublin, Ireland
2006 *Living in Alicetime*, Sakshi Gallery, Mumbai; Rabindra Bhavan,
New Delhi, India
2005-2006 *Exposing the Source: The Paintings of Nalini Malani,
A retrospective exhibition*, Peabody Essex Museum, Salem, MA, USA
2002 *Nalini Malani*, Apeejay Media Gallery, New Delhi, India
1999 *Remembering Toba Tek Singh*, Prince of Wales Museum,
Mumbai, India
1997 *The Job*, Max Mueller Bhavan, Mumbai, India
1996 *Medea*, Max Mueller Bhavan, Mumbai, India
1966 Pundole Art Gallery, Mumbai, India

Group Exhibitions

2009 *MATER*, Universidad de Jaén, Jaén, Spain
2009 National Galleries of Modern Art, New Delhi, Bangalore,
Mumbai, India
2009 National Museum of Modern Art, Tokyo, Kyoto, Japan;
Seoul, South Korea
2009 *Prospect 1*, CAC, New Orleans, LA, USA
2008 *India Moderna*, Institut Valencià d'Art Modern, Valencia, Spain
2008 *Revolutions – Forms That Turn*, Biennale of Sydney, Cockatoo
Island, Sydney, Australia
2008 *Machines à rêve / Video Short list*, Vocatif, Passage de Retz,
Paris, France
2008 *Excavations: Memory / Myth / Membrane*, Art Musings Gallery,
Mumbai, India
2007 *Frame, Grid, Cell*, Bodhi Art, Mumbai, India
2007 *Think with the Senses, Feel with the Mind – Art in the Present Tense*,
52nd Venice Biennale, Venice, Italy
2007 *Urban Manners*, Hangar Bicocca, Milan, Italy
2007 *New Narratives: Contemporary Art from India*, Chicago Cultural
Center, Chicago, IL, USA
2006 *Cinema of Prayoga*, Tate Modern, London, UK
2006 *Local Stories*, Modern Art Oxford, UK
2005 *Recent Paintings, The Armory Show*, New York, NY, USA
2004 *Crossing Currents – Video Art and Cultural Identity*, Lalit Kala
Akademi Galleries, New Delhi, India
2004 *Edge of Desire*, Art Gallery of Western Australia, Perth, Australia
and Asia Society, New York, NY, USA
2003 *Body.City*, House of World Culture, Berlin, Germany
1982 *Myth and Reality*, Museum of Modern Art, Oxford, UK

Awards / Residencies

2005 Lucas Art Residencies, Montalvo, CA, USA
2003 Civitella Rainieri, Umbertide, Italy
1999–2000 Fukuoka Asian Art Museum, Fukuoka, Japan
1999 Lasalle-SIA, Singapore
1989 USIA Fellowship at Fine Arts Work Center, Provincetown, MA, USA
1988 Kasauli Art Centre, Kasauli, India

Nalini Malani
Listening to the Shades (detail
of panel 40 of 42), 2008
Reverse painted acrylic, enamel
and ink on acrylic sheet
54 x 73.6 cm

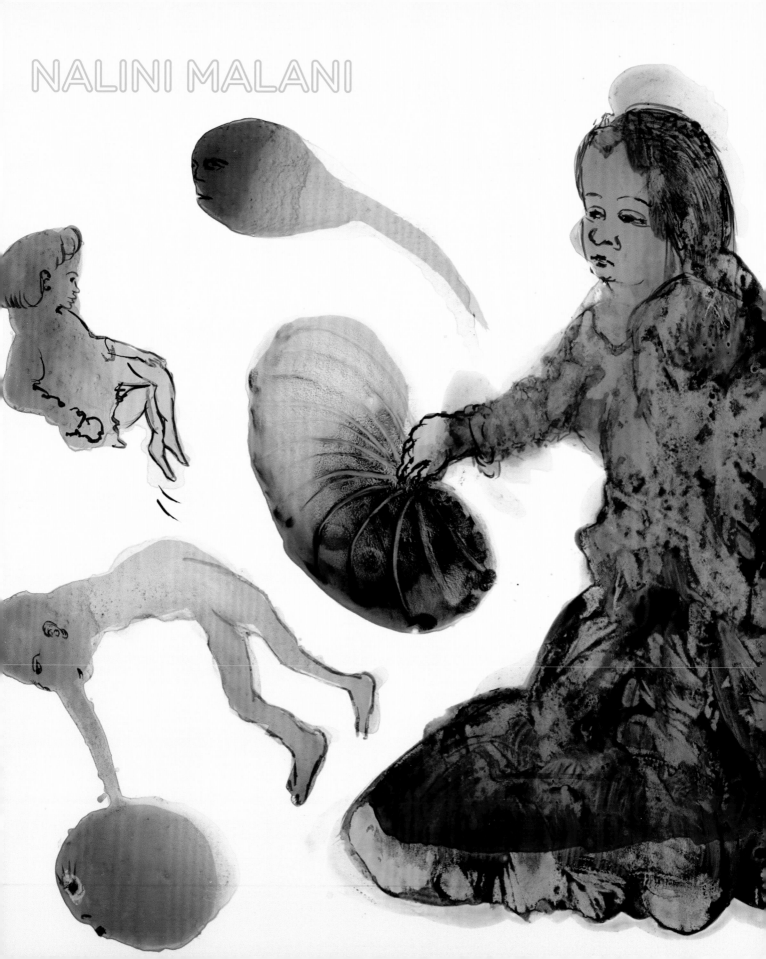

NALINI MALANI

Nalini Malani emerged in the late-1960s when the Indian art scene was male-dominated. Among a new generation of women artists who wove personal narratives and histories into their practice, her early works were cathartic autobiographies. The female protagonists of her paintings expressively negotiate family relationships by showing previously unexposed family dynamics including female rebellion and isolation within a patriarchal society. With a focus on the body, interaction and layering become a metaphor to illustrate the complexities of Indian society and the emotions they elicit: oppression, anxiety, self-absorption and anger.

Working initially with overtly Indian themes, Malani eventually sexualised and de-gendered her female protagonists, highlighting the extreme roles for women in Indian society, from urban proletarian to street acrobat. Her focus has been on unconventional women – Mad Meg from Brueghel's painting, Medea, Sita, Radha, Akka, Alice from Lewis Carroll's *Alice in Wonderland*. Some of these women existed, others are legend, each subverted male-dominated social customs to define new roles. Figures appear in isolation or intertwined – not in expected contexts but in multilayered narratives open to interpretation.

Malani started to receive international acclaim in the 1980s and by the 1990s she became part of India's first-generation of video artists. Her practice also encompasses multi-media installation and experimental theatre, although painting and drawing remain central. Her experimentation in post-painterly media such as video and multi-media installation is, for her, a means of retrieving the early experience of learning to paint. Video provides unrestricted spatial and temporal density with which to explore a painterly approach.

Always attuned to global discourses which shape female identity, Nalini uses a singularly personal idiom which weaves local history and social issues to communicate her position. Her works are populated with appropriated and reappropriated imagery, which furthers her narrative, in itself often a telling and a retelling within a work. Her collaboration with Alaknanda Samarth, theatre actress and director, in the performance/installation *Medeamaterial*, 1993–94, based on Heiner Müller's a play by the same name, inspired her to explore human emotions and expression through bodily changes.

Medeamaterial, where actors interacted with painted forms on stage, was followed by the first of her installations in which she combines painting with light and shadow, but in her art installations the human presence is removed. These works further explore layering, as she paints onto transparent cylinders that then rotate with light projected through them to populate the room with shadows. Referencing Buddhist prayer wheels whose rotations express a desire for change within the stability of cyclical continuity, the cylinders' revolutions and images build a continuous narrative of epic proportions that appears and vanishes simultaneously. Accompanied by music and text, the historical, cultural, personal and psychological elements combine to present allegories of political and ecological dangers, with images recalling the horrors of war, the industrial revolution and the subsequent utopia/dystopia.

The 12-piece suite entitled *Tales of Good and Evil*, 2008, featured in *Indian Highway*, alludes to forms of communication and oral transmission of tales, myths and legends of Indian origin, which were circulated through the centuries via the great commercial arteries connecting roads that linked north and south, east and west. **S.A., R.M.**

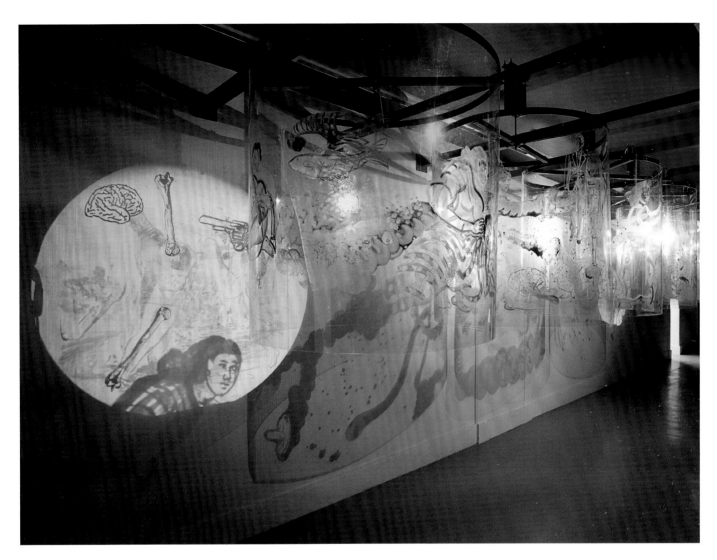

Nalini Malani
Remembering Mad Meg, 2007
Acrylic reverse painting on Lexan sheet, motors, steel
armature and 2 DVDs
Dimensions variable

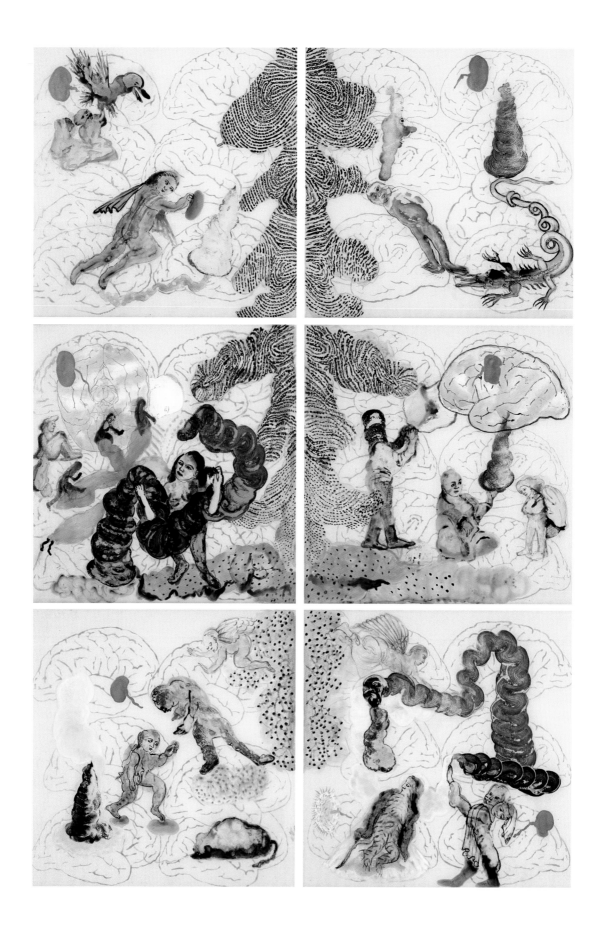

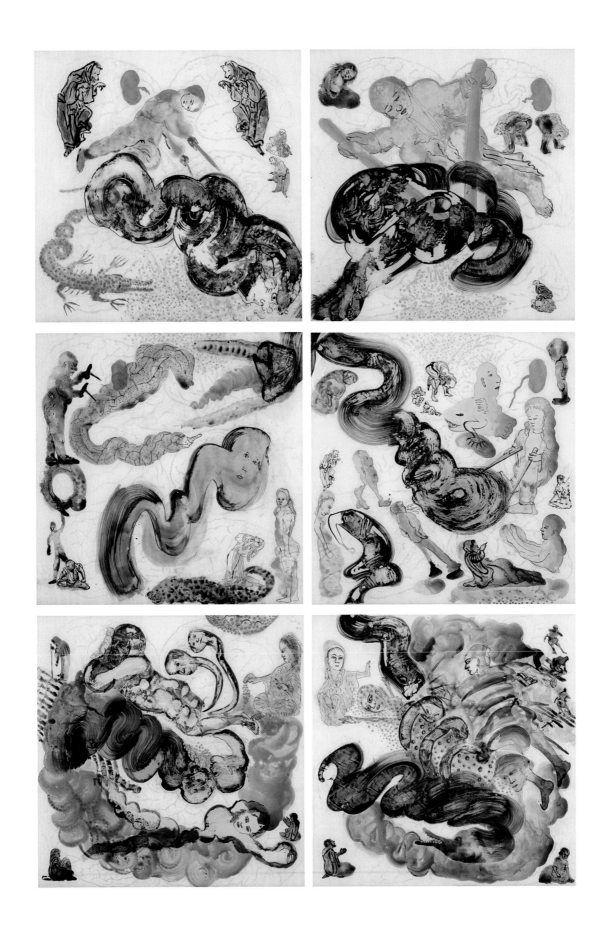

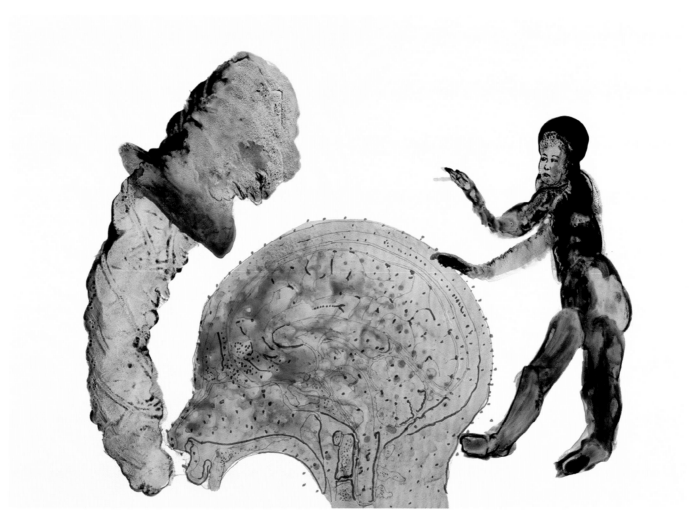

Nalini Malani
Listening to the Shades (panel 6 of 42), 2008
Acrylic, enamel and ink reverse painting on acrylic sheet
Each 54 x 73.6 cm

Previous pages:
Nalini Malani
Tales of Good and Evil, 2008
Ink on Hahnemeuhle Bamboo paper
Diptych: each panel 68.5 x 68.5 cm
Overall dimensions: 205.5 x 274 cm

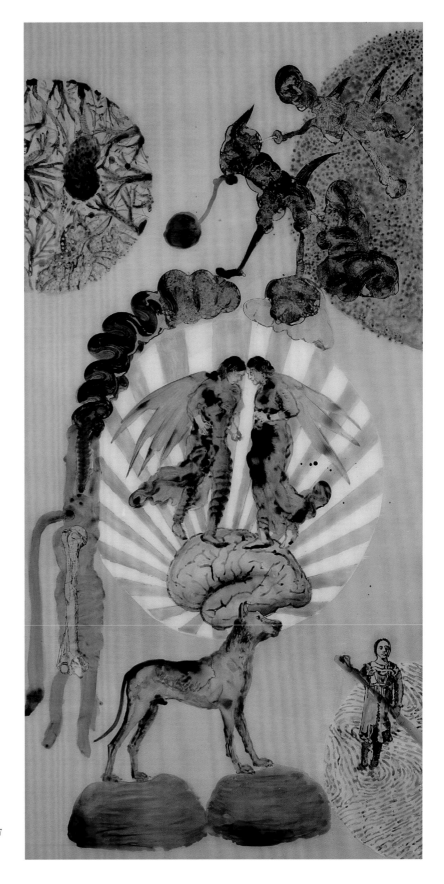

Nalini Malani
Splitting the Other (panel 6 of 14), 2006-2007
Acrylic, ink and enamel on acrylic sheet
Each 203 x 103 cm

Jagannath Panda

Born in 1970, Bhubaneswar, India
Lives and works in New Delhi, India
Studied at B. K. College of Art & Crafts, Bhubaneswar, India;
M S University of Baroda, Gujarat, India; Fukuoka University of
Education, Japan; and Royal College of Art, London, UK

Solo Exhibitions
2009 *The Action of Nowhere*, Alexia Goethe Gallery, London, UK and
New Delhi, India
2007 *Nothing is Solid*, Gallery Chemould, Mumbai, India
2006 Berkeley Square Gallery, London, UK
2005 Gallery Nature Morte, New Delhi, India
2000 Gallery Chemould, Mumbai, India
2000 Nature Morte, Hungarian Information Cultural Center,
New Delhi, India
1998 Za Moca Foundation Gallery, Tokyo, Japan

Group Exhibitions
2010 *Finding India*, Art for the New Century, MOCA, Taipei, Taiwan
2010 *Inside India*, Luce Gallery at Palazzo Saluzzo di Paesana,
Turin, Italy
2010 *Transformation*, MOT – Museum of Contemporary Art, Tokyo,
Japan
2010 *Midnight's Children*, Studio La Città, Verona, Italy
2010 *Dialogues – A Selection of International Contemporary Artists*,
Gallery Bartha and Senarclens, Singapore
2009 *INDIAN XIANZAI Contemporary Show*, MoCA, Shanghai, China
2009 *Chalo India*, Mori Museum, Tokyo, Japan; Korean Contemporary
Art Museum, Seoul, South Korea; Essl Museum, Austria
2008 *Where in the World*, Devi Art Foundation, Gurgaon, India
2008 *Argent Conversations*, Art Alive, New Delhi, India

Awards / Residencies
2003 KHOJ International Artists' Association, New Delhi, India
2002 Centre Prize, C.I.I.C London, UK
2001 Cité International des Arts, Paris, France
1996 All India Fine Art and Crafts Society Award, New Delhi, India
1995 National Academy Award from Central Lalit Kala Academy,
New Delhi, India

Jagannath Panda
Cult of Survival (detail), 2010
Plastic pipe, car paint, fibreglass, Rexine,
plastic flowers and acrylic
63 x 190 x 145 cm

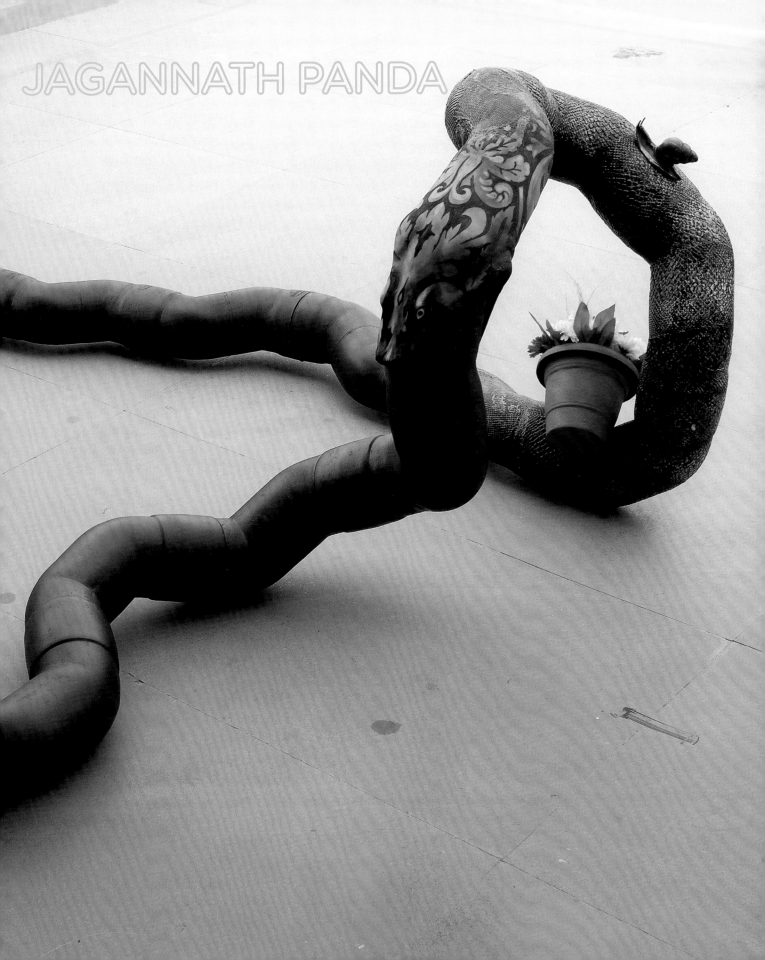

Jagannath Panda is as much a marker of an evolving urban landscape as he is a participant in it. The son of a temple priest in Orissa, Panda has since travelled globally while making Delhi his home for several years now. These journeys have served as the substrate for his work. His newest series, *The Action of Nowhere*, gestures to the new forms of Indian urbanism. In fact, these new works bear the stamp of his relatively recent shift to the splashy, overbuilt, Gurgaon to the south of Delhi, from his previous East Delhi home.

The new Gurgaon bursts open most decisively in the theatrical trio of crashing cars: *The Lost Site*, *Failure of the Faith* and *Fatal Sublime*. In these three works, Panda creates deadly car accidents on canvas, in which the metal of the automobiles is crumpled like sheets of paper, irretrievably destroyed. The textile of the ripped seat-cover pours out of the car in *Fatal Sublime*. It is riveting in its directness, bringing out our inner voyeur. Look carefully – there are trees and branches being smashed, their death forced upon them by an out-of-control automobile. There is a strong likeness to the everyday assault on green urban areas, as cities are created or expand. The works become a metaphor for these occurrences; the seamy underside of fashioning the brave new city.

It would be unwise to ignore the seeping-in of new forms of popular culture into Panda's work. In *An Avatar*, a lone hyena looks over a drab apartment complex, the only vegetation being a shrub on a single balcony. The hyena's forehead is prettily adorned with unapologetic 'bling' – glittery beads and jewels – 'crystal', as a local tailor would call them. It is as if the hyena were a creature from the popular, melodramatic Saas Bahu television soaps, where every character seems to have been outfitted in a jewellery store and whose loud, audacious fashion occasionally slips off the screen and into real wardrobes. It is from here that it has, undoubtedly, entered Panda's toolkit.

But Panda simultaneously creates a parallel fantasy, with animals as protagonists. Most of his works comprise an animal bearing witness, as it were, to these urban shifts and to its own slow demise. The hyena in *An Avatar* is not a cunning, menacing creature about to prey on something in its environment. It is in fact uncharacteristically melancholy, watching in defeat over its own displacement, marking out a territory that doesn't exist any more. There is a sense of tension between these binary opposites: the animal that seeks territory and the absence of such territory, physically and metaphorically, in the new urbanity.

In the tragic *The Migrant (Anywhere, Anytime)*, a muscular deer stares out at the viewer, a sunny yellow car whizzing by behind it. The car is reduced to a mere flash, but the deer, like its vulnerable counterpart in the film *The Queen*, meets our gaze. It is almost a moment of truth – the deer has escaped becoming road-kill, but this is only a temporary victory. He is standing on un-built ground, but it is already asphalted. In his horns rests a falcon with its nest, seeking refuge in the closest approximation to a tree. Like an unbalanced equation, as one world begins its expansion, another is on the verge of collapse.

Marking their presence – in a ghostly kind of way – is precisely what Panda hopes to accomplish with such dramatic animal portraiture. His favourite act, of decorating animals with skin-tight brocade and orna-mentation, mimics an ancient ritual of dressing up the dead, before their burial, to celebrate their lives and optimise their chances of a smooth afterlife. The act of repeatedly using fabric in such work becomes a performance, not unlike the ritualistic tasks of his own forebears in Orissa's temples. Thus every time Panda creates such works, he maps his own personal history.

Bharati Chaturvedi

Jagannath Panda
Cult of Survival, 2010
Plastic pipe, car paint, fibreglass, Rexine,
plastic flowers and acrylic
63 x 190 x 145 cm

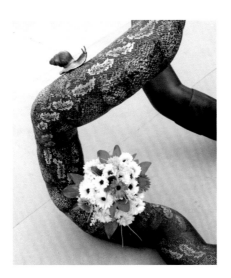

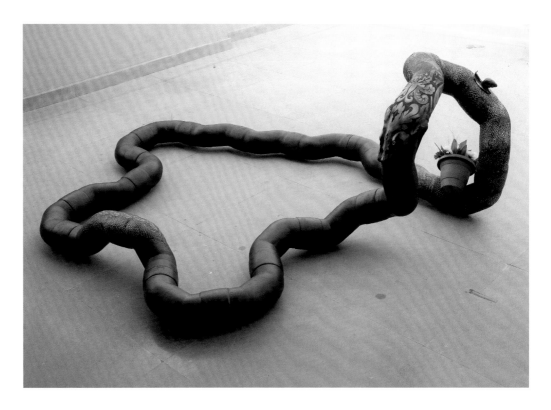

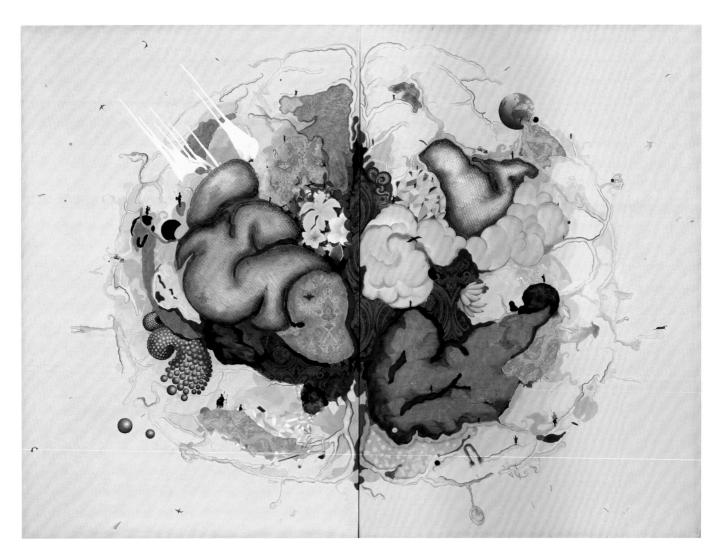

Jagannath Panda
Embryonic Space, 2010
Acrylic, fabric and glue on canvas
223 x 305 x 5 cm

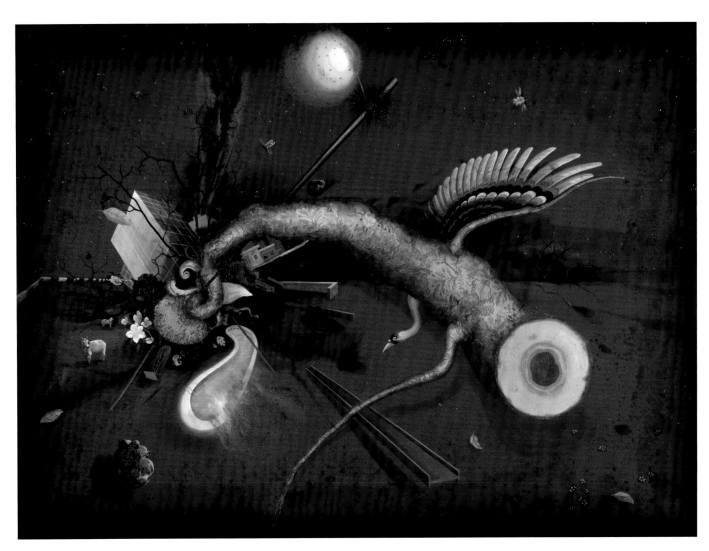

Jagannath Panda
Summer Happening – II, 2010
Acrylic and glue on canvas
170.7 x 231.7 cm

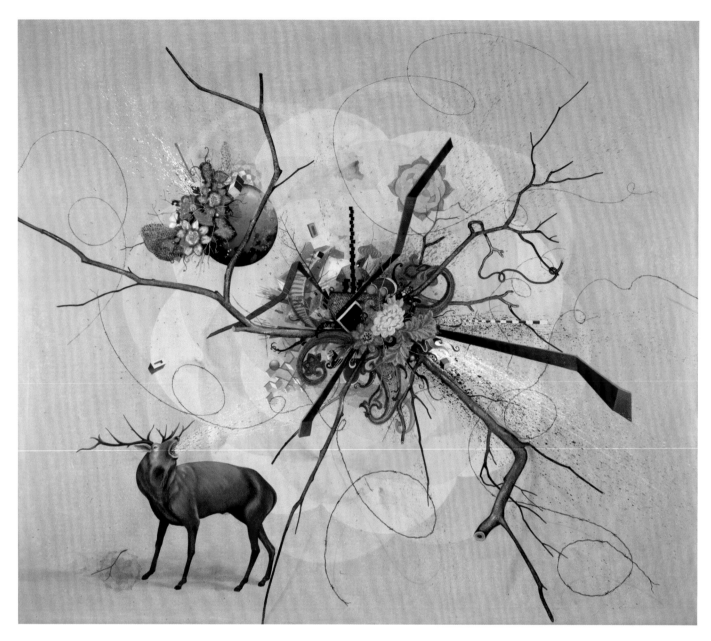

Jagannath Panda
Echoes of Intensity, 2010
Acrylic, fabric and glue on canvas
198 x 229 x 5 cm

Jagannath Panda
The Feral Sphere, 2007
Fibreglass, fabric and glue
170.7 x 170.7 x 170.7 cm

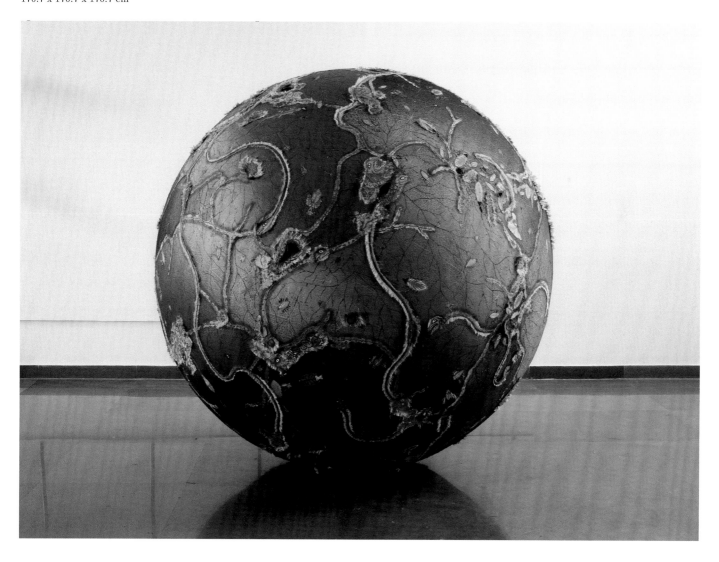

Prajkata Potnis

Born in 1980, Mumbai, India
Lives and works in New Delhi, India
Studied at Sir J J School of Art, Mumbai, India; Film Appreciation,
Film and Television Institute of India (FTII); and National Film
Archive India (NFAI), Pune, India

Solo Exhibitions

2008 *Porous Walls*, The Guild, Mumbai, India
2008 *Membranes and Margins*, Gallery Em, Seoul, South Korea
2006 *Walls-in-Between*, The Guild, Mumbai, India

Group Exhibitions

2010 *Under the Banyan Tree – India Awakens*, Essl Museum of
Contemporary Art, Vienna, Austria
2010 *The Evolution of the Species,* Institute of Contemporary Indian
Art (ICIA), Mumbai, India
2010 *Legacy: A-vanguard*, Gallery Threshold, New Delhi, India
2010 *ARTPARIS+Guests*, Paris, France
2010 *Punctum II: A Critical Look at Landscape in South Asian
Photography*, Lakeeren, Mumbai, India
2009 *Evidentia,* Gallery Sumukha, Bangalore, India
2009 *Sez Who*, a collaborative project on the special economic zones
in and around Mumbai, India
2009 *Experimenter*, Kolkata and KHOJ International Artists'
Association Delhi, India
2009 *Sculpture*, The Guild, Mumbai, India
2009 *India Art Summit*, New Delhi, India
2009 *ARCOmadrid*, International Contemporary Art Fair,
Madrid, Spain
2009 *Living off the Grid*, Anant Art Centre, New Delhi, India
2009 *Recycled*, Bose Pacia, Kolkata, India
2009 *Re-claim/ Re-cite/ Re-cycle*, Latitude 28, New Delhi, India
2009 *The Landscape of Where*, Galerie Mirchandani + Steinruecke,
Mumbai, India
2009 *Multitudes*, Goethe-Institut, Max Mueller Bhavan,
Bangalore, India
2009 *Home*, Travancore Art Gallery, New Delhi, India
2009 *Material Texts*, Kashi Art Gallery, Kochi, India
2008 Dubai Art Fair, Dubai, United Arab Emirates
2008 *Everything 2008: 12 Artists from India*, Willem Baars Projects,
Amsterdam, Netherlands
2008 *Moscow to Mumbai*, Eugene Gallery, Seoul, South Korea
2008 *The Sakshi Show,* Sakshi Art Gallery, Mumbai, India
2007 Contemporary Istanbul Art Fair, Turkey
2007 *Membranes and Margins – II*, Singapore Art Fair, Singapore

Awards

2010 Sanskriti Award for Arts, Sanskriti Pratisthan, New Delhi, India
2003–2004 Inlaks Fine Art Award, Mumbai, India

Top:
Prajakta Potnis
Still Life, 2009
Digital print on archival paper
87.6 x 137.2 cm
Edition of 5 + 1 AP

Bottom:
Prajakta Potnis
Still Life, 2010
Digital print on archival paper
86.4 x 152.4 cm
Edition of 5 + 1 AP

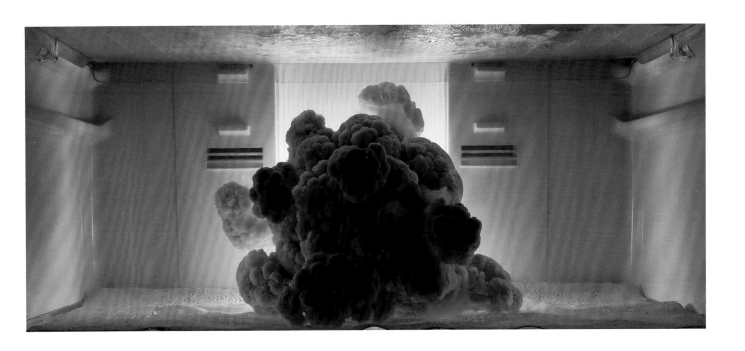

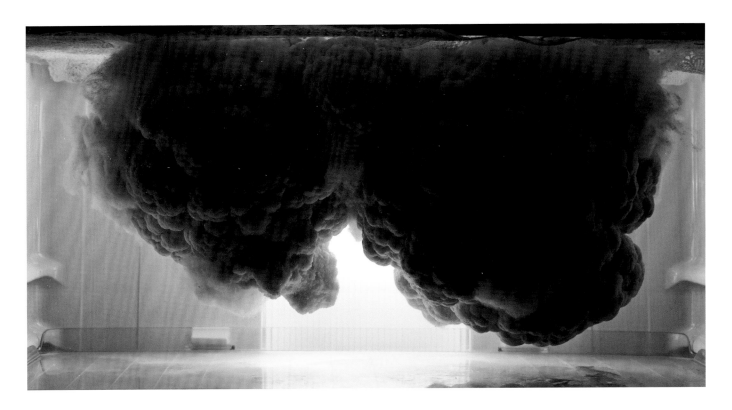

Globular growths erupt from the smooth purple skin of aubergines like tiny tumours. Stringy, red, coiled strands snake from a bisected tomato. A cauliflower looms in the enclosed space that appears like a film set or a theatrical stage for the subtle drama in Prajakta Potnis' *Still Life* photography works of 2010. The bulbous cauliflower appears suspicious and warty; white froth festering among its clumps makes it appear like a cancerous anomaly.

The locus of this stealthy drama is the interior of a typical household refrigerator. It is a controlled environment that suggests a larger matrix of human pretensions and fears. It is a space of paradox as well, for while it showcases its contents when open, it becomes a dark space of concealed mystery when closed. The space evokes attempts to create the kind of hyper-sterile, managed environment to which shopping malls and airports aspire. Yet the impulse behind such spaces reveals an underlying terror of the unmanageable. Thus the refrigerator functions as a symbolic setting, where the global reach of public policies and corporate machinations is manifested not only in the private, intimate space of one's own fridge, but perhaps also in our own bodies, should these genetic interventions prompt our own cells to secretly mutate and mutiny against us.

Investigating the glacial, interior drama of genetically modified crops, Potnis creates a tableau in which the boundaries between the natural and the engineered are blurred, and the potential for arrogant human inter-ferences in nature to metastasise beyond our control is ever present. The spectre of genetically modified foods also offers insights into the prevailing double standard at the intersection of public interest (food safety and health guarantees) and private (corporate) gain; conversely it ties into public interest and private loss in a different way: in the promise (false or not) of bountiful, healthy crops to feed multitudes and the concomitant demise of the small-scale, local farmer at the hands of multinational mega-corporations. Here consumer's and producer's fates are intertwined like a Möbius strip.

Still Life extends the explorations of Potnis' earlier work, which consists of painting and subtle site-specific installations and spatial interventions performed on everyday objects, as well as the places that house them and us. Potnis investigates along multiple visual and conceptual axes that are tied to a coherent set of preoccupations. Boundaries between inside and outside are violated, the cellular and bodily are grafted onto the built and manufactured, and the relationships between objects and their environments are blurred and confounded.

In her installations, Potnis transforms the walls of a room into a surface resembling pocked human skin; she infects light fixtures, fans and other quotidian house-hold objects with 'viral growths', and the holes of an electrical outlet meander down the wall. Similarly, her paintings depict pillows whose dots have spread like measles to the walls; chairs whose legs are stockinged with the texture of the floor; or floors whose mottled surface is studded with stalagmite-like growths rising from the patterns in the flooring.

Potnis' works are rife with images that hint at infection, uncontainable contagion and the porosity of the inter-face between our spaces, objects and life itself. Skins and membranes are metaphors in her work for walls and boundaries, while tumours, cancers and fibroids are metaphors for out-of-control growth. The seamless reciprocity between her conceptual investigations and their visual manifestations is a trademark of Potnis' inter-textual practice. Her works meditate on the social and scientific anxieties of our times that permeate public and private, as well as eat away at the boundary between them. **Maya Kóvskaya**
PhD, Independent Critic, Curator, Scholar, New Delhi / Beijing

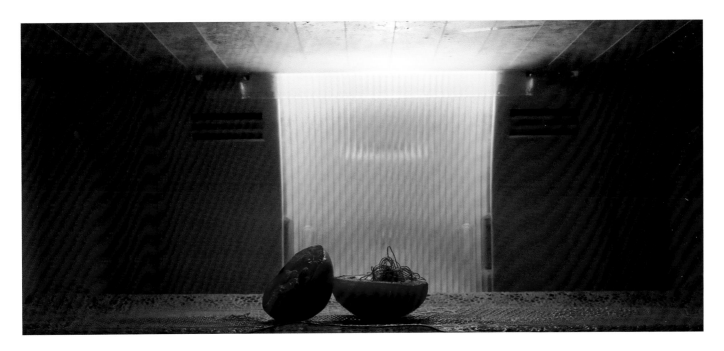

Prajakta Potnis
Still Life, 2009
Digital print on archival paper
76.2 x 152.4 cm
Edition of 5 + 1 AP

Prajakta Potnis
Still Life, 2009
Digital print on archival paper
86.4 x 152.4 cm
Edition of 5 + 1 AP

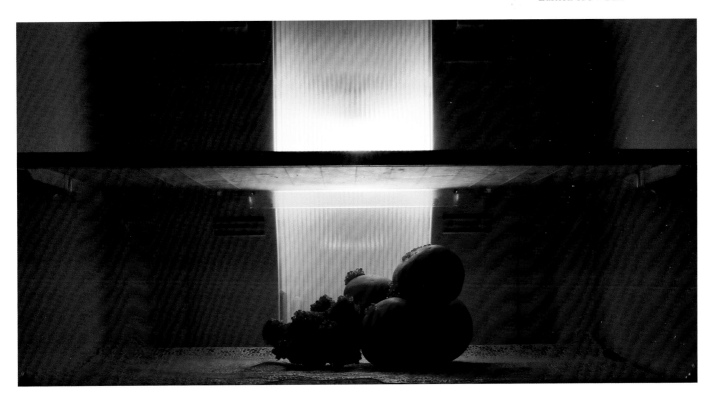

Prajakta Potnis
Still Life, 2009
Digital print on archival paper
87.6 x 137.2 cm
Edition of 5 + 1 AP

Prajakta Potnis
Still Life, 2009
Digital print on archival paper
86.4 x 137.2 cm
Edition of 5 + 1 AP

Prajakta Potnis
The Curtain, 2005
Cotton fabric on wall
Dimensions variable

Prajakta Potnis
From the *Porous Walls* series, 2008
Digital print on archival paper
20.3 x 25.4 cm

RAQS MEDIA COLLECTIVE

Founded in 1992 by Monica Narula (born in 1969), Jeebesh Bagchi (born in 1965) and Shuddhabrata Sengupta (born in 1968), who live and work in New Delhi, India

Solo Exhibitions

2010 *The Capital of Accumulation,* Project 88, Mumbai, India
2010 *The Things That Happen When Falling In Love,* Baltic Centre for Contemporary Art, Gateshead, UK
2009 *The Surface of Each Day is a Different Planet,* Art Now Lightbox, Tate Britain, London, UK
2009 *When the Scales Fall From Your Eyes,* Ikon, Birmingham, UK
2009 *Escapement,* Frith Street Gallery, London, UK
2009 *Decomposition,* Asia Art Archive, Hong Kong
2006 *The KD Vyas Correspondence: Vol.1,* Museum of Communications, Frankfurt, Germany
2006 *There Has Been a Change of Plan,* Nature Morte Gallery, New Delhi, India
2004 *The Impostor in the Waiting Room,* Bose Pacia Gallery, New York, NY, USA
2004 *The Wherehouse,* Palais des Beaux-Arts, Brussels, Belgium
2003 *The Co-ordinates of Everyday Life,* Roomade, Brussels, Belgium

Group Exhibitions

2010 *There is always a cup of sea to sail in*, 29th São Paulo Biennial, Brazil
2010 *Better City, Better Life*, 8th Shanghai Biennale, Shanghai, China
2008 *The New Décor,* Hayward Gallery, London, UK; The Garage Center for Contemporary Culture, Moscow, Russia
2008 *The Art of Participation: 1950 to Now*, San Francisco Museum of Modern Art, San Francisco, CA, USA
2007 *India: New Installations*, Mattress Factory, Pittsburgh, PA, USA
2005 *Icon: India Contemporary*, 51st Venice Biennale, Venice, Italy
2003 *When Latitudes Become Forms*, Walker Art Centre, Minneapolis, MN, USA
2002 *Documenta 11*, Kassel, Germany

Curated Shows

2008 *The Rest of Now* for *Manifesta 7*, Bolzano, Italy
2008 *Scenarios* for *Manifesta 7*, Fortezza / Franzensfeste, with Adam Budak, Anselm Franke and Hila Peleg, Bolzano, Italy
2006 *Building Sight* for *On Difference 2*, Wurttembergerische Kunstverein, Stuttgart, Germany

Residencies

2007 Atlas II Season Residency, Iniva, London, UK
2005 Sally and Don Lucas Artists' Residency Program, Montalvo Arts Centre, Saratoga, CA, USA
2004 Das TAT, Frankfurt, Germany
2003 Office for Contemporary Art Norway, Oslo, Norway

Raqs Media Collective
Steps Away From Oblivion, 2008
Installation view *Indian Highway 1*,
Serpentine Gallery, London
(10 December 2008 – 22 February 2009)

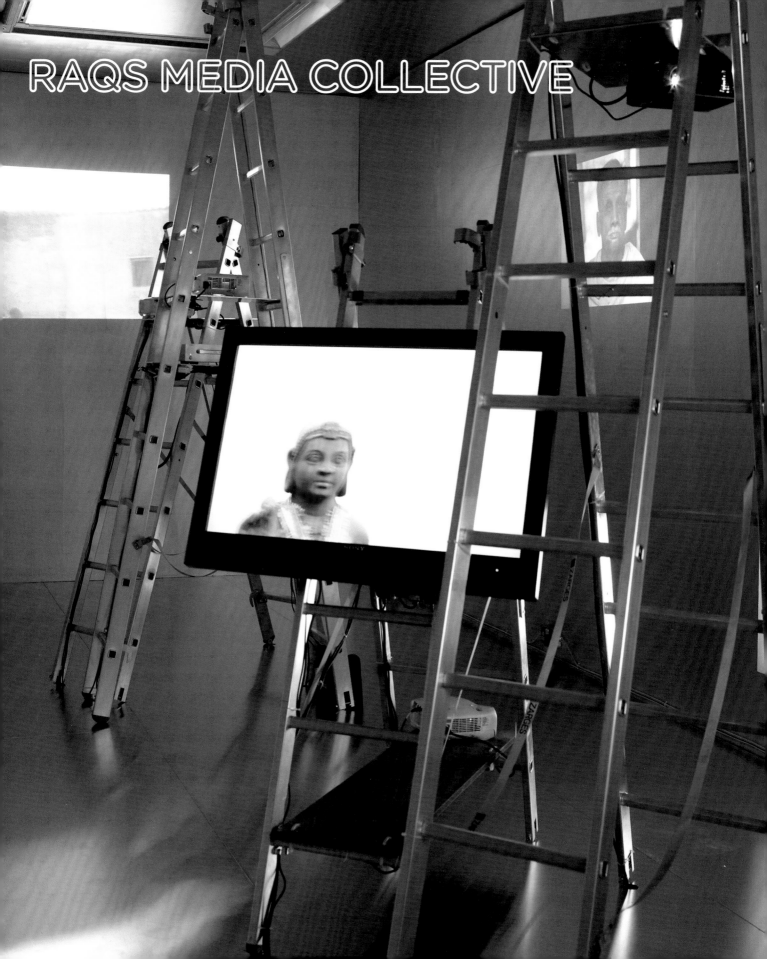
RAQS MEDIA COLLECTIVE

Formed in 1992, Raqs Media Collective have been described as artists, media practitioners, curators, researchers, editors and catalysts of cultural processes. The documentary films made by Raqs in the 1990s were noted for avoiding conventional narrative, deemed to be loaded by dominant power structures. These early films cover recurrent themes such as the urban landscape – embracing private, public, social and economic factors – and the meaning and uses of media and technology; the nature of knowledge and learning; and the creative capacity of individuals in society.

Raqs' sustained ambivalence towards modernity and resistance to its organising principles – progress, development, the nation-state – is evident in such works as *The Imposter in the Waiting Room*, 2004, which explores the conceptual imposition of boundaries between public and private life, especially in situations related to immigration and travel. This work uses video, photography and text to reference spaces of transience and incompleteness (the waiting rooms and antechambers of modernity) where a host of characters, such as airport travellers, missing persons and stateless beings marooned in non-places, rehearse the moves they hope will earn them a discounted ticket to history.

Raqs occasionally references material from epic narrative forms to draw intriguing parallels to the contemporary. *The KD Vyas Correspondence: Vol 1*, 2006, is an installation based on 18 fictional "letters" between Raqs and KD Vyas, the allegedly immortal redactor of the Mahabharata. The reference to the traditional Sanskrit epic and the way in which stories are extrapolated prompts a reconsideration of time and the dissemination of meaning and myth in our media-laden age. The work is presented as 18 'video-enigmas' on screens set into *The Node House* – a structure conceived by the artists in dialogue with the architects Nikolaus Hirsch and Michel Müller – who have also collaborated on the structures to support Raqs' 'show within a show' at the Serpentine Gallery. The structure in *Steps Away from Oblivion* is designed to create a provisional, immersive environment that expresses the state of being 'between' things.

For their curatorial undertaking in *Indian Highway*, Raqs have invited a number of documentarists whose work – over the last two decades – has produced images that intimate and anticipate transformations that are fundamental to the time we inhabit, yet often lie just below the surface of mainstream visibility. Their invitation asked the artists to revisit these images and produce a 'landscape' that provides a unique vantage point from which to think through the present conditions of turbulent anxiety, visceral conflict and unprecedented opportunity. **Serpentine Gallery**

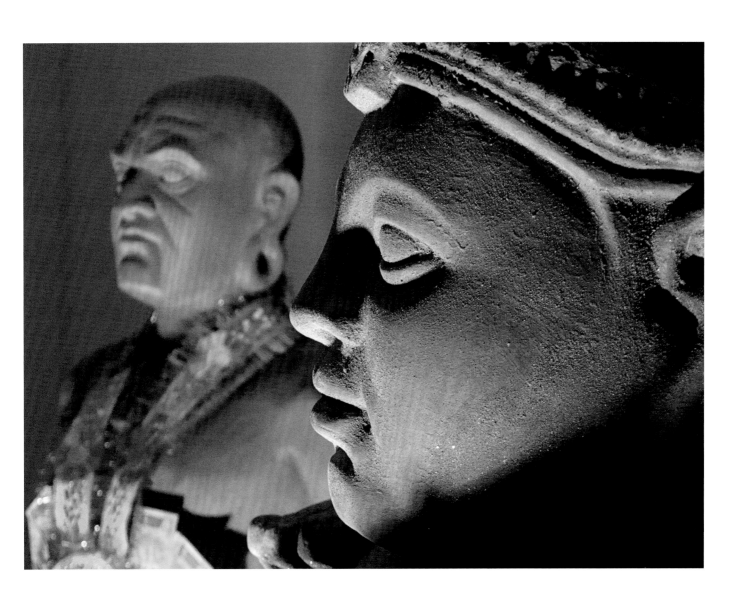

Raqs Media Collective
Sleepwalkers' Caravan (detail), 2008
Video, featuring fibreglass sculptures
Dimensions variable

Raqs Media Collective
Steps Away From Oblivion, 2008
Installation view Indian Highway, Serpentine Gallery, London
(10 December 2008 – 22 February 2009)

Step One
RAQS MEDIA COLLECTIVE
Curated by the Raqs Media Collective for *Indian Highway I*

Featured artists: Debkamal Ganguly, Ruchir Joshi, M R Rajan
Raqs Media Collective, Priya Sen, Surabhi Sharma
Kavita Pai / Hansa Thapliyal, Vipin Vijay

As our contribution to *Indian Highway*, Raqs curates *Steps Away From Oblivion*, a circuit of eight videos, which includes a new work of our own. These videos invoke eight different rhythms of transformation and repose in the landscape of India today.

Much of the current discussion about India's emergence as a global power seems to fall into an easy intoxication with the promise of wealth, influence and power – an intoxicating oblivion where questions are forgotten. The works in this show are assembled as moves made in the course of persistent attempts to steer away from this vacuum.

Thinking back over independent documentary films from the last 15 years – the period of India's increasingly effulgent ascent onto the bandstand of global attention – we were struck by a number of images that seemed to look askance at the parade of contemporary pomp and circumstance, and whose fascination and relevance seemed only to have increased over time. In curating *Steps Away From Oblivion*, we asked the filmmakers who authored these images to revisit this material – to re-edit or remix, or to shoot again – in order to see what new resonances might emerge today.

Our own video presents the wandering figures of a Yaksha and a Yakshi, mythic male and female guardians of treasure and keepers of riddles in different Indic traditions. The Yaksha and the Yakshi provide a crepuscular subjectivity to the entire show, their gaze passing softly over the city we live in, and the landscapes opened out in the other videos.

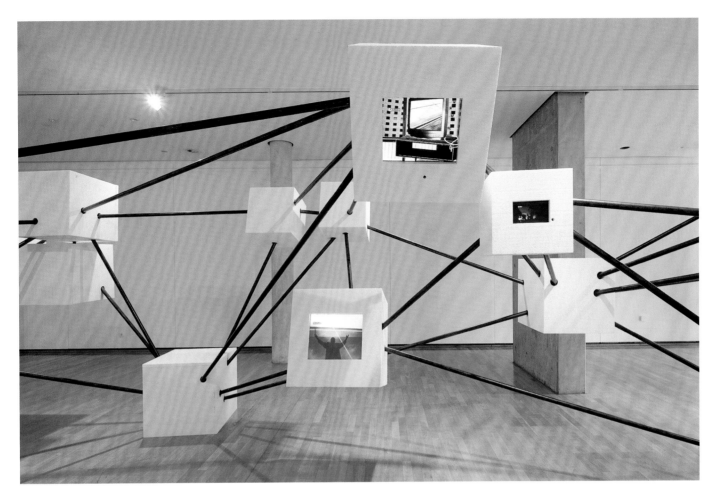

Raqs Media Collective
The KD Vyas Correspondence: Vol 1, 2006
18 screens, 9 soundscapes, metal architecture
and polystyrene

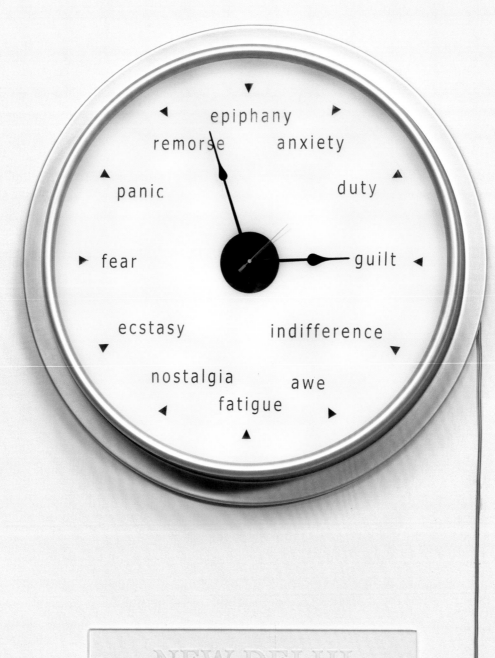

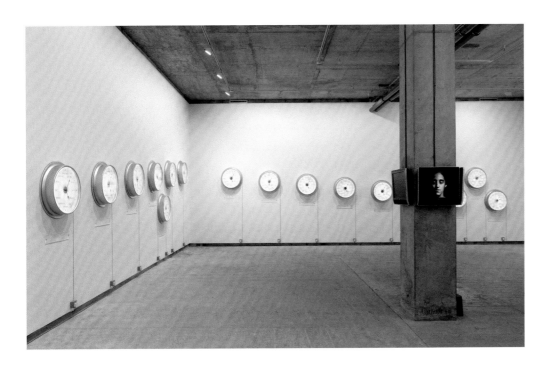

Raqs Media Collective
Escapement, 2009
27 clocks, high gloss aluminium with
LED lights, four flat screen monitors,
video and audio looped
Variable dimensions
Edition of 2

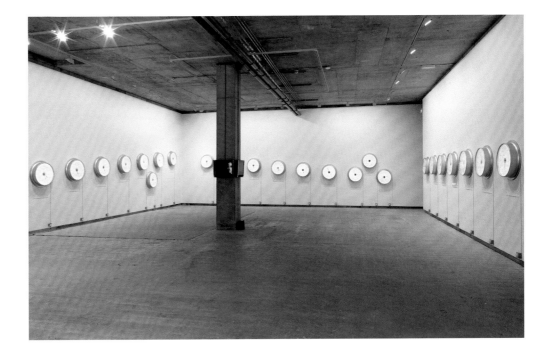

Tejal Shah

Born in 1979, Bhilai, India
Lives and works in Mumbai, India
Studied at RMIT University, Melbourne, Australia; School of the Art
Institute, Chicago, IL, USA; Bard College, New York, NY, USA

Solo Exhibitions

2009 *Pentimento*, Kashi Art Gallery, Kochi, India
2006 *What are You?*, Galerie Mirchandani + Steinruecke,
Mumbai, India
2006 *What are You?*, Thomas Erben Gallery, New York, NY, USA
2003 *The Tomb of Democracy*, Alexander Ochs Gallery, Berlin, Germany
2000 *In-Transit*, Viscom9 Gallery, RMIT University,
Melbourne, Australia

Group Exhibitions

2010 *The 11th Hour*, Tang Contemporary, Beijing, China
2010 *Cityscapes,* Kala Ghoda Café, Mumbai, India
2010 *Punctum I: A Critical Look at the Body in South Asian
Photography*, Lakeeren Art Gallery, Mumbai, India
2010 *Black & White*, Galerie Mirchandani + Steinruecke,
Mumbai, India
2010 *A Cry from the Narrow Between*, Tejal Shah & Han Bing, Gallery
Espace, New Delhi, India
2010 *Re/Gendered*, Platform Artist Group Inc., Degraves Street
Subway, Melbourne, Australia
2010 *Photography from India, Pakistan and Bangladesh*, Whitechapel
Gallery, London, UK; Fotomuseum Winterthur, Winterthur,
Switzerland
2009 *Gender – Genesis – Genetics*, Gallery Espace, New Delhi, India
2009 *Images of Desire: Queer Fantasy*, The Nigah Queer Fest,
New Delhi, India
2009 *Littoral Drift,* University of Technology Sydney Gallery,
Sydney, Australia
2009 *Shifting Shapes/Unstable Signs,* 32 Edgewood Gallery, Yale
School of Art, New Haven, CT, USA
2009 *My Little India*, Marella Gallery, Beijing, China
2009 *India: Auteur Films, Independent Documentaries and Video Art
(1890–2008)*, La Casa Encendida, Madrid, Spain
2008 *Asian Triennial Manchester*, Cornerhouse, Manchester, UK
2008 *Still Moving Image*, Devi Art Foundation, New Delhi, India
2007 *Global Feminisms*, Brooklyn Museum, New York, NY, USA
2006 *Subjected Culture – Interruptions and Resistances on Femaleness*,
Museo Provincial Timoteo Navarro, San Miguel de Tucuman,
Argentina
2006 *Saturday Live*, Tate Modern, London, UK
2006 *Sub-Contingent: The Indian Subcontinent in Contemporary Art*,
Fondazione Sandretto Re Rebaudengo, Turin, Italy

Awards and Residencies

2009 Sanskriti Award in Visual Arts
2008 International Artist Residency, Kashi Art, Kochi, India
2007 Artist in Residence, Point Éphémère, Paris, France
2004 Artist in Residence, KHOJ International Artists' Residency,
New Delhi, India

Tejal Shah
I Love My India, 2003
DVD
10 minutes

TEJAL SHAH

TEJAL SHAH

Tejal Shah works in video, photography, performance and installation, blurring boundaries of subject matter and visual language. Informed by a range of sources from different histories and cultures, including her life experiences and stories from disenfranchised subcultures, Shah is primarily concerned with issues of identity, politics, gender and sexuality.

Shah has been working with the body as a gendered and sexualised entity from the beginning of her career. She focuses on the social and biological constructs of gender. Protagonists are often women, transgendered or transsexual people who have been marginalised by the historical narrative. Shah's work both references and transcends otherness.

What are You?, 2006, explores the malleable language of gender, physically manipulated not only by her chosen subjects, the hirja (transgender) community, but also through the deployment of various forms of media. In the two-channel video installation with screens positioned side by side, super-8mm home-video-style footage is fused with music video, photography and documentary, not only reflecting an interest in the formal aspects of her work but also replicating the complexities of the hirjas' lives and the ways in which they negotiate and live with their identity.

A vortex of emotion and aesthetics – at once celebratory, humorous and fantastical, the work becomes a site of contestation and transformation where the hirja protagonists become the potential artisans of a new vision; the work becomes an emphatic form of activism that proposes a utopian vision of gender.

Produced during the artist's residency in Paris, the video *There is always something absent..*, 2007–8, follows Shah's interest in the systematic control of women's sexuality and mental illness. Collaborating with the Paris-based dancer and choreographer Marion Perrin, the work critically deals with historical and social constructs such as female hysteria.

The narrative focuses on the story of Augustine, a patient at the Salpêtrière Hospital from 1875 to 1880. Through the juxtaposition of images from past and present, an affinity is created that links the viewer to the women trapped by the 'hospitality' of the Salpêtrière. With the clinical recital from Dr. Charcot's notes as a voice-over, Shah questions accepted historical imaginings and social constructs of gender – it is only when the protagonist escapes, disguised as a man, that she expresses feelings.

As well as the exploration of gender and sexuality, Shah also deals with concepts of religion, national identity, self and community in her acclaimed film, *I Love My India*, 2003. Situated within the conditions of genocide against the minority Indian Muslim community in Gujarat in 2002, Shah dispels the purported notion of India as one of the world's largest democracies. Filmed and narrated by the artist in the banal location of a public recreational ground at Nariman Point, Mumbai, combined with the format of an opinion poll, the candid and direct testimonies ranging from loss, apathy, prejudice and ignorance, not only question democracy at a local level but also humanity. Within the post-9/11 context, the video asks the viewer to re-examine their own political stance and poses the question whether it has become more acceptable to commit such acts of violence with the war on terror positioned as a universal cause and the bulwark of democracy. **L.H.**

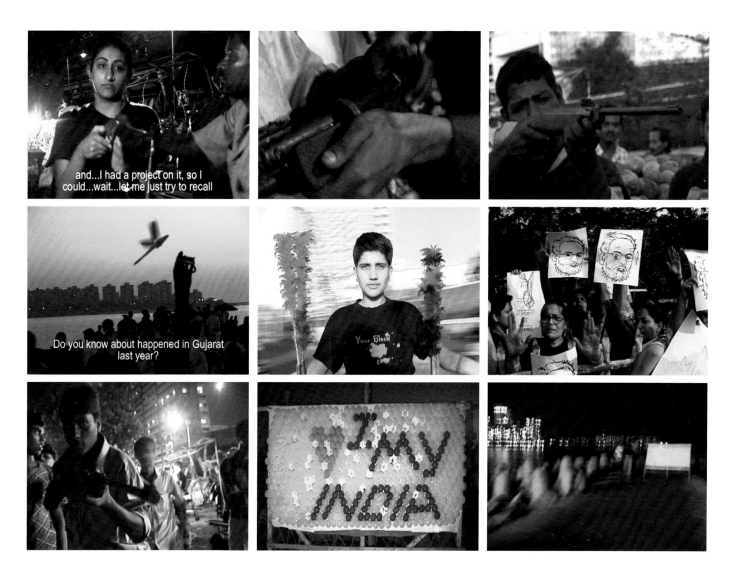

Tejal Shah
I Love My India, 2003
DVD
10 minutes

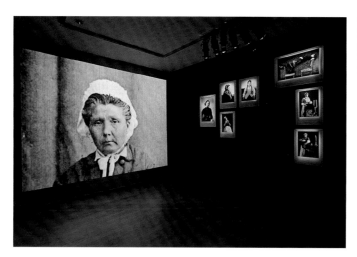

Tejal Shah
Installation view, *There is always
something absent...*, 2007-2008
DVD
12 minutes

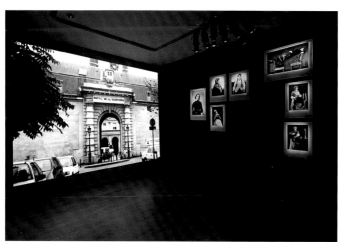

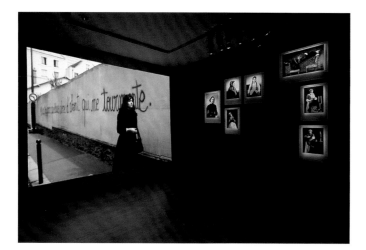

Opposite page:
Tejal Shah
*There is always something
absent...*, 2007–2008
DVD
12 minutes

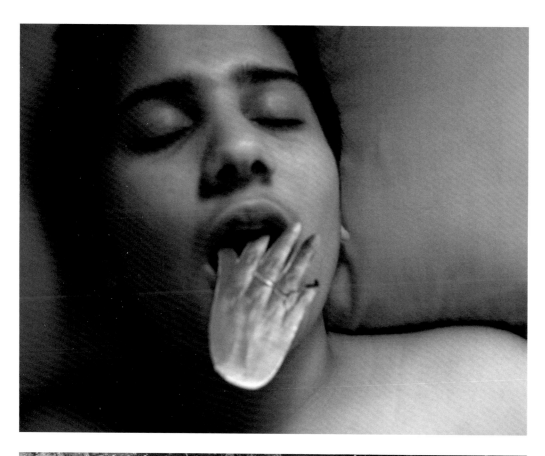

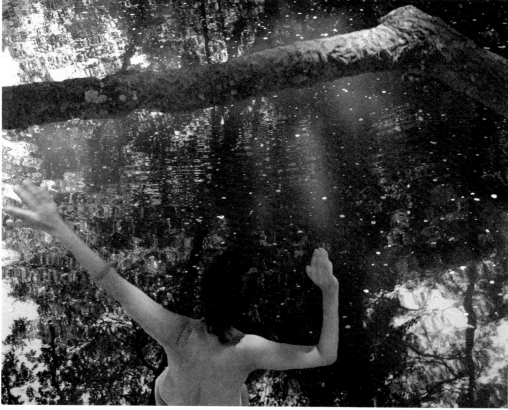

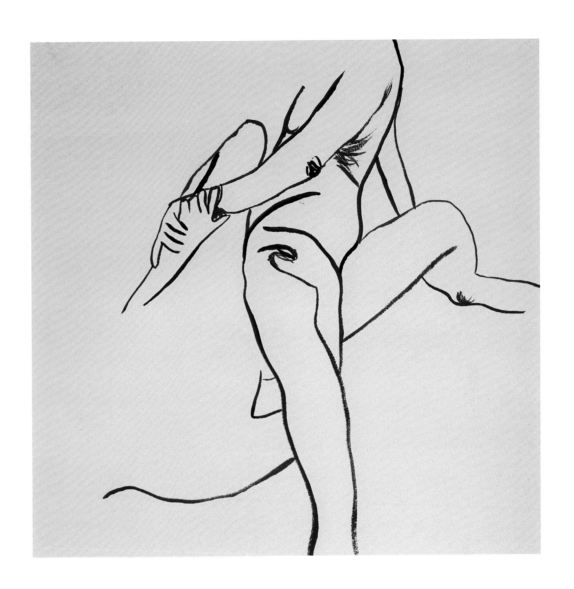

Above and opposite page:
Tejal Shah
There is a spider living between us, 2008
DVD
6 minutes

Valay Shende

Born in 1980, Nagpur, India
Lives and works in Mumbai, India
Studied at Sir J J School of Art, Mumbai, India; and C.M.V. Nagpur,
Maharashtra, India

Solo Exhibitions
2009 Kashya Hildebrand, Zurich, Switzerland
2009 Sakshi Gallery, Mumbai, India
2007 Sakshi Gallery, Mumbai, India

Group Exhibitions
2010 *Third Dimension*, Sakshi Gallery, Mumbai, India
2010 *Roots*, Sakshi Gallery, Mumbai, India
2009 Art Hong Kong 2009, Hong Kong, China
2009 Art Dubai 2009, Madinat Jumeirah, Dubai, United Arab Emirates
2009 Scope Basel 2009, Basel, Switzerland
2009 *ARCOmadrid*, International Contemporary Art Fair,
Madrid, Spain
2009 *Astonishment of Being*, Birla Academy of Art and Culture,
Kolkata, India
2009 *Spectrum*, Emirates Palace, Abu Dhabi, United Arab Emirates
2009 *Finding India*, Seoul, South Korea
2008 ART COLOGNE, Cologne, Germany
2008 *Pulse Miami 2008*, Miami, FL, USA
2008 Art Dubai, Madinat Jumeirah, Dubai, United Arab Emirates
2008 *Gallery Collection*, Sakshi Gallery, Mumbai, India
2008 *New Narratives Contemporary Art from India*, SALINA Art
Center, Salina, KS, USA
2008 *Still Moving Image*, Devi Art Foundation, Gurgaon, India
2007 *Inaugural Show*, Sakshi Gallery, Mumbai, India
2007 *New Narratives Contemporary Art from India*, Chicago, IL, USA
2007 *Best of Discoveries*, ShContemporary 07, Shanghai Exhibition
Centre, Shanghai, China
2007 *Indian Art at ART SINGAPORE 2007*, Suntec Hall, Singapore
2007 *Frontières*, Musée de Saint-Brieuc, Saint Brieuc, France
2007 *Art on the Corniche*, Abu Dhabi Authority for Culture and
Heritage & Abu Dhabi Tourism Authority, Abu Dhabi, United Arab
Emirates

Awards / Residencies
2010 Glenfiddich Artists in Residence Programme 2010, Dufftown, UK
2006 Artist in Residence, Point Ephémère, Paris, France
2004 K. K. Hebbar Foundation Award, Monsoon Show, Jehangir Art
Gallery Mumbai, India
2002 1st Prize, Art Installation, India Sabka Festival, Mumbai, India

Valay Shende
Transit (detail), 2010
Stainless steel and IPAD screens
365.8 x 271.8 x 701 cm

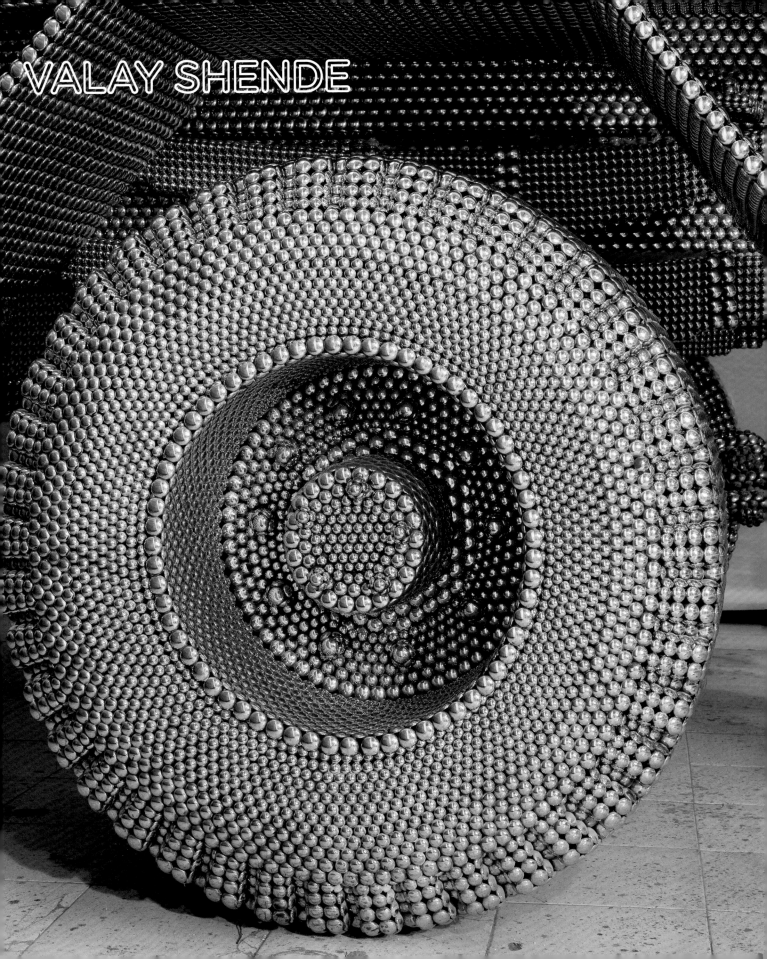

VALAY SHENDE

Valay Shende's works are powerful statements asserting the socio-political realities of modern India. He is a conscious observer of his surroundings and, through his works, insightfully conveys the pathos and ethos of urban Mumbai. Invariably life-size and brilliantly crafted, his sculptural installations demonstrate his technical deftness and his ability to transform a thought into a work of art with outstanding skill and precision.

In his latest work, Valay Shende addresses a painful dichotomy that plays over and over in all the burgeoning cities across the world, from Bangalore and Mumbai to Shanghai and Dubai. Every day thousands of Indians travel from the country's hinterlands to its big cities to try their luck at becoming a part of the nation's growth story. The looming metropolises that testify to the country's booming economy hold the promise of a better tomorrow for these migrants. Yet, for most of those who make this journey, the dream ends on a construction site somewhere in the vast badlands of Mumbai, Bangalore or New Delhi. There, undernourished and underpaid, these migrant labourers live in make-shift shanties while constructing magnificent castles for the country's swelling middle class and the nouveau riche. From Valay's point of view these itinerant workers are the interpreters of urban maladies and, using their haunting metaphor, he articulates the larger history of our construction boom, which consumes millions of workers in its pursuit of ever-taller mega-structures.

The work mixes material and media as it depicts a glittering, life-size, open truck, filled with human-scale workers. Gaunt men, emaciated women with infants on their arms, and children stare out blankly as they make their journey from their impoverished living quarters to their construction sites. Screens are set into the truck's rear-view mirrors playing moving images of grand cities to foreground the stark contrast between the condition of these workers and their creations. The work attempts to mirror the darker side of our ruthless cities under construction in order to pay tribute to the lives and stories of these workers who are forgotten in the magnificence of their creations.

One of the most celebrated of his icons has been that of the Indian buffalo. Shende's buffalos are adorned with his signature gold-plated discs, which create an ironic effect in the light of the unassuming manner of the common-place cattle. When considering these pieces, Shende's aptitude for treating the mundane with novelty and originality comes to the fore. This is especially true in the overtly political aspects of his art, which, though raising familiar concerns about globalisation, exploitation and violence, treat these without becoming banal, visual platitudes.

Shende thus revisits popular symbols of urban India and represents them in new and surprising ways. One reason for his works' immediate appeal is his bold, playful style which is expressed in life-size and blown-up sculptures that are eye-catching and iconic. It is his ability to reconceptualise even the most charged of symbols and objects that makes him such a potent artistic commentator on contemporary India.

Sakshi Gallery

Valay Shende
Transit, 2010
Stainless steel and IPAD screens
365.8 x 271.8 x 701 cm

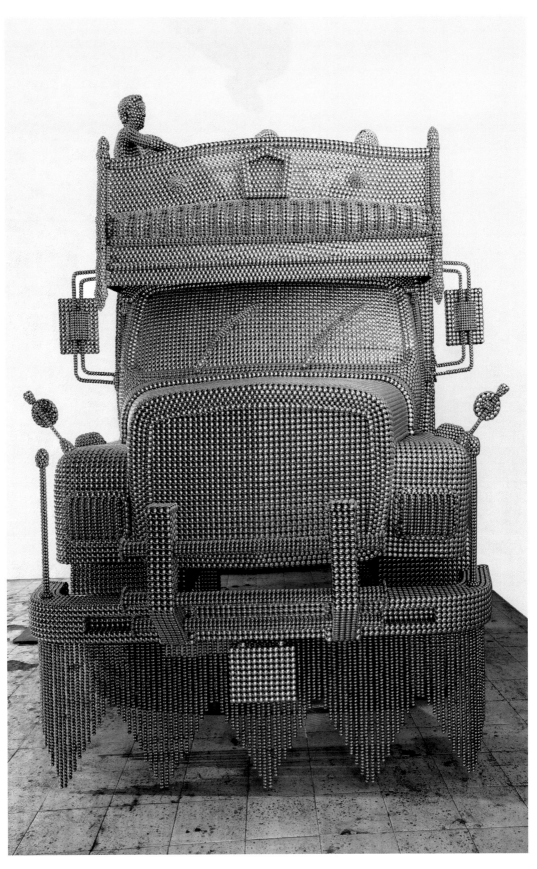

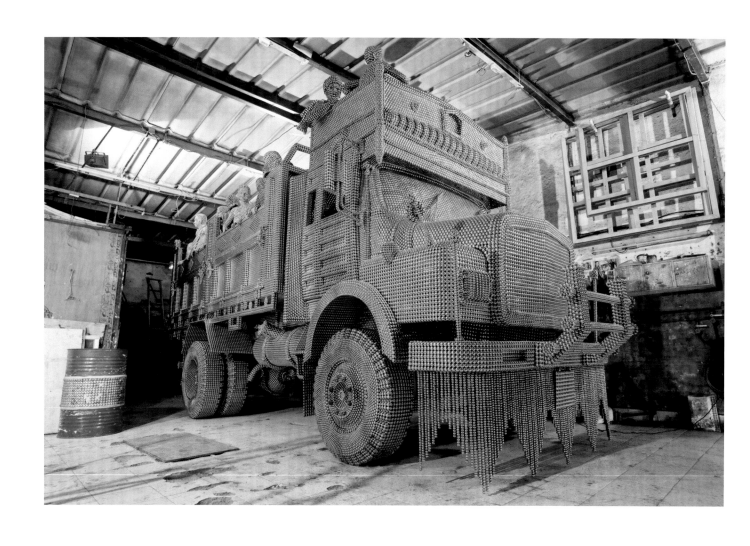

Valay Shende
Transit, 2010
Stainless steel and IPAD screens
365.8 x 271.8 x 701 cm

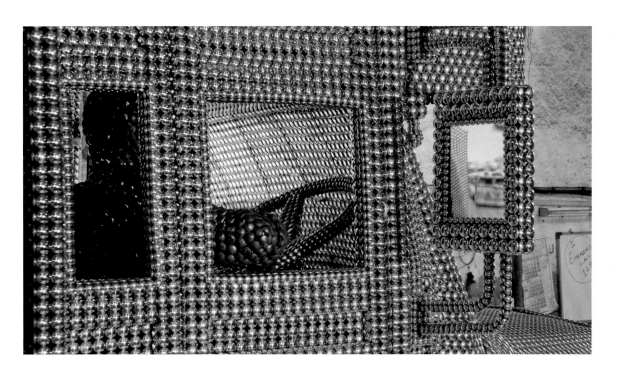

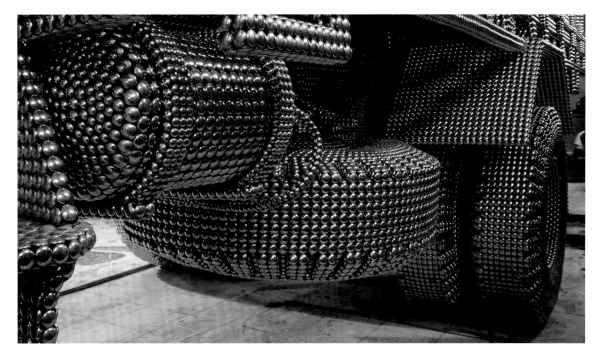

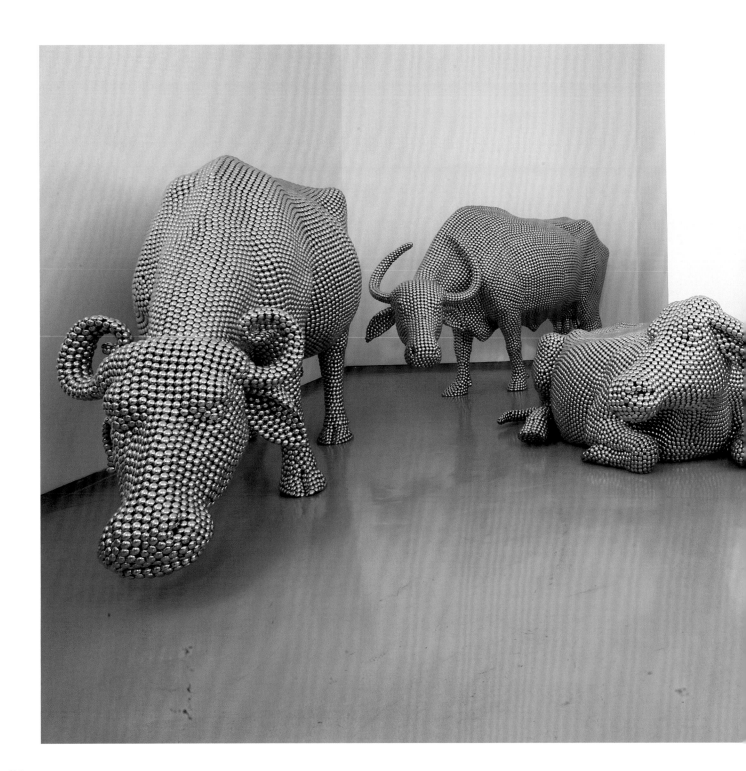

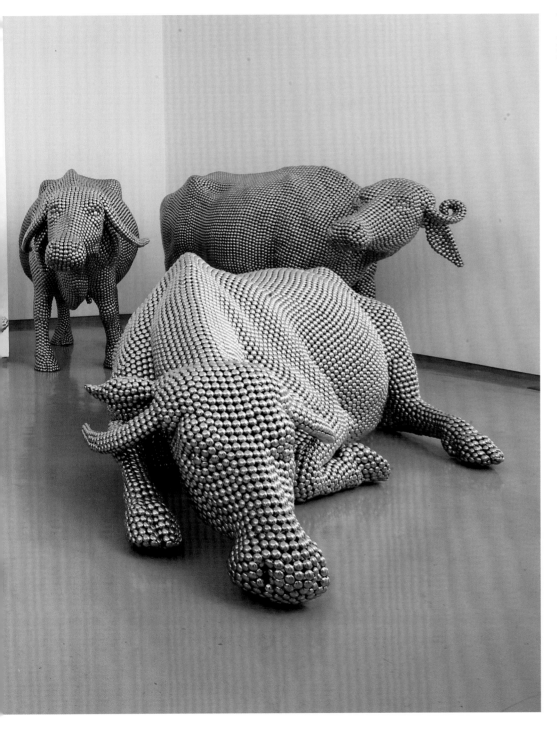

Valay Shende
Untitled, 2008-2009
Brass disks
Life size

Sudarshan Shetty

Born in 1961, Mangalore, India
Lives and works in Mumbai, India
Studied at Sir J J School of Art, Mumbai, India

Solo Exhibitions

2011 GALLERYSKE, Bangalore, India
2010 *This too Shall Pass*, Dr. Bhau Daji Lad Museum, Mumbai, India
2010 *The More I Die the Lighter I Get*, Tilton Gallery,
New York, NY, USA
2010 *From Here to There and Back Again*, Ierimonti Gallery,
Milan, Italy
2009 Galerie Daniel Templon, Paris, France
2009 *Six Drops*, GALLERYSKE, Bangalore, India
2008 *Leaving Home*, Galerie Krinzinger, Vienna, Austria
2008 *Saving Skin*, Tilton Gallery, New York, NY, USA
2006 *Love*, GALLERYSKE, Mumbai, India
2005 *Eight Corners of the World*, GALLERYSKE, Bangalore, India
2005 *Shift*, a collaborative architectural installation with Shantanu
Poredi and Manisha Agarwal, Philips Contemporary, Mumbai, India
2005 *Party is Elsewhere*, Jamaat Art Gallery, Mumbai, India

Group Exhibitions

2010 *Contemplating the Void*, Guggenheim Museum,
New York, NY, USA
2009 *India Contemporary*, Gem Museum for Contemporary Art,
The Hague, Netherlands
2009 *For Life: The Language of Communication*, Tilton Gallery,
New York, NY, USA
2009 *in-TRANSIT-ion*, Vancouver Biennale, Vancouver, Canada
2008 *Dark Materials*, GSK Contemporary, Royal Academy of Art,
London, UK
2008 *The Destruction Party*, Hôtel Royal Monceau, Paris, France
2008 *Ten Light-years*, Kashi Art Gallery, Kochi, India
2008 *Affair*, 1 x 1 Gallery, Dubai, United Arab Emirates
2007 *Unholy Truths*, Initial Access, Frank Cohen Collection,
Wolverhampton, UK
2007 *India 20*, Rabindra Bhavan, Lalit Kala Academy, Delhi, India
2007 *Pink*, Galerie Mirchandani + Steinruecke, Mumbai, India
2006 *With Love*, GALLERYSKE and Tilton Gallery, Miami, FL, USA
2005 *Bombay Boys*, Palette Art Gallery, New Delhi, India
2005 *Configurations*, Anant Art Gallery, New Delhi, India
2005 GALLERYSKE, Bangalore, India
2005 *Endless Terrain*, New Delhi, India

Awards / Fellowships / Residencies

2007 The Mattress Factory, Pittsburgh, CA, USA
2006 Ford Foundation Fellow at the New School for General Studies,
New York, NY, USA
2004 KHOJ International Artists' Association, Mumbai, India

Sudarshan Shetty
Untitled (from *Love*) (detail), 2006
Aluminium skeletons, brass, metal hammer
and electrical device
279.4 x 281.9 x 55.9 cm

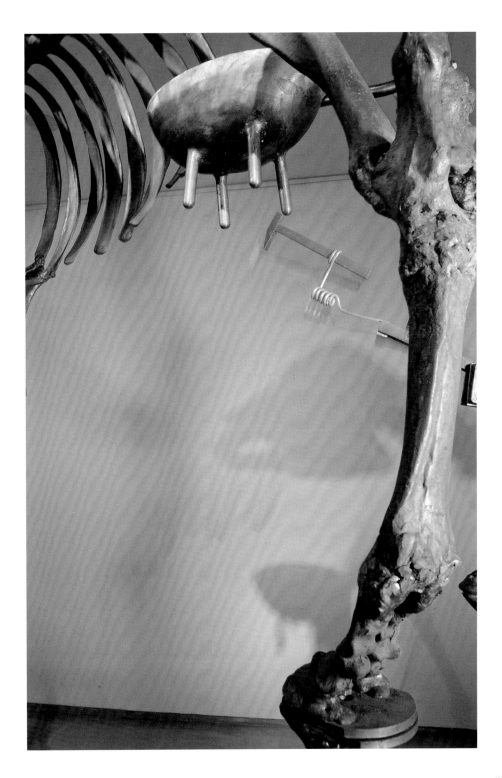

Sudarshan Shetty is best known for his enigmatic and moving sculptural installations. Moving from painting exclusively to installation early on in his career, Shetty explores the fundamental ontological challenges presented by our immersion in a world of objects. His assemblages meticulously raise questions about, and address challenges arising from, materially rendering imaginations of scale and form, and experiences of space and repetition, concrete and material. Working with the mechanical animation of objects and the philosophical implications of the quest for mechanical life, Shetty draws on a terrain that centres on the social life of things and their capacity to offer new kinds of subjective experience.

His installations develop around a rigorous grammar of materials, mechanical exposure and unlikely juxtapositions of things that may belong to culturally distinct spheres. A sofa set that 'bleeds' or a cabinet that encloses waterfalls of 'milk' connect the aspirational spheres of an Indian middle-class domesticity with biological, mythological and cosmological matters of blood, milk and cultural meaning. But Shetty's object language eschews narrative as well as established symbolism. While inviting the viewer into an uncanny and seemingly occult universe of objects, this language also puzzles by embedding contradictions in the forms themselves and playfully parodying the possibility of a 'natural' order of things and a 'normal' order of humans as makers of meaning. In many of his earlier works, the smooth, continuous and repetitive mechanical animation of objects appears together with the physical exposure of the analogue, DIY mechanics and the processes of making.

These works engage what Shetty refers to as 'memory at large', playing on the viewer's encounters with the quotidian worlds of the city, home and street as they incorporate everyday objects, machine parts and readymades, easily available in the streets around his home and studio in Mumbai. The installations made from these materials embed traces of urban processing as the city itself serves as the artist's studio, while the gallery is infused with the performative qualities of the street. Shetty's forceful intervention in the canonical artistic sites in which he has extensively exhibited rejects ironic, well-meaning and didactic commentary on the supposed alterity or identity of his origins from the hegemonic frame of colonialism, modernisation and globalisation,

even though the traces of such processes are clearly visible. Instead, his practice takes these origins as points of departure for a rigorous investigation of concepts of self and nature, things and beings, effect and affect and absence and presence.

Drawing on a world of shared meaning, the object-assemblage materially incorporates and disperses those shared meanings into the viewer's experience. Shetty is concerned with what Jacques Rancière calls the 'terrain of the sensible' as a surface upon which unpredictable affect is produced. This unpredictable, affective viewing experience displaces the fundamental and desired predictability of cultural meaning. If the ethnographic account aims to persuade the viewer of the self-evidence of location, Shetty's understanding of location is tied to a residual, corporeal zone of memory. Yet the kind of interaction his objects demand from the spectator ensure that location is anything but self-evident. But in order to enter this residual and physical zone of memory, the viewer must contend with the absence of narrative itself, with the silence of memory, rather than counting on its illustrative abundance or its powers of fabrication.

Circulations without bodies and transformations from the 'natural' to the 'artificial' invoke and activate the spectatorial imagination. These circulations and transformations are closely connected to Shetty's interest in absence as an affect produced through repeated interactions with mechanical beings and processes. Mimicking the circulation of things in the world, Shetty's objects – gigantic or miniature, souvenir-like multiple editions or singular, site-specific installations – seem to seek to transcend and annihilate the boundary between inside and outside and to substitute icon and thing for organic connections, put in the place of inner experience, affect, sentiment and feeling. Within his visual-aesthetic system, these images, icons and things function as hinges between the natural and non-natural, the animate and the differently animate and the cultural and the commercial. Understood theoretically as artefacts of the continuous and mundane articulation of the body, technology and subjectivity in the contemporary world, these dualities are explored in Shetty's work through a disciplined and material meditation on the metaphysical problem of absence playing on turning things and their attendant processes inside out.

Vyjayanthi Rao, New York, August 2009

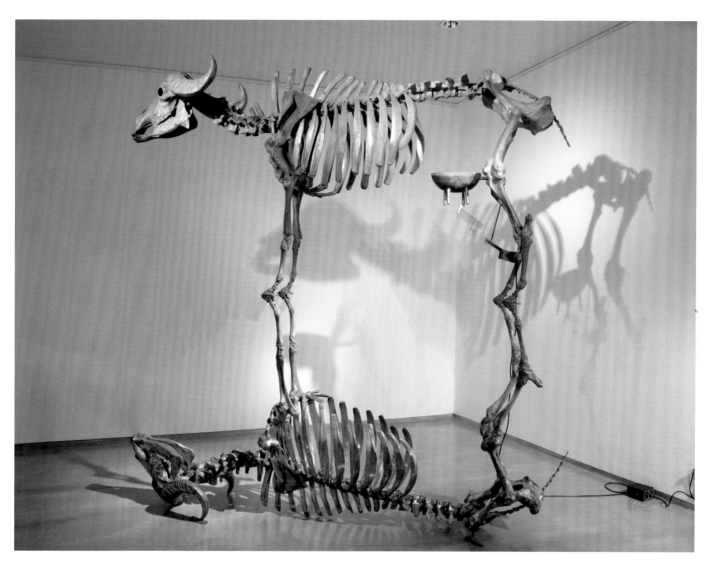

Sudarshan Shetty
Untitled (from *Love*), 2006
Aluminium skeletons, brass, metal hammer and
electrical device
279.4 x 281.9 x 55.9 cm

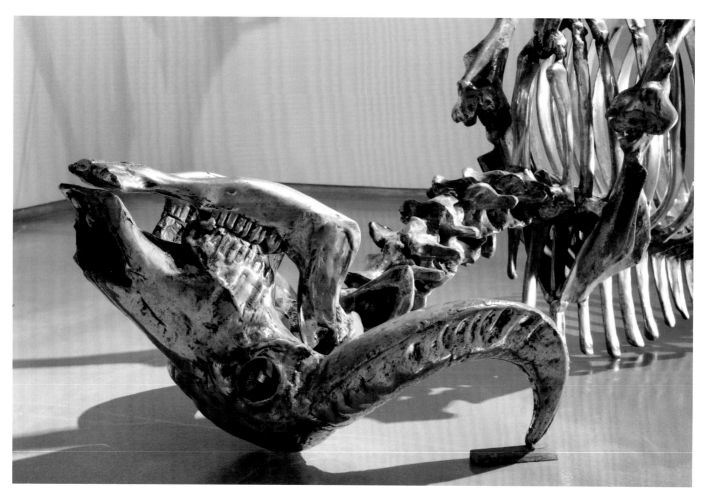

Sudarshan Shetty
Untitled (from *Love*) (detail), 2006
Aluminium skeletons, brass, metal hammer and
electrical device
279.4 x 281.9 x 55.9 cm

Sudarshan Shetty
Untitled (from *'this too shall pass'*), 2010
Gold leaf on fibreglass, mild steel, coin box and
etched brass
Dimensions variable

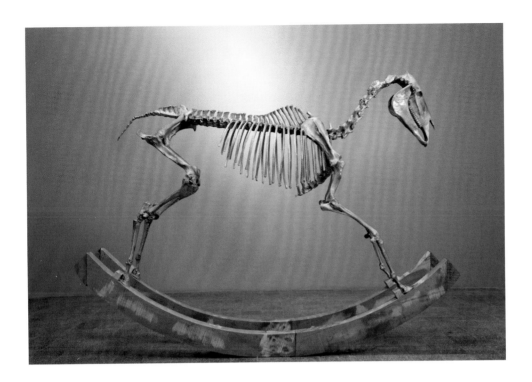

Sudarshan Shetty
Untitled (from *'this too shall pass'*), 2010
Aluminium and wood
245 x 189 x 45 cm

Opposite page:
Sudarshan Shetty
Untitled (from *'this too shall pass'*), 2010
Carved wood, electromagnetic mechanism,
steel sword and mild steel
354 x 278 x 106 cm

Dayanita Singh

Born in 1961, New Delhi, India
Lives and works in New Delhi, India
Studied at the National Institute of Design, Ahmadabad, India;
International Centre of Photography, New York, NY, USA

Solo Exhibitions

2010 Museum Voor Fotografie, Amsterdam, Netherlands
2010 Mapfre Foundation, Madrid, Spain
2010 *Dream Villa,* Nature Morte, New Delhi, India
2009 *Blue Book*, Nature Morte, New Delhi; Galerie Mirchandani +
Steinruecke, Mumbai, India
2008 *Let You Go*, Nature Morte, Berlin, Germany
2008 *Dream Villa,* Frith Street Gallery, London, UK
2008 *Sent a Letter*, National Gallery of Modern Art, Mumbai, India
2008 *Ladies of Calcutta*, Bose Pacia Gallery, Kolkata, India
2007 *Go Away Closer*, Nature Morte, New Delhi, India
2005 *Chairs*, Isabella Stewart Gardner Museum, Boston, MA, USA
2003 *Privacy*, Hamburger Bahnhof, Berlin, Germany
2000 *I am as I am*, Ikon Gallery, Birmingham, UK
1997 *Images from the 90s*, Scalo Galerie, Zurich, Switzerland

Group Exhibitions

2010 *Where Three Dreams Cross: 150 Years of Photography from
India, Pakistan and Bangladesh,* Whitechapel Gallery, London, UK;
Fotomuseum Winterthur, Winterthur, Switzerland
2009 *Au féminin,* Centre Calouste Gulbenkian, Paris, France
2009 *Vases,* Arden and Anstruther, Petworth, West Sussex, UK
2008 *The Home and the World*, Hermès Store, New York, NY, USA;
Paris, France; Berlin, Germany
2008 *The photograph, painted posed and of the moment,* National
Gallery of Modern Art, Mumbai, India
2008 *A Year in Exhibitions,* 7th Gwangju Biennale,
Gwangju, South Korea
2008 *Manifesta 7,* The European Biennial of Contemporary Art,
Bolzano, Italy
2006 *The Eighth Square*, Ludwig Museum, Cologne, Germany
2000 *Century City*, Tate Modern, London, UK
1999 *Another Girl, Another Planet*, Greenberg Gallery,
New York, NY, USA
1999 *So Many Worlds – Photographs from DU Magazine*, Holderbank,
Aargau, Switzerland

Awards / Residencies

2008 Prince Claus Laureate
2008 Robert Gardner Fellowship in Photography, Harvard University
Art Museums, MA, USA
2002 Artist in Residence, Isabella Stewart Gardner Museum,
Boston, MA, USA

Dayanita Singh
Dream Villa 11–2007, 2008
C-print
45.7 × 45.7 cm

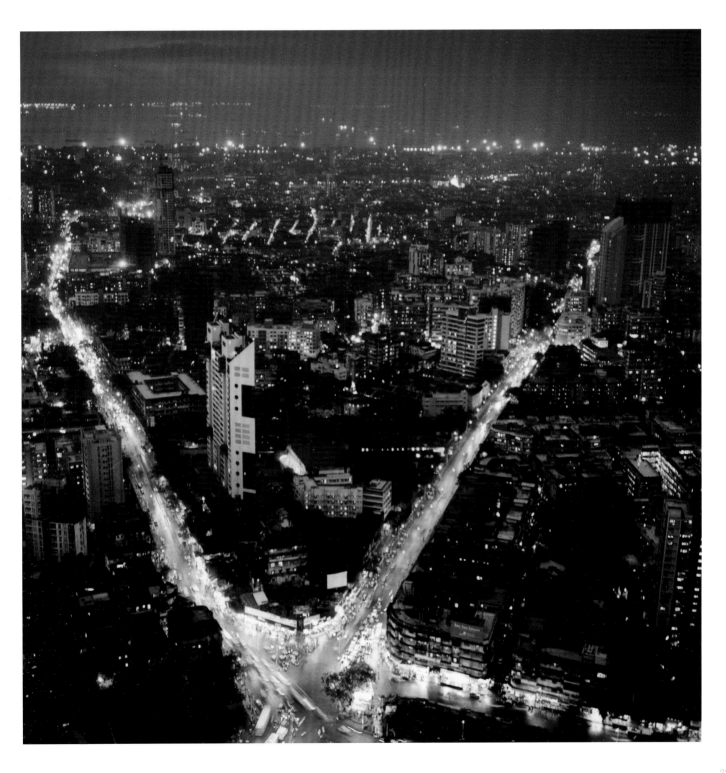

DAYANITA SINGH

Dayanita Singh is a photographer known for portraits and interior views of Indian domestic life, especially urban-middle and upper-class families documented in the Steidl publication, *Privacy*, 2003. Singh reveals the nature of relationships between family members and communities. Her abiding interest in poignant narratives is made accessible to her audience through the medium of photography. She uses alternative means to achieve accessibility that supersedes the gallery system. For instance, she has produced posters and calendars that are distributed openly with the expectation that the viewer will take the work home and install it within her own domestic space. This is a response to and comments on the commodification of art and culture prevalent today as well as a means of shifting the interior views of her broad audience.

Her first photographic series documented the tabla maestro Zakir Hussain. This developed for Singh into a symbiotic relationship with her subject, as well as the medium of photography. She gained insight and a sense of Hussain's way of life while capturing him, which in turn provided insights for him into his photographic presence revealing, over their extended exchange, depths of his character that were not previously apparent. This relationship initiated a journey of self-discovery both for Singh and her subjects that has resulted in numerous intimate and elegant images.

Singh's earliest photographic series are in black and white. With an absence of colour articulating departure, memory and loss and are depicted most tenderly in *Go Away Closer*, 2007. With her accordion book *Chairs*, 2001, Singh gave ten books each to friends she felt were vital points of contact and asked them to disseminate the books to other friends, resulting in a sort of aural transfer of her visual production. The concertina format permits expandability, making her books constant works-in-progress, and allows for a teleological sequencing. Singh has transformed seven of her journeys into a series of accordion books known as *Sent a Letter*, 2008, which are like portable museums. Each is addressed to a fellow traveller. *Sent a Letter* is encased in a handmade cloth box that reads 'SENT A LETTER to my friend on the way he dropped it. Someone came and picked it up and put it in his pocket', embodying the circular and random nature of disseminating Singh's ideas while continuing her engagement with intimate subjects through making the books small-scale and cherished objects.

Ladies of Saligao, 2001, is a series in which she photographed women from the village in Goa where she lives. The prints were hung at the local community centre and the women were encouraged to carry their prints home from the exhibition to install in their own homes.

Another significant series is Singh's documentation over a period of 13 years of Mona Ahmed, her closest friend. Singh maps Mona's intimate life, her adopted daughter, banishment from the community of eunuchs for alcoholism and her eventual illegal activities in a cemetery. Singh has documented several subjects, tracking complex and difficult lives. These images of people working, celebrating or resting show life without embellishment.

Singh captures a sense of poignancy not only with human beings but with buildings as well. Her more recent photographs, the *Blue Book* series, has introduced the element of colour into her work. Although Singh has preferred small-scale and finely printed photography, she has recently been experimenting with other formats.
S.A.

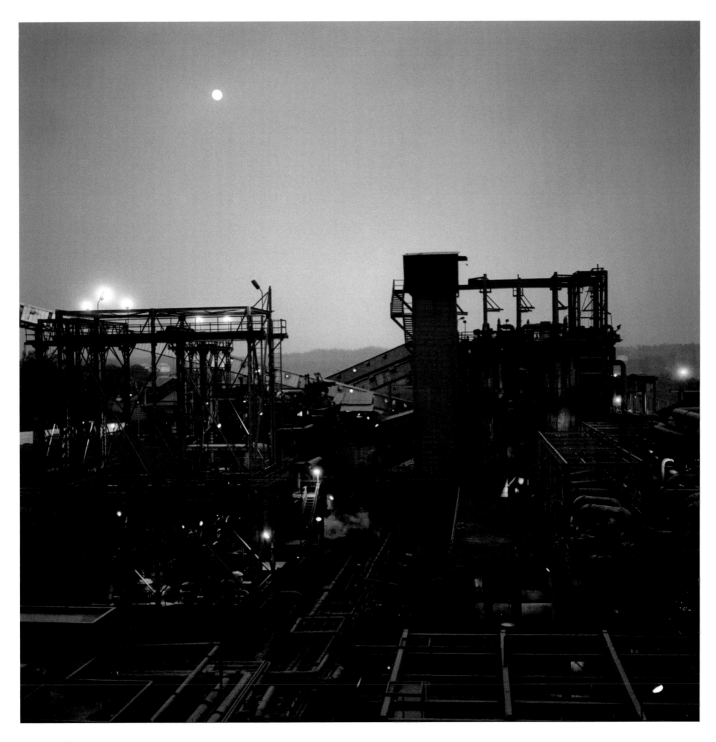

Dayanita Singh
Untitled from the series *Blue Book*, 2008
C-print
45.7 × 45.7 cm

Dayanita Singh
Dream Villa (Blue Forest), 2010
C-print, edition of 1
102 x 102 cm

Dayanita Singh
Dream Villa 20, 2007 2008
C-print, edition of 1
102 x 102 cm

Dayanita Singh
Bombay book from *Sent a Letter*, 2008
Box-set of 7 books
Each book 13.7 x 9 x 0.7 cm

Dayanita Singh
Sent a Letter, 2008
Box-set of 7 books
Each book 13.7 x 9 x 0.7 cm

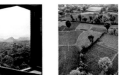
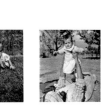

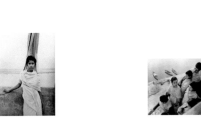
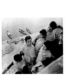
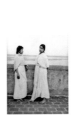

Sumakshi Singh

Born in 1980, New Delhi, India
Lives and works in New Delhi, India
Studied at M S University of Baroda, Gujarat, India; School of the Art
Institute of Chicago, IL, USA; and Skowhegan School of Painting and
Sculpture, Skowhegan, ME, USA

Solo Exhibitions
2008 *Peel till They Bloom,* Kashya Hildebrand, Zurich, Switzerland
2006 *Lumps, Bumps and Things That Are Art,* Van Harrison Gallery,
New York, NY, USA
2005 *elsewHERE,* Halsey Institute of Contemporary Art,
Charleston, SC, USA
2004 *Absence and Extension,* Sub-City Projects, Chicago, IL, USA
2004 *Flux,* UBS 12 x 12, Museum of Contemporary Art,
Chicago, IL, USA
2004 *Flaw, Prizenner Show,* Creative Arts Workshop,
New Haven, CT, USA
2003 *Void,* Gallery 400, University of Illinois at Chicago (UIC),
Chicago, IL, USA

Group Exhibitions
2010 CAMAC Centre d'Art – Marnay Art Center, Marnay-sur-Seine,
France
2009 *Memory Threads,* Fondazione Pistoletto, Biella, Italy
2009 *Indian Art Summit,* New Delhi, India
2008 *Engendered,* Lincoln Center, New York, NY, India
2008 *Outer Circle,* Arts I, New Delhi, India
2008 Nature and the City, Indian Habitat Center, New Delhi, India
2008 ART COLOGNE, Cologne, Germany
2008 Art Shanghai, Shanghai, China
2007 *Double Consciousness,* Mattress Factory Museum of
Contemporary Art, Pittsburgh, CA, USA
2007 *Interiority,* Hyde Park Art Center, Chicago, IL, USA
2007 Susan Geschidle Gallery, Chicago, IL, USA
2007 *Us and Our Katamari,* Lisa Boyle Gallery, Chicago, IL, USA
2006 *Interlude,* Art in Odd Places, New York, NY, USA
2005 *Drawn Out,* Gallery 400, Chicago, IL, USA
2005 *Remembering Memories,* Zola Lieberman Gallery,
Chicago, IL, USA
2005 Art Chicago, Van Harrison Gallery, Chicago, IL, USA
2004–2005 *Think Small,* Illinois State Museum, Chicago, Springfield,
Lockport, IL, USA

Awards / Residencies
2011 MacDowell's Colony Fellow, Peterborough, NH, USA
2010 CAMAC Centre d'Art – Marnay Art Center,
Marnay-sur-Seine, France
2009 UNIDEE, Cittadellarte – Fondazione Pistoletto, Italy
2009 Awarded full fellowship by Ermenegildo Zegna Grant,
Trivero, Italy
2009 Ecomuseo Ronce Biellese, Award and production of ceramic design
2008 The Camargo Foundation, Residency, Cassis, France
2008 Sculpture Space Fellow, Residency, Utica, NY, USA

Sumakshi Singh
Sight Specific, 2007
Installation presented at the Hyde Park Art Center, Chicago
Installation in situ and acrylic on aluminium foil
on walls and floor
1,036.3 x 137.2 cm (perceived to be 152.4 cm tall
from appropriate vantage point)

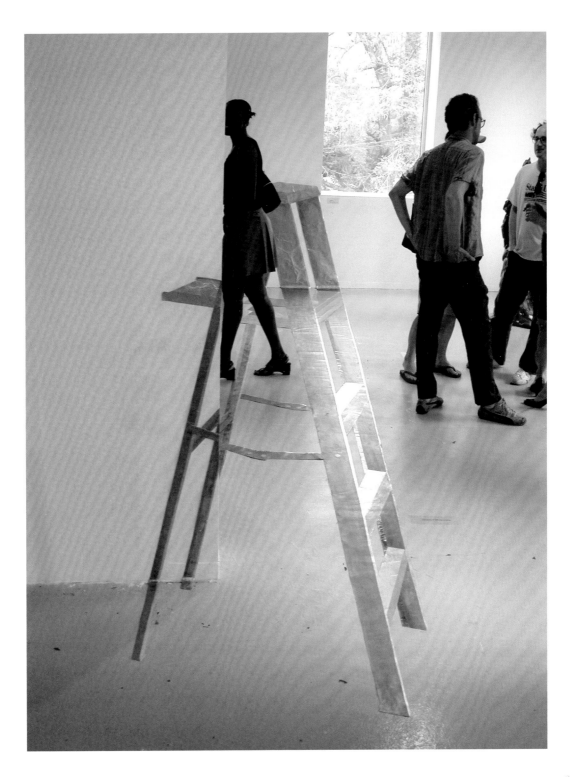

SUMAKSHI SINGH

Sumakshi Singh's work traverses the lines between metaphor, reality and illusion, ranging from plays on space-time theories to cultural, historical and physical critiques of place, manifested in various media.

Moving from India to artificially constructed 'natural' environments of the USA, Singh's work began by responding to the uninvited weed in the sidewalk as a welcome perversion of manicured space. Appropriating microcosmic activity, her installations call for a slowing down and re-reading of visual information, de-privileging the culture of immediate gratification.

In *Peel till They Bloom*, 2008, viewers approach the peeling, splitting space to discover meticulous layered paper constructions along with subtly placed, miniature interventions like *Urban Fungus* and *Plateau* made of painted polymer clay, moss, fungi, metal, plaster and other materials. At the Musée d'art contemporain de Lyon, viewers enter a seemingly empty or perhaps recently de-installed gallery space. The sterile architectural surfaces transform into proliferating, saturated membranes via the accompaniment of deliberately amplified/created flaws and miniscule scars. These activate what are presumably transitional voids between 'pieces', which are allowed to migrate into each others' territories, resisting efficiency in viewing, decoding and digesting, and making it impossible to decide where the art begins or ends. Tension is created between the cultural idea of the gallery space (as a neutral ground) and its physical/natural perception.

The viewing demands a de-bracketing of visual attention, like infants that zoom in too close or zoom out too far to frame what they 'are supposed' to see. This un-framing/de-conditioning of vision, enables viewers to carry this way of looking out of the gallery and into (a re-evaluation of) their familiar visual landscape, blurring the boundaries between the white cube space, set aside for witnessing intellectual/cultural activity, and the mundane space.

Singh's work also investigates this breaking of the visual frame within the recognisable object. Returning yearly to her grandfather's home, Singh familiarised herself with his carefully collected objects, seemingly frozen in time. After his death, with the referent gone, these objects demanded a renegotiation of her relationship to them. In *Mapping the Memory Mandala*, 2008, Singh maps the illusion of her grandfather's living room in dry pastels onto pre-existing objects and the architecture of her studio. Viewed from the entrance this perceptual space obliterates the 'real'.

As viewers enter the installation, her grandfather's furniture breaks into strange shapes, stubbornly fighting the architecture and retaining angles of a now-inaccurate perspective. A space-time hiccup is generated: viewers are free to move but their earlier perception is not. Unaltered portions of the actual objects and architecture of the room reveal themselves. A contradictory co-existence of the real and the virtual begins.

While this direct phenomenological experience of their frozen vision becomes abstract and hard to negotiate, participants simultaneously watch themselves in a live video projection. There they move through the perfectly aligned illusionist space. The mediated experience of the video, becomes a more graspable solution until one sees oneself walking through a seemingly concrete object, disconcertingly challenging the boundaries of form and matter. Participants are confronted with awkwardly trying to locate themselves in the multiple spaces set up – the fractured 'here', the mediated (video) 'there' and finally the space of memory (a prior understanding of the room). Bodies slow down, movements gets amplified as participants concentrate on re-familiarising themselves with their own bodies; trying to understand what the implications of a movement in this space will have on the others.

Singh's work uses disconcerting phenomenological encounters to ask questions about permanence and transience, object and image, fact and illusion, mapping and displacement, perception and knowledge, here and there, while critiquing notions of 'fixed' universes and exposing the fragile set of givens upon which meaning is constructed. **Sumakshi Singh**

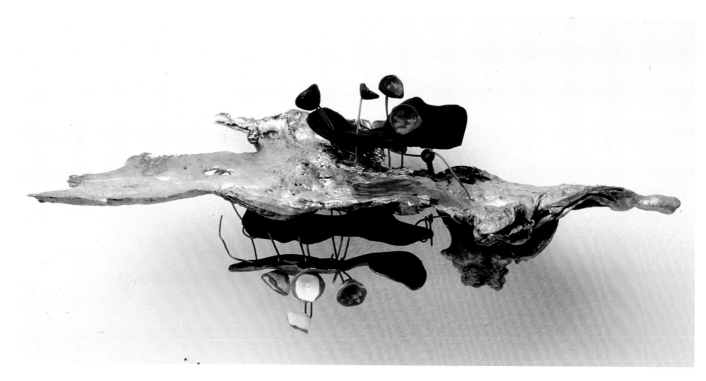

Sumakshi Singh
Reflections, 2004
Aluminium and acrylic on polymer clay
17.8 x 12.7 cm

Previous page:
Sumakshi Singh
Void, 2003
Acrylic on polymer clay, wood, mirror and moss inserted into
found and created flaws in the floor
Between 2.5 cm² and 10.1 cm²

Sumakshi Singh
Plateau, 2004
Acrylic on polymer clay, plaster, wire and nails
5.1 x 5.1 x 3.8 cm

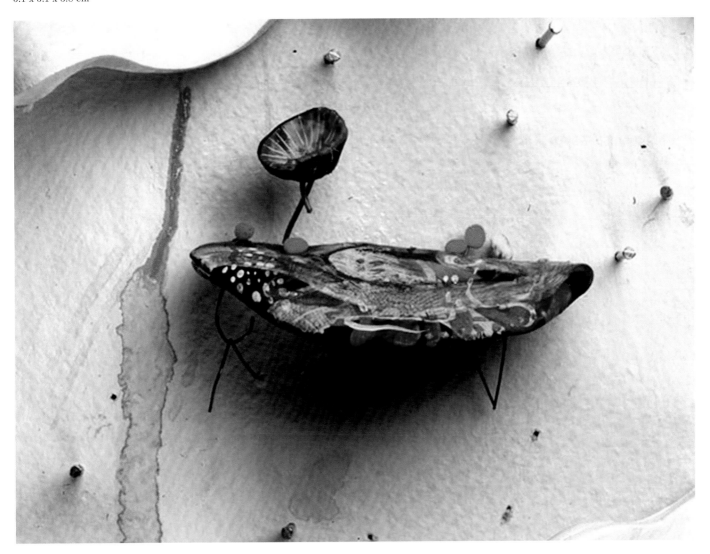

Sumakshi Singh
Ear and Shadow, 2006
Exhibition view, *Lumps, Bumps and Things That Are Art,*
Gallery Van Harrison, New York
Acrylic on polymer clay and resin
5.1 x 5.1 x 3.8 cm

Sumakshi Singh
Urban Fungus, 2004
Acrylic on polymer clay, petroleum jelly, nails and scratches
5.1 x 3.8 cm

Kiran Subbaiah

Born in 1971, Sidapur, India
Lives and works in Bangalore, India
Studied at the Royal College of Art, London, UK; M.S. University of
Baroda, Gujarat, India; Kala Bhavan, Santiniketan, India

Solo Exhibitions
2009 *Sleepwalker Daydream*, C&L, Mumbai, India
2002 *Shhhhh!,* Karnataka Chitrakala Parishath, Bangalore, India
2002 *All My Belongings*, Rijksakademie, Amsterdam, Netherlands
1997 *Revised Lessons in Taking and Giving*, Images Gallery,
Bangalore, India
1996 *Confronting Gift-wrapped Curses*, Fine Arts Faculty, Baroda, India

Group Exhibitions
2010 *Video Art India*, Fundació la Caixa, Barcelona, Spain
2010 *I Think Therefore Graffiti*, The Guild, Mumbai, India
2010 *Last Words*, 4A Center for Contemporary Art, Sydney, Australia
2009 *Analytic Engine,* Bose Pacia, Kolkata, India
2009 *On Certainty*, Bose Pacia, New York, NY, USA
2009 *India: Auteur Films, Independent Documentaries and Video Art
(1890–2008),* La Casa Encendida, Madrid, Spain
2009 *The View from Elsewhere*, Sherman Art Foundation, Sydney,
Australia; Gallery of Modern Art, Brisbane, Australia
2008 *First Left Second Right*, Thomas Erben Gallery,
New York, NY, USA
2008 *Still Moving,* Devi Art Foundation, New Delhi, India
2008 *East West Encounter*, Gallery Kashi, Cochin, India
2008 *By All Means*, C&L, Mumbai, India
2008 *Wonder*, Singapore Biennale, Singapore
2008 *Chalo! India: A New Era of Indian Art*, Mori Art Museum,
Tokyo, Japan
2006 *Subcontigent*, Fondazione Sandretto Re Rebaudengo, Turin, Italy
2005 *Are We Like This Only?*, Vadhera Gallery, New Delhi, India
2004 9th Biennial Festival of Film, Video and New Media, LA
Freewaves, Los Angeles, CA, USA
2002 *Open Ateliers*, Rijksakademie, Amsterdam, Netherlands
2002 *Private Mythologies*, Apeejay Media Gallery, New Delhi, India
2001 *On the Edge of Volume*, Alliance française, Bangalore, India
1998 *The Show*, Royal College of Art, London, UK
1996 *Garden of Delight*, Vlaardingen Boomgard, Netherlands

Residencies
2008 KHOJ Sonic Art Residency, New Delhi, India
2005-2006 Artist in Residence, Stiftung Künstlerdorf,
Schoeppingen, Germany
2005 Artist in Residence, KHOJ Workshop, Mumbai, India
2002-2003 Artist in Residence, Rijksakademie van Beeldende Kunsten,
Amsterdam, Netherlands
1999-2001 Artist in Residence, Shankara Centre for the Arts,
Bangalore, India
1997 Inlaks Scholarship to Study at Royal College of Art, London, UK
1995 UNESCO – Ashberg Bursaries for Artists, European Ceramic Work
Centre, Netherlands

Kiran Subbaiah
Use_Me.EXE (detail), 2003
Pseudo-virus for Windows OS
48 KB

KIRAN SUBBAIAH

KIRAN SUBBAIAH

Formally trained as a sculptor, Kiran Subbaiah works in a range of media, including assemblage, video and internet art. A common approach of his practice is subverting the form and function of objects, through which he questions the relationship between use and value, highlighting contradictions inherent in everyday life. Irony, deadpan humour and a crude aesthetic provide Subbaiah with simple binaries – functional/defunct, action/reaction and cause/effect to tease out his ideas and observations.

Often found-object sculptures are manipulated by Subbaiah forming paradoxes. *Thirst*, 1998, presents a glass tumbler that is anything but refreshing, in that it contains pebbles and is precariously balanced between mouth-drying materials: a mound of salt and a tower of plaster, cloth, tissue paper, expanded polystyrene and cotton wool. *Love All*, 1999, is a football with a tessellated surface studded by unlit matches positioned for kick-off on a circle of matchbox lighting strips, threatening to ignite the ball should a match commence.

In public spaces, Subbaiah uses the language and format of street-signs and official notices. With phrases such as 'Prohibitions Strictly Forbidden' and 'Ignore This Corner' or symbols such as a bicycle with feet instead of wheels, he challenges the authority of such common directions to the public who are expected to adhere to the rules.

The artist becomes actor in his videos, performed in an earnest, deadpan seriousness. *Flight Rehearsals*, 2003, extends Subbaiah's interest in subversion beyond objects, as he questions our understanding of gravity and scale. Subbaiah claims to have discovered the secret of human flight. He demonstrates this by jumping up and then, before he falls back down, quickly jumping again

thereby seemingly defying the laws of gravity. The action moves to a bedroom, where a ringing alarm clock in the 'foreground' is slowly revealed by the camera to be oversized and distant, creating an unsettling distortion of the sense of space as it was first perceived by the viewer.

Under the heading of net.art on his website (www.reocities.com/antikiran), Subbaiah presents a number of internet and computer-based projects. These include a series of downloadable mock-viruses that simulate an attack on the computer, complete with shrieks of pain from the machine. Computer viruses interest the artist particularly as something that exists between function and dysfunction – their purpose is to drain the use-value from a computer.

Subbaiah's website also presents as yet unrealised ideas and propositions, which are themselves social commentaries. These include a toilet roll dispenser that prints sheets with up-to-the-minute news reports, reflecting on the contemporary appetite for uninterrupted access to information and the speed with which news is disposed. He also proposes an amplifier and loud-speaker for bicycle horns, to help cyclists combat the brutal use of vehicular horns in Indian cities. Commenting not only on the noise of urban life, Subbaiah notes the tendency to fight fire with fire, rather than with more peaceful solutions.

Subbaiah considers his work as a form of emancipation for objects, whereby they no longer need to conform to the function for which they were created, or even to have any function at all. He states: 'I see the whole advantage of making art in the fact that it need not serve any purpose.' **R.M.**

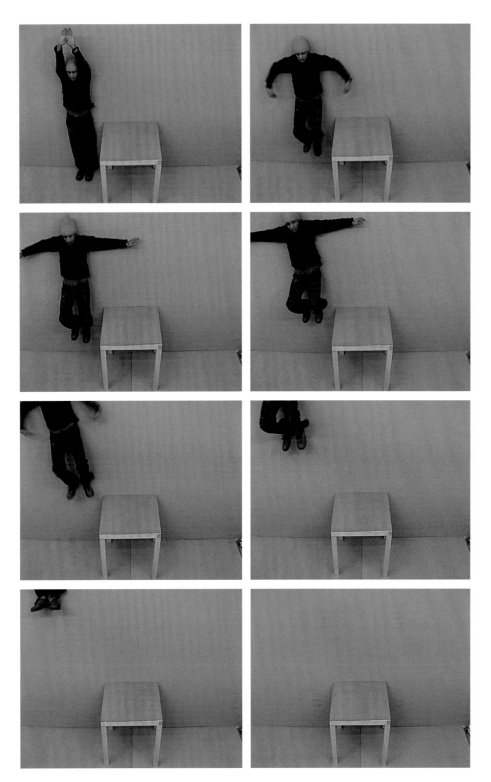

Kiran Subbaiah
Flight Rehearsals, 2003
DVD
4:40 minutes

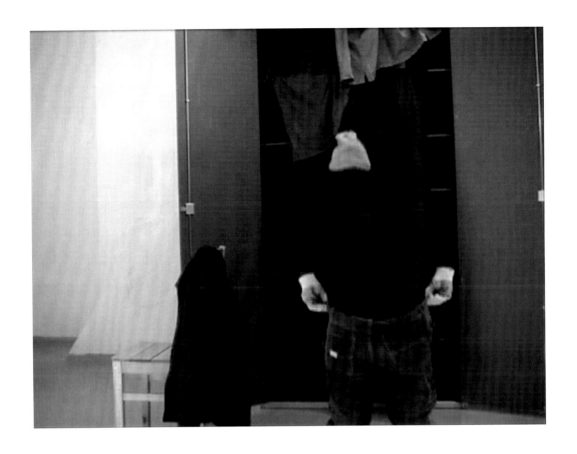

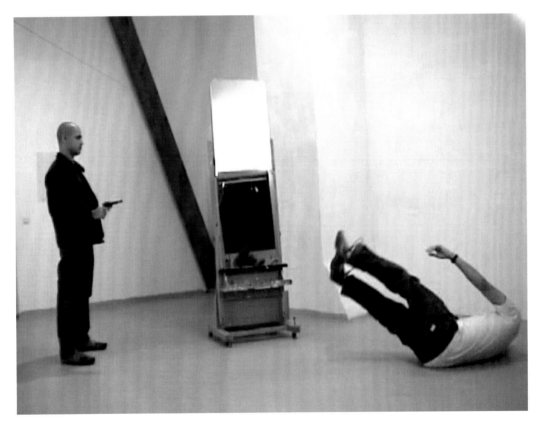

Kiran Subbaiah
Suicide Note, 2006
Video
26:00 minutes

Kiran Subbaiah
Suicide Note, 2006
Video
26:00 minutes

Kiran Subbaiah
Untitled (Walking Bicycle), 2002
Sticker on public traffic sign
72 cm diameter

Kiran Subbaiah
Love All, 1999
Matchsticks, wax ball and matchboxes
32 x 100 cm

Ashok Sukumaran

Born 1974, Sapporo, Japan
Lives and works in Mumbai, India
Studied at the School of Planning and Architecture, New Delhi, India;
University of California, Los Angeles, CA, USA

Solo Exhibitions

2009 *The Neighbour,* Arts Catalyst, London, UK
2008 *Glow Positioning System and Other Forms of Address*, Thomas
Erben Gallery, New York, NY, USA
2005 *Interior Design*, Kitab Mahal, Mumbai, India; Harvestworks,
New York, NY, USA

Group Exhibitions

2010 *Al Jaar Qabla Al Dar: The Neighbour Before the House*, Liverpool
Biennial, Liverpool, UK
2009 *Autonomies of Disagreement, Transitio-Mx,* Mexico City, Mexico
2009 *Concrete Culture,* Ivan Dougherty Gallery, Sydney, Australia
2009 *Wharfage, Radio Meena,* by CAMP, publication and radio
broadcasts, Sharjah Biennial, Sharjah, United Arab Emirates
2008 *Motornama Roshanara, 48°C Public.Art.Ecology,* New Delhi, India
2008 *Shelter, Visibility, Love,* by CAMP, Alexandria, Egypt
2008 *Tourism: Spaces of Fiction*, Design Museum, Barcelona, Spain
2008 *Dictionary of War*, Taipei Biennale, Taipei, Taiwan
2008 *Concrete Culture*, Ivan Dougherty Gallery, Sydney, Australia
2008 *Dak'Art Off*, Dakar, Senegal
2006 *Park View Hotel*, ISEA|ZeroOne, San Jose, CA, USA
2006 *Redoubt* and *Everything is Contestable*, Singapore Biennale,
Singapore
2006 *City of Glass*, COLAB Art and Architecture, Bangalore, India
2005 *Changes of State, World Information City*, Bangalore, India

Awards / Residencies

2008 Ker Thiossane, Dakar, Senegal
2008 Gasworks, London, UK
2007 Golden Nica, Prix Ars Electronica, Linz, Austria
2005 First Prize, UNESCO Digital Arts Award
2005 Prix Ars Electronica, OK Centrum, Linz, Austria
2005 Sally and Don Lucas Artist Residency Program,
Montalvo, CA, USA

Ashok Sukumaran is a co-initiator of Code About Moral Politics
(CAMP), Mumbai, India, and of the Public Access Digital Media
Archive (PAD.MA).

Shaina Anand

Born 1975, Mumbai, India
Lives and works in Mumbai, India
Studied at Xaviers College, Mumbai, India; R.D. National College,
Mumbai, India; and Temple University, Gujarat, India

Group Exhibitions

2010 *Al Jaar Qabla Al Dar: The Neighbour Before the House*, Liverpool
Biennial, Liverpool, UK
2009 *Gasworks Residency,* Gasworks, London, UK
2008 *Motornama Roshanara, 48°C Public.Art.Ecology,* New Delhi, India
2008 *If we can't get it Together' Artists rethinking the (mal)function of
Communities,* The Power Plant, Contemporary Art Gallery,
Toronto, Canada
2008 *The Impossible Prison*, Galleries of Justice Nottingham
Contemporary,
Nottingham, UK
2008 *Dak'Art Off*, Dakar, Senegal
2008 *Shelter, Visibility, Love,* as CAMP, Alexandria, Egypt
2008 *What do you Want?,* Asian Triennial Manchester, Cornerhouse,
Manchester, UK
2008 *Dictionary of War, Taipei Biennale,* Taipei, Taiwan
2008 *Reality Effects*, Henie Onstad Art Centre, Oslo, Norway
2008 *Broadcast Yourself: Artists Interventions into Self-broadcasting
from the 1970s, AV Festival*, Hatton Gallery, Newcastle, UK;
Cornerhouse, Manchester, UK
2006 *Impossible India: Parallel Economies and Contemporary Art
Practices*, Frankfurt Kunstverein, Germany
2005 *WI City TV*, World Information City, Bangalore, India
2005 *Rustle TV*, Ars Electronica, Vienna, Austria

Residencies

2008–2009 Gasworks, London, UK
2008 Kër Thiossane, Dakar, Senegal
2007 Honorary Mention Interactive Art, Prix Ars Electronica
2006 KHOJ International Artists' Association,
Delhi Associate Residency

ASHOK SUKUMARAN
& SHAINA ANAND

Ashok Sukumaran and Shaina Anand are the co-founders of CAMP (www.camputer.org), a recent collaborative venture linking independent artistic and media projects across Mumbai. CAMP is a continuously changing acronym, thereby stretching its own boundaries with new meanings. Together, the artists examine the diffuse construction of the private and the public realm shapes human habitat and infrastructure between individuals and spaces as forms of aesthetics.

Sukumaran is an architect and media artist best known for his 'new-and-old' media installations, inserted within urban infrastructure to embody complex ideas of ransmission and insulation technology within society. He has often produced exterior projects utilising electricity networks that require activation of the public. His seminal piece *Glow Positioning System*, 2005, was a 500-metre ring of lights installed around several buildings at a busy Mumbai intersection, controlled entirely by a small hand crank in the centre of the square. As the public turned the handle, the light pulse raced around the square's architectural horizon. Sukumaran describes the hand crank as a way for the audience to 'scroll' the landscape, a reference to pre-cinematic animation.

Everything is Contestable, 2006, offered the public a chance to illuminate a church exterior in Singapore by pressing one of two switches. The likelihood of each switch working correlated to either the amount of electricity supplied by the state (24%) or the electricity from the 'contestable market' (76%), where electricity is traded like a commodity and customers have access to multiple providers, thus correlating the economic power structures behind an everyday material to chance and risk.

These projects, among others, led to *Recurrencies – Across Electricity and the Urban*, an ongoing body of work focused on electrical supply for which Sukumaran has collaborated with film-maker, artist and media activist Anand. In these explorations, electricity 'leaks' between economically disparate areas, connects spaces, separates them and travels the gamut of public and commercial topography, foregrounding issues of contemporary power, information flows, property and metered relationships.

Anand's solo work, known since 2001 under the umbrella title *ChitraKarKhana*, draws from her background in film and documentary and produces an 'expanded video' practice. In *World Information City TV*, 2005, Anand developed a collaboration with local cable operators in Bangalore to telecast local programming to 3000 homes, mirroring and intervening into a conference on 'information politics' happening at the same time. *Khirkee Yaan*, 2006, pushed further these approaches to site, community and 'televisuality' by combining cheap, readily available CCTV equipment with cable TV equipment and household televisions. This produced conversations and performances across class and caste lines in a Delhi neighbourhood.

In *Cold Clinic*, 2008, Anand gained access to CCTV control rooms in Manchester, UK, and opened them up to members of the public. Those normally 'watched' by these networks came into the control rooms to observe and monitor this situation, one prevalent in the UK. Through such access, using cheap, re-wired infrastructures, Anand seeks equitable forms of technological encounter, encouraging evolving subjectivities, performance and storytelling, which she records and presents in her films and installations. **R.M.**

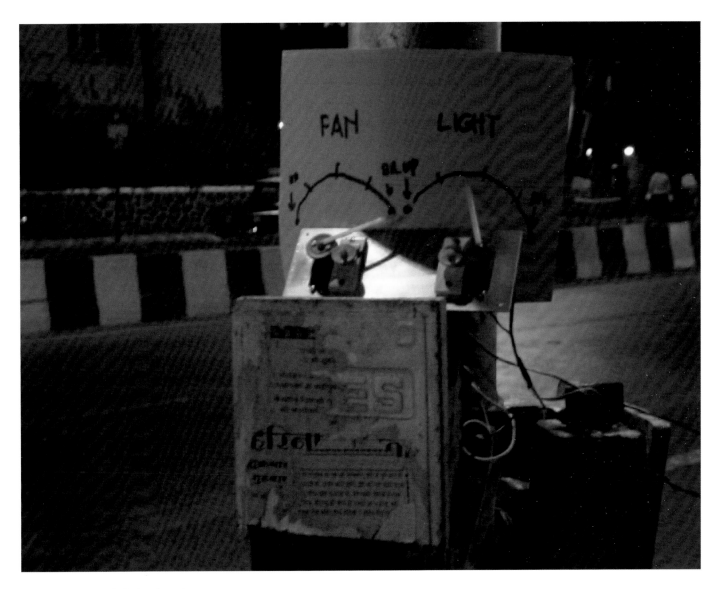

Ashok Sukumaran & Shaina Anand
Recurrencies: One Agreement, 2007
Modified electronics, 2 lamps, 2 fans, dimmers, wireless
control system
Dimensions variable

Previous page:
Ashok Sukumaran
Everything is Contestable (detail), 2006, Singapore Biennale
Audience-controlled exterior lighting of the Church of Saint
Gregory the Illuminator

Ashok Sukumaran
Glow Positioning System, 2005
Audience-controlled exterior lighting of the General Post
Office, Kabutarkhana Chowk, Mumbai

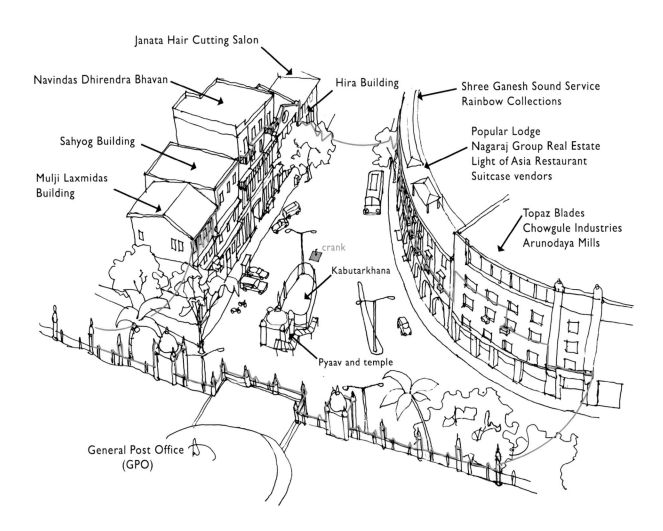

Janata Hair Cutting Salon

Navindas Dhirendra Bhavan

Hira Building

Shree Ganesh Sound Service
Rainbow Collections

Sahyog Building

Popular Lodge
Nagaraj Group Real Estate
Light of Asia Restaurant
Suitcase vendors

Mulji Laxmidas
Building

Topaz Blades
Chowgule Industries
Arunodaya Mills

crank

Kabutarkhana

Pyaav and temple

General Post Office
(GPO)

Ashok Sukumaran
Glow Positioning System, 2005
Birds-eye map of installation area

253

Shaina Anand
Khirkeeyaan,2006
CCTV cameras, televisions, microphones, audio mixer,
video quad box, coaxial and XLR cable and networked
conversations in 7 episodes

Shaina Anand
Capital Circus, 2008
Video still and CCTV in the control room of the Arndale Centre,
Manchester, UK

Thukral & Tagra

Jiten Thukral

Born in 1976, Jalandhar, Punjab, India
Lives and works in New Delhi, India
Studied in Chandigarh Art College, Chandigarh, India; New Delhi
College of Art, New Delhi, India

Sumir Tagra

Born 1979, New Delhi, India
Lives and works in New Delhi, India
Studied in Shankar's Academy of Arts, New Delhi, India; National
Institute of Design, Ahmadabad, India; New Delhi College of Art,
New Delhi, India

Solo Exhibitions

2011 Nature Morte, New Delhi, India
2011 Thukral & Tagra Foundation – Project Booth, Art Summit,
New Delhi, India
2010 *Low-Tech Family Vacations*, Singapore Tyler Print Institute,
Singapore
2010 *Middle Class Dreams*, Arario Gallery, Seoul, South Korea
2010 *Match Fixed/Fixed Match,* Ullens Center for Contemporary Art,
Beijing, China
2009 *Nouveau Riche*, Nature Morte, Berlin, Germany
2009 *Thukral & Tagra, 315 Sector 23, Opp Bosedk Mall*, Gallery Barry
Keldoulis, Sydney, Australia
2008 *New Improved Bosedk*, Gallery Chatterjee and Lal, Mumbai, India
2008 *Somnium Genero 02*, Gallery Barry Keldoulis, Sydney, Australia
2008 *Somnium Genero Café*, Tokyo Art Fair, Tokyo, Japan
2007 *Adolescere-Domus* Art Statements, Art Basel 38, Nature Morte
and Bose Pacia, Basel, Switzerland
2007 *Put it On,* Bose Pacia, New York, NY, USA
2007 *Everyday Bosedk*, Nature Morte, New Delhi, India

Group Exhibitions

2011 *Maximum India*, Kennedy Center, Washington D.C., USA
2010 Richmond Art Gallery, Vancouver, Canada
2010 *Urban Matters 2*, SESC Pompie, São Paulo, Brazil
2010 *48ºC Public.Art.Ecology*, New Delhi, India
2010 *11ᵗʰ Hour* Tang Contemporary, Beijing, China
2010 *Inside India*, Palazzo Saluzzo di Paesana, Turin, Italy
2010 *Commonwealth Games Exhibition*, Lalit Kala Akademie,
New Delhi, India
2009 *Chalo! India: A New Era of Indian Art*, National Museum of
Contemporary Art, Seoul, South Korea
2009 *Escape for the Dream Land*, Asia Pacific Triennial of
Contemporary Art 06, Queensland Art Gallery, Brisbane, Australia
2008 *The Audience & the Eavesdropper*, Phillips de Pury, London, UK;
New York, NY, USA
2008 *Chalo! India: A New Era of Indian Art*, Mori Art Museum,
Tokyo, Japan
2008 *Make Art Stop AIDS*, UCLA Fowler Museum,
Los Angeles, CA, USA
2008 *Imaginary Realities*, Max Wigram Gallery, London, UK
2008 *Face East*, Wedel Fine Art, London, UK
2007 Animamix Biennial, Museum of Contemporary Art, Shanghai,
China
2007 *New Delhi New Wave*, Marella Gallery, Milan, Italy
2007 *Size Matters*, Art Consult, New Delhi, India
2007 Galerie Mirchandani + Steinruecke, Mumbai, India

Awards

2006 101 Emerging Designers of the World – *Wallpaper Magazine*,
Global Edit, London, UK
2005 D&AD, London, UK
2004 One Show Design, New York, USA
2003 One Show Design, New York, USA
2003 London International Awards

Thukral & Tagra

Jiten Thukral and Sumir Tagra work collaboratively in a wide variety
of media including painting, sculpture, installation, video, graphic and
product design, websites, music and fashion.

Thukral & Tagra
PUT IT ON, 2007
Flip-flops

01 Carefully open the package so the condom does not tear.

02 Pinching the tip of the condom to squeeze out air. roll the condom until it reaches the base of the penis.

Most of our art practice addresses the issues, cultural shifts, problems and beliefs of people living in India today.

PUT IT ON is an ongoing research project which explores alternative media with which to raise awareness regarding HIV transmission and the AIDS epidemic. Based on research conducted in India, where more than 5 million people are infected with HIV, the project aims to identify the gaps in the current communication surrounding education and prevention and strives to provide creative solutions where existing media have failed to achieve results. Begun in 2005, the project aims to use multiple platforms and media to target diverse sections of the public. Through the use of visuals and mass-produced commodities, the goal is to infiltrate multiple strata of society in which discussions about sex education and healthcare are fraught with shame, taboos, embarrassment and restrictions.

The project was first exhibited at Bose Pacia Gallery in New York in 2007. The intention was to create greater awareness of, and vigilance in relation to, HIV through the visual arts, by combining products such as undergarments and footwear with paintings to create a larger installation. We described the project as 'an eye opener' which has 'taken us to places where things have become transparent, sensitive and responsible'.

PEHNO! is the most recent and localised version of this project, going to the heart of the new Indian consumer society and introducing the subject with humour and wit. The plan is to present a spectacular and appealing façade to draw unsuspecting people into the discussion, reaching those who may consciously want to avoid the subject.

Our target audience here is the rapidly developing adolescent and young adult community, who are beginning to become sexually active and may have little or no knowledge of HIV, how it is spread and how it can be prevented. This demographic group, with a disposable income and access to privacy, may be among those most at risk in India today.

For the exhibition *Indian Highway IV* in Lyon, the project will go a step further, with a new narrative and tongue-in-cheek metaphors, to emphasise the importance that condom use can have in the prevention of the spread of HIV. **Thukral & Tagra**

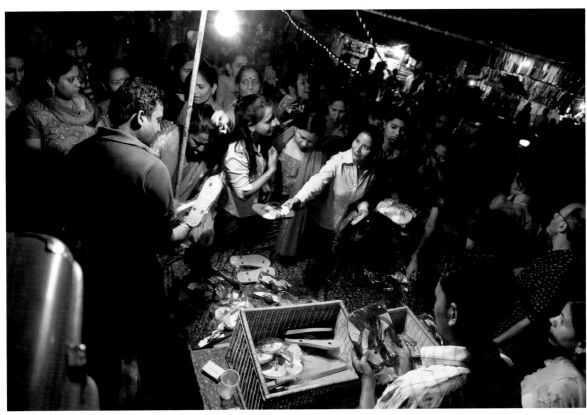

Previous page:
Thukral & Tagra
PEHNO! (PUT IT ON), 2010
Local market, New Delhi, April 2010

Right:
Thukral & Tagra
View of the exhibition *PUT IT ON*
Bose Pacia, New York, April 2007

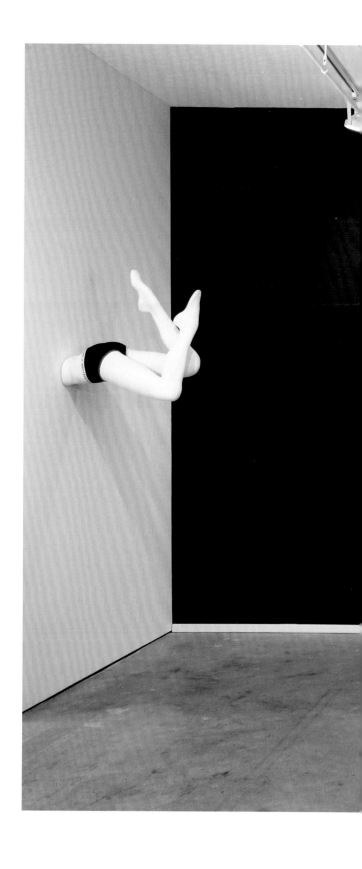

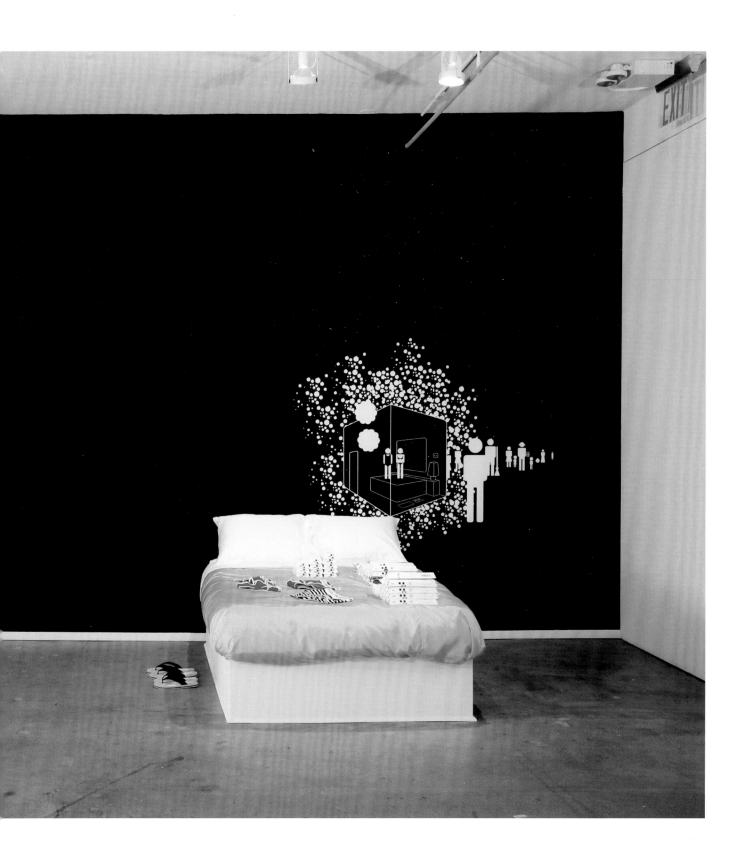

Thukral & Tagra
Lets Play Safe – 1, 2007
Oil on canvas
182.9 x 304.8 cm

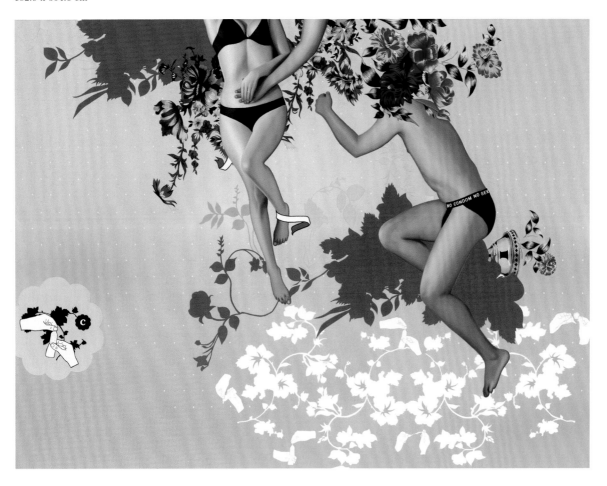

Hema Upadhyay

Born in 1972, Baroda, Gujarat, India
Lives and works in Mumbai, India
Studied at Maharaja Sayajirao University of Baroda, Gujarat, India

Solo Exhibitions

2010 *Where the Bees Suck, There Suck I*, Studio La Città, Verona, Italy;
Macro Museum, Rome, Italy
2008 *Universe Revolves On*, Singapore Tyler Print Institute, Singapore
2004 *Underneath*, Gallery Chemould, Mumbai, India
2001 *The Nymph and the Adult*, Institute of Modern Art, Brisbane;
Art Space, Sydney, Australia
2001 *Sweet Sweat Memories*, Gallery Chemould, Mumbai, India

Group Exhibitions

2010 *SAMTIDIGT – at the same time*, Kulturhuset, Stockholm, Sweden
2010 *Arts and Cities*, Aichi Triennial 2010, Nagoya, Japan
2010 *Midnight's Children*, Studio La Città, Verona, Italy
2010 *The Empire Strikes Back: Indian Art Today*, Saatchi Gallery,
London, UK
2010 *Home Less Home*, Museum on the Seam, Jerusalem, Israel
2009 *India 2: Mumbai – Under the Surface*, Galerie Krinzinger,
Vienna, Austria
2009 *The Power of Ornamentation*, Orangery Lower Belvedere,
Vienna, Austria
2009 *India Xianzai*, Museum of Contemporary Art, Shanghai, China
2009 *Chalo! India: A New Era of Indian Art*, Essl Museum, Vienna,
Austria; The National Museum of Contemporary Art, Seoul, South
Korea
2008 *India Moderna*, Instituto Valenciano de Arte Moderno(IVAM),
Valencia, Spain
2008 *Eurasia – Geographic Cross-overs in Art*, Mart Museum,
Rovereto, Italy
2008 *Indian Focus*, Espace Claude Berri, Paris, France
2008 *India Crossing*, Studio La Città, Verona, Italy
2008 *The Audience and the Eavesdropper – New Art from India and
Pakistan*, Phillips de Pury, London, UK
2008 *Six degrees of separation: chaos*, KHOJ International Artists'
Association, New Delhi, India
2008 *International Artist Association*, New Delhi, India
2008 *New Narrative*, The Zimmerli Art Museum, New Brunswick,
NJ, USA; Chicago Cultural Centre, Chicago, IL, USA
2007 *India: New Installations Part II*, Mattress Factory,
Pittsburgh, PA, USA
2006 *Bombay: Maximum City, Tri Postal*, lille3000, France
2006 *Parallel Realities* – Asian Art Now, 3rd Fukuoka Asian Art
Triennale, Blackburn Museum, Blackburn, UK

Residencies

2010 Atelier Calder, Saché, France
2008 Singapore Tyler Print Institute, Singapore
2007 Mattress Factory, Pittsburgh, CA, USA

Hema Upadhyay
8 feet x 12 feet, 2009
Aluminium sheets, car scrap, enamel paint,
plastic sheets, found objects, M-Seal,
resin and hardware material
243 x 366 x 243 cm

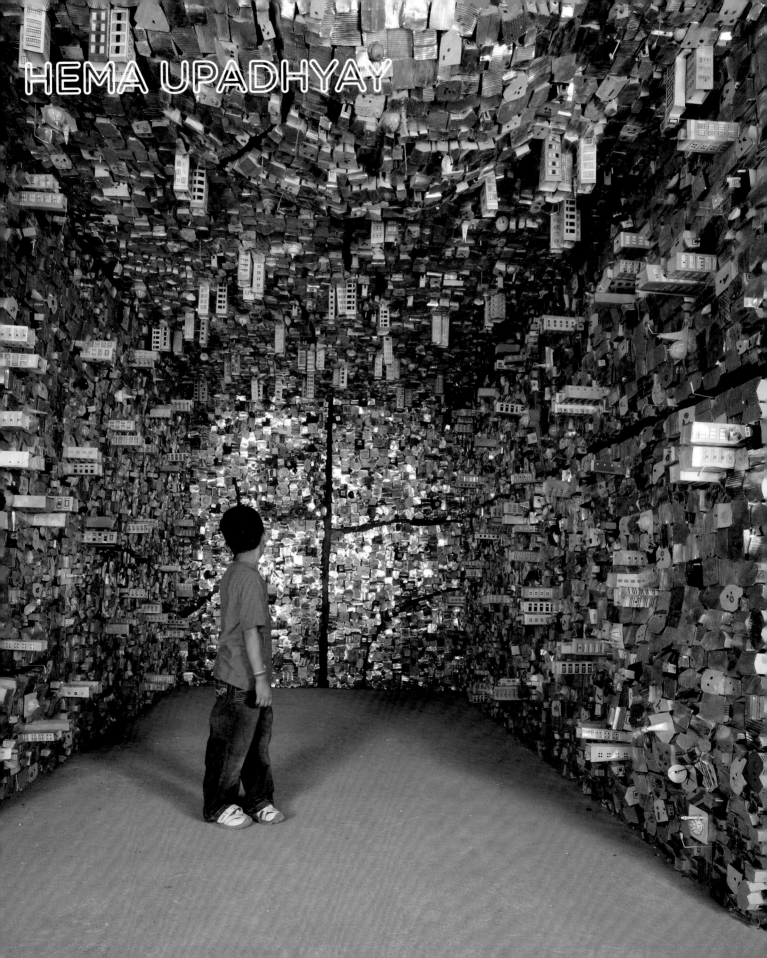

HEMA UPADHYAY

Hema Upadhyay constantly experiments and researches with materials, ideas and spaces, and our psychological link with them. Upadhyay's challenging aesthetic often makes the viewer deal with multiple emotions simultaneously, creating a dialogue across all sections of society. Her photography and sculptural installations explore notions of dislocation and nostalgia in which one often finds artificial environments created through juxtaposed allegory and urban landscapes.

Upadhyay's paintings, *Visitors 1972 until 1998*, 2001, *I have a feeing that I belong*, 2001, and *I live in a match box*, 2004, speak of a sense of alienation and loss and at the same time the feeling of awe and excitement one usually feels when in a new place. She has incorporated her own photographs to communicate her ideas about migration, having moved to Mumbai in 1998. Upadhyay's paintings are usually characterised by the inclusion of small, collaged photographic self-portraits. Miniaturising images of herself in various poses, she inserts them into her allegorical landscapes allowing them to interact with the decorative and fictive environments she creates. The de-monumentalisation of her visage in these works results in an anti-fetishised version of the female body, and her portraits, such as *Pedestrian*, 2008, act like records of her meanderings through these spaces.

In 2001 Upadhyay had her first international solo show at Artspace, Sydney, and the Institute of Modern Art, Brisbane, where she exhibited an installation entitled *The Nymph and the Adult,* 2001, for which she hand-sculpted 2,000 lifelike cockroaches, infesting the gallery with them, to draw repulsion as well as fascination from her viewers. There was a purpose, however, to this display: during a very politically and militarily tense time in the South Asian Subcontinent, it raised the question on everyone's mind. The work asked the viewers to think about the consequences of our military actions. It made one wonder what would survive and what the state of the world would be – at the end of all our wars and nuclear experiments would cockroaches be the only survivors?

Loco foco motto, 2007, (exhibited at the Hanger Bicocca, Milan) dwelt on the fragility of materials and human life, with the artist speaking about the India-Pakistan divide in relation to her own family history in terms of its relationship to the partition of India. The works were also a break from her trademark symbolism, being more craft oriented, making use of matchsticks and glue to create chandeliers. Constructed out of thousands of unlit matchsticks, assembled into elaborate chandeliers, these pieces embody an important element of Hindu ritual, symbolising creation and destruction – a trend in her work that explores violence co-existing with beauty. A nascent violence is implied in these works, a com-mentary on the hostilities, intolerance and cruelty that touches so many lives throughout the contemporary world. At once delicate, nostalgic and yet dangerous, the disparity of creating a chandelier out of matchsticks takes the object out of the realm of logic and situates it firmly in the metaphoric.

Upadhyay's large-scale and highly detailed works are sublime, often made of everyday materials, altering their physical aspects as a metaphor for the human mental space. Upadhyay has often engaged the experience of the Mumbai landscape: her well-known sculptural installations, *Dream a Wish, Wish a dream*, 2006, and *8 feet x 12 feet*, 2009, are sublime large-scale pieces, like Mumbai itself. Upadhyay's installation is seductive, making the audience take on the role of a voyeur, using lighting and the composition of dioramic elements to recreate the aura and ambience with which the city impresses its inhabitants and visitors. It privileges the organic construction and ubiquitous urban development characteristics of Mumbai, although this development is often concentrated around areas of slums and the amenities of the working poor. Employing realism as an approach in these works, the installation is created from Upadhyay's meticulous, almost obsessive application of miniaturised forms and materials (often the materials used in the real built elements themselves). Upadhyay creates the 'Romanticism' in the revolt and energetic striving that emerges from the squalor and inadequate conditions of the city's slums. Through her works she takes the position of the voyeur and looks at elements that not only create a socio-economical hierarchy, but also an aesthetic one.

Hema Upadhyay

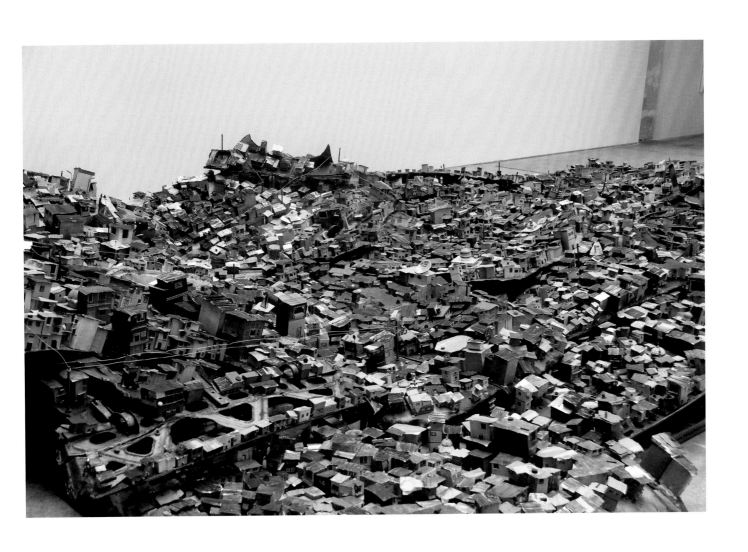

Hema Upadhyay
Dream a Wish, Wish a Dream, 2006
Car scrap, aluminium, plastic, resin and hardware objects
762 x 457 cm

Hema Upadhyay
Where the Bees Suck, There Suck I, 2009
Aluminium, car scrap, plastic, resin, enamel paint,
hardware objects, wood, iron and steel pipe
The installation is set up in a room 1,219 cm wide
with a ceiling height of about 760 cm

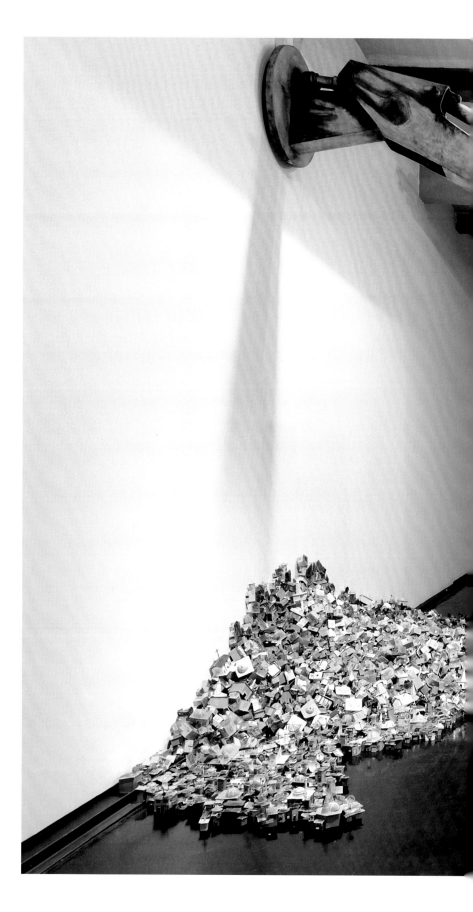

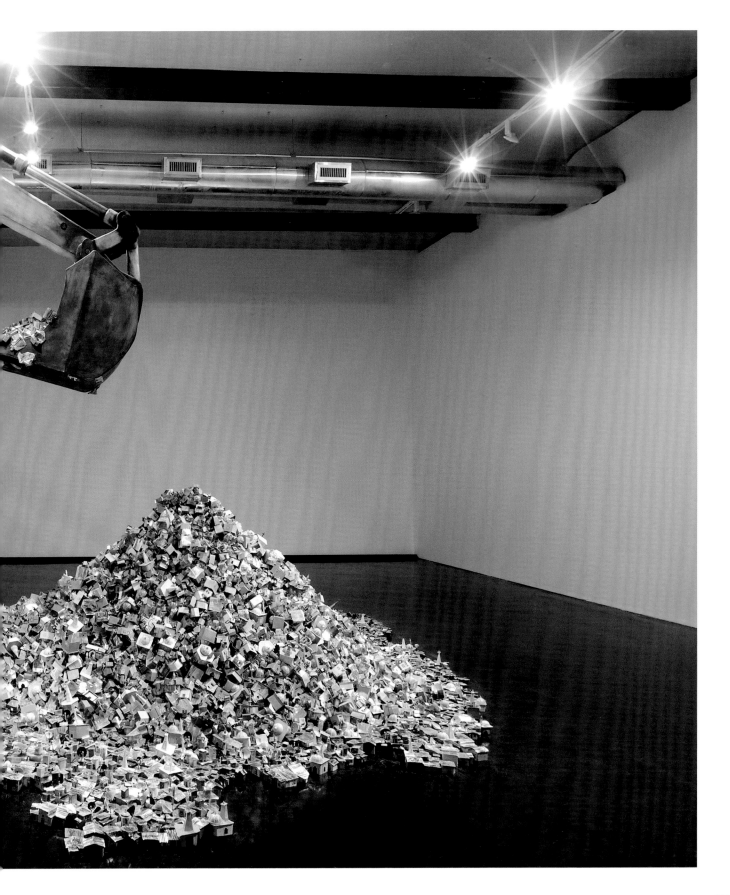

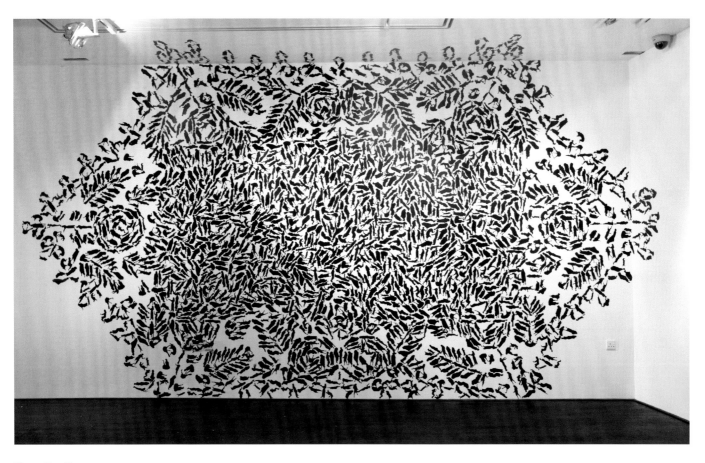

Hema Upadhyay
Untitled, 2008
Vinyl cut-outs
Dimensions variable

Hema Upadhyay
Only Memory has Preservatives, 2010
Installation, silkscreen on plexiglas,
nylon wire and black thread
Dimensions variable
Work produced at the Atelier Calder,
Saché, 2010, with support from
Centre National des Arts Plastiques (CNAP) /
Hema Upadhyay received a research
and subsistence grant from CNAP.

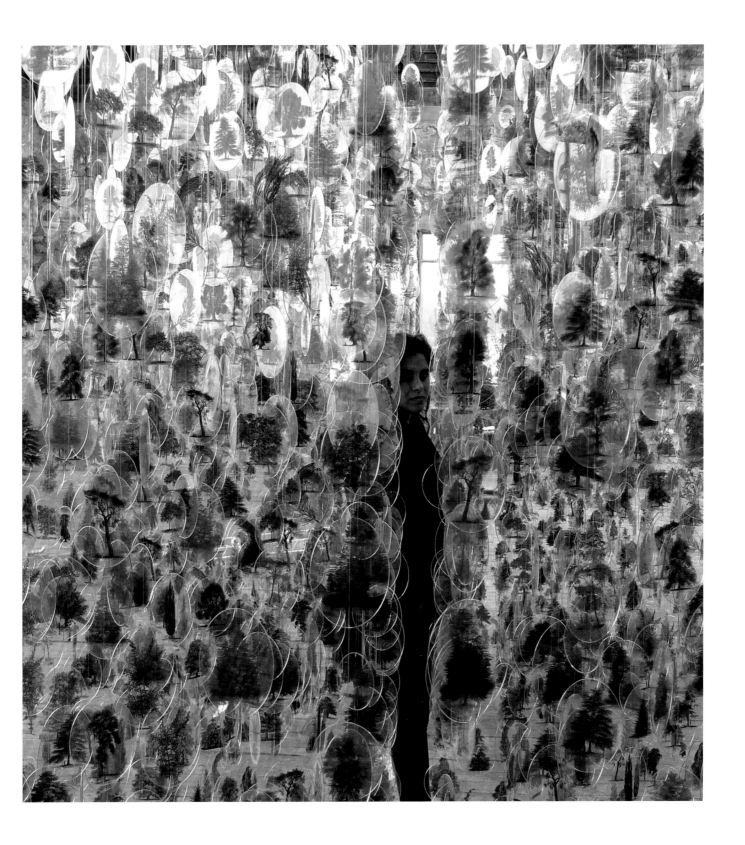

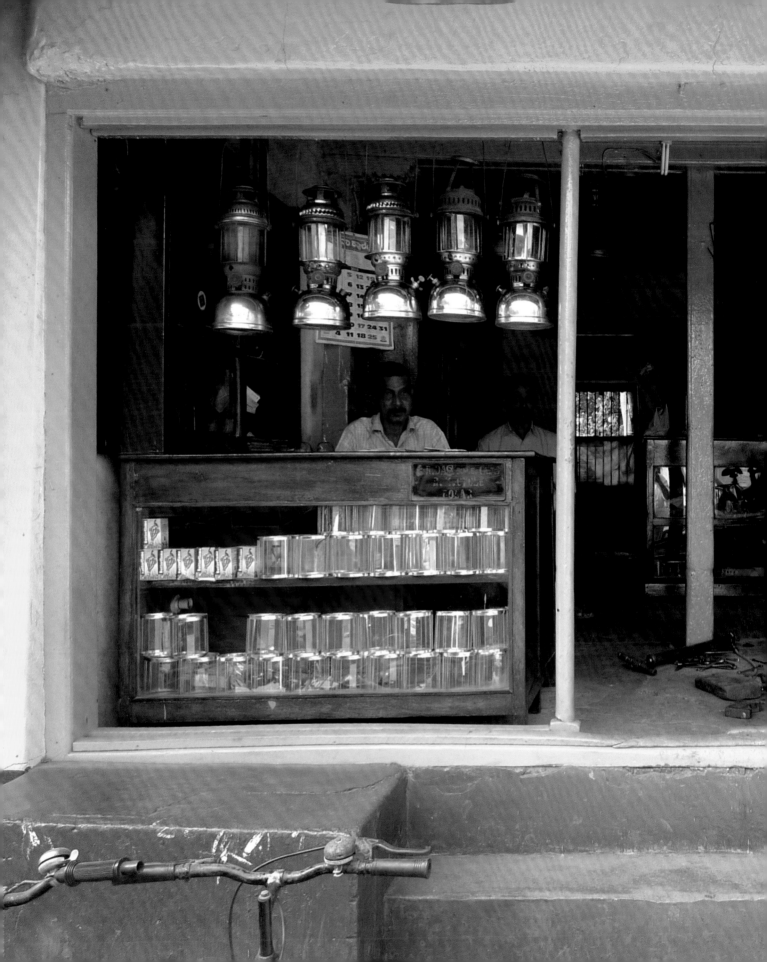

STUDIO MUMBAI ARCHITECTS & MICHAEL ANASTASSIADES

Michael Anastassiades trained as a civil engineer at London's Imperial College of Science and Technology and Medicine before taking a master's degree in industrial design at the Royal College of Art. He Lives and works in London.

Bijoy Jain was born in Mumbai in 1965. He studied in the United States and gained his master's degree in architecture at Washington University in St. Louis (USA) in 1990. He worked in Los Angeles and London and he spent some time travelling before returning to live and work in Mumbai. Studio Mumbai was formed under his direction.

Studio Mumbai and Michael Anastassiades have collaborated together on several projects including the 2010 Venice Architecture Biennale and the installation 'In-Between Architecture' at the Victoria and Albert Museum in London. Their work explores contemporary notions of culture and aesthetics through architecture, interior space, furniture, objects, and materials, and aims to provoke dialogue, participation and interaction.

In the patient evolution of projects they have developed a hybrid approach by combining Indian notions about the nature of living with ideas of both contemporary design and ecology.

Ideas are explored through the production of large scale mock-ups, models, material studies, sketches, and drawings, and projects develop through careful consideration of place and a practice that draws from traditional skills, local building techniques, materials, and an ingenuity arising from limited resources. They exhibit a care that speaks about the nature of ones engagement with an artefact through space, use, and ritual.

Studies, 2011

Our immediate environment is a space we subconsciously create and inhabit. We can make this space very familiar or we can expose ourselves to unfamiliar elements that provoke our response and re-evaluation. There are many sources of inspiration – one only has to observe closely. It is possible to have set ideas of what architecture should be, but first we need to understand why things are a certain way.

Our proposal is a carefully curated series of found conditions formed between the boundaries of public and private space, whose inspiration forms an integral part of our design process. Continuously observed and documented from our travels throughout the country, they are not just isolated ingenious solutions to the everyday, but as a group they demonstrate the spirit of spontaneity that exists so strongly throughout the Indian landscape.

These architectural studies are vital tools that enable us to look at the complexity of relationships. The scale measure of these structures is the human being; they are a series of intimately proportioned spaces that are able to adapt to personal and emotional needs. They inspire versatility as well as order, calm and dignity.

These structures are ambiguous, existing as part and whole, creating an abstraction of the relationship between artificiality and nature. It is a depiction of another reality, seen almost by accident; the idea is not to guide visitors through a specific process, but to allow their minds to discover their own findings through the visual layers.

Our purpose is to show a genuine possibility for creating spaces formed at these boundaries that emerge from imagination, intimacy and modesty.

**Studio Mumbai
Architects**

Opposite:
Studio Mumbai Architects & Michael Anastassiades
Bicycle shop
Proposal for Musée d'art contemporain de Lyon

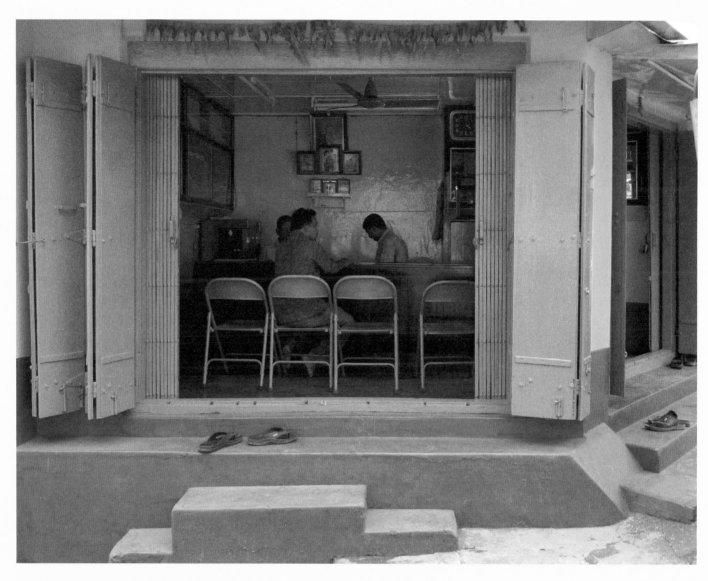

Studio Mumbai Architects & Michael Anastassiades
Corner shop
Proposal for Musée d'art contemporain de Lyon

Opposite:
Studio Mumbai Architects & Michael Anastassiades
(top) *Preparatory drawing,* 2010
Ink on paper, 25,4 x 17,8 cm
(bottom) *Work Place Kadia Tools* and *Work Place,*
Venice Biennale, 2010

Following pages:
Studio Mumbai Architects & Michael Anastassiades
Preparatory drawings, 2010
Ink on paper, 25.4 x 17.8 cm per page

M.S. Sheet

Ky Blue

Red

22"

9½

27½ 45½ 11 25 8½ 12½ 10

3"

①

Break Wall

②

41"

7/8"

2½" x 3¾"

10½"

10½"

18"

16"

3/4" x 2¼"

PROJECT/ योजना

DATE/ तारीख

DRAWN BY/ रचयिता

DESCRIPTION/ वर्णन

8'-9"

6'-0

17"

कोकरी

17"

53½"

3½"

53½"

डोर

शिकरी

शिकरी

After STDP

2"x4¾

2½"

14½"

9'11"

75½"

280

19/12/2010

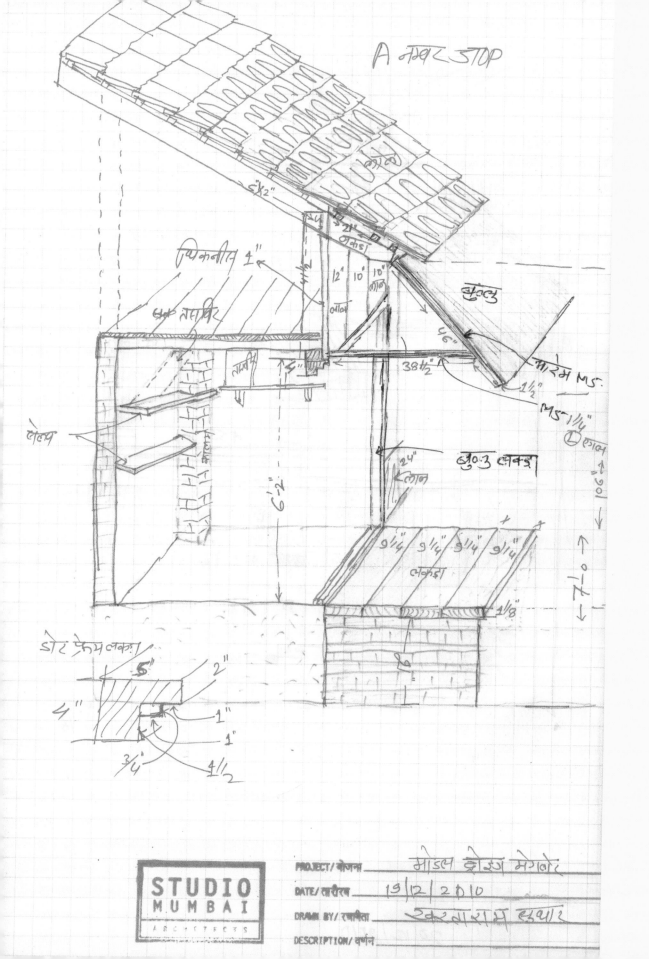

A नंबर STOP

STUDIO
MUMBAI
ARCHITECTS

PROJECT/योजना ___ मोडल हौज मेंगलोर

DATE/तारीख ___ 19/12/2010

DRAWN BY/रचायिता ___ रूपनारायण सुधार

DESCRIPTION/वर्णन ___

281

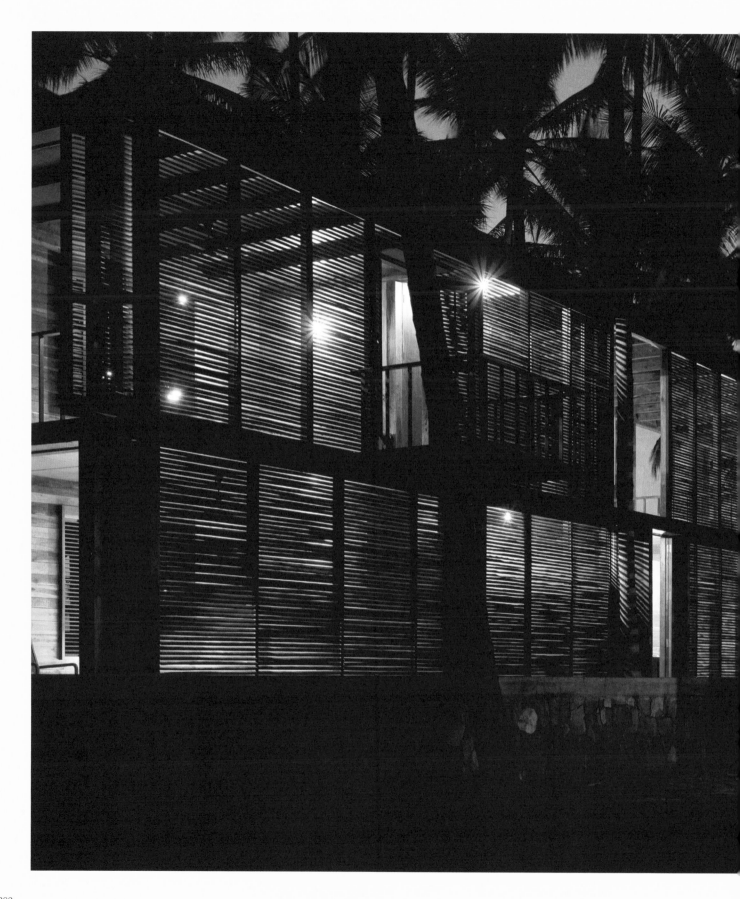

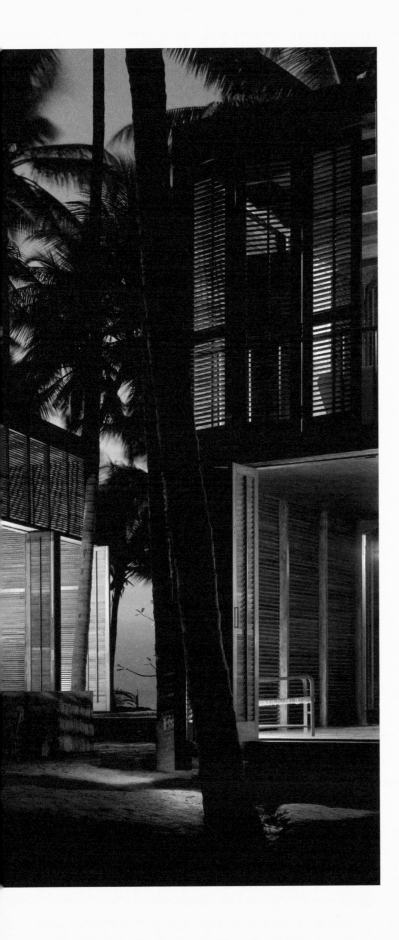

TRACKING*

The Politics of Place

As art gains ever-higher visibility through the economy and ideology of globalisation, the politics of place – community, country, region, nation, even the margin or exile – tends to lose the privilege of direct address. Investigating the interstices of urban archipelagos could help us obtain those suppressed signs of place and belonging that seep into the practice of art.

The rights of belonging were won by large populations of ordinary people as new continents of possibility in the process of decolonisation. The ideologies of these liberatory claims were subsequently elaborated and critiqued by postcolonial discourse. Within the new Empire, the ground won in the cause of self-determination tends to become only a marker of identification and the national reduced to a territorial defense-base, letting the politics of place collapse into retrogressive nostalgia.

My focus is on art practice in the social, political and psychic terrain of global cities that have emerged outside the west. Here too the contemporary surfaces in the wake of a deconstructed modernity, but through different trajectories. While the western artist set up an elaborate masquerade around the theme of what Freud called 'civilisation and its discontents', this discourse was taken further by a revolutionary working-class history, and further still by the history of decolonisation that added new contours to the very idea of civilisation by revealing the vast limitations of a Eurocentric universe. The latter half of the 20th century saw the emergence of differently positioned modern artists all across the world whose acknowledged presence shaped a hermeneutic retake on the (political) unconscious of the contemporary. It also necessitated the relatively privileged interlocutor – the artist – to assume the position of a conspicuously underprivileged subject of an unequal social order, leading to variously located (regional, national, 'third world') interventions in and through art.

In India, this dissent has often tended to assume identification with the bearer of a subaltern consciousness abiding in peasants, workers, women, the urban poor and the *dalits* (meaning the 'oppressed', *dalit* being a name adopted by politicised 'untouchables' to oppose the Hindu caste hierarchy). In this transaction an artist (writer, film-maker) has to accept being subjected, like any other citizen, to the pressures of a given, often turbulently unsettled, society and State. The political price of such deliberate 'entrenchment' is not translatable into aesthetic value, but the very recognition of the problem, of new types of marginalisation promoted by hegemonic powers in national and international politics, sharpens the language of art.

The responsible and transgressive artist-citizen is one who can imagine appropriate forms of praxis in historically specific situations; if there is a political task for artists in present-day India, it is to hold up against oppressive ideologies – of right-wing nationalism and of coercive globalisation – while keeping in mind wider solidarities across the world. I speak of artists who struggle from within the rapidly changing and competitive but systematically ravaged worlds within worlds that constitute the global; artists who make art practice a politically viable proposition not only in the grand manner but also through smaller initiatives, articulating criticism, dissent and transformation in the 'norms' of civil society at the level of the everyday.

In more modest terms, therefore, the implied locus of the artwork may after all be the body – of the artist and the artist's subject(-matter). Just as the body of the colonial subject is marked by signs of struggle against the multiple hierarchies of race, caste, religion and class, the body in its more recent re-articulation of sexual identity, as gendered subjectivity, is a major site for contestation. The body provides immanent ground for desire, the body in extremis reveals the anatomy of pain. And our concerns become as much those of politics as of poetics: the pleasure in beholding repossessed bodies, in decoding allegories that spell mortality, in translating fragments into signs that can be ingested, disgorged, relayed – in mapping metonymies that retrieve desire.

I speak of signs read in and through the criteria of art, but equally of those that are embedded in and 'found' across the less hierarchical field of a city's visual culture. The cross-sectioned profile that exposes the inner fabric of the city also, at the same time, unravels the urban body inscribed within its core. The mode of cross-referencing is indexical: the body is positioned in a contiguous relationship with the city, so that we look for mutual trace and imprint in the body-city interface.

* This text reconfigures elements from previously presented/published material. See, Geeta Kapur, 'subTerrain: artists dig the contemporary', in *Body.City: Siting Contemporary Culture in India*, edited by Indira Chandrasekhar and Peter C. Seel, Tulika Books, Delhi/House of World Cultures, Berlin, 2003 (reprinted in another version in Third Text, Vol. 21, Issue 3, May 2007); and Geeta Kapur, 'Tracking Images', in the exhibition catalogue for *Experiments with Truth*, curated by Mark Nash, The Fabric Workshop and Museum, Philadelphia, 2004.

It is at the same time metonymic: a part to whole equation between the body and the city, so that we discover the displaced (sometimes invisible) parts of discrete human entities in the urban topos. Or we follow trails of body-fragments imbricated in the city to refigure the space in temporal terms: a palpable flow, a subterranean narrative setting up a continuum between body, city, polity.

Unfolding the urban morphology of a generic city, or several city-loci (including specific, culturally-differentiated cities), engages the contemporary imagination with ever greater fascination. Among other things, the stakes placed on the contemporary mediascape are steep: the urban entanglement is seen to be available for express interpretation through such media connectivity. The new communication culture includes surreal navigational strategies across hard reality; it is a new freedom accessible to ordinary, disenfranchised denizens of the city even as it is based on a parallel and often 'illegal' economy that challenges bourgeois ethics and hegemonic property rights. Equally, there are glitches in the democratic promise of such media connectivity. It is subjected to perverse forms of Statist surveillance, even as it disintegrates easily into a cruel condition of entropy for millions of cyber-workers in this new phase of global imperialism.

The relationship between radical art practice and existing politics is only available indirectly, through the production and placement of artworks in the public domain. Artworks inscribed along the fault lines of a society expose implicit questions about citizenship, and artists can rescue a residual politics where their ambiguously positioned identity as citizen-subjects takes hold of a fraught contemporaneity and deflects it to dream a more democratic society.

I propose situating the artist in the 'subterrain' of the contemporary, where the levelling effect of no-history, no-nation, no-place, promoted by cyber-fantasies, global markets and exhibitory circuits, is upturned to rework a passage back into the politics of place. Then, as we reckon with the loss and gain of place, we may discover forms of absence – of pain or fear or guilt or desire – mediated by the artist's performance of her subjectivity, except that even such expressions of subjectivity that count for being political are now likely to be ironic and elusive, and we must read against the grain to decode new forms of alterity whereby the artist re-places the self as witness in the lived moment of history.

Documentary and Democracy
I refer now to the relatively recent groundswell in the Indian documentary scene (including video/digital/celluloid films) to demonstrate how spontaneous resistance

to reactionary ideologies can bestow on scattered practitioners the status of a movement that is at the same time virtually 'underground' as it is fully public.

Let me set the context for the argument that follows. The five-year run of the right-wing Hindu majoritarian party (Bharatiya Janata Party/BJP), and the government it led from 1998 to 2004, peaked with a ruthless logic in 2002. A State-supported pogrom against the Muslim community in Gujarat consolidated the Hindutva ideology as fascist. The witnessing vocation of the documentary film-maker came into its own in mobilising opposition to the brutal politics put in place by the then ruling party and, not surprisingly, a confrontation on the censorship law became the actual occasion for the documentary movement to emerge.[1] These film-makers sought a mandate under the title *Vikalp: Films for Freedom* in the year 2004.

Documentary evidence assumes access to citizens as co-witnessing spectators. Place this development within the terms of the nation and the State – both based on privileged identities, legal sanctions and the hierarchy of command – and the balance of freedoms sanctioned by the State becomes unacceptable. The constitutional right to freedom of speech and expression is also, of course, a useful euphemism to win the right of dissent, and that in turn is bracketed within other constitutional provisions that constrain these rights. This well-marked battle involves legal interpretation and a complex political discourse; it involves a proactive definition of the rights of representation in relation to theories of spectator-address and reception.

There might also be an unstated correspondence between the 'deconstructed' technology of the video-medium and what is now perceived and debated to be the *already disassembled* nation. The rejection of censorship arises as much from a precipitate political moment as from video technology itself: an easy accessibility of equipment, the unobtrusiveness of the camera, unprecedented economies in production and post-production facilities and, as a consequence of these changed technical and institutional factors, altogether different possibilities of distribution, viewing, reception, and response. That is to say, there is a different private and public interface, suggesting an almost new understanding of what it means to function in and shape a contemporary public sphere, asking also for an interrogation of the type of politics this produces.

The upsurge in the production and reception of documentary films in India is to do with 'a crisis in democracy' says Amar Kanwar, now among the most important documentary film-makers at the forefront

of the movement. Equally or, rather, inversely, one might say the movement is the result of a more extensive democratic consciousness which reveals gaps and losses in the existing processes. This consciousness translates either into the activist mode – connected to identifiable ideologies and political movements, especially labour movements – or it is anthropologically driven, and supports grassroots politics (both rural and urban) that prioritises the immanent nature of community structures. Either way, political space is sought to be captured by direct access assumed by a communicational ethics, and while any one video documentary unravels the issues piecemeal, the synergy of many eyes/hands/expositions at work with the camera provides a crucial positioning of the medium in the present juncture.

But let me backtrack a little. If we mark 2003–4 as the moment when the Indian documentary movement names itself, it is preceded by a decade – nearly two decades – of interventionist documentary film practice. A major protagonist in this battle is the pugnaciously political Anand Patwardhan who has been at the forefront of the documentary scene since the late-1970s. In this argument, we position him in the dire moment of national shame, in 1992, when the 16th-century Babri Mosque is demolished by militant Hindus, the event serving as a signal for right-wing activists to stage their vicious victories right through to parliamentary elections during 1998–99. Patwardhan's film *In the Name of God*, 1993, is made during and after the demolition of the Babri Mosque; it is followed by *Father, Son and Holy War*, 1994, which traces the origins of the fascist tendency among other causes to a pathological regret over lost manhood perpetrated by the false ideology of 'modernised' Hindutva, and then by *War and Peace*, 2002, which exposes the belligerence between India and Pakistan culminating in nuclear tests and horrifying rhetoric on both sides.

Patwardhan's films are based on a rationalist, cause-effect dialectic, their spirit entertaining, volatile, provocative, their form pedagogic. The dialectical form is associated with avant-garde moments in culture and politics from the 1920s to the 1960s. More specifically, Patwardhan is contextualised by the revolutionary vigour of early-Soviet Avant-Gardism through to the Third Cinema movement in Latin America during the liberationist decade of the 1960s and early-1970s. In India, Patwardhan constantly runs into trouble with the State and fights with guerrilla tactics and legal aplomb, repeatedly claiming the point that the State is a reality, that it can be fought and made to bend, and at best even taught by citizens' initiatives to rectify its ideological (mis)understanding of a living democracy.

The much younger film-maker Amar Kanwar is on common ground with Patwardhan regarding some issues:

positioned outside the framing ideologies of the organised Left, they associate with grassroots movements and work to strengthen civil society, but by deliberately cross-hatching the bourgeois concept of civil society with precipitate demands coming from other political (anarchist/revolutionary) traditions. The agenda, usually overt, works towards a human rights and civil liberties framework and in most cases there is a call for resistance by and on behalf of the disenfranchised populace. Both approach the subaltern protagonists situationally, locally, showing them winning rights for the community with a subversive (even secessionist) strategy of survival and inhabiting a fragmented map that no longer coincides with that of the nation.

In what he calls his more activist documentaries, such as *The Many Faces of Madness*, 2000, and *Freedom…!*, 2001 Kanwar's carefully researched, morally pitched sympathies range across the *dalits*, agricultural labour, ethnic and religious minorities, and dispossessed tribal communities fighting the devastation wreaked on their living environments by the development policies of independent India. Since the 1990s, this development policy is aided and superseded by multinational corporates allowed to enter the liberalised Indian economy on an iniquitous basis, and more recently by the special dispensation to SEZs ('special economic zones') whereby the State, on behalf of national and global capital, expropriates land from the people with unequal compensation. Kanwar interrogates the rhetoric of development within the parameters set by 20th-century ideology of progress, accompanying this with a philosophical discourse on human (environmental and planetary) survival.

Following long, arduous journeys undertaken by the seemingly anonymous representatives of a local movement for justice, Kanwar's camera and the rhythm of his tracking image corresponds to the nature of these protagonists who need no heroic identification beyond their courage and patience. The method of investigation too is analogous to the pursuit of local knowledge (by anthropologists) and consonant with the modes of social reparation implicitly demanded (by grassroots activists). Kanwar advances the idea of freedom and ethics as natural correlates of film practice, as they are of citizenship, and then goes on to privilege a documentary form that defines the contemporary in a way that the private and the public, the subjective and the moral, form a continuum designated as the politics of the everyday.

Hereon the differences between Patwardhan and Kanwar emerge. Patwardhan foregrounds an 'objective' interlocutor in the film; with Kanwar it is an extension, or the very person, of the speaking subject – the film-maker himself. Working in the interstices of the social, Kanwar develops

a 'documentary' form of intersubjectivity, but through a ruse. He displaces social issues onto more philosophic, aesthetic, affective planes of thought and feeling. Using poetry and reflexion above argument and dialectics as his preferred style, he defers any programmatic definition of praxis.

But what I schematically designate as two alternatives in documentary film practice in India may, equally, be seen as a generational change in the nature and pursuit of politics itself. Patwardhan's is, as I said, a dialectical form; it is based on a thesis/antithesis dynamic and on the praxiological 'resolution' of contradictions. Aligned with the convergent ideology of the broad Left, echoing a revolutionary call for social justice, Patwardhan is cast in the energetic ranks of the political vanguard with clear-cut interventionist tactics styled to seize the future. Patwardhan courts history; Kanwar's is an exploration of ground reality by a film-maker who prefers to hold a premium on subjective knowledge and on a doubting, tarrying discourse over means and ends set apace by history.

Testimonies
Kanwar's films undertake critical rethinking of the two supposedly contradictory categories of interrogation and affect. They thereby rethink action, especially action inducing (as it often does) the spectre of violence. In *A Season Outside*, 1997, the slowly materialised, sensuously held image arrests the attention of the spectator until it reaches the stage of what Walter Benjamin calls 'mimetic innervation'. A melancholy voice-over grips us in a vexed relation with the film-maker who is himself gripped by an existentially driven conscience. This uncanny film is about violence within and outside an Indian identitarian crisis and towards the end it ruminates over the place of an icon of non-violence, Mahatma Gandhi. Amar Kanwar brings Gandhi's lean and fleeting image into his films time and again (the short *To Remember*, 2003, is about Gandhi). By virtue of the pale, flickering, silent, scratchy stock, and by virtue of the way Kanwar frames the archival shots in his films, Gandhi is a liminal figure, yet all the more does he lend himself to signify poverty, compassion, eccentricity, intransigence and courage – and the ambivalences that attend these moral attributes in a political leader.

Kanwar's *A Night of Prophecy*, 2002, builds on the material base provided by *Freedom…!*, but allows itself to develop a rhetoric of social pain. It critiques, through the idiom of protest poetry, the repressive operations of the Indian nation-state – federal in its constitution but seen to be practising on its 'constituted' polity procedures of centralised violence. As the unique metaphors of

distinct language-cultures condense into master metaphors flashing in the form of rebel-epiphanies, *A Night of Prophecy* sets up a near-melodramatic narrative of (self)-discovery, a journey through the country, the nation, the State. Kanwar is witness to the status of the *dalits* who exemplify 'bare life' in almost the strict sense of the term, the untouchable being the one who is so degraded – by the exigency of birth – that s/he may be killed with impunity but not, under the taboo of pollution, be ever consecrated, ever sacrificed to the gods, ever become sovereign-self or sovereign-citizen in normal public life. Kanwar's cinematographic choices ground the *dalit* poets' expletives – which are the ground zero of social existence played across the country and the city (of Mumbai, home to many *dalit* writers) – and the film acquires an allegorical form popular in *dalit* literature: here nihilism provides the deferred moment of resistance and of action, even as it serves as the trope to rethink the discourse and practice of sovereignty itself.

Amar Kanwar tunes his cinematic mise-en-scene, style of narration and cinematographic 'point of view' to the figure of the disenfranchised citizen. And, withholding well-meaning contextualisation that characterises the documentary genre, he investigates through the figure of this disenfranchised citizen the very means of representation. I refer to the cinematic means whereby the face and body of the referent is hidden or refracted, where the viewer's gaze is subtly persuaded to find its way to the image. I refer to the holding capacity of the camera and even more to the cinematographer's look and how it sustains itself before the site of humiliation. What Kanwar tracks has to actually survive its own representation – the subject, left precariously suspended by the very temporality of the medium, the time-image that blurs the body into its own sign and 'dies', has to survive in the ethical orbit as an after-image.

In order to determine the subject-position of the disenfranchised citizen, Kanwar as film-maker has to determine his own, not by stamping his will but, rather, by leaving that position at risk, by yielding to impingements, to the demand of the voice that comes from elsewhere. His film *A Night of Prophecy* reverberates with that voice from elsewhere, which is the elsewhere of the Indian nation, to be precise. And so as not to miss the tone and pitch and metaphor by which moral demands are relayed, Kanwar allows the self to be in doubt about the rights of representation involving others. The film-maker becomes, in a sense, an ambiguous presence – he is very much present, nevertheless, accounting for himself in speech, narration and in the style of his own itinerancy.

The pact between objectif (camera), the empirical world and the moving image – the 'realist' aesthetic of the cinema – is always in a sense exceeded by Kanwar. And the attribute of redundancy, the fact of absences within the 'legitimate' space of society, is raised to become a form of metaphysics. Even as he establishes continuities with philosophic traditions that reflect on metaphysics, mortality and pacifism – Buddhism for example (in *A Season Outside*) – the attendant melancholy is redeemed by a reflexivity, by an active debate between non-violence and peoples' struggle, between memory and history. Kanwar's films elicit the course of justice from an anguished discernment of means and ends. He suggests how a combination of eccentric and disciplined moves can launch public action that is simultaneously a call for resistance and a call for participation, and again how, through such action, we can approximate to that one universal aim: the restoration of human dignity.

The afterword to this essay is provided by Kanwar himself, by his most ambitious film, *The Lightning Testimonies* (2007). Long-researched and shot through with historical agony, it is also the most difficult among his films to speak about. Appropriately so, as the impossibility of articulation and the depth of silence is precisely what leads us to the archive of evidence, or what can be claimed as 'truth'-accounts of missing witnesses. Social violence against women does not require a test of veracity; what it asks for is a form of narration within a mise-en-scene that can contain the suffering but annotate consciousness with the indelible sign of political recognition. Erased by history or yet surviving liminally as 'victims', there is a tribe of protagonists that wear the face of courage and Kanwar's *Testimonies* puts a wager on these fierce fighters.

[1] During a routine selection procedure for the Mumbai International Film Festival (MIFF 2004), the requirement, prescribed by the State (Films Division/Ministry of Information and Broadcasting), for all Indian films to obtain a censor certificate (from the Central Board of Film Certification) became a sudden rallying point. A Campaign Against Censorship (CAC) developed into an alternative film festival (*Vikalp: Films for Freedom*) in 2004 and then an all-India travelling circuit (Travelling Vikalp). Very quickly, 300 short and documentary film-makers came to be associated with this action platform. A majority of film-makers have opted to exhibit their films without the censor certificate, sometimes under threat from the authorities. They are working to build a momentum for alternative spaces and diverse forums, making the democratic dissemination of documentaries the main agenda of the movement.

GEETA KAPUR

SIGNPOSTING THE INDIAN HIGHWAY

You Can't Drive Down the Same Highway Twice...
...as Ed Ruscha might have said to Heraclitus. But to begin this story properly: two artists, two highways, two time horizons a decade apart in India.

Atul Dodiya's memorable painting, *Highway: For Mansur*, was first shown at his 1999 Vadehra Art Gallery solo exhibition in New Delhi. The painting is dominated by a pair of vultures, a quotation culled from the folios of the Mughal artist Ustad Mansur; the birds look down on a highway that cuts diagonally across a desert. The decisiveness of this symbol of progress is negated by a broken-down car that stands right in the middle of it. The sun beats down on the marooned driver, whose ineffectual attempts at repairing his vehicle are viewed with interest by the predators. In the lower half of the frame, Dodiya inserts an enclosure in which a painter, identifiably the irrepressible satirist and gay artist Bhupen Khakhar, bends over his work. Veined with melancholia as well as quixotic humour, this painting prompts several interpretations. Does the car symbolise the fate of painting as an artistic choice, at a time when new media possibilities were opening up; is the car shorthand for the project of modernism? Or is this an elegy for the beat-up postcolonial nation-state, becalmed in the dunes of globalisation? In an admittedly summary reading, *Highway: For Mansur* could be viewed as an allegory embodying a dilemma that has immobilised the artist, even as he contemplates flamboyant encounters with history in the confines of his studio. Should Dodiya retrieve the elegiac high-seriousness of the past symbolised by the courtly Mansur; or should he align himself instead with the defiant, playful Khakharesque avant-garde, risking his claim to posterity on a precarious wager?[1]

Contrast Dodiya's painting with a recent, untitled video work by Shilpa Gupta, extracted from an ongoing series concerning the contamination of everyday life by militarisation and shown at the *7th Gwangju Biennale* (2008). Gupta shot her video while driving from Srinagar to Gulmarg along National Highway No. 1 in Kashmir, a region over which Indian forces, Pakistani irregulars and Kashmiri militants have fought with increasing ferocity since the early-1990s. The subject matter of the video seems, at first sight, to be perfectly innocuous: we are presented with a blurred, continuously unfurling view of fields, trees, scattered buildings and sky. Over the visuals, the car radio and the polyglot cross-talk of the vehicle's occupants compete for aural attention. But the video is interrupted with metronomic regularity; each time this happens, the image seizes up, the sound-track hangs in raucous mid-note. The cause of each such interruption is identical: every few yards, the camera spots a soldier, one of nearly 500,000 deployed throughout the Valley of Kashmir; the video is programmed to alert us to the brutal militarisation of a landscape once synonymous with idyllic beauty. In Gupta's work, we find ourselves addressed by the artist as decisively politicised subject. She acts as documentarist and commentator, and as an undercover agent who does not produce propaganda but conveys the urgencies of a conflict zone through a visual meditation that is paradoxically subtle yet declarative, ironic yet passionate, ostensibly objective in its transcription of a quotidian act of passage yet empathetically partisan in its oblique portraiture of a site of oppression and anguish.[2]

Dodiya (born 1959) is a major presence in the generation of Indian artists that came to prominence during the mid-1990s; Gupta (born 1976) is an equally key figure in the generation of artists that has come to prominence since the turn of the century. While Dodiya has established a strong national context for his work with major international shows only since 2001, Gupta's trajectory has followed the opposite course; her work has been shown widely on the international circuit and only recently has been presented at home. And although their careers overlap and their works have been shown together in a number of survey exhibitions internationally, the distance between their thematic concerns and formal choices is instructive. It is not merely symptomatic of the difference in outlook and opportunity between two generations. Taken as two ends of a spectrum, Dodiya's homage to Mansur/Khakhar and Gupta's Kashmir video allow us to chart the dramatic transition that has taken place in contemporary Indian art during the last decade. I will reflect on some of the major aspects of this transition, writing as one who has participated intensely in the contemporary Indian art situation since 1988 as critic, theorist and curator, but also as a friend and co-conspirator, with artists in various image-making and discursive adventures.

The Market and the Margins
The global attention contemporary Indian art has received in recent years has been focused mainly on the boom in the Indian art market. While such dazzling visibility might possess tactical value in the short run, it will eventually be exposed as premature and specious. Premature because the boom has largely been the result of steep escalations in price orchestrated by the interests of a narrow collector base; specious because the volumes

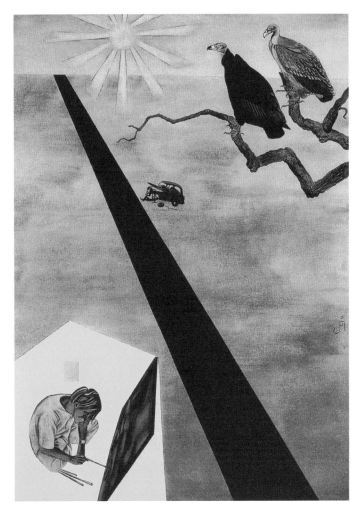

Atul Dodiya
Highway: For Mansur 1999
Oil, acrylic and marble dust on canvas
213.3 x 152.4 cm

public question of environmental change; Amar Kanwar, who addresses the complex politics of violence in the Indian subcontinent; and the Raqs Media Collective, whose three members combine a commitment to dissent and its defence with their articulation of plural, layered narratives of place and belonging as a guarantee against the monopolistic claims of religion, nation and State. Agarwal, Kanwar and Raqs were all, interestingly, first presented in the context of international contemporary art by Okwui Enwezor in his artistic direction of *Documenta 11*, 2002.

If I were to describe the changing ecology in which Indian art has developed during the last decade, I would annotate the Indian art market boom as reflecting a resurgent economy and identify it as only one among four key vectors of change, the other three being: the schisms and scissions within the Indian nation-state, which have altered the textures of public life and the scope of cultural expression; newly available media and technologies of image-making and communication; and transcultural experiments in travel, dialogue and collaboration.

Although the first decade of the 21st century is not identified with any single, major political event (as the 1990s were with the cataclysmic violence following the destruction of the Babri Masjid in Ayodhya, 1992), this period has borne witness to the deepening of the schisms that afflict India. While the ascendancy of the Hindu-majoritarian Bharatiya Janata Party was broken electorally by the centrist Congress Party and its allies in 2004, the national debate remains sharply polarised. An aggressive, upper-caste Hindu majoritarian movement claims the ground of hypernationalism; it is opposed by equally assertive subnational movements and lower-caste mass mobilisations. Since successive governments have followed a policy of even-handed populism, aimed at appeasing the ultra-orthodox in every community, the general tenor of public life has grown illiberal, intolerant of dissent or idiosyncrasy. This has had a particular effect on the artist's claim to intervene in the national debate; the artist's freedom of expression has been infringed repeatedly by the discourses of politicised religiosity and ethnic pride, most viciously in the case of M F Husain, a foundational figure in the history of modern Indian art. The nonagenarian painter, writer and film-maker has been self-exiled in the UK and the UAE, due to a sustained campaign of legal harassment and mob violence by the Right. At the same time, wresting opportunity from catastrophe, many artists have been prompted by the situation to mobilise alliances with writers and cultural activists to organise platforms of protest against illiberalism and censorship.[3]

of trade diminish to their correct measure when viewed, for instance, against the corresponding international auction house sales figures for contemporary Chinese art. It is also specious because much of the compelling work of the imagination in India is being conducted beyond radar range of the market, at those richly productive margins where a self-critical art practice bypasses the studio-gallery-auction house circuit to forge solidarities with other disciplines and cultural practices.

This rubric embraces not only video and intermedia art, but also social projects and new-media initiatives, interfaces between image-making, pedagogy and activism, and research and archival projects. Within *Indian Highway*, this tendency in contemporary Indian art is represented by Ravi Agarwal, who attends closely to the crises of ecological devastation and the important

Alongside these political developments, Indian artists suddenly found themselves in possession of newly available technologies of imaging and communication from the late-1990s onward. The advent of advanced video technology, the Internet, graphic interfaces, virtual-reality software and digital retrieval systems has amplified the scope of artistic production and also, crucially, transformed the nature of artistic practice. For many artists, the work of art has been rendered unstable, versional, re-programmable and open-ended; it is no longer the irreducible summation of a process so much as it is a provisional statement of the process, not a destination but a log entry.[4]

The globalisation-era potential of the Indian art world was most productively realised in the variety of transcultural experiments in dialogue, encounter and travel beginning in the late-1990s. With agencies like the Japan Foundation, Goethe-Institut, Triangle Arts Trust and Prince Claus Fund underwriting these experiments, Indian artists, critics, theorists and curators benefited enormously from the cross-fertilisation of ideas that took place in residencies, workshops, conferences, collaborations and exchanges held both in India and overseas. The most revolutionary outcome of these transcultural experiments was the transformation of perspective for an entire generation of Indian artists who abandoned the colonialist centre-periphery model of the world – in which the West was always the donor and the non-West always the recipient of contemporary culture, marked by belatedness, imitation and permanent apprenticeship – and became socialised into the world as an assembly of multiple, improvisational, self-renovating modernisms, a conversation among regional trajectories of the contemporary.[5]

The Changing Locus of the Studio
One of the most palpable changes that took place in Indian art practice during the early years of the 21st century was the transformation of the studio. Until relatively recently, most artists worked in single rooms hived away from their homes or in close proximity. Now many artists, such as Bose Krishnamachari and Riyas Komu in Mumbai, have found it possible and indeed necessary to extend their studios into factory-style production lines, with work departmentalised and delegated among an army of assistants. For another kind of artist, such as Ashok Sukumaran, the studio has become portable, virtual and tactically mobile: often no larger than a laptop opened up and worked on in airport lounges and while on residency in remote parts of Europe or North America; often, the studio has no materiality beyond an exchange of drafts and diagrams via email. And yet, both for Sukumaran and Shaina Anand, his collaborator in a series of social and community-based projects, public space often becomes

the widest possible studio space: they tune into social relationships, trace the contours of political asymmetries of access over sidewalks and hydrants, map the invisible metropolitan architecture built around electrical connections and cable television networks.

The economies of making in which Indian artists now operate may usefully be described by the opposition of distribution and delegation. By distribution, I mean a participatory process of art-making that is fundamentally democratising and transformative; that empowers its participants with information, skills and a potential autonomy; that activates an audience. Under this rubric, I would place the Raqs Media Collective, the Cybermohalla initiative undertaken by Sarai in the shantytowns of Delhi, the discursive platforms orchestrated by CAMP (Critical Art and Media Practices) in Mumbai, and the *Periferry festival* of the arts organised by the collective, Desire Machine in Guwahati, in turbulent north-eastern India. In all these projects, expressive and critical activity fold into one another; collaborations among artists, theorists, curators and activists are encouraged; and an effort is made to convene a new and engaged audience for cultural practice from among various social classes. The work of art, in this sector of the contemporary Indian art scene, is emphatically a verb rather than a noun.

Delegation, on the other hand, implies the production of individual art works whose realisation – for reasons of scale or technical complexity – requires mixed teams of art-school-trained assistants, technicians and labourers. While its apologists present this tendency as a return to the 16th-century atelier, it is really a simple industrialisation of art practice inspired by the practices of 20th-century monumental sculptors, functioning between studio and factory. This operational method is a response to the voracity of collectors, to cavernous exhibition spaces and the pressures of a career that typically begins with art school recruitment and is pursued by complex negotiations with dealers, gallerists, collectors and investors across the globe.

The Collaborative Production of the Contemporary
The artists represented in *Indian Highway* are participants in defining the contemporary – collaboratively produced across the abandoned borders of Cold War geopolitics. As we escape the conventional narrative of Modernism and the contemporary as universally executable programs exported across the planet from art world institutions of Western Europe and North America, we realise the global contemporary proceeds from highly differentiated starting points, from vigorous theatres of the Now being staged in Abidjan and Buenos Aires, Jakarta and Mumbai, Rabat and Beirut, Seville and New Orleans,

Manila and Ljubljana. The contemporary is a series of entanglements among diverse histories of political struggle, cultural vision and artistic exploration. In this context, the Indian art situation offers an extraordinary traversal of choices and temporalities.

With four generations of artists working simultaneously and prodigiously, and subscribing to one or another of at least five major perspectives, contemporary Indian art is festive in its diversity. The gamut includes artists whose work has evolved from critical apprenticeship to the Schools of Paris or New York and found anchorage in a renewed classicism or a renegotiated Sublime (M F Husain, Akbar Padamsee, Tyeb Mehta, Mehlli Gobhai); artists who formulate a language reflecting the local and immediate, mapped onto sophisticated and historically informed references to the 1960s Western avant-gardes (Nalini Malani, Sudhir Patwardhan, Rameshwar Broota, Gulammohammed Sheikh); artists whose subtle politics of self has inspired them to combine autobiography with allegories of the nation-state (Atul Dodiya, Surendran Nair, Subodh Gupta, Dayanita Singh, Gargi Raina); artists who deconstruct fixed identity through the ambiguities of plural belonging, often in risky, performative modes (Bharti Kher, Nikhil Chopra, Tejal Shah); and artists who confront terror in an epoch whose leitmotifs are occupation, torture, surveillance, migration and genocide (Krishen Khanna, Baiju Parthan, Praneet Soi, Sumedh Rajendran, Riyas Komu).

Such entanglements, which I have elsewhere described as forming 'continents of affinity' mapped in contradistinction to nationalist and Cold War geography, are increasingly being recorded by new curatorial and theoretical frameworks emerging from India. Significantly, 2008 marks the first time major biennales were co-curated by Indians – *Manifesta* by the Raqs Media Collective and the *Gwangju Biennale* by me.[6]

Correspondingly, the rubrics of debate have changed. The tedious themes that dominated much discourse in the Indian art world between the 1950s and the 1990s have been rendered irrelevant. The anxiety of national identity, typically phrased in the form of apocalyptic binaries such as 'Indianness v internationalism' or 'tradition v modernity', has receded; the chimera of auto-Orientalism, with its valorisation of a spurious 'authenticity', to be secured as the guarantee of an embattled local against an overwhelming global, has been swept away. I speculate the vacuum left behind by this lapsed, unproductive rhetoric will gradually be filled by awareness that transcultural experience is the only certain basis of contemporary artistic practice. As the cultural theorist Nancy Adajania and I have argued elsewhere, transcultural experience – and the corresponding stance of 'critical transregionality' – gives the cultural practitioner 'strategic and imaginative freedom … to link regions on the basis of elective affinities arising from common cultural predicaments, jointly faced crises, and shared choices of practice.'[7] This is not a means of escaping the urgencies of the globalised local; rather, it underwrites a responsible and responsive encounter with the contemporary with all its multifarious provocations. The Indian highway is a work in progress; it has, to paraphrase the visionary modernist poet Mohammed Iqbal, 'many more horizons to traverse'.
— *Gwangju, October 2008 – Mumbai, November 2008)*

[1] For a discussion of *Highway: For Mansur* and the suite of paintings of which it forms a part, see Ranjit Hoskote, 'An Autobiography in Fifteen Frames: Recent Works by Atul Dodiya' (exhibition catalogue essay; New Delhi: Vadehra Art Gallery, 1999).

[2] For a discussion of Gupta's works based on the situation in Kashmir, see Nancy Adajania, 'A Shadow in Search of a Body' (Introduction to *Shilpa Gupta*; Mumbai/New Delhi: Sakshi Gallery & Apeejay Media Gallery, 2007).

[3] For an account of the foundational proposals of postcolonial India, framed through the debates among Mahatma Gandhi, Rabindranath Tagore and Jawaharlal Nehru, among other thinkers, see Sunil Khilnani, *The Idea of India* (New Delhi: Penguin, 1998). For a study of the major social and political developments that have taken place in India since Independence, see Ramachandra Guha, *India after Gandhi: A History of the World's Largest Democracy* (New Delhi: Picador, 2007).

[4] For a detailed account of technological change and its effect on Indian art practice, see Ranjit Hoskote, 'The Elusiveness of the Transitive: Reflections on the Curatorial Gesture and Its Conditions in India', in Joselina Cruz et al eds, *Locus: Interventions in Art Practice* (Manila: National Commission for Culture and the Arts, 2005), pp 225–37.

[5] For a substantial account of the opening up of transcultural exchange and dialogue, and its formative influence on the younger generation of Indian artists from the late 1990s onward, see Nancy Adajania, 'Probing the Khojness of Khoj', in Pooja Sood ed, *Ten Years of KHOJ* (New Delhi: Harper Collins, forthcoming 2009).

[6] Ranjit Hoskote, 'Scales of Elaboration', in Okwui Enwezor ed, *Annual Report: A Year in Exhibitions* (curatorial essay in the exhibition catalogue of the *7th Gwangju Biennale*; Gwangju: Gwangju Biennale Foundation, 2008), pp 40–53.

[7] See Ranjit Hoskote, 'Retrieving the Far West: Towards a Curatorial Representation of the House of Islam', in Shaheen Merali ed., *Re-Imagining Asia: A Thousand Years of Separation* (London/Berlin: Saqi & Haus der Kulturen der Welt, 2008), p 121.

RANJIT HOSKOTE

Nataraja Siva as the Lord of the Dance
Madras, India, 10th century
Bronze

CONTEXTUALISING THE CONTEMPORARY

In India, tradition is generally understood as elastic, constantly evolving and reinvigorating. In contrast, there is a certain Western tradition that is considered unchanging, outmoded and static. These distinctions present an unusual cultural paradigm and, consequently, Indian art forms are communicated with an enduring consciousness of these past traditions as relative to the ever-changing present.

Although Indian art does not manifest a seamless history from the prehistoric urban civilisations of Mohenjo Daro to the present, there are definite continuities of style and form. In *Indian Highway*, continuity is most discernable in the exterior continuous painting by M F Husain, with references to both traditional and Modern Indian imagery. The contemporary artists presented in *Indian Highway* could be seen as the most recent manifestations of an unbroken tradition sustained for five thousand years − many of their practices are infused with a traditional iconography. For instance, N S Harsha references the social and political role of Indian miniatures with a contemporary inflection.

Art is one of the principle agencies through which Indian society has perceived and defined itself. Through consecutive incursions, the assimilation of techniques, materials, ideas and forms have been selective, meaningful, creative and, often, highly original. Indian art through the centuries manifests a palimpsest of influences with unbroken formal and stylistic characteristics traced to the earliest phases of urban civilisation. For example, one of the oldest sculptural pieces in India is a bronze figurine of a dancing girl. She stands, right hand on hip, knee bent, hip thrown out in one direction and her head counterbalanced facing the other way. Known as a tribhanga pose, this posture typifies the Indian female figure as depicted in 12th-century Chola bronzes. Apparent in successive centuries, the *tribhanga* pose infiltrates both contemporary sculpture and painting, as evidenced in Husain's works.

As a member of the Progressive Artists Group, the first cogent group of artists in the postcolonial Indian period, Husain and the Progressives projected themselves simultaneously as the newest expression of tradition and as instigators of revolutionary conventions establishing the precedent for contemporary Indian art practice. This awareness that tradition offered formal and stylistic direction enabled the Progressive Artists to evolve a modernism unique to India. The Progressives did not reject tradition in favour of a more exotic other, but

accessed, assimilated and incorporated tradition to evolve a new visual culture. Exquisitely refined artistic traditions as well as popular cult imagery, vibrant folklore, myth and legend infiltrated and enervated Indian Modernism.

Contextualising Indian Art
Early Indian art was produced for practical, ritual use in the service of religious architecture and functioned through the symbolic power of divine forces, which were contained and represented in sculptural and painted forms. Sculpture was the more sensuous and vigorous, counterbalanced by painting, which was more lyrical and tender. The distinction between two- and three-dimensionality was intentionally blurred in cave paintings, which like the subsequent temple sculptures demonstrate the synaesthetic intention of Indian art and exhibit the syncretic use of a multi-layered media. There is a notable absence of recession; instead all of the figures advance towards the eye so as to engulf the viewer. This visual equivalent of *surround sound* is the result of the controlled use of almost equal tones. Directional light is absent and figures appear to bask in their own light. The full effect is complete only when all the senses work in harmony and the eye is subordinated to the totality.

Wall paintings and temple friezes were created for an audience un-conditioned to the linear reading demanded by text. Instead, these forms were intended to be perceived by scanning. Piecemeal scans facilitate the shifting viewpoint and multiple perspectives of the continuous narrative. Multiple images compress the scheme into a simultaneous description of various actions and past, present and future are concurrently apprehended. Contemporary experiments in cognitive psychology have demonstrated that scanning vision imposes its own non-linear scheme on narrative technique. The eye moves from centre to periphery, alternating regularly to yield a spiralling path through the image without coming to rest at the centre, in accordance with the Indian concept of time. Stylistic logic demanded that movement and gesture be described in terms of the space in which they occurred. The result is every thing is foregrounded; everything is simultaneous, existing in the eternal present. Time and existence were not conceived of teleologically but as a system of interconnected cycles with the past coexistent to the present. This belief encourages the sympathetic referencing of tradition. Although creating images did not compete with the divinity, linear perspective did. The concept of linear perspective and a vanishing point was deemed unimportant

since humanity was not the centre of the universe: that position was reserved for the Supreme Being. Whereas time was the principle of change, space was seen as the principle of conservation.

From the third century AD, texts were compiled on the origin of art to illustrate a divine source and interrelation of the arts. Art forms were categorised dependent on whether they elicited visual or auditory sensations or a combination of both. According to myth, and eloquently phrased in the *Visnudharmottarapurana* in the story of King Vajra, the arts are interrelated and knowledge of one presupposes knowledge of the others. The pious and devout ruler, hoping to make his own idol, asks the sage Markandeya to reveal the secrets of image-making, principles closely guarded by priests and art guilds. Though the sage appreciates the king's sentiments and his position, he enquires if the king knows the techniques of painting. The king confesses he does not, but asks to be taught painting as a pre-requisite to learning sculpture. The sage informs the king that to learn the basics of sculpture one must first learn to dance. To learn dance, one is required to have rudimentary knowledge of instrumental music, which in turn needs a foundation in vocal music. King Vajra comes to understand how painting is related to sculpture, sculpture to dance, dance to drama, drama to poetry and poetry to music.

Notwithstanding this interrelationship between the forms, each art conformed to its own specific canon of creation and appreciation, which in turn, were codified in specialised treatises, compiled both for priestly theoreticians and to provide practical advice for artistic production. Significantly, this did not curtail the artist; rather the strictures were liberating, encouraging time-honoured forms that reiterated, glorified and perpetuated the Cosmic Law maintaining all life.

The codified texts also counselled the viewer in aesthetic appreciation, introducing the notion of *rasa* (aesthetic pleasure or rapture) first described in the *Natyasastra*, the treatise on dramaturgy written by Bharata, who enumerated the elements *gunas* (virtues), *dosas* (faults) and *alamkaras* (ornaments), aided in the development of *rasa* and anticipated modern theories of semiotics. These elements were the source of the fundamental features which, singly or in combination, continue to characterise Indian art: ornamentation, narrative and figure.

Rasa, with origins in the theatre, was challenged, extended and elaborated over the centuries to embrace other arts.[4] *Rasa* theory expanded to facilitate a semantics of emotive communication by equating different colours and gestures to a range of human emotions and further treatises demonstrated that *rasa* was dependent on a amalgamation of *bhavas* or emotions and were elicited in complex combinations by a work of art. In spite of the demands of this multi-faceted connoisseurship, Indian aesthetic theories were resolute that the prerequisite of an informed viewer did not presuppose art to be the purview of an elite minority. Art was integral to ordinary life, just as it is deeply woven into both the religious warp and secular weft of India.

Rather than being constrained by formulaic interpretations, art forms were liberated by the introduction of the concept of *dhvani*, which privileged the notion of suggestibility and layered meanings. *Dhvani* emphasised subtle aspects of art, beyond style, to generate subjective interpretations. According to the combined theory of *rasadhvani*, aesthetic pleasure was independent of art's imitation of an external reality. Rather, art was successful if it led the spectator to a state of mind freed from the perception of both reality and imitation.

A truly aesthetic object stimulated the senses while exciting the imagination and transporting the viewer. Successful art possessed not just *abhida* (literal meaning) and *laksana* (metaphorical meaning) but also *vyanjana* (suggested meaning). *Rasadhvani* affirmed that artistic communication was achieved through the act of artistic creation and the intentionality of the artist. The fundamental assumption was that communication was the basic function of a work of art; therefore *rasadhvani* allocated equal responsibility to the genius of the artist and the perceptive acumen of the spectator. *Rasadhvani* encompassed the depiction, inference and transmission of emotion through art. Although the artist was of prime importance in suggesting a particular emotion, the viewer was equally as important because of his perceptibility to suggestion.

The intimate relationship between painting and sculpture nurtured over centuries devolved with the Islamic catalyst. This was a divergence that resulted from an altered world-view and manifested itself in an efflorescence of painting, which combined the best of the Persian *qalam* (literally, pen) with indigenous practice under the courtly patronage of the Mughals. At its height, Mughal art exhibited an urbane wit and elegance and a documentary recording of courtly pursuits. Mughal miniatures embraced linear flattening, multiple perspectives and reduction, heralding a phase of a high artistic refinement.

Colonial art education signalled a change in patronage and shifting tastes and presented artists with a significantly altered world-view; consequently, the imitation of reality became paramount. Like previous cultural upheavals, India's encounter with colonialism was far

more complex than a simple polarisation of attitudes.[6] The subject matter, theme and medium of art changed and with them, the status of the artist. Art was used to record new experiences but it also served to reinforce older paradigms. During this period, the strength of the visual image in forming a pan-Indian identity was fully exploited and art began to play a critical role in the political struggle for independence. Throughout, village and tribal art forms continued to engage with tradition and to invigorate Indian artists. These art forms maintained a more direct approach and immediate appeal.

Towards the contemporary
Hybridity and the eclectic appropriation of tradition produced rich art forms reflecting the pattern and rhythm of Indian life and highlighting the relationship and interdependency between *purush* (man) and *prakriti* (nature). Art continued to be a celebration of the multiplicity of life and form; its principle focus remained the cosmos in all its profusion. In a society largely dependent on oral transmission, art provided a visual means to reinforce the philosophies of everyday life in the service of religion. Sculpture especially confirmed the multi-dimensional hierarchy of interdependence in Indian society. Each body and hand movement was imbued with meaning to create a language of motion to impart the sacred myths while promising the transcendence of mundane human existence to an ultimate divinity.

Rich treatises on art, artistic traditions and techniques were preserved for generations by means of oral transmission. Each artistic guild communicated and conserved both the paradigms of art and their own specific stylistic secrets through the *guru shishya* organisations which encouraged apprenticeships and promoted workshop structures. Accordingly, the language and terminology of *rasadhvani* pervaded the vernacular languages of India, ensuring its endurance and continued relevance.

Rasadhvani's acknowledgement of individuality, for the artist as well as the viewer, makes the concept relevant to 21st-century critics and artists. In the 20th century, this principle was echoed by Marcel Duchamp, both with his exposition of the urinal and his recognition that the creative act was not performed by the artist alone – that engagement with a work of art presupposes a form of interpretation. Both viewed the artistic creation as the agent of a dialogue between the artist and the informed spectator. Accordingly, a lack of communication between the artist and the viewer may result not only from poor artistic quality but also insensitive spectatorship. The responsibility for communication or lack thereof, lies equally with the artist and the viewer.

The traditional focus on line and narrative is contemporised by Harsha, who often incorporates everyday rites and rituals with global events. This personal idiom is assembled from a combination of Mughal, Rajasthani and Pahari sources assimilated within a contemporary context and incorporated with Ajanta and Mattancheri mural techniques. In *Indian Highway*, Harsha's wall painting recalls these traditional cave paintings and marries successfully with the contemporary format of the miniature, investing it with a sense of monumentality, as he does all his paintings regardless of size.

The interpretation of works of art that originate in cultures unfamiliar to one's own is a difficult but not insurmountable process. Cultural specificities can be explained and world views can be translated. However, as the theories of deconstruction have illustrated, insight into different cultures is not a natural process and aspects are lost in translation; nowhere is this better exemplified than in the visual arts with their inherent difference of signifiers. The pervasive use of symbols and signifiers in Indian art is vital to decoding a world of impermanence and illusion.

Ideas from Indian religions include such concepts as *maya*, which deems reality to be a function of the mind limited to the purely physical in which everyday consciousness becomes entangled. This concept of reality and illusion continues to the present day, not as a doctrine but as an attitude towards life. It is articulated and nuanced in the video works of many Indian artists whose works highlight contemporary manifestations of the concept of *maya*. Video art is an accentuation of two-dimensionality and illusion. As such, it demands an immersion from the viewer and an absorption into its continuous narrative structure, much in the same way as sculptural friezes dating from the third century BCE, made in the service of Buddhism. Ancient artists, like their contemporary counterparts, did not depict reality, but the friezes are replete with naturalistic details, demonstrating keen observation and exhibiting many of the qualities that were to become distinctive features of Indian art. Stupa and temple friezes evidence an abundance of human, animal and plant motifs and the characteristic continuous narrative structure. The video works in *Indian Highway* are merely contemporary expressions of a continuous narrative.

In Internet age, access and concomitant ease of travel, international influences have been absorbed, incorporated and assimilated with unprecedented immediacy. Indian artists reflect local concerns using global languages and *vice versa*, weaving contemporary narratives into traditional formats. The continuing relevance of figure, narrative and ornament, the fundamentals of Indian art,

are today refracted through institutional education, shifting patronage and identity politics.

Indian Highway is a testament to the indispensability of tradition and the unique sanctuary and re-invigoration that tradition allows. This living tradition permits the past to co-exist with the present and is constantly being reshaped by contemporary artists. Each innovation re-inflects the language inherited from the past. Tradition is used as a catalyst and not considered a monolithic force. Contemporary Indian artists recognise tradition for what it is – not a seamless, unchanging, unified entity, but rather, a continuously evolving, consciously invented and regularly improvised phenomenon. They recognise that the notion of tradition is rooted in social life rather than time alone and that traditions are created through the selection of certain historical events and invented pasts.

SAVITA APTE

[1] From the prehistoric Indus Valley civilisation of Mohenjo Daro 2300–1750 BCE.

[2] Known either as the Progressive Artists Group or the Bombay Progressives, the group was instigated by F N Souza and comprised of M F Husain, S H Raza, H A Gade, K H Ara and S Bakre. For an exhaustive account of their antecedents and their role in Indian modernism see S Apte, *Unchallenged Dichotomies: Modernism and the Progressive Artists Group*, unpublished PhD thesis.

[3] See *The Psychology of Graphic Images* by Manfredo Massironi

[4] Most notably by Abhinavagupta c 975–1025.

[5] See Jhanji, R *Aesthetic Communication*, Munshiram Manoharlal, Delhi,1985 for a more detailed account of the various theories of aesthetics as well as a chronological analysis of the commentaries that led up to the rasadhvani theory.

[6] See Gayatri Spivak and Homi Bhabha who have rewritten the colonial encounter and re examined post coloniality.

[7] Marcel Duchamp, from *Session on the Creative Act*, Convention of the American Federation of Arts, Houston, Texas, April 1957

Iftikhar and Elizabeth Dadi
Magic Carpet 2005
Light bulbs on painted metal
178 x 87 x 10 cm

CONTEMPORARY
PAKISTAN

INVESTIGATING TRADITION, INTERROGATING THE POPULAR

Contemporary art from Pakistan refers to an increasingly diverse range of media, themes and practices, so attempts to summarise its valences are tangential and reductive. Nevertheless, one can identify two salient threads from the last two decades – the interrogation of 'tradition' and the exploration of 'popular' culture.

Until the early-1990s, most Pakistani artistic practice was late-Modernist. Its modes encompassed formalism and abstraction, calligraphic modernism, landscapes and deployment of regional or historical symbols. Its achievements included the fashioning of a deep sense of artistic subjectivity; use and transformation of the language of transnational Modernism to create works that provided metaphoric analogues to existential and social dilemmas; and the formation of a durable field of art within patronage structures, audiences and institutions. While most art moved between studio-gallery-collector circuits, some artists created public works and critical statements to create new audiences through social interventions.

Since the 1970s, a constellation of crises precipitated the emergence of contemporary practice in the early-1990s: The rise of Islamist politics was given state support during General Zia's reign, 1977–88; the rise of women's activism (including prominent women artists such as Salima Hashmi and Lala Rukh) in the 1980s resisting Zia's directives against women's rights; the restoration of an unstable democracy, 1988–99; IMF- and World Bank-led privatisation and the growth of sprawling mega-cities; large migrations to the Arab world and the West; the arrival of global satellite TV in the early-1990s and later the Internet; and the impact from international curators, biennials and galleries.

The emergence of newer media and post-medium approaches have arguably enabled a more sustained critical and direct social address than was possible with earlier Modernism. Group exhibitions especially in the UK, such as *Intelligent Rebellion: Women Artists of Pakistan*, 1994[1]; *Tampered Surface: Six Artists from Pakistan*, 1995[2]; *Pakistan: Another Vision*, 2000[3]; *ArtSouthAsia*, 2002[4]; and *Beyond the Page: Contemporary Art from Pakistan*, 2006[5], signpost the development of contemporary art. Artist, author, teacher and curator Salima Hashmi has been key in fostering the contemporary art scene. In Islamabad, the National Art Gallery's inaugural exhibition, 2007, showcased numerous artists' works from a variety of curatorial viewpoints.

One might trace the rise of contemporary Pakistani art to the crucibles of Karachi and Lahore. A city pregnant with memories of Mughal art and architecture, Lahore is also home to key colonial and postcolonial educational institutions, most notably the National College of Art (NCA – formerly the Mayo School of Art, founded c.1881), the Punjab University Department of Fine Arts (founded in 1940), and the recent School of Visual Arts at Beaconhouse National University. Thus much contemporary practice emerging from Lahore has engaged with 'tradition', most visibly in the rise of new miniature painting from the early-1990s at the NCA, which had been taught at the NCA for decades. By the 1980s under the pedagogy of Zahoor ul Akhlaq – an artist interested in the miniature's conceptual architecture – converged with other aesthetic and social frames. Students began fracturing the traditional narrative and space of the miniature, which already possessed considerable narrative, arabesque and allegorical potential. A generation of artists trained in the exacting Persian, Mughal, Rajput and Pahari styles transform these traditions to critically interrogate contemporary uncertainties, often productively with other media. Shahzia Sikander has placed the miniature form in dialogue with postmodern and post-national identity. Aisha Khalid has incisively explored gender, confinement and interiority via the ornamental and decorative schemas of the miniature. Saira Wasim has created potent allegories of contemporary geopolitics based on Mughal archetypes. Meanwhile, Imran Qureshi has painted miniature forms directly on architectural spaces, escaping the confines of the page and rendering a transcendent form into everyday space.

Significantly, many Pakistani artists are globally dispersed, participating in international art discourses. The exhibition *Karkhana: A Contemporary Collaboration*, 2005–6[6], has signposted the global spread of the miniature by exhibiting the work of six miniature artists living in Pakistan and abroad. Many Lahori artists not formally trained in the miniature use its conceptual modalities. Rashid Rana's photographic mosaics – which assemble dissonant images to compose larger images of nationalism or 'tradition' such as military parades, carpets or landscape paintings – deploy a miniaturist sensibility with a minimalist phenomenology of perception to index underlying conditions of everyday life subsumed by the overall image, while addressing both 'tradition' and the 'popular'.

A port city that grew uncontrollably, becoming a megalopolis, Karachi possesses few historical markers as the commercial capital of Pakistan. Democracy was restored in 1988, which accelerated the rise of non-state groups but brought little relief to Karachi. During the manifold crises of the 1980s and 1990s – the economy was severely depressed, bloody violence between the government and identitarian political groups was rampant, and a charged atmosphere of threat permeated the streets – it became clear to some artists that while the nation-state was an important frame against which much of this unfolded, it was but one actor engaged in struggles that were local as well as transnational. A critical artistic modality striving to address contemporary predicaments emerged. Along with Elizabeth Dadi and others, my own practice during the 1990s engaged the 'popular'. We attempted to articulate a post-conceptual practice in dialogue with the vitality of popular urban visualities to create photography, sculpture and installations commenting on the visual theatrics of violence, urban identity, and critique of nationalisms. Initially few local opportunities and little critical reception existed for this work but interest from outside was encouraging.

The Karachi-based artist Naiza Khan similarly ventured into popular urban motifs with henna silhouettes of the female figure using intricate ornamental stencils – applied directly on graffiti laden city walls, acknowledging the fragile presence of women in public. The equation of Lahore with tradition and Karachi with the popular is, of course, schematic and often productively breached. For example, Farida Batool also explores gender and nationalist-inflected themes in everyday life in Lahore in her incisive lenticular photographs and videos.

The establishment of the Indus Valley School of Art and Architecture (IVS) in 1989 provided training for artists in Karachi with an emphasis on the popular. While some efforts have been anthropological and celebratory, other practices critically address contemporary predicaments. IVS graduate Adeela Suleman has developed an ensemble of absurdist motorcycle helmets and biomorphic forms from cooking utensils, visualising the role of the female body in everyday urban modernity. Samina Mansuri, an influential teacher at IVS during the 1990s painted organicist metaphors of the female body. Her more recent work, executed in Canada and the USA, reconfigures these as futuristic cyborg and post-human figures within wall-drawing installations of architectural forms.

It is pertinent to briefly situate links between India and Pakistan via art. Many key Pakistani Modernist artists were raised in India and retained numerous affiliations and memories. Artists from both countries occasionally travelled and exhibited across borders in the 1970s and 1980s, despite poor official relations. Suketu Mehta has provocatively noted that both nations are locked in an impossible relationship of 'fatal' intimacy, in which hostility and threat of destruction is sympathetic of their unbearable closeness. Contemporary artists who explore Pakistan's complex ties to India thus do so without affirming either a forced harmony or a complete separation, but rather retain or even sharpen the dialectical edge. They include Bani Abidi, who divides her time between India and Pakistan and whose video installations and digital prints interrogate Pakistani nationalist myths at the popular level. Hamra Abbas has reworked Islamic arabesque patterns and Rajput erotic forms to comment on the aporias of personal and national identity, alienation and violence in relation to India and Islam.

Broader exchange of artists, exhibitions and works is a welcome development in the current period. The Indian curator Pooja Sood has played a key role in supporting many such interactions within South Asia. *Mappings: Shared Histories, A Fragile Self*, 1997[7], an exhibition which brought three artists each from Pakistan and India to comment on the fiftieth anniversary of Independence / Partition, toured both countries. *AarPaar*, ongoing since 2000, has subverted official restrictions by sending works electronically across borders to be produced and displayed locally. The exhibition *Beyond Borders: Art from Pakistan*, 2005[8], brought a range of modern and contemporary art to Indian attention. During the last decade, Pakistani artists have attended residencies and workshops in India, and have exhibited with Indian galleries and alongside South Asian artists within South Asia and aboard. Indian collectors have provided Pakistani artists with much needed support. All this suggests that the highway metaphor is being productively extended beyond the national borders of South Asian countries.

Despite the political and economic travails Pakistan has experienced over the last two decades, contemporary art practice remains charged with increasing boldness and innovation. The need for good critical and art historical approaches to situate and productively contest its development however, remains pressing.

[1] Cartwright Hall, Bradford Museum.
[2] Huddersfield Art Gallery; Oldham Art Gallery; and other venues.
[3] Brunei Gallery, London; and other venues.
[4] Harris Museum and Art Gallery, Preston.
[5] Manchester Art Gallery; and Asia House, London.
[6] The Aldrich Contemporary Art Museum, Ridgefield, CT; and Asian Art Museum, San Francisco, CA.
[7] Eicher Gallery, New Delhi; Gallery Chemould, Mumbai; and NCA Gallery, Lahore.
[8] National Gallery of Modern Art, Mumbai.

IFTIKHAR DADI

T Shanaathanan
The One Year Drawing Project: May 2005–
October 2007 (detail), 2007
Charcoal on paper
29 x 21 cm

CONFLICTS OF INTEREST

Surveying the published material about cultural activity in Sri Lanka reveals a significant, if curious, discovery. One finds, books on the country's rich archaeological heritage, usually hard-bound and into third or fourth editions; lavish coffee-table volumes of landscape and wildlife photography; a small but significant handful of photo-journalistic accounts of the war; several scholarly tributes to the eminent architect Geoffrey Bawa; one or two artfully produced books documenting the country's architectural history; a handbook on Sri Lankan style and a lean measure of commemoratory monographs on the country's key Modernist painters. The list is telling for what it reveals as much as for what it hides: namely, the absence of contemporary art. Were this trove to include the veritable archive of pamphlets, leaflets, staple-stitched catalogues and newsprint brochures documenting the provocative array of art projects and exhibitions of the last 15 years, Sri Lanka's contemporary art activity would not be questioned. Importantly this ephemera might ultimately signal the strong roots and determined influence of contemporary art outside the mainstream but within the fringes of Sri Lanka's cultural activity.

Sri Lanka's fringe culture is economically sustained via the interests served by NGOs, including international foundations[1]. Their collective presence, which accounts for the largest source of infrastructural investment, conceals the critical lack of government-sponsored support for contemporary art. This deficiency of cultural policy, and political unwillingness to engage with contemporary art, has resulted in successive governments of the Independence era neglecting to address the role of contemporary art within broader strategies of cultural development. Not surprisingly, this predicament has spawned the creation of a meaningful counter-culture, with roots in the 43 Group, an artists' collective that combined the tenets of Modernism with the idioms of a culturally specific viewpoint, as a reaction to Victorian-style easel painting introduced under British occupation[2]. Since the formation of the group in 1943, however, much has changed. After independence from the British in 1949, hostilities between the new Socialist Republic of Sri Lanka and the armed Tamil separatists have dominated the country's cultural politics. As the cause of the country's slow demise into war, this civil rift has also created the circumstances for the ascendancy of a new wave of artistic engagement.

Like other capital cities, Colombo hosts the majority of Sri Lanka's contemporary art initiatives, organisations and artists[3]. Concentrated mostly in the maze of Colombo's outer suburbs, where lower land prices and rents prevail, the collective presence of this alternative culture, boosted by a number of important architectural practices, forms a burgeoning cultural network. It is here that the Vibhavi Academy of Fine Arts (VAFA)[4], an independent art school founded in 1993, and the Theertha International Artist's Collective[5], founded in 2001, are located. Led by artists, these ventures have evolved from small, interventionist-based initiatives into medium-scale cultural organisations. Fostering experimental and conceptual-orientated practices, their combined activities are pivotal in promoting critical discourse, curatorial frameworks and the development of a socially engaged practice. VAFA is an art school-cum-gallery founded to readdress the insular offerings of state sponsored art education and has offered training to many of Sri Lanka's progressive contemporary artists. The state-backed Institute of Aesthetic Studies, after years of strikes, departmental politics and apathetic teachers, aspires to emulate VAFA, benefiting the growing student body of artists. Though such changes might reflect VAFA's impact, similar questions of governance, resources and expertise seem likely to challenge VAFA's future. Such problems typify the progress of institutional bodies within a cultural economy, heavily reliant on goodwill, yet hard-pressed to grow beyond project-based initiatives.

The creation of a critical painting language owes much to Jagath Weerasinghe, whose expressionistic, turbulently painted depictions of broken Buddhist stupas, disenfranchised soldiers, dancing Shivas, political microphones and malevolent serpents embody one of the most provocative studies of political and religious violence in Sri Lanka. Contemporary art has flourished across several directions and spawned what continues to be a growing circle of emerging artists under the ambit of Weerasinghe and the Soviet-trained painter Chandraguptha Thenuwara, VAFA's founder, well-known for his process-based camouflage paintings.

Taking the lead in promoting the younger generation, Theertha's Red Dot Gallery provides a vital exhibition space. Formerly a house, this simple yet functional gallery focuses on showcasing an array of practices examining the malign influence of conflict within society. Anura Krishantha's fabrication of chairs from toy guns, Anoli Perera's crocheted lace installations and Pala Pothupitiya's ornately painted artificial limb sculptures are all examples of works that address the country's violence and social upheaval through materials resonant with form and meaning. Such works combine the sensibilities of a

Dada-esque anti-art aesthetic with the concrete realism of mundane existence. United more by collective association than stylistic similarity, the artists behind Theertha give expressive voice to the challenges of how or if art can engage with the violence of a conflict-ridden culture.

Outside Theertha, several artists have developed independent practices that by contrast acknowledge the presence of politics without recourse to remonstrative strategies or principled undertakings. Chief amongst them, Muhanned Cader, T Shanaathanan, Tissa de Alwis and Arjuna Gunaratne make extensive use of uncanny associations combining mythic and mundane references without visual constraint or illogic. In De Alwis' fantastical installations of miniature plasticine armies, recycled toothpaste caps and coat hangers assume the role of military headgear and futuristic flying machines. The use of appropriation to effect equivocal, often poetic compositions also belies Cader and Shanaathanan's whimsical drawings that frequently employ fragments of an image, such as Cader's collection of graphite doodles, collectively known as *79 Days in Lahore* or Shanathanan's beguiling combinations of Hindu mythology, torn maps and random incidents. For both artists, the use of collage lends a sense of order to an otherwise disembodied set of elements. The elusive character of much of this work – usually small-scale and/or on paper – shifts from large-scale expressions of violent terror seen in the last decade. Given the prevailing climate of political instability, such changes also give form to the resilient nature of artistic innovation in the face of adversity.

The momentum to innovate is restricted by resources and skills. In contrast to painting and drawing, work in new media and video is rarely explored. Photography has imaginatively been used to explore themes of memory in a photo-journalistic manner, as seen in the work of

Menike van der Porten or the photo-documents that record Pradeep Chandrasiri's 1997 *Broken Hand* installation. With the exception of T P G Amarajeeva's haunting photographic study of male conscription *Don't Measure Me*, 2001, experimental photography remains quietly absent. A situation that, at least unconsciously, might have arisen in consequence to the medium's own conscription by the state-controlled media and the instinctive preference by artists to work outside visual frameworks closely associated with the war effort. The relationship between art and the media is also characterised by a lack of informed art journalism in English, Tamil or Sinhala. Until independent initiatives in curatorship and scholarship expand further, art audiences will remain limited to a coterie of passionate yet dedicated individuals.

Affecting these developments is the inevitable challenge of the encroaching art market. Apart from important commercial galleries such as Barefoot Gallery[6] and Paradise Road[7], opportunities to view and buy contemporary art are mainly served through direct contact with artists. Theertha's Red Dot Gallery is exemplary as the first attempt to merge an artist's commercial and career interests. It is an impetus, likewise, explored by several local private collectors who have converted homes and offices to display contemporary art. Importantly both these precedents reveal an acute need for professional assistance to manage artists' careers and nurture collectors, to protect and value local interests competing with international markets. If such a transition can manage to overturn the adverse circumstances of the country's ongoing ethnic conflict in a manner that does not exploit it, the passage of contemporary art from the fringes to the foreground of contemporary culture promises to be a cause worth struggling for.

SHARMINI PEREIRA

[1] For example: Hivos, Ford Foundation, Lunuganga Trust, Goethe Institute, British Council, Neelan Tiruchelvan Trust and Colombo Institute for the Advanced Study of Society and Culture.
[2] The development of modern art in Sri Lanka is marked by the formation of the 43 Group in 1943, a collective of Sri Lankan middle-class, English-speaking artists who were opposed to the academic and culturally removed outlook propagated by the Ceylon Society of Arts (established in 1891 under British rule). The group was comprised of: Geoffrey Beling, George Claessen, Aubrey Collette, Justin Deraniyagala, Richard Gabriel, George Keyt, L.T.P Manjusri, Harry Pieris, Ivan Pieris and Lionel Wendt. The Sapumal Foundation, formerly the home of Harry Pieris, was established in 1974 to house a permanent collection of the 43 Group.
[3] The historic fort-city of Galle, located 119 km south of Colombo, plays host to the Galle Literary Festival.
[4] Vibhavi Academy of Fine Arts (VAFA) was founded by the artist Chandraguptha Thenuwara in 1993 upon his return from studies at the Moscow State Institute between 1985–1992. VAFA was originally started as the Vibhavi Fine Arts Studio, offering weekend classes in Fine Art to students unable to gain admittance to the Institute of Aesthetic Studies

(IAS). In 1995 it evolved into a non-government and non-profit institution under the auspices and funding from Hivos.
[5] Theertha was established in 2001 as an independent, artist-led, non-profit initiative aimed at promoting opportunities for contemporary artists across a broad program of activity. It is affiliated to the Triangle Arts Trust and the South Asian Network of KHOJ (India), Britto Arts Trust (Bangladesh), Sutra (Nepal) and Vasl (Pakistan). It was founded by the following artists: Jagath Weerasinghe, Anoli Perera, Chandraguptha Thenuwara, G R Constantine, Bandu Manamperi, Pradeep Chandrasiri, Koralegedera Pushpakumara, T P G Amarajeeva, Sarah Kumarasiri, Pala Pothupitiya and Anura Krishantha.
[6] The Barefoot Gallery is a commercial exhibition space located in the centre of Colombo. It exhibits artists from Sri Lanka and overseas and hosts a variety of live art events. It is attached to the retail outlet of the well-known handloom designer and artist Barbara Sansoni.
[7] Paradise Road Gallery holds solo exhibitions of upcoming and mid-career artists. It is housed in the former offices of the architect Geoffery Bawa, which was converted into a fashionable restaurant and retail design studio in the mid-1990s.

Naeem Mohaiemen
Another Baul Movement
2008
C-print

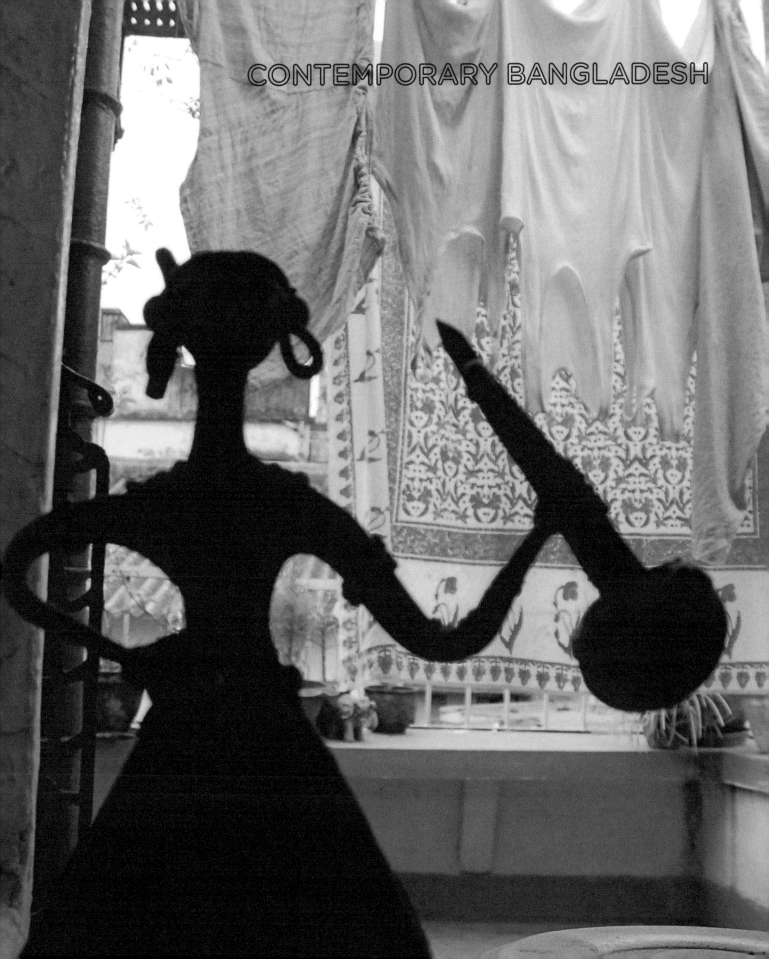

Very few utensils inhabit the cafeteria of the Bitopi advertising agency – mostly it's a holding room for a ping-pong table. On the wall behind it is a giant wall painting of a Dhallywood liquid movie poster. Splashed in day-glow concentric colour flows are the Bangla words 'Da Deadline'. A piss-take on irritated agency clients and the ember-frozen dhishoom Bangla film, the wall is a private joke. A recent art show flyer 'It's In The Paper' has been defaced to 'SHIt's In The Paper'. In a third corner, a movie poster of a giant Nordic man in battle mode. The title of this film is *Eric AasChe* – 'Eric is coming', Eric Aas being the former CEO of largest mobile company Grameenphone/Telenor (five of the top Bangladesh mobile phone operators are majority foreign owned and the un-integrated expatriate is a familiar and foreign presence).

Courtesy of old-lion agency Interspeed is another bizarre mix of ads on our TV screen. Celebrating the arrival of mobile phone towers to Chittagong Hill Tracts, the last area of Bangladesh that lacked phone coverage, these are willfully naive imaginaries of bucolic Pahari life. The colourful costume mela sets the tone for a fetish-ready tourist postcard. Hidden in plain sight is the history of an intermittent, 30-year guerilla war for the regional autonomy of the Jumma people – blind spot of Bangali nationalism. No space for people who look and talk nothing like us, but yes useful as props for regional sports meets. They sing, they dance, they wear colourful costumes (only disappointment is that they don't go topless). Look closely at images of smiling 'chinkie' boy and he is wearing an unmistakable army camo t-shirt. Given the fraught history of the Bangladesh Army as a pacification force in the hills, it seems a particularly twisted joke. I credit Interspeed for making image war a flatline element in daily work.

For the longest time, people complained about art school graduates heading to the agencies. Agency gula amader matha khailo. Mobile co's were the villains, but also British American Tobacco, Lux Soap, Rexona Sunsilk, Pran Mango, and yes yes Fair & Lovely. But for the artists who have risen to head creative or intermediate toolster at boutique agencies, crafting a condom ad with an explicit reference to oral, while evading mullah squad, can be more subversive than cha-stall lampooning of wealthy art collectors. Recent history shows that when we get invited to establishment space of Shilpakala or Chitrak, or new money sheen of Art Club and Bengal Gallery, the work is a pale shadow compared to low-stakes excursions in the commercial world.

Consider Shishir Bhattacharjee, one of the gifted surrealists of the Shomoy generation. His solo show in 2008 after a seven-year break showed him as a bravura showman taking on the military industrial complex. But he is really known to millions through phenomenal editorial cartoons in the *Prothom Alo* newspaper. Mayor Khoka as Donald Duck escaping from the mud pit of politics reflects, in 2x2 column size, the flying man-reversed grass-living sandal-tanks on parade cacophony of his Gallery Kaya show. This creates entertaining frisson when a garments millionaire turned art collector comments that he doesn't collect cartoonists. Rafiqun Nabi (now dean of art school Charukala department) began this trend in the 1970s with his cartoon character Tokai, the beggar boy with savage barbs at Gulshan elites. But Nabi separated this wily creation from his formalist canvas work, a divide that led to wintry morning shrinkage.

Nisar Hossain of Charukala reminds me that Bangla artists have historically found expression within commercial work rather than galleries. From television set design (Mustafa Manawar, Keramat Mowla), to industrial product decoration (Qamrul Hasan), to book covers for a voracious publishing industry. Abul Kashem, Pranesh Mandal, Hashem Khan and Golam Sarwar for text books, and Qayyum Chowdhury for high literature. The exploding popularity of Masud Rana brought Devdash Chakrabarty's photo collage to penny dreadful James Bond. In a pre-Mac time, the thin outlines where the glue had not set brought runny lipstick perversion to teenage readers.

A recent show of Indian artists originally from East Bengal reminded the viewer of Partition's rupture on the art space. Artists of Hindu origin (Paritosh Sen, Atul Bose, Somnath Hore, Bijan Chowdhury, Ganesh Haloi, Jogen Chowdhury, Haren Das) migrated to or stayed back in West Bengal after 1947, leaving both a gap and opportunity. Zainul Abedin, a supernova in the Kolkata art scene and Communist Party for his famine sketches, was recruited to start a new art academy in East Bengal/Pakistan. On the reverse flow, Muslim artists Qamrul Hasan, Shafiuddin Ahmed, Shafiqul Amin, Anwarul Huq, and Khaja Shofiq moved to Dhaka from West Bengal. It was from Zainul's academy that the next generation of artists, from Aminul Islam to Rashid Chowdhury and Abdur Razzaque, began their work. Charukala started in 1940s, but local resistance to image-making (described as idol worship by the Islamist bloc) prevented the opening of a sculpture department until 1968. Fast-forward to the current and installation, video and new media forms are entering at a glacial pace – perhaps it's a slow art movement, far from madding crowds.

Art and politics collided with the recent controversy over the statues of Baul Sufi mystics outside Zia International Airport. ZIA is always a space for contentious visual polarity. In a nod to the brackish influence of Gulf oil money in local politics, the airport's main facade now has its name in Arabic, Bengali and English – in a country where no one speaks Arabic except in the rote memorisation each of us learned while reading the Quran. Fakir Lalon and his current heirs of Bauliana, with their cocktail of Sufi mysticism, Hindu-Muslim syncretism, god-complexity lyrics and local art scene embrace, has always been anathema to traditionalists. The placement of the statues adjacent to the airport Hajj camp gave the Islamists a pitch-perfect cause – graven images next to pilgrims in waiting. On the day before the 118th death anniversary of Lalon, the army government caved in to pressure and removed the statues. The photo-op of enthusiastic 'Islamist' activists joining government officials in pulling down statues seemed a photocopy of Satyajit Ray's prediction in *Hirak Rajar Deshe*.

Forced involvement in national politics is necessarily healthy for local artists, bringing them out of institutional navel-gazing into larger questions of image making, ownership and their role as public intellectuals. Like the protests that torpedoed Musée Guimet's planned loan of artifacts from Bangladesh museums, the Baul statue supporters used art venues as organising spaces. Ad hoc coalitions formed around poets, writers, academics and fusion musicians such as Anusheh and Buno. As this confrontation plays out, the mobilisation will open up larger questions of critical cultural dissent, as Bangladesh re-enters an era of security state, surveillance culture and militarisation. While cultural players fetishise pre-NGO rural life and produce flat paintings for nouveau buyers, the messy conflict of defending Bauls while accepting corporate sponsorship of Lalon Mela promises some creative friction.

Sitting in architect Salahuddin Ahmed's Café Mango the other day, I saw out the window the mystery graffiti punks who spray 'MS-13' and 'Khilafat Boyz' all over Dhanmondi walls. Is this a mystery public art project waiting for decoding? A melding of Islamism and mobile culture? Or will excavations reveal that it's a clever campaign for a new computer coaching centre? Whichever way, it's like the label on the Dry Amla bottle. Tasty & Digestive. And then the ingredients: 'Honey, Amla etc'.

It's that etc that gives the culture wars the bitter, fruity taste of sugar and arsenic.

NAEEM MOHAIEMEN

INDIAN HIGHWAY I

Serpentine Gallery, London, UK
10 December 2008 to 22 February 2009
Exhibition within the Exhibition
STEPS AWAY FROM OBLIVION
Curators: Raqs Media Collective
(Jeebesh Bagchi, Monica Narula and
Shuddhabrata Sengupta)
Artists:
Debkamal Ganguly
Ruchir Joshi
M. R. Rajan
Raqs Media Collective
Priya Sen
Surabhi Sharma (together with
Gautam Singh)
Kavita Pai / Hansa Thapliyal
Vipin Vijay

INDIAN HIGHWAY II

Astrup Fearnley Museum of Modern Art,
Oslo, Norway
02 April to 6 September 2009
Exhibition within the Exhibition
ON THE ROAD TO THE NEXT
MILESTONE
Curator: Bose Krishnamachari
Artists:
Anant Joshi
Riyas Komu
Prajakta Potnis
Sumedh Rajendran
Sudarshan Shetty
Avinash Veeraraghavan
Vivek Vilasini

INDIAN HIGHWAY III

HEART, Herning Museum of Contemporary
Art, Herning, Denmark.
13 March to 12 September 2010
Exhibition within the Exhibition
FILM PROGRAMME
Curator: Shilpa Gupta
Artists:
Nikhil Chopra
Baptist Coelho
Sunil Gupta
Tushar Joag
Sonia Khurana
Nalini Malani
Kiran Subbaiah
Vivan Sundaram

INDIAN HIGHWAY IV

General curatorship
Artistic direction under the supervision of
Julia Peyton-Jones, Hans Ulrich Obrist,
Serpentine Gallery
and Gunnar B. Kvaran, Astrup Fearnley
Museum

Lyon curatorship
Curator: Thierry Raspail, Director of
macLYON
Exhibition design: Thierry Prat, Production
Manager

Exhibition assistant
Marilou Laneuville

Registrar
Xavier Jullien

Student support
Delphine Bellon
Laurenne Gat
Marc Szaryk
Maud Tainturier

Musée d'art
Contemporain de Lyon

Director
Thierry Raspail
assisted by Françoise Haon

Production manager
Thierry Prat

Administration
François-Régis Charrié
assisted by Catherine Zoldan

Conservation
Hervé Percebois

Press office
Muriel Jaby
assisted by Elise Vion-Delphin

Education
Isabelle Guédel

Exhibition
Isabelle Bertolotti

Technical services
Olivier Emeraud
assisted by Samir Ferria
and Didier Sabatier

With the additional assistance of
Chantal Alcalde
Maria Arquillière
Marie-Claude Bellion
Eryck Belmont
Georges Benguigui
Nabila Benkhelifa
Yves Blanchard
Sylvie Bouguet
Estelle Cherfils

Karel Cioffi
André Clerc
Patricia Creveaux
Serge Dalleau
Philippe Demares
Didier Fabrer
Yvette Gabiaud
Christine Garcia-Pedroso
Anne-Sophie Gaumy
Régis Gire
Nathalie Janin
Gaëlle Philippe
Monique Renard
Anne-Marie Reynaud
Pascal Rohr
Franck Segura
Fanny Thaller
Frédéric Valentin
Elisabeth Vican

Installation:
Bastien Aubry
Frédéric Bauby
Loïc Charbonneau
Russell Childs
Karine Delerba
Anne-Sophie Duranson
Pascal Gabaud
Anne-Lyse Gaudet
Yann Granjon
Marie Grosdidier
Karim Kal
Yann Lévy
Gaël Monnerau
Rodolphe Montet
Laurent Morati
Jean-Robin Poirot
Damir Radovic
David Rolandey
Fiorella Scarabino
Julie Sorrel
Philippe Spader
Bruno Spay
Benoît Stéfani
Magali Vincent

Gallery staff:
Sandra Aguirre
Sylvain André
Joséphine Bellon
Rodolphe Besset
Mickaël Bottollier-Depois
Ludivine Combes
Rachel Decloitre
Géraldine Ferra
Jean-Yves Gay
Delphine Graciotti
Jérémy Parrot
Aurélien Specogna
Nina Suiffet
Miglena Thomasset
Coline Voignier

Media services:
Amandine Bonnassieux
Emmanuelle Coqueray
Virginie Duthil
Guillaume Perez
Stéphanie Royer

Acknowledgements:

We would like to express our warmest thanks to all the artists, without whom the exhibition could not have been what it is, as well as to all the lenders.

Collection Astrup Fearnly Museum, Oslo
Collection Shumita and Arani Bose, New York
Collection D. Daskalopoulos
Collection Monica de Cardenas
Collection Ruggero and Rebecca Fiorini
Collection Frahm, Londres
Collection Niall and Sunitha Kumar Emmart
Collection Marco Marrone
Courtesy Arndt, Berlin
Courtesy CAMP, Mumbai
Courtesy Chemould Prescott Road, Mumbai
Courtesy Chitra Karkhana, Mumbai
Courtesy Frith Street Gallery, London
Courtesy Galerie Emmanuel Perrotin, Paris
Courtesy Galerie Lelong, Paris
Courtesy Galerie Marian Goodman, Paris / New York
Courtesy Galleria Continua, San Gimignano / Beijing / Le Moulin
Courtesy GALLERYSKE, Bangalore
Courtesy Hauser & Wirth, Zurich and London
Courtesy Haunch of Venison, London
Courtesy In Situ, Fabienne Leclerc, Paris
Courtesy Luce Gallery, Turin
Courtesy Nature Morte, Berlin
Courtesy Project 88, Mumbai
Courtesy Sakshi Gallery, Mumbai
Courtesy Serpentine Gallery, London
Courtesy The Guild, Mumbai and New York
Courtesy Thomas Erben Gallery, New York
Courtesy Victoria Miro Gallery, London
Courtesy Yvon Lambert, Paris, New York

And in particular
Diane Amiel
Kushal A.N.
Grete Årbu
Matthias Arndt
Myriam Attali
Samuel Barclay
Florian Berktold
Carole Billy
Floria Boillot
Arani Bose
Shumita Bose
Maria Brassel
Marion Brun
Julie Burchardi
Vijay Dalsukh Parmar
Dimitris Daskalopoulos
Rebecca Davies
Monica de Cardenas
Sanyogita Deo
Caroline Dowling
Thomas Erben
Claire Feeley
Agnès Fierobe
Ruggero and Rebecca Fiorini
Elise Foster Vander Elst
Nicolai Frahm

Jean Frémon
Shireen Gandhy
Usha Gawde
Sree Goswami
Jane Hamlyn
Sara Harrison
Whitney Hintz
Tom Hunt
Abhinit R. Khanna
Toby Kress
Sunitha Kumar Emmart
Sadashiv Kuncolienker
Yvon Lambert
James Lavender
Marcel Lawson Body
Fabienne Leclerc
Julia Lenz
Shabnam Lilani
Erin Manns
Marco Marrone
Dale McFarland
Geetha Mehra
Eglantine Mercadet
Nina Miall
Victoria Miro
Maneksha Monteiro
Julie Morhange
Gregor Muir
Deepti Mulgund
Peter Nagy
Nicolas Nahab
Amruta Nemivant
Leonie Nichol
Dimitris Paleocrassas
Emmanuel Perrotin
Johan Pijnappel
Sandhini Poddar
Prateek
Julia Prezewowsky
Sunny Pudert
Sadia Rehman
Shalini Sawhney
Navin Shende
Abhinav Singh
Tobias Sirtl
Annapriya Sleight
Aarthi Sridhar
Emma Starkings
Matt Watkins
Iwan Wirth

We would also like to thank the contributors to this catalogue:
Savita Apte
Sarnath Banerjee
Kaushik Bhaumik
Bharati Chaturvedi
Iftikhar Dadi
Suman Gopinath
Leila Hasham
Ranjit Hoskote
Shanay Jhaveri
Geeta Kapur
Maya Kóvskaya
Naeem Mohaiemen
Rebecca Morrill
Amruta Nemivant
Sharmini Pereira
Vyjayanthi Rao
Sakshi Gallery

Sumakshi Singh
Studio Mumbai Architects
Alok G. Sudarshan
Thukral and Tagra
Hema Upadhyay
Grant Watson

Lastly, we wish to express our gratitude to Vidya Shivadas and Deepti Mulgund for organizing, with the collaboration of Bose Krishnamachari, a round of visits to art studios in Bombay and New Delhi in June 2010.

Acknowledgments for *Indian Highway I*

Trustees of the Serpentine Gallery
Lord Palumbo *Chairman*
Felicity Waley-Cohen and
Barry Townsley *Co-Vice Chairmen*
Marcus Boyle *Treasurer*
Patricia Bickers
Mark Booth
Roger Bramble
Marco Compagnoni
David Fletcher
Bonnie Greer
Zaha Hadid
Rob Hersov
Peter Rogers
Colin Tweedy

40ᵗʰ Anniversary Founding Benefactors
Jeanne and William Callanan
The Highmont Foundation
The Luma Foundation
And Founding Benefactors who wish to
remain anonymous

Council of the Serpentine Gallery
Rob Hersov *Chairman*
Marlon Abela
Basil and Raghida Al-Rahim
Shaikha Paula Al-Sabah
Goga Ashkenazi
Mr and Mrs Harry Blain
Mr and Mrs F. Boglione
Mark and Lauren Booth
Sarah and Ivor Braka
Alessandro Cajrati Crivelli
Jeanne and William Callanan
Raye Cosbert
Aud and Paolo Cuniberti
Carolyn Dailey
Guy and Andrea Dellal
Griet Dupont
Denise Esfandi
Jenifer Evans
Mark Evans
Lawton W. Fitt and James I.
McLaren Foundation
Kathrine and Cecilie Fredriksen
Jonathan Goodwin
Mr and Mrs Lorenzo Grabau
Richard and Odile Grogan
Mala and Oliver Haarmann
Susan and Richard Hayden
Jennifer and Matthew Harris
Michael Jacobson
Mr and Mrs Tim Jefferies
Dakis Joannou
Ella Krasner
Mr and Mrs Jonathan Lourie
The Luma Foundation
Giles Mackay
Pia-Christina Miller
Martin and Amanda Newson
Catherine and Franck Petitgas
Eva Rausing
The Red Mansion Foundation
Yvonne Rieber
Thaddaeus Ropac
Spas and Diliana Roussev
Robin Saunders and

Matthew Roeser
Silvio and Monica Scaglia
Anders and Yukiko Schroeder
Robert Tomei
Andrei Tretyakov
Andy Valmorbida
Robert and Felicity Waley-Cohen
Bruno Wang
Andrew and Victoria Watkins-Ball
Mr and Mrs Lars Windhorst
Manuela and Iwan Wirth
Anna and Michael Zaoui
And members of the Council who wish to
remain anonymous

Council's Circle of the Serpentine Gallery
Eric and Sophie Archambeau
Len Blavatnik
Wayne and Helene Burt
Nicholas Candy
Edwin C. Cohen and
The Blessing Way Foundation
Ricki Gail Conway
Marie Douglas-David
Johan Eliasch
Joey Esfandi
The Hon Robert Hanson
Petra and Darko Horvat
Mr and Mrs Michael Hue-Williams
Jolana Leinson and Petri Vainio
Elena Bowes Marano
Jimmy and Becky Mayer
Matthew Mellon, in memory of Isabella Blow
Tamara Mellon
J. Harald Orneberg
Stephen and Yana Peel
Olivia Schuler-Voith
Mrs Nadja Swarovski-Adams
Phoebe and Bobby Tudor
Hugh and Beatrice Warrender
Michael Watt
John and Amelia Winter
And members of the Council's Circle who
wish to remain anonymous

Founding Corporate Benefactor
Bloomberg

Exclusive Professional Services Adviser
Deloitte LLP

Platinum Corporate Benefactors
Arup
Bloomberg
BlueLabel
Design Supermarket, La Rinascente
Finch & Partners
The Independent
Jaguar Cars
Mace Group
Meyer Sound
Omni Colour Presentations
Pringle of Scotland
Stanhope Plc
Weil, Gotshal & Manges

Gold Corporate Benefactors
Arper
Elliott Thomas
The Kensington Hotel

Laurent-Perrier
RBC Mobilier
Stage One
The Times
Wallpaper

Silver Corporate Benefactors
AEL Solutions / Stobag
Hasmead Plc
Knight Frank LLP
Kvadrat
NG Bailey
Perspex Distribution Ltd
The Portman Estate
Sake no Hana
Vitra
Westbury Polo Bar

Bronze Corporate Benefactors
Absolute Taste Ltd
agnès b
Ainscough Crane Hire Ltd
The Arts Club, Mayfair
Barbed Ltd
By Word of Mouth
Campeggi srl
The Coca-Cola Company
Davis Langdon LLP
De Beers Diamond Jewellers Ltd
DLD Media GmbH
DP9
DPA Microphones
Eckelt Glas
Emeco
EMS
Established & Sons
Ethos Recycling
Fermob
Floorscreed Ltd
Flos
Fred & Fred
Graphic Image Solutions Ltd
The Groucho Club
GTL Partnership
Hiscox
HTC
The Hub
J. Coffey Construction
John Doyle Group
Lend Lease Projects
Le Petit Jardin
Lettice
LMV Design
Maker's Mark
Morgan Stanley
Next Maruni
Phoenix Electrical Company Ltd
Ronacrete
Samsung
Site Engineering Surveys Ltd (SES)
Smeg Ltd
Smoke & Mirrors
Swift Horsman (Group) Ltd
Table Tennis Pro
Warburg Pincus International LLC
we-ef
Wingate Electrical Plc

Catherine Patha
Anja Pauls
Julia Pincus
Carlos and Francesca Pinto
Harry Plotnick
Julia Prestia
Mike Radcliffe
Farah Rahim Ismail
Laurent Rappaport
Piotr Rejmer
Alexandra Ritterman
Claudia Ruimy
Poppy Sebire
Xandi Schemann
Alyssa Sherman
Tammy Smulders
Christopher Thomsen
Jonathan Tyler
Andy Valmorbida
Mr and Mrs Vincent Van Heyste
Rachel Verghis
Sam Waley-Cohen
Trent Ward
Lucy Wood
Omar Giovanni Zaghis
Mr and Mrs Nabil Zaouk
Fabrizio D. Zappaterra

Benefactors

Mr and Mrs Allahyar Afshar
Shane Akeroyd
Mr Niklas Antman and Miss Lisa Almen
Paul and Kia Armstrong
Jane Attias
Anne Best and Roddy Kinkead-Weekes
Roger and Beverley Bevan
Anthony and Gisela Bloom
Mr and Mrs John Botts
Marcus Boyle
Mervyn and Helen Bradlow
Vanessa Branson
Benjamin Brown
Ed Burstell
Mrs Tita Granda Byrne
Lavinia Calza Beveridge
Azia Chatila
Paul Clifford
Sadie Coles
Carole and Neville Conrad
Matthew Conrad
Gul Coskun
Yasmine Datnow
Mr and Mrs Christopher Didizian
Robin and Noelle Doumar
Mike Fairbrass
Mr and Mrs Mark Fenwick
John Ferreira
Hako and Dörte, Graf and Gräfin von Finckenstein
David and Jane Fletcher
Eric and Louise Franck
Alan and Joanna Gemes
Zak and Candida Gertler
Leonardo and Alessia Giangreco
Hugh Gibson
Peter Gidal
David Gill
Dimitri J. Goulandris
Richard and Judith Greer
Linda and Richard Grosse

Louise Hallett
Liz Hammond
Jeremy Hargreave
Susan Harris
Timothy and Daška Hatton
Maria and Stratis Hatzistefanis
Alison Henry
Mrs Christine Johnston
Marcelle Joseph and Paolo Cicchiné
Jennifer Kersis
James and Clare Kirkman
Mr and Mrs Lahoud
Geraldine Larkin
George and Angie Loudon
Sotiris T.F. Lyritzis
Mr Otto Julius Maier and Mrs Michèle Claudel-Maier
Cary J. Martin
Mr and Mrs Stephen Mather
Ruth and Robert Maxted
Viviane and James Mayor
Warren and Victoria Miro
Gillian Mosely
Dr Maigaelle Moulene
Georgia Oetker
Tamiko Onozawa
Teresa Oulton
Desmond Page and Asun Gelardin
Maureen Paley
Dominic Palfreyman
Midge and Simon Palley
Julia Peyton-Jones OBE
Sophie Price
Mathew Prichard
Mrs Janaki Prosdocimi
Ashraf Qizilbash
Bruce and Shadi Ritchie
Kasia Robinski
Kimberley Robson-Ortiz
Jacqueline and Nicholas Roe
Victoria, Lady de Rothschild
James Roundell and Bona Montagu
Michael and Julia Samuel
Ronnie and Vidal Sassoon
Joana and Henrik Schliemann
Nick Simou and Julie Gatland
Bina and Philippe von Stauffenberg
Tanya and David Steyn
Simone and Robert Suss
The Thames Wharf Charity
Britt Tidelius
Gretchen and Jus Trusted
Audrey Wallrock
Lady Corinne Wellesley
Alannah Weston
Helen Ytuarte White
Dr Yvonne Winkler
Mr Ulf Wissen
Henry and Rachel Wyndham
Mr and Mrs Nabil Zaouk
And Patrons, Future Contemporaries and Benefactors who wish to remain anonymous.

Supported by
Arts Council England
The Royal Parks
Westminster City Council

Special Thanks To
The British High Commissioner to India His Excellency Sir Richard and Lady Stagg
Nancy Adajania
V N Aji
Navjot Altaf
Anupam Bansal
Zainab Bawa
Poonam Bhagat
Nitin Bhayana
Carole Billy
Flora Boillot
Shumita and Arani Bose
Rattan Chadha
Miriam Chandy Menacherry
Mortimer Chatterjee
Radhika Chopra
Sangeeta Chopra
Zasha Cooah
Richard Couzins
Gillian Da Costa
Carolyn Dailey
William Dalrymple
Bidyut Das
Anshuman Dasgupta
Devika Daulat-Singh
Anita Dawood
Shezad Dawood
Mary-Ann Denison-Pender
Mukul Deora
Chris Dercon
Rajesh Dongre
Balkrishna Doshi
Dilip D'Souza
Joyce D'Souza
Anita Dube
Lyn Dyer
Sunitha Kumar Emmart
Kodwo Eshun
Jacqueline Fernandes
Agnès Fierobe
Paul Frantz
Jean Fremon
Toby Froschauer
Shireen Gandhy
Sunil Gawde
Usha Gawde
Pheroza J Godrej
Marian Goodman
Jane Hamlyn
Sara Harrison
Ursula Hauser
Ann Huber-Sigwart
Catia von Huetz
Farah Rahim Ismail
Anubha Jayant Dey
Priya Jhaveri
Amit Judge
Zehra Jumabhoy
Reena Kallat
Rajeev Kathpalia
Pankaj Kaushal
Anurag Kashyap
Radhika R Khimji
Lakshmi Kutty

317

Tara Lal
Julia Lenz
Celia Lilly
Rajeev Lochan
Madhavi Tangella
Nivedita Magar
Sarat Maharaj
Mamta Mantri
Geetha Mehra
Rahul Mehrotra
Yogesh Mehta
Nina Miall
Usha Mirchandani
Victoria Miro
Renu Modi
Sharmistha Mohanty
Mamta Murthy
Hammad Nasar
Peter Nagy
Amruta Nemivant
Bob Pain
Khushnu Panthaki Hoof
Vipul Patel
Stéphane Paumier
Don Bosco Peter
Johan Pijnappel
Rochelle Pinto
Anupam Poddar
Lekha Poddar
Rashmi Poddar
Sandini Poddar
Maithili Pradhan
Marc Quinn
Niru Ratnam
Sharmistha Ray
Sadia Rehman
Rotem Ruff
Sadan Jha
Anjalika Sagar
Namita Saraf
Abhay Sardesai
Ritu Sarin
Rakhi Sarkar
Shalini Sawney
Charlotte Schepke
Rajeeve Sethi
Czaee Shah
Rajesh Shah
Suketu Shah
Kumar Shahani
Deepak Shahdadpuri
Nirupama Shekhar
Niyatee Shinde
Vandana Shiva
Vidya Shivadas
Laxman Shreshtha
Bharat Sirka
Tenzing Sonam
Pooja Sood
Gerhard Steidl
Claudia Stockhausen
Deepak Talwar
Sheba Tegani
Arun Vadehra
Parul Vadehra
Ritu Vadehra
Roshini Vadehra
Dinesh Vazirani
Minal Vazirani
Chitra Venkataramani

Schweta Wahi
Felicity Waley-Cohen
Matt Watkins
Iwan Wirth

Credits

Artwork Credits

Aicon Gallery, London, p 167
Arario Gallery, New York, pp 100, 169, 171,
174-175
Arndt, Berlin, pp 142-143
Atelier Calder, Saché and CNAP, p 271
Bose Pacia, New York, pp 78-79, 260-261
Chatterjee & Lal, Mumbai, pp 57, 61
Chemould Prescott Road, Mumbai, p 265
Collection Shumita and Arani Bose, New
York, pp 76-77
Collection Dp Daskalopoulos, pp 163-165
Collection Monica de Cardenas, p 180
Collection Frahm, London, pp 217, 219-220
Collection Reshma and Ashish Jain, p 222
Collection Niall and Sunitha Kumar
Emmart, pp 113, 116-117
Collection Marco Marrone, p 182
Espace Claude Berri, Paris, p 267
Foundation for Indian Contemporary Art,
New Delhi, p 55
Frank Cohen, p 183
Frith Street Gallery, London, pp 193, 195,
196-199, 225, 227-229
Galerie Lelong, Paris, pp 172-173
Galleria Continua, San Gimignano / Beijing
/ Le Moulin, p 94
Gallery 1 x 1, Dubai, p 270
Gallery Espace, New Delhi, p 54
GALLERYSKE, Bangalore, pp 81, 83-87, 113,
115, 116-119, 221, 223
Green Cardamon, London, p 301
Haunch of Venison, London, pp 137, 140-141
Hauser & Wirth, Zurich and London, pp 99,
155, 157
In situ / Fabienne Leclerc, Paris, pp 97,
102-103
Jack Shainman Gallery, New York, pp 156,
158-159
KHOJ International Artists' Association,
pp 59, 190
Luce Gallery, Turin, pp 177, 179
Marian Goodman Gallery, Paris, pp 145,
147-151
Montalvo Arts Residency, Saratoga, p 55
MpSp University, Baroda, pp 49, 52-53

Nature Morte, New Delhi, p 101
Project 88, Mumbai, pp 41, 43-47, 49, 51,
52-53
Raking Leaves, London, p 305
Sakshi Gallery, Mumbai, pp 108-109, 166,
209, 211-215
Steidl, Germany, pp 230-231
Studio La Città, Verona, pp 268-269
The Guild, Mumbai and New York, pp 185,
187-189
Vadehra Gallery, New Delhi, p 123
V&A Images / Victoria & Albert Museum,
London, p 295
Victoria Miro Gallery, London, pp 105, 107
Yashodhara Dalmia, p 181
Yogesh Mehta, pp 124-125
Yvon Lambert, Paris, New York, pp 91-92,
94-95

Photographic Credits

Blaise Adilon, pp 97, 102-103
Nikhil Arolkar, pp 65, 67-71
Didier Barroso, p 94
Hélène Binet, pp 275 (below), 282-283
Guillaume Blanc, p 271
Mike Bruce, p 153
Sylvain Deleu, pp 193, 196
Alex Delfanne, pp 198-199
David Ettinger, pp 235-237, 239
David Flores, pp 76-79, 257, 260-262
Parastou Forouhar, p 190
Julia Fuchs, p 75 (right)
Bill Gidda, p 230
Hugo Glendinning, p 99
Katrin Guntershausen, pp 148-149
Iris Dreams, Mumbai, pp 9, 140-143
Munir Kabani, pp 57, 61-62
Mallikarjun Katakol, p 105
Andy Keate, p 155
Mark Lapwood, p 60
Vinay Mahidhar, pp 217, 219-223
Roman März / documenta GmbH, p 75 (left)
Naeem Mohaiemen, p 309
Girish Patil, pp 169, 172-174
Johan Pijnappel, p 171
Anil Rane, pp 209, 211-215, 265
Vinod Sebastian, pp 81, 83
Michele Sereni and Beatrice Barbuio, Italy,
pp 268-269
Norbert Thigulety, p 197
Stephen White, p 107

Published on the occasion of the exhibition *Indian Highway IV* at the Musée d'art contemporain de Lyon, 24 February to 31 July 2011.

Indian Highway I was presented at the Serpentine Gallery, London, 10 December 2008 to 22 February 2009; *Indian Highway II* was presented at the Astrup Fearnley Museum of Modern Art, Oslo, 2 April to 6 September 2009 and *Indian Highway III* was presented at Heart – Herning Museum of Contemporary Art, Denmark, 13 March to 12 September 2010. Following its presentation at Musée d'art contemporain de Lyon, *Indian Highway* will then tour to institutions including MAXXI, Rome and Garage Centre for Contemporary Culture (CCC), Moscow.

Indian Highway IV has been reselected by Thierry Raspail, Director, Musée d'art contemporain de Lyon. The exhibition is based upon *Indian Highway I*, curated by Julia Peyton-Jones, Director, Hans Ulrich Obrist, Co-Director, Serpentine Gallery, and Gunnar B Kvaran, Director, Astrup Fearnley Museum.

Indian Highway IV is a revised and expanded edition of *Indian Highway*, edited by Serpentine Gallery, London, 2008, and first published by Koenig Books, London, 2008. In addition to the texts featured in *Indian Highway*, this updated version of the catalogue includes new entries by critics and participating artists, which have been kept in their original, unedited form.

The opinions expressed in this publication are those of the authors and may not reflect the views of the publishers.

Sponsored by

with additional support from

 FOUNDATION FOR INDIAN CONTEMPORARY ART

outset.

with additional in-kind support from

ARUP

 ZUMTOBEL

DP9

The exhibition *Indian Highway IV* has been staged with the public and private support of:

The City of Lyon, and in particular the City of Lyon Department of Cultural Affairs, Ministry of Communication and the Arts, Regional Department of Cultural Affairs (Rhône-Alpes).

Evene.fr, UGC, 20 Minutes

The Astrup Fearnley Museum of Modern Art is generously supported by the Thomas Fearnley, Heddy and Nils Astrup Foundation, and Astrup Fearnley AS.

The Serpentine Gallery is generously supported by

 Supported by City of Westminster · THE ROYAL PARKS

Edited by
Kathleen Madden & Thierry Prat, assisted by Marilou Laneuville

Translation (Preface Thierry Raspail)
John Doherty

Copy-edited by
Sam Phillips & Thierry Prat, assisted by Marilou Laneuville

Original design by
APFEL (A Practice for Everyday Life)

Layout by
Andreas Tetzlaff (probsteibooks), Cologne

Produced by
DZA Druckerei zu Altenburg GmbH

Printed in Germany

First published by Koenig Books, London
Koenig Books Ltd
at the Serpentine Gallery
Kensington Gardens
London W2 3XA
www.koenigbooks.co.uk

Distribution
in Germany, Austria and Switzerland
Buchhandlung Walther König, Köln
Ehrenstr. 4, 50672 Köln
T: +49 (0)221/20 59 6-53
F: +49 (0)221/20 59 6-60
verlag@buchhandlung-walther-koenig.de

Outside the United States and Canada, Germany, Austria and Switzerland
Thames and Hudson Ltd, London
www.thamesandhudson.com

United States and Canada
D.A.P./Distributed Art Publishers, Inc.
155 6th Avenue, 2nd Floor
New York, NY 10013
T: +1 (0) 212 / 627-1999
F: +1 (0) 212 / 627-9484
eleshowitz@dapinc.com

ISBN 978-3-86560-963-2

Serpentine Gallery

Serpentine Gallery
Kensington Gardens
London W2 3XA
T +44 (0) 7402 6075 / F +44 (0) 7402 4103
www.serpentinegallery.org

 ASTRUP FEARNLEY MUSEET FOR MODERNE KUNST
ASTRUP FEARNLEY MUSEUM OF MODERN ART

Astrup Fearnley Museum of Modern Art
Dronningens gate 4
Oslo, Norway
T +47 22 93 60 60 / F +47 22 93 60 65
www.afmuseet.no

 musée d'art contemporain de Lyon

Musée d'art contemporain de Lyon
Cité Internationale
81 quai Charles de Gaulle
69006 Lyon
T +33 (0) 4 72 69 17 17 / F +33 (0) 4 72 69 17 00
www.mac-lyon.com